New Orleans Museum of Art

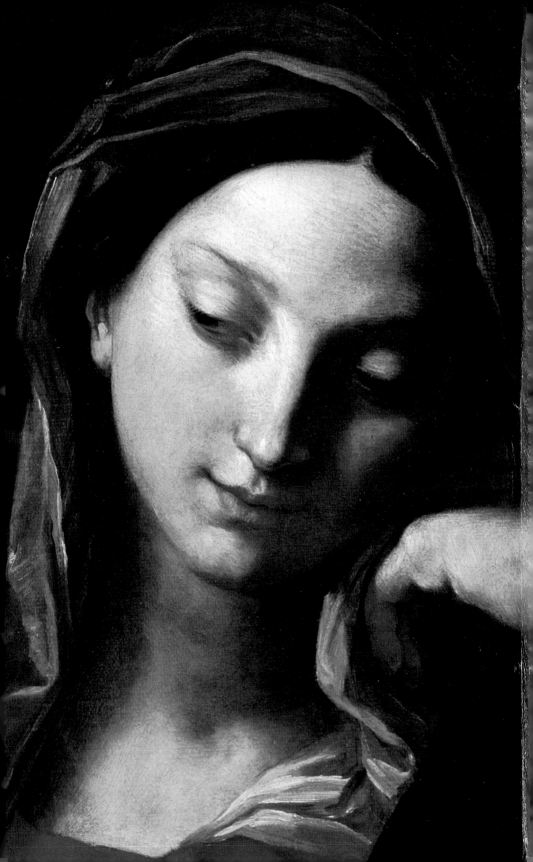

New Orleans Museum of Art

Selected by E. John Bullard

Coordinated by Sharon E. Stearns

Entries written by

Stephen Addiss

Joan G. Caldwell

Edward P. Caraco

William A. Fagaly

Cheryl Felder

Cybele E. Gontar

John W. Keefe

Renee K. Levine

Steven V. Maklansky

Lisa Rotondo-McCord

Steven G. Schmidt

Sharon E. Stearns

Paul J. Tarver

This publication was made possible by generous grants
from the National Endowment for the Arts, Washington, D.C., a Federal Agency,
and The Ella West Freeman Foundation, New Orleans.

Published on the occasion of the 85th anniversary of the New Orleans Museum of Art.

ISBN 0-89494-051-1

Library of Congress Catalog Card Number: 95-69921

Design by Ed Biggs, New Orleans, LA
Editorial assistance by Floyd Zula, Fullerton, CA
Photographs of art works by Owen Murphy, New Orleans, LA
Photographs of building by Alan Karchmer, Washington, D.C.
Printed by Garrity Printing, New Orleans, LA

CONTENTS

Since the publication of the first *Handbook of the Collection* of the New Orleans Museum of Art in 1980 nearly 8,000 new works of art have been acquired for the collection. So it was an even more difficult task to select from the current total of 40,000 works just 300 examples to illustrate the strengths and breadth of eighty-five years of collecting by a public art museum. Inevitably many beautiful and unique works had to be left out of the new *Handbook*. The true purpose of this publication is to give the reader, whether a past or future visitor to the Museum, an overview of the richness of a collection which encompasses four thousand years of world art.

In 1910 Isaac Delgado provided funds to build an art museum for his adopted city of New Orleans, only the third such institution to open in the Southeastern United States. Delgado envisioned the museum as a "temple of art for rich and poor alike." Today his vision has been fulfilled, even surpassed. In 1993 a $23 million, fifty-five thousand square foot addition was opened which, combined with a complete renovation of the original Delgado building and its first 1972 additions, created a state-of-the-art facility totaling 130,000 square feet. The principal aim of the expansion was to provide greatly increased exhibition space for the permanent collection. This has been magnificently achieved in forty-six galleries where visitors may now see for the first time the great diversity and high quality of NOMA's art collection.

This publication is the result of the collaborative effort of the Museum's curatorial staff. The overall supervision of the project was the responsibility of Sharon E. Stearns, Curator of European Art. The individual entries for each art work were written by the curators of the collection and their assistants, who are listed on the title page. I deeply appreciate the considerable effort made by the staff to produce this new *Handbook*. The high quality of our curators' professional expertise is a resource in which the Museum takes great pride.

A number of other individuals and organizations also contributed to the success of this project. Prescott N. Dunbar, longtime trustee and author of the 1990 history of NOMA, *The New Orleans Museum of Art: The First Seventy-five Years*, wrote a succinct introduction about the formation of the collection. This new *Handbook* has been produced in full color from transparencies made by Owen Murphy, the Museum's able photographer. The handsome design of the *Handbook* is the creative product of Ed Biggs, who has designed many of the Museum's recent publications. The Museum is most grateful for the generous financial support for this project received from the National Endowment for the Arts, Washington, D.C., and The Ella West Freeman Foundation, New Orleans.

The *Handbook* documents the tremendous effort made during the past eight-five years by trustees and collectors who contributed so magnificently to the formation and growth of the collection. When the Museum first opened in 1910 it owned not one work of art. Building a collection of national stature has been possible only with the generosity of individual donors of both works of art and purchase funds. The *Handbook of the Collection* of the New Orleans Museum of Art is dedicated to their collective vision, the equal of Isaac Delgado's, of a great art museum for the citizens of New Orleans and Louisiana.

E. John Bullard, Director

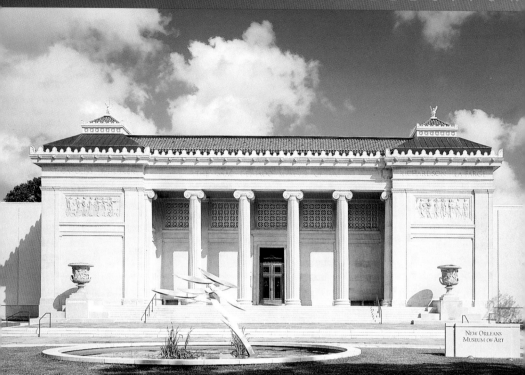

1910

was a propitious year for the founding of an art museum in New Orleans. Historically the most cosmopolitan city in the region, New Orleans was enjoying a new prosperity. Fortunes were being made in shipping, import and export, finance, and agriculture in the City, then the third busiest seaport in the United States with 339,000 inhabitants. Isaac Delgado was one of the most successful of the new generation of civic and business leaders. Born in Jamaica in 1839, Delgado arrived in New Orleans at the age of fourteen, later joining the sugar business founded by his uncle, Samuel Delgado.

A millionaire bachelor with no heirs, Delgado dispersed his fortune to several New Orleans charities. In 1905 he gave $180,000 to Charity Hospital, while he eventually bequeathed the bulk of his estate to establish what is now the Delgado Community College. In February 1910 Delgado offered to donate $150,000 to construct an art museum in City Park. The Commissioners of the City Park Improvement Association accepted his generous gift by providing an appropriate site and a national competition was immediately announced for the design of the building. The winning design, submitted by Samuel A. Marx of the Chicago firm of Lebenbaum & Marx, was for a handsome neo-classic Beaux Arts structure, described by the young architect as, "inspired by the Greek [but] sufficiently modified to give a subtropical appearance."

When the Isaac Delgado Museum of Art was opened to the public on December 16, 1911, it was only the third such institution in the South. Since Delgado had provided no funds for the maintenance of the Museum or for the acquisition of works of art, the City of New Orleans was called upon to provide an annual appropriation for the operating budget, while the exhibition program was sponsored by local art organizations, particularly the Art

Association of New Orleans. Works in the inaugural exhibition, including 400 paintings and a number of plaster casts of antique sculptures, were lent primarily by local collectors. To build its permanent art collection, the Museum had to depend on the generosity of individuals and organizations interested in art.

During the years before World War I, enthusiasm for the Museum ran high in the community and several art collections were donated that served as the core of the permanent holdings for many decades. First, in 1912 Major Benjamin M. Harrod bequeathed a group of paintings to the Museum, most by Louisiana artists, including two landscapes by Richard Clague. In 1914 the Museum received the bequest of the Morgan Whitney collection of Chinese jades and other hard stone carvings, which were cataloged and illustrated that year in the Museum's first scholarly publication. Also received in 1914 was a collection of fifty-six pieces of American and European silver, including works by the New Orleans firm of Hyde & Goodrich, the gift of Eugenia U. Harrod in memory of her husband Benjamin M. Harrod. In 1916 Alvin P. Howard gave his collection of Greek vases and ancient glass.

By far the most important art donation received by the Museum during its first forty years was the collection of paintings and sculpture by various 19th century French Salon, Barbizon School and Munich Group artists, bequeathed in 1915 by Mrs. Chapman H. Hyams. The collection of forty-one works, described in the catalog published in 1915 as, "the most important artistic unit south of Washington," included fine paintings by Corot, Vibert, Bouguereau and Gérôme.

The decades of the 1920s and 1930s were

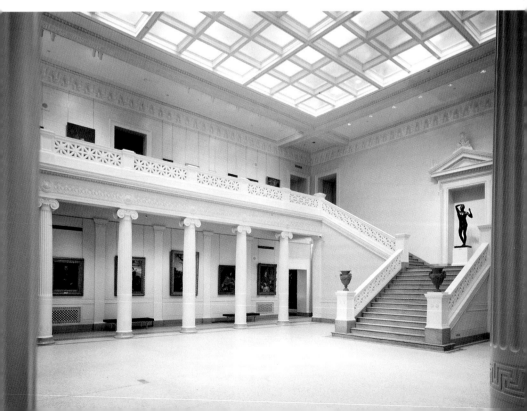

static ones for the growth of the Museum's art collection. During this period the Museum and the art world in New Orleans were dominated by Ellsworth Woodward, Professor of Art and Dean of the Newcomb College Art School, President of the Art Association of New Orleans, and founder and President of the Southern States Art League. Woodward was one of the nine original Trustees of the Delgado Museum and, as the only member with professional art training, served from the first as Chairman of the Art Committee. After the death of the Museum's first curator, local artist Charles W. Boyle, Woodward served as volunteer acting director from 1925 to 1939, as well as President of the Board from 1934 to 1939.

Ellsworth Woodward believed that the Museum's first priority was the education and moral uplift of its visitors, while the formation of an art collection of historical scope was secondary. Woodward also took great pride in the resurgent South and used the Museum to foster and promote contemporary Southern artists, who were featured in the majority of the exhibitions at the Museum during his tenure.

While no significant art works were acquired by gift or purchase in the 1920s, the 1930s saw the donation of three important works by Italian old masters, the first of high quality to enter the Museum's collection, from the great New York collector and philanthropist Samuel H. Kress. The first of these paintings, given in 1931, was an early Renaissance Madonna and Child by Giovanni del Biondo, followed in 1934 by a Portrait of Pope Clement XIII, now attributed to Anton Raphael Mengs, and finally The Blessing Saviour by Carpaccio in 1938. Samuel Kress also lent a selection of fifty-two Italian Renaissance and later paintings to the Museum

in 1933, the most important special exhibition presented at the Delgado in that decade.

Arthur Feitel, a young New Orleans architect elected to the Museum's Board in 1933, and a few other trustees attempted in the late 1930s to schedule new and stimulating art exhibitions and to reorganize the cluttered galleries. However, real progress and change were only possible after 1939, when Feitel succeeded the late Ellsworth Woodward as volunteer Acting Director of the Museum and President of the Art Association. While funds for acquisitions were scarce during World War II, Feitel was able to present several important exhibitions that awakened new interest in the Museum. Outstanding among these were Forty Years of Picasso from The Museum of Modern Art, which included Guernica, and the first American museum exhibition of the work of Hans Hoffman, arranged in 1941 by one of his students, the New Orleans-born artist Fritz Bultman. The only important acquisition of the war years came in 1940 with the purchase of the large Natoire Toilette of Psyche, which originally came to New Orleans in 1845 when it was purchased by James Robb from Joseph Bonaparte's collection.

With the quadrupling of the City of New Orleans' annual appropriation to the Museum in 1947, Board President Arthur Feitel was able to realize the long-sought goal of hiring the Museum's first professionally trained director. Alonso Lansford, serving as director from 1948 to 1957, achieved remarkable results in building the permanent collection, acquiring in ten years art works of a far higher quality than most acquired during the Museum's first four decades. Certainly the most important acquisition was the permanent loan and promised gift (finalized in 1961) of

twenty-nine Italian old master paintings from the Samuel H. Kress Foundation, part of the dispersement of this huge collection to the National Gallery of Art and selected museums throughout the country. Added to the earlier Kress gifts, this collection allowed the Museum to present for the first time a comprehensive, historical survey of one of the major schools of European art. The Kress Foundation required major renovations to the galleries where its collection was to be displayed, thus beginning long-needed physical improvements to the Delgado building.

During the 1950s donations of both collections of objects and individual works, as well as several major purchases, occurred with increasing frequency. William E. Campbell, author of such books as *The Bad Seed* under the name William Marsh, gave several fine paintings by American and French artists, including Gottlieb's *Dream* and a Fauve period Derain. Unfortunately the bulk of his collection, including nine Soutines, was sold in New York following his premature death in 1954. Several other important 20th century works were acquired at this time from members of the Bultman family. In 1955 Mrs. Muriel Bultman Francis donated a Baziotes, while in the following year her father, A. Fred Bultman, Jr., gave Hoffman's doublesided *Still Life/Self Portrait* and her brother, Fritz Bultman, gave a collection of graphics by German and, later, French artists. The Bultman family's involvement with the Museum continued for many decades, with both A. Fred Bultman, Jr., and Mrs. Francis serving as trustees. During her years on the board, Mrs. Francis regularly donated important art works to the Museum. In a final magnificent gesture of support she bequeathed

nearly her entire collection to the Museum in 1986. The Muriel Bultman Francis collection of 185 works was one of the most important art donations in the Museum's history. Particularly rich in drawings, it includes major examples by Ingres, Degas, Redon, Picasso, Matisse, and David Smith.

In 1955 Lansford convinced Melvin P. Billups of New York to donate his large and growing collection of glass to the Museum. By the time the Museum received possession of the Billups collection in 1969 it numbered over 3,000 objects, ranging in time from ancient Egyptian to Victorian—one of the most important such collections in the United States. Among individual donations received during Lansford's directorship were two American works from New Orleans collector William S. Groves, including a George Caleb Bingham portrait. Ten years later Mr. Groves would add substantially to this gift with the donation of a large group of Louisiana paintings. Also given in the mid-fifties was a Max Ernst oil from Mr. and Mrs. Isaac Heller; the Museum's first work by Edgar Degas, a bronze *Walking Horse* from the Musson family; and the first African work to enter the collection, a *Head of an Oba* from the Benin Kingdom of Nigeria. Among acquisitions made during the same period from meager purchase funds were the monumental bronze *Archer* by Bourdelle and paintings by Utrillo and Vlaminck.

During Sue Thurman's brief directorship from 1958 to 1961 few works were acquired for the collection, the Lipchitz bronze being the most important. However, the appointment of James B. Byrnes as director in 1962 marked the beginning of a decade of accelerated growth for the Museum and its art collections. At the start of his directorship the Museum

was able to convince the city administration not only to increase its annual appropriation (thereby expanding the professional staff), but also to give $135,000 to complete the renovation of the Delgado building. The first major additions to the collection under Byrnes began in 1964 with a series of gifts from Mrs. Edgar B. Stern of 20th century works by European Constructivists and Op artists, such as Kandinsky, Gabo, Arp, and Vasarely.

Undoubtedly the most important acquisition made during the 1960s was Edgar Degas' *Portrait of Estelle Musson Degas*, painted during the artist's visit to his maternal relatives in New Orleans in 1872-73. The excitement aroused in completing the Museum's first fund drive to raise the necessary $190,000 to purchase this work in 1964 focused the community's attention and pride on the Museum as never before, making possible further growth and expansion.

While a number of outstanding gifts were made to the collection, the Museum still lacked the funds to make significant art purchases. To begin to remedy this situation, in 1965 a public auction was held of surplus objects, not of Museum quality, from the collection which netted $35,000. Of more lasting importance was the organization of the Women's Volunteer Committee and the start of its annual fundraising benefit the Odyssey Ball. The first Ball was held in November 1966 to open an exhibition of the collection of Mr. and Mrs. Frederick M. Stafford of New York. For the next twenty-two years, proceeds from the Odyssey Ball, totaling $1,750,000, were dedicated to art purchases. The exhibition of the Stafford collection also marked their active involvement and support, which over the years resulted in the gift of numerous art works of great variety and quality by such artists as Bonnard, Miró, Rouault, and objects from Africa, China, Japan, and India. In addition, since 1967 many works from the Stafford collection have remained on extended loan to the Museum and thus broadened its survey of the art of various cultures and national schools.

In 1966 the Museum received a matching grant of $200,000 from The Ella West Freeman Foundation for art acquisitions. The successful completion of the fund drive to match this grant continued the momentum of Museum growth. With major funds now available the director and trustees examined the Museum's future acquisitions policy and determined that an effort should be made to build a cohesive, specialized collection. The area of specialization selected was the arts of the Americas, specifically work produced in North, Central and South America from the Precolumbian period to the present. During the next five years a great number of works were purchased in this area, resulting in a concentration of Precolumbian art from Mexico, particularly from the Maya, and Spanish Colonial painting from Peru. In addition, donations of objects from such collectors as Mr. and Mrs. P. Roussel Norman and Mr. and Mrs. Richard McCarthy, Jr. further enriched the Precolumbian collection.

An important result of the Freeman grant was the updating of the City of New Orleans' commitment to support the passage of a bond issue to finance Museum expansion. In 1968 the citizens of New Orleans voted in favor of a $1.6 million bond issue to construct a new wing to provide galleries for the permanent collection and special exhibitions. At the same time the Stern Fund provided monies for a separate auditorium and office wing and the

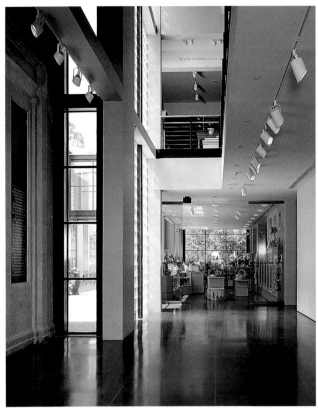

undervalued art form and that it was possible to build a major, comprehensive collection with limited funds, Bullard convinced the Trustees to actively begin purchasing photographs. As a result the Museum now has one of the country's premier photography collections, numbering nearly 8,000 works. With the generous support of Dr. Kurt A. Gitter and later other donors, in 1973 the Museum also began to build a large and comprehensive collection of Japanese art of the Edo period (1615-1868). Now with over 300 Japanese screens and scrolls,

Edward Wisner Donation provided funds for an education wing. These three additions tripled the size of the original building. In recognition of the support of the city and other donors since 1910, the trustees voted to change the name to the New Orleans Museum of Art. The new wings were opened in November 1971 with a major loan exhibition, *New Orleans Collects*, which documented the parallel growth of private art collections in the city during the past two decades.

In 1973 the trustees appointed E. John Bullard as director. Building on the accomplishments of the past, Bullard continued the accelerated expansion of the art collection in both old and new areas. Early in 1973, recognizing that photography was then an NOMA has built another area of specialization of national stature.

The 1974 bequest of seventeen paintings and sculptures and 180 African and Oceanic objects from Victor K. Kiam was the greatest art donation the Museum had received since the gift of the Kress Collection. Although raised and educated in New Orleans, Mr. Kiam had lived in New York City for many years. However, realizing the importance and place of honor his art collection would have in a regional museum, he decided to bequeath it to NOMA. The Kiam collection significantly increased the Museum's representation of 20th century European and American art, with works by Miró, Picasso, Braque, and Pollock among others, while immeasurably broadening

and strengthening the African and Oceanic collection. Also received in 1974 was the magnificent collection of 347 English and continental portrait miniatures, the gift of Mrs. Shirley Latter Kaufmann in memory of her parents, Harry and Anna Latter. Collected by Mrs. Kaufmann and her father over many years, it includes examples by Nicholas Hilliard, Samuel Cooper, Richard Cosway, and John Smart.

Having exhausted the Ella West Freeman Foundation Matching Fund some years before, in 1975 the Trustees of the Museum launched a major fund drive to raise $2.5 million in art acquisition funds and works of art. The acquisition policy was revised by Bullard, placing emphasis on the acquisition of major works by French artists of the 17th through mid-19th centuries to complement the later French art already in the collection and American painting of the 18th and 19th centuries to further augment the arts of the Americas collection. The Acquisitions Fund Drive was successfully completed in 1978 with the donation of two period rooms of American colonial and Federal furniture and decorative arts, the gift of Emile N. Kuntz, Karolyn Kuntz Westervelt, and Rosemonde Kuntz Capomazza in memory of Rosemonde E. Kuntz, Emile Kuntz and Felix H. Kuntz. Specially designed galleries to house the Kuntz Collection were opened in 1980. With eventually $1 million in cash received from the 1977 Art Acquisitions Fund Drive the Museum purchased a number of major works by American and French artists, which added new levels of quality to these areas of the collection. The most important of these purchases were Copley's *Portrait of Colonel George Watson*, Peale's *Portrait of Robert Morris*, Sargent's *Portrait of Mrs. Asher B. Wertheimer*, and Claude Lorrain's *Ideal View of Tivoli*.

The presentation of the international blockbuster exhibition, *The Treasures of Tutankhamen*, from September 15, 1977 to January 15, 1978, was the most momentous event in NOMA's history. Seen by over 870,000 visitors and earning $75 million in tourist revenues for the city, the exhibition generated a tremendously increased recognition locally, regionally and nationally of the importance of the Museum. This led to higher levels of support in all areas of the Museum's operation and established NOMA as the prime venue in the South during the next decade for other international exhibitions, including *The Gold of El Dorado*, *The Search for Alexander* and *Carthage: A Mosaic of Ancient Tunisia*.

Although the Louisiana economy was in decline due to the collapse of world oil prices, the 1980s was a decade of incredible growth for NOMA. All areas of the art collection expanded dramatically and several new areas were developed. The period began spectacularly with the long-term loan of the collection of the late Madelyn Kreisler, a native New Orleanian who had lived in New York for many years. With her husband Bernard, she formed an impressive collection of Impressionist and 20th century works. The loan was made possible by her niece and nephew, New Orleanians Mrs. John N. Weinstock and Richard M. Wise, who donated from the collection in her memory a 1918 Metzinger *Still Life*. In 1993 Mrs. Weinstock made a promised gift to NOMA of her portion of the Kreisler collection, including paintings by Monet, Gauguin, Münter, Vlaminck, Van Dongen, Braque and Chagall.

1981 saw the gift of an important collection of old masters. Bert Piso, born of Dutch parents in Indonesia in 1915, emigrated to the United

States after World War II. An early interest in Dutch 17th century painting led him to collect works by the "Little Masters," many discovered in antique stores and galleries on his business travels in the South. A discerning eye and scholarly knowledge offset his limited funds and he was able to assemble a collection of quality, which he bequeathed to NOMA. The twenty works in the Piso collection significantly expanded the Museum's representation of the Dutch School and attracted gifts from other collectors, including Dr. and Mrs. Richard W. Levy and Mr. and Mrs. Henry H. Weldon of New York.

Throughout the 1980s the collection of European and American painting continued to expand with both gifts and purchases. Single gifts such as the popular Mary Cassatt, *Mother and Child in the Conservatory*, purchased with funds donated by Mr. and Mrs. Harold

Forgotston in 1982, and the "white period" Utrillo of Sacré-Coeur, Montmartre, a 1989 gift of Mrs. Charles Kohlmeyer, Jr., further strengthened the collection of 20th century masters. Similarly the donation of five Italian, Dutch and French old masters by the Azby Art Fund in memory of Herbert J. Harvey, Jr. and Marion W. Harvey enriched the three national schools that have evolved as NOMA's areas of concentration in European art. With increased purchase funds available from the Odyssey Balls, the director and curators could seek out specific works to fill gaps in the historic survey. Most major purchases of European art were by French masters, including works by Largilliere, Van Loo, Boucher, and Vincent. The most spectacular of these acquisitions was the life-size *Portrait of Marie Antoinette, Queen of France*, by Elisabeth Vigée-Lebrun, purchased with funds raised by the Women's Volunteer Committee in honor of the Museum's 75th anniversary in 1986.

Before 1984 the Museum had an art endowment of less than $100,000. The unexpected bequest of half a million dollars from Miss Carrie B. Heiderich, began a concerted effort by the staff and Board to significantly increase endowment funds for art purchases. With the creation of funds in the names of Robert Gordy, Mervin and Maxine Morais, George S. Frierson, Jr., P. Roussel Norman, Leah Norman Schreier, and most recently, William McDonald and Eva Carol Boles, by gifts and bequests the art endowment has increased to $4 million. With an aggressive planned-giving program, it is expected that this endowment will grow exponentially in the years ahead, thus ensuring a guaranteed source of significant monies to enrich the art collection.

Building on established strengths in the collection, John Bullard and the curators cultivated and encouraged collectors in New Orleans and throughout the country resulting in a steady stream of donations. John W. Keefe, Curator of Decorative Arts, through a series of exhibitions focused on local collectors secured a number of gifts which have significantly broadened the holdings of glass, ceramics, and silver. Among these gifts— promised, partial, or completed—are the Irving Gerson collection of Wedgwood, the Elinor Bright Richardson collection of silver by Paul Storr and his contemporaries, the Elizabeth Danos and Paul P. Selley collection of European faience, the Jack Sawyer collection of art glass, and the Harold Newman collection of silvered glass. With limited purchase funds and gifts, Keefe also has developed strong holdings of Old Paris porcelain and American art pottery, two diverse ceramic productions with strong ties to New Orleans.

The collection of Asian art continued to be strengthened in the area of Japanese painting of the Edo period with additional gifts from Dr. Kurt A. Gitter and Mr. and Mrs. George L. Lindemann of New York. The collection of Chinese art attracted important works from past donors, such as Mrs. Frederick M. Stafford and Mr. and Mrs. Moise S. Steeg, Jr., as well as from new ones. Beginning in 1980, NOMA received a number of extraordinary gifts from Jun Tsei Tai, an important connoisseur and dealer in Chinese art in New York. His and his wife's gifts have included archaic bronzes, tomb ceramics, and Buddhist sculptures, particularly a seven-foot high 12th century *Bodhisattva*, now the centerpiece of the Chinese gallery. The collection of Chinese ceramics was

immeasurable strengthened with the partial and promised gift of the Dorothy and Robert Hills collection of blue-and-white porcelains, containing over two hundred fine examples from the Ming and Qing Dynasties. The Museum also has been fortunate to receive from Dr. Robert S. Barron, III, a number of beautiful ceramics of the Song Dynasty, a period of great aesthetic refinement. Most recently the Museum has begun to seriously expand its small collection of the art of India with the support of Dr. Siddharth K. Bhansali, Mrs. Harriett von Breton, and the ever-generous Mrs. Frederick M. Stafford.

The 1974 bequest of Victor Kiam elevated an already fine collection of African art to the rank of one of the country's finest. Since then, with the guidance of William A. Fagaly, NOMA's longtime Curator of African Art, this collection has continued to grow both with purchases, made possible in part by the Robert Gordy Endowment, and gifts from numerous collectors both locally and nationally. African art has become the special interest in recent years of Mrs. Françoise B. Richardson, a NOMA Trustee and past Board President. Her donations have included a number of important works from Nigeria, including a Benin bronze *Leopard Hip Ornament*, a pair of *Ibejis* by the master Yoruba carver, Olowe of Ise, and in 1995 a rare Nok terra cotta *Head of a Court Figure*. Other outstanding works have been given by Dr. H. Russell Albright, Mr. and Mrs. Charles B. Davis, III, Mrs. P. Roussel Norman, Robert Gordy, Helen and Robert Kuhn of Los Angeles, and an anonymous East Coast collector.

In the early 1970s NOMA was one of the pioneers in the acquisition of photography.

By the eighties the market for photographs had become world-wide and highly competitive. The resulting increase in prices, with works going from hundreds to tens of thousands of dollars, meant that the Museum's purchases declined from hundreds of prints annually to dozens. Fortunately in the 1980s a number of significant donations were received that further enriched NOMA's already comprehensive collection. In 1982 New Orleans master photographer Clarence John Laughlin gave the Museum his personal collection of 347 photographs by various American and European artists, most of which he obtained by exchanging his own work with his colleagues. The Laughlin gift features work by unknown and famous photographers, which he valued equally, including groups of a dozen or more prints by Cunningham, Bernhard, and Bullock. In 1986 long-time NOMA Trustee and patron Mrs. P. Roussel Norman added a large number of photographs to ones previously given, including examples by Adams, Weston, Cunningham, Brassai, Kertész, and Robert Frank. In the same year, Dorothy and Eugene Prakapas of New York gave over 400 19th century photographs, greatly strengthening the historic part of the collection. In the past ten years, as photography achieved equal status with painting and sculpture, many contemporary artists selected the medium for their most provocative work. The Museum has been able to keep abreast with these cutting edge developments through the ongoing donations of Dr. H. Russell Albright. From his extensive collection NOMA has received work by Cindy Sherman, William Wegman, Robert Mapplethorpe, and David Levinthal, among many others.

During the past fifteen years NOMA has continued its commitment to collect the work of living artists, particularly those working in Louisiana and the Southeast. The 1988 bequest of New Orleans artist Robert Gordy brought the Museum over one hundred paintings, sculptures, drawings, prints and photographs by artists as diverse as Richard Hamilton, Jim Nutt, H. C. Westermann, and William T. Wiley. The 1988 exhibition of selections from the Frederick R. Weisman collection unexpectedly led to the enrichment of the Museum's contemporary collection. Based in Los Angeles, Weisman was one of the country's leading collectors of modern and contemporary art, acquiring thousands of works. An instant love of New Orleans prompted him to purchase a French Quarter house in 1988, which he filled with a small portion of his collection. Following his election to NOMA's Board Weisman began purchasing works for the Museum, the most visible being the Lin Emery kinetic sculpture installed in the pool at the front entrance. His support of Louisiana artists led him to endow a gallery in the soon-to-be-expanded Museum dedicated to the exhibition of such work and to create a fund for future purchases.

In the 1990s there has been a burgeoning interest nationally in the work of contemporary self-taught artists. The South, particularly Louisiana, is home to many of these artists and NOMA in past years has been the first to give shows to artists such as Clementine Hunter, Sister Gertrude Morgan and David Butler. The Museum organized a landmark exhibition of this work in 1994, *Passionate Visions of the American South: Self-Taught Artists from 1940 to the Present*, which toured to five other museums. NOMA's commitment to this area of contemporary art has resulted in significant gifts from many collectors, particularly, Herbert W. Hemphill, Jr., of New York and Dr. Kurt A. Gitter and Alice Rae Yelen.

By 1979 the Museum clearly recognized the great need to expand in order to properly accommodate its growing collection. While it

took nearly fifteen years to achieve this essential goal, the dedication of the staff and trustees finally resulted in the creation of a facility that provided a beautiful setting for a great art collection. Following a national architectural competition in 1986, preliminary plans were developed so that a Capital Campaign could be launched to raise the necessary funds. The fund drive was a classic example of the combination of public and private support that characterizes the history of so many American institutions. In November 1987 the voters of New Orleans overwhelmingly passed a capital bond issue which included $5 million for the Museum. The Capital Campaign, chaired by Louis M. Freeman, was officially launched in April 1988 with commitments of $3 million from three local foundations. By the time ground was broken in January 1991, the campaign had surpassed its goal of $20 million and by the time the doors opened in April 1993 nearly $23 million had been raised. This was almost ten times the amount raised in the 1977 Art Acquisitions Fund Drive, a giant step in the Museum's development efforts and an indication of the high reputation it now enjoys in the community.

Beginning in 1990 in anticipation of the opening of the expanded museum, a major effort co-chaired by Mrs. P. Roussel Norman and Prescott N. Dunbar was made to acquire new art works to inaugurate the new building. This three-year campaign resulted in more than 2,000 new acquisitions by purchase, bequest, and full, partial or promised gift with a value of more than $10 million. Among these many acquisitions were such major works as a Renoir *Vase of Flowers*, from Mrs. Randolph A. Kidder of Washington, D.C.; a 1913 Kirchner landscape given by Eleanor B. Kohlmeyer; *Portrait of a Young Woman* by Modigliani, gift of Marjorie Fry Davis and Walter Davis, Jr., through the Davis Family Fund; a Pascin painting done in New Orleans in 1916 from Mr. and Mrs. Moise S. Steeg, Jr.; a 1947 Ralston Crawford oil from Paul J. Leaman, Jr.; and a collection of Native American objects given by Los Angeles artist Emerson Woelffer, to name but a few.

With the opening of forty-six new or renovated galleries, a significant portion of the permanent collection could be seen to its full advantage for the first time. Visitors may now appreciate the many masterworks which highlight the in-depth presentation of world art. With its expanded facility and great collection the New Orleans Museum of Art has truly become what on the day of its opening in 1911 the *Daily Picayune* had described it as being, the "City's splendid possession."

Prescott N. Dunbar

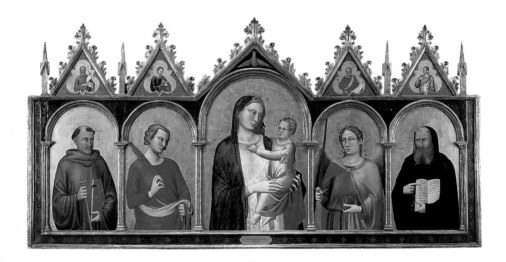

Follower of Bernardo Daddi

Italian, Florentine, 1312-1348

Madonna and Child with Saints.
circa 1340

tempera and gold leaf on linden wood,
50 5/8 x 101 3/4 in. (128.6 x 258.4 cm.)
The Samuel H. Kress Collection. 61.60

Madonna and Child with Saints has been attributed to a close follower of Bernardo Daddi. A Florentine, Daddi seems to have been a pupil of the St. Cecilia Master who was, in turn, an assistant of Giotto at Assisi. Works by Bernardo Daddi harmoniously assimilate the monumental qualities both from Giotto and from the sculptor Giovanni Pisano, along with the decorative linear elegance of Sienese painting.

Daddi's influence lasted throughout much of the second half of the 14th century because of the large number of his followers. Among them was the master of the New Orleans polyptych. Reflections of Daddi are evident in the sturdy bodies of the figures; these in turn are combined with faces that show a stylistic relationship to the Sienese painters Simone Martini (1315-1344) and Lippo Memmi (1317-1346). There is no attempt to suggest depth or perspective. The figures are placed in a shallow setting, turned towards the central group of the Madonna and Child in a highly stylized attitude of reverence and adoration. The flatness of the picture plane of this highly gilded polyptych, set in an elaborate Gothic frame, is related to Byzantine art whose influence was beginning to wane at this time.

Formerly, this polyptych was in the Rucellai Palace in Florence; consequently, the painter has come to be regarded as the Master of the Rucellai Polyptych. Probably the painting came to the palace from the family chapel in the Church of San Pancrazio or St. Pancras, shown here holding a martyr's palm. Other saints in the polyptych are St. John Gualbert, St. Michael with the sword, and St. Benedict with a book of the Benedictine Rule.

J.G.C.

Bartolomeo Vivarini

Italian, Venetian, circa 1432-1491

The Coronation of the Virgin.
1460-1470

tempera and gold leaf on linden wood,
35 1/8 x 23 5/8 in. (89.4 x 60.2 cm.)
The Samuel H. Kress Collection. 61.67

Born into a family of painters from Murano, an island near Venice, Bartolomeo Vivarini owed his training to his older brother, Antonio. Later he was influenced by the Paduan School and by the artist Mantegna. Bartolomeo never successfully assimilated Renaissance developments but retained a style characterized by lingering Gothic strains: sharp edges, hard modelling and a limited color range.

The theme of *The Coronation of the Virgin* is a French Gothic invention introduced into Italy in the late 13th century. By the late 15th century it was part of a formulaic composition which had become traditional in Venice. In detail the New Orleans painting closely follows the main panel of an altarpiece by the Vivarini in the Palazzo Communale in Osimo, Italy. X-rays indicate changes in the left side of the Virgin's robe which was originally much closer to the Osimo design. The angels at the top of the painting resemble others by Antonio Vivarini. All of this suggests a date of 1460 for the painting as the brothers were collaborating then.

This painting was the center panel of an altarpiece. Possibly related to it are other panels in the collections of the Philadelphia Museum of Art and the Museum at Capua, Italy.

J.G.C.

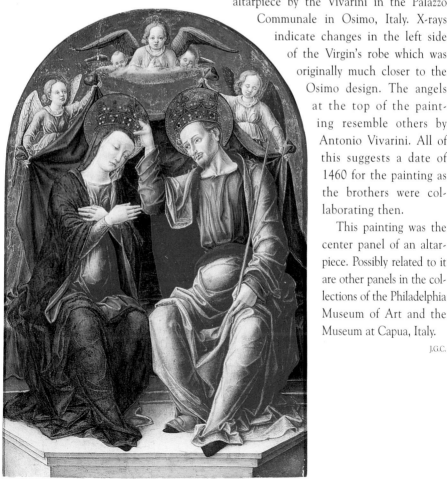

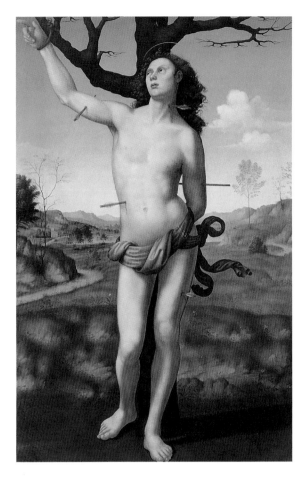

Giuliano Bugiardini

Italian, Florentine, 1475-1554

Saint Sebastian. circa 1517-1520

oil on canvas, 65 ³/₈ x 42 in. (166 x 106.6 cm.)
The Samuel H. Kress Collection. 61.89

Giuliano Bugiardini, a Florentine contempo-
rary of Michelangelo, began his career as a
pupil of Domenico Ghirlandaio. Influenced
by Raphael and Fra Bartolommeo, the artist
spent most of his productive
life in Florence, except for a
brief trip to Rome and a few
years in Bologna.

Saint Sebastian, a popular
Renaissance subject, was a
member of the Praetorian
Guard under the Roman
Emperor Diocletian (245-313
A.D.). Sebastian's secret con-
version to Christianity was
revealed when he encouraged
two Christian officers of his
corps, being tortured for their
beliefs, to be steadfast in their
faith. The Emperor then ordered
Sebastian shot with arrows.
Miraculously this torture
failed to kill the saint who was
later clubbed to death in a pub-
lic arena in Rome. Arrows
became symbolic of Saint
Sebastian's martyrdom.

This monumental painting
reflects the sculptural con-
cerns of Fra Bartolommeo,
who in 1515 had painted a
large Saint Sebastian for the altarpiece in the
church of San Marco in Florence. The saint's
nudity was so shocking that the painting was
removed from the altar soon after Fra
Bartolommeo's death on October 31, 1517.
In Bugiardini's painting the suave modelling
and hard sculptural qualities may be the
closest approximation to Fra Bartolommeo's
original intention: a demonstration of the
possibilities of the heroic nude in Florentine
High Renaissance painting.

J.G.C.

Bernardino Luini

Italian, Lombardian, 1507-1532

Adoration of the Christ Child and Annunciation to the Shepherds.
circa 1520-25

oil on wood transferred to canvas,
69 ³/₄ x 47 in. (177.2 x 119.4 cm.)
The Samuel H. Kress Collection. 61.77

Bernardino Luini's artistic style appears to have developed under various influences, but his greatest artistic debt is owed to Leonardo. While it is not clear if he actually studied with him, Luini was certainly aware of, and influenced by, Leonardo's pictorial innovations. This influence is most apparent in Luini's subtle atmospheric effects and soft chiaroscuro (arrangement of light and dark) which recall Leonardo's own sfumato (smoky color gradations).

Luini's painting is a simultaneous depiction of the Adoration and the Annunciation. In the foreground the traditional Adoration characters gaze upon the Christ Child with loving reverence, while in the window above, the angel Gabriel is seen announcing the holy event to the shepherds. Also part of Luini's pictorial treatment are the traditional symbolic allusions to church doctrine. Mary's blue robe refers to heavenly truth and her red tunic to heavenly love. The animals who warm the Infant with their breath represent the union Jesus would come to build between the Jews, the ox, and the Gentiles, the ass. Yet Luini, one of the least intellectual painters of this time, probably did not intend his paintings to provoke strenuous contemplation of church doctrine. The strong colors, clear forms and simplified presentation convey, instead, the naive charm that establishes Luini's original manner.

S.E.S.

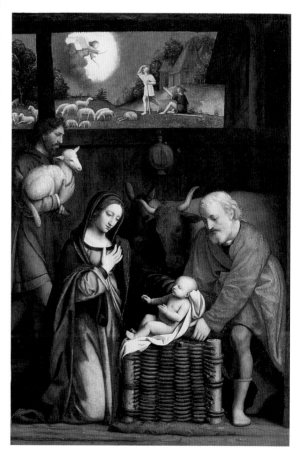

Francesco d'Ubertino, called Bacchiacca

Italian, Florentine, 1494-1557

Portrait of a Young Lute Player.
circa 1524-1525

oil on poplar wood, 38 ³/₈ x 28 ³/₈ in. (97.5 x 72.1 cm)
The Samuel H. Kress Collection 61.75

Portrait of a Young Lute Player incorporates a theme of Petrarch, the first celebrated poet of the Renaissance. This theme, the Triumph of Love, suggests that this composition is one of a series of original paintings which matched Petrarch's six Triumphs—Love, Chastity, Death, Fame, Time and Divinity—to famous literary figures whose works embod-

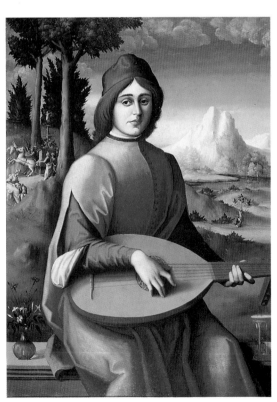

ied the central theme of each Triumph. In this particular case, *Portrait of a Young Lute Player* is a posthumous portrait of a famous love poet, Mattia Maria Boiardo (1441-1494), the author of *Orlando Inammorato*, the best known epic poem in the quattrocento. Consequently, the figures in the background are all thematically associated with the idea of love. Samson and Delilah, famous biblical lovers, were borrowed from a print by Lucas Van Leyden, while Daphne and Apollo, the fabled mythological pair, were copied from a painting by Perugino.

This is typical of Bacchiacca's methods as he made a career of the eclectic borrowing of figures from other painters and from prints.

The motto on the right of the parapet beneath the hourglass reads, "Cito pede labitur etas," or "Time flies on swift feet." It is a quotation from Ovid's *Ars amatoria,* (III, line 65), warning that love and youth are momentary. The sands running through the hourglass and the evanescent flowers, as well as the background episodes of profane love, reinforce the theme of the dangers of fleeting, erotic attachment.

Two other paintings from the series are known to exist: a pendant portrait with a *Triumph of Death* in Kassel, Germany and a small fragment of a *Triumph of Time* in Switzerland.

J.G.C.

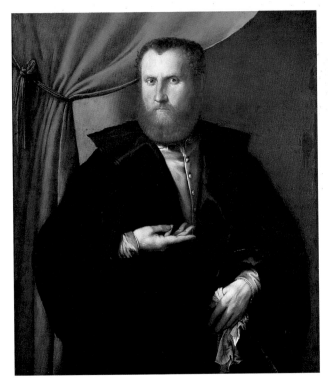

Lorenzo Lotto

Italian, Venetian, circa 1480-1556

Portrait of a Bearded Man. circa 1540

oil on canvas, 38 1/2 x 33 1/2 in. (97.8 x 85.1)
The Samuel H. Kress Collection. 61.79

Lorenzo Lotto was born in Northern Italy in the town of Bergamo. Among his formative influences were the painters Giorgione, Titian and Raphael. Although his first great altarpieces were executed in Bergamo, the artist spent much of his life working in provincial cities along the Adriatic coast: Treviso, Jesi and Ancona.

Lotto's *Portrait of a Bearded Man* is a brilliant study in the red and blue harmonic colors made famous by Bellini and Titian. The painting was executed during Lotto's mature period, spent in Venice and in the region of the Marches, when he had already achieved mastery of a number of subtle compositional devices. For instance, he uses the corner drapery and the position of the subject's right hand to interrupt the insistent verticality of the portrait.

In addition to his technical skill, Lotto is noted for executing portraits with exceptional psychological insight. He successfully penetrates to, and then captures on canvas, the sitter's innermost thoughts. Preferring to allow the character of the subject to dictate the mood of the painting, Lotto seldom followed one single formula in his portraiture. The clarity of the composition and the assured air of the sitter are interesting reflections of the emerging age of humanism spreading through Europe during the high tide of the Renaissance.

This painting has been cited as a significant example of Italian portraiture that influenced the Swiss-English painter Holbein and his circle about 1550.

J.G.C.

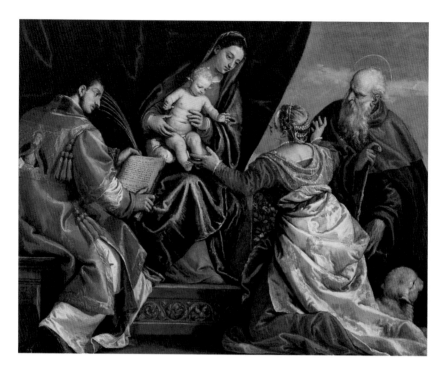

Paolo Veronese and Assistants

Italian, Venetian, 1528-1588

Sacre Conversazione. circa 1560-70

oil on canvas, 40 ⁴/₈ x 50 ³/₁₆ in. (103.2 x 127.48 cm.)
The Samuel H. Kress Collection. 61.80

The characteristic for which Veronese is most noted is his intense color, said to evoke a kind of intoxication. As in his *Sacre Conversazione*, Veronese's color is almost always high and clear, dominated by lemon-yellows, light blues, silvery whites, bright oranges and delicate salmons. His love of color for its own sake, rather than for descriptive ends, is evident in the brilliant play of his hues. The liquid marks of his brush dance across the picture's surface, enlivening it with flickering patterns and facets of delicious color.

As a *sacre conversazione*, a devotional image of the Virgin and Child accompanied by a group of saints, this painting includes the Saints Lorenzo, Agnes, and Anthony Abbot. The arrangement of the figures emphasizes a lateral movement across the picture's surface. This is typical of Veronese who avoided deep spatial recession in respect for the picture plane. Another frequent device in his work is the repoussoir, a strongly defined form that directs the viewer's attention to the focus of the picture, here enacted by the figure of Saint Lawrence. The focus indicated by Saint Lawrence seems to be a void, the empty space enclosed by the reciprocated gestures of the Child and Saint Agnes. It is this gesture of adoration and affection, then, that is the focal point of the painting.

S.E.S.

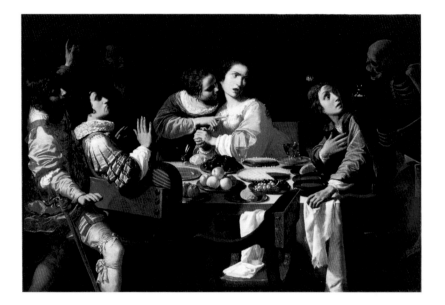

Giovanni Martinelli

Italian, Florentine, 1610-1659

Memento Mori (Death Comes to the Banquet Table).

oil on canvas, 47 ¹/₂ x 68 ¹/₂ in. (120.6 x 174 cm.)
Gift of Mrs. William G. Helis, Sr. in memory of her husband. 56.57

The theme of the *memento mori*, a picture that reminds the viewer of the ephemeral nature of human life, often includes the sensual pleasures associated with food and drink as a symbolic warning against human vanity. In Martinelli's version of this tradition a lavish feast is disrupted by the dramatic appearance of Death. Each guest's reaction is vividly expressed through a melodramatic gesture, ranging from the shock and denial expressed by Death's chosen, to the horror of the new bride, to the displeasure of the sybaritic guests at the interruption of their feast. The emphasis upon the man and woman on the right as well as the festive clothing of the group suggest that the celebration had been in honor of the couple's marriage, precipitously ended by Death's summons of the bridegroom.

In its emphatic use of chiaroscuro and the presentation of religious ideas through the guise of a daily event, the painting illustrates Martinelli's response to the artistic trend generated by the innovations of Caravaggio, the Italian Baroque painter noted for his intense realism and revolutionary use of light and shadow. The subject is especially analogous to Caravaggio's early work which was concerned with the appreciation of such sensual pleasures as food and drink. The central role of the table, as both a compositional and social catalyst, enhances the *memento mori* symbolism of Martinelli's painting. The religious theme with which the table motif is most widely identified is that of the Last Supper which, for the unfortunate bridegroom, this appears to be.

S.E.S.

Simone Cantarini (Il Pesarese)

Italian, Bolognese, 1612-1648

Madonna and Child with Goldfinch.
circa 1640

oil on canvas, oval, 40 ⅝ x 30 ⅝ in. (103.2 x 77.8 cm.)
Gift of the Azby Art Fund in memory of
Herbert J. Harvey, Jr. and Marion W. Harvey. 83.52

Madonna and Child with Goldfinch illustrates Simone Cantarini's assimilation of the various influences around which 17th century Bolognese painting developed. His manner of composing undulating surfaces from small, broken planes, visible in the Madonna's garments, is derived from Federico Barocci. Guido Reni's classicism is evident in the composition of the figures, harmoniously balanced in a pyramidal form. The believability of the firm and full-bodied figures alludes to the rational naturalism championed by the Carracci family.

Cantarini's use of the goldfinch motif is derived from an established iconographical tradition and perhaps also from the naturalistic impulse of his Bolognese heritage. A large number of devotional paintings, particularly images of the Madonna and Child, incorporate the goldfinch as an allegorical symbol. The iconographical allusions of the bird are several: it refers to the soul as opposed to the body; to the spiritual in contrast to the earthly; to resurrection; and even to fertility. In a secular context, the goldfinch refers to a popular domestic custom. The bird was often given as a toy to children who amused themselves by letting it fly at the end of a tether. The association of the goldfinch with the Madonna and Child theme is a result of the general humanization of religious art that occurred during the Renaissance. This tendency encouraged the portrayal of the Christ Child as a child rather than as a small adult. The appropriation of this element from domestic reality gave the devotional image a naturalistic, genre appeal and established the reputation of the goldfinch as the beloved bird of Jesus.

S.E.S.

Carlo Dolci

Italian, Florentine, 1616-1686

The Vision of St. Louis of Toulouse.
circa 1675-81

wood, 21 3/4 x 14 1/2 in. (55.3 x 36.8 cm.)
The Samuel H. Kress Collection. 61.84

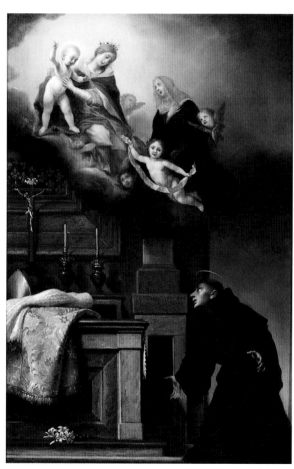

Florentine-born Carlo Dolci studied painting under Matteo Roselli and Jacopo Vignali. Except for a trip in 1672 to Innsbruck where he painted Claudia Felicitas, the bride of Emperor Leopold I, Dolci remained in Florence all of his life. He is best known for his depiction of visionary religious figures, especially beatific saints in moments of emotional ecstasy.

The Vision of St. Louis of Toulouse represents the moment when St. Louis of Anjou, Bishop of Toulouse, sees a vision of the Virgin and Christ Child adored by the Beata (Blessed) Solomea, a rarely depicted 17th century holy woman who was sanctified but not canonized. The small New Orleans painting is a modello, or study, for the altarpiece ordered by Canon Bocchineri for his family chapel in the Church of San Francisco in Prato, outside Florence. The modello differs in only minor respects from the finished altarpiece. In the altarpiece the right hand of St. Louis is raised and the visionary figures are more densely organized than in the study.

Inscriptions in Italian on the back of the panel record the beginning of the original commission, "1676 a Novembre" with a list of payments for the painting. These installments for the altarpiece confirm Dolci's slow working habits which were described in the contemporary accounts of the biographer, Filippo Baldinucci. The altarpiece was still unfinished and in Dolci's studio when he died in 1686.

J.G.C.

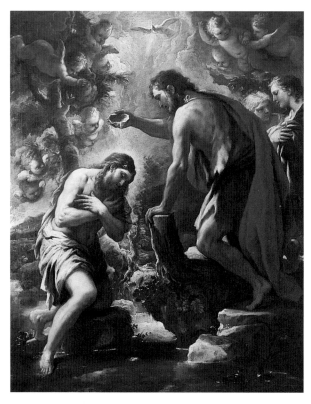

Luca Giordano

Italian, Neopolitan, 1632-1705

The Baptism of Christ. circa 1680

oil on canvas, 93 ¹/₂ x 76 in. (237.5 x 193 cm.)
Women's Volunteer Committee and
General Membership Funds. 74.43

Precocious at the age of thirteen, Luca Giordano left Naples for Rome to study the Renaissance masters. By assisting Pietro da Cortona, he learned to compose the great narrative fresco cycles which were to shape the course of Neopolitan painting. In Venice in 1653 and again in 1667 he absorbed the lessons of Veronese's color and synthesized this with the compositional qualities of Pietro da Cortona. Traveling extensively during his long and successful career, he executed frescoes in the Palazzo Medici-Riccardi for Grand Duke Cosimo III in Florence, decorated the Escorial for King Carlos II of Spain and continued to paint for King Philip V in Naples until his death.

One of the most brilliant painters of the late Baroque period, Luca's artistic facility and stupendous output led his contemporaries to call him "Fa Presto," or "Luca goes fast." He was perhaps the first virtuoso of painting in the 18th century sense. Yet his light touch and the brio of his performance as an artist anticipated the Rococo.

The Baptism of Christ was painted during Luca's last trip to Venice and shows the influence of Veronese's color and Tintoretto's brilliant handling of light. In style it is closely related to a study for the Preaching of the Baptist at Naples dated 1685, just as the identical arrangement of flying cherubs appears in the Flight into Egypt (Madrid, San Marca Collection), painted during the same period. All three paintings, with their great luminosity, dextrous handling and bright color, demonstrate the style characteristic of Luca in the 1680s.

J.G.C.

Giovanni Battista Tiepolo

Italian, Venetian, 1696-1770

Boy Holding a Book.
1725-1730

oil on canvas, 19 x 15 ³/₈ in. (48.2 x 39.1 cm.)
The Samuel H. Kress Collection. 61.87

During a career lasting more than fifty years, Giovanni Battista Tiepolo, the most popular Italian painter of his era, produced a prodigious body of work. By assimilating a variety of influences and synthesizing the best elements of Venetian 18ᵗʰ century painting Tiepolo forged a mature style that is considered to have revived Venetian painting. He introduced light to the preponderantly murky painting of the preceding era and infused Venetian painting with a greater naturalism.

Boy Holding a Book is from Tiepolo's early phase which is characterized by an affinity with the work of Piazzetta and a palette of deep, earthy colors. Tiepolo conducted an unceasing study of movement which enabled him to naturalistically describe a variety of animated gestures. His ability to conjure figures full of life and vibrant energy is evident in the image of this boy who, in a movement at once exuber-

ant and restrained, turns to look over his shoulder. This diagonal motion is a favorite compositional device of Tieplolo's as well as a continued link with the Baroque. Illuminated against a dark background, the figure radiates the vital force and intensity expected of a young and energetic boy. A lively play of light and shadow, especially upon the white shirtsleeve, animates the picture surface which is further enlivened by Tiepolo's rapid, vigorous brushstrokes. The confident speed with which Tiepolo rendered his figures complements the evocation of a fresh and vivid immediacy and indicates the virtuosity of his talent.

S.E.S.

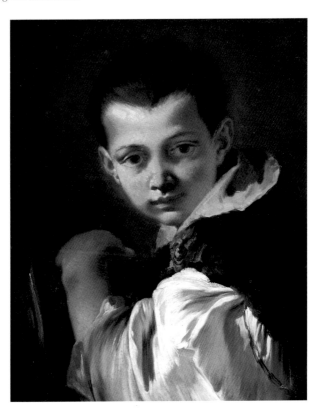

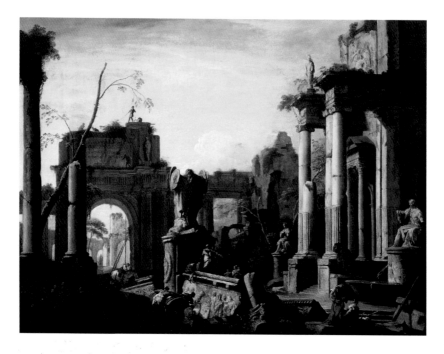

Sebastiano Ricci
Italian, Venetian, 1659-1734

Marco Ricci
Italian, Venetian, 1676-1730

Imaginary Scene with Ruins and Figures. circa 1725

oil on canvas, 53 ³/₄ x 69 in. (136.5 x 175.3 cm.)
The Samuel H. Kress Collection. 61.85

Paintings by Sebastiano Ricci and his nephew Marco belong to the category of *capricci*, or caprices, of landscape, as opposed to vedute, or actual views, as painted by the Venetian artist Bernardo Belloto. Both the Ricci were born in Belluno, near Venice. Sebastiano, who flourished during the transition between the Baroque and Rococo styles of painting, was Marco Ricci's first teacher. Thereafter the two painters often collaborated. While Marco is chiefly known as a great innovator of landscape, Sebastiano helped lighten the color palettes of painters in major Italian art centers, leading the way toward the Rococo style.

Many paintings such as *Imaginary Scene with Ruins and Figures* from the Ricci studio were executed in partnership; the large settings were painted by Marco, the figures by Sebastiano. In this painting the setting is Roman, but the monuments are selected for visual interest rather than for topographical accuracy. The Pyramid of Caius Cestius, represented as a crumbling ruin, appears in the background on the right. Next to it stands the Arch of Dolabella. The ruined building, also on the right, suggests the porch of the Temple of Antonius and Faustina. As is usual in such *capricci*, the figures are extremely small-scaled in contast to the surrounding ruins. This theatrical tour de force helps exaggerate the size of the monuments.

J.G.C.

Francesco Guardi

Italian, Venetian, 1712-1793

Esther at the Throne of Ahasuerus.
circa 1747-1753

oil on canvas, 29 ½ x 39 ½ in. (74.9 x 100.3 cm.)
Gift of Mr. and Mrs. Harold L. Bache. 62.9

Francesco Guardi is recognized as the greatest Venetian view painter of the 18th century. Influenced by Canaletto, Guardi began painting romantic scenes of Venice according to his own personal vision, a poetic manipulation of light and color. In the period 1747 through 1753 he mainly executed his lesser known figure paintings. At this time he was influenced by the brio of other artists and particularly by the impasto brushwork of Sebastiano Ricci, whose compositions he sometimes copied.

Esther at the Throne of Ahasuerus corresponds closely to a study for the same subject by Sebastiano Ricci now in the National Gallery in London. However, Francesco makes the composition his own by bringing the figures close to the spectator and by deleting the soldiers on the left of Ricci's painting. These devices allow Francesco to focus more closely on the chief protagonists of the scene and thus to heighten the drama of the meeting. Francesco retains Ricci's color scheme for the robes of Esther as well as for the curtain and the pelmet of the king's throne. Additionally, Francesco stretches the composition, converting it from a vertical to a horizontal format.

The story of Esther, who was first concubine and then queen of Ahasuerus (Xerxes of Persia), is recounted in the *Old Testament* (Esther v: 1-2, 8-9). The heroine, although faint with emotion and supported by handmaidens, pleads successfully to save her people, the Jews, from extermination at a date set by Haman, the king's chief minister. In the painting Haman is seen, isolated in front of the arch in the middle ground, viewing the scene.

J.G.C.

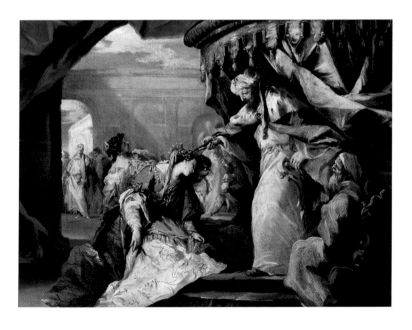

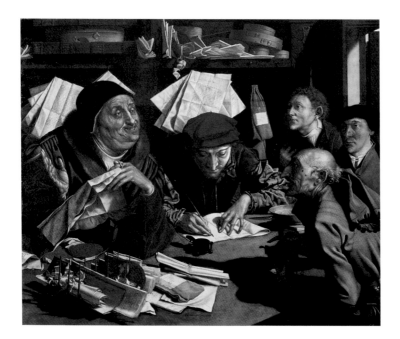

Marinus van Reymerswaele (Claeszon)

Flemish, circa 1495-1566

The Lawyer's Office. 1545

oil on wood, 40 ³/₈ x 48 ⁵/₈ in. (102.5 x 123.5 cm.)
Ella West Freeman Foundation Matching Fund. 70.7

Marinus van Reymerswaele received his first artistic training as an apprentice to an Antwerp glass painter named Simon van Daele in 1509. Known as a painter of genre and satire, Marinus was famous enough to have been mentioned by the Italian historian Guicciardini and the art historian and painter Vasari.

Paintings by masters of Northern Renaissance realism often recorded official contracts or acts, and The Lawyer's Office is a remarkable example of this practice. Recent research has demonstrated that the documents, which form the background of the painting, refer to an actual lawsuit begun in 1526 in the town of Reymerswaele on the North Sea. The suit arose between three heirs of Anthonius Willem Bouwensz and Cornelius vander Maere, the latter having purchased a salt refinery from the heirs of Anthonius. Difficulties began when Cornelius vander Maere refused to make the initial payment and subsequently had his goods seized. The legal transactions lasted until 1538, by which time the property under dispute had probably been submerged or destroyed by storms. Ironically, the court fees still had to be paid.

Several versions of this composition exist in Munich, Amsterdam, Cologne and Brussels. While the New Orleans version is apparently the last in the series, it is painted with the greatest detail, thus clearly revealing the documents in the lawsuit.

J.G.C.

Maerten van Heemskerk

Dutch, 1498-1574

Apollo and
the Muses. circa 1555-1560

oil on oak wood, 38 ³/₄ x 54 ¹/₂ in. (99.7 x 138.5 cm.)
Museum Purchase. 82.163

By the 1540s the theme of *Apollo and the Muses*, established during the early 16th century Italian Renaissance, had made its way into northern Europe where Maerten van Heemskerk seems to have been one of its principal champions. Heemskerk was one of the first Dutch painters to travel to Italy for art studies after which he devoted his career to propagating the Italian style in his northern homeland. The somewhat crowded quality of this composition is typical of Heemskerk's images. This crowding, as well as the monumentality of his figures, reflects the work of Michelangelo, the most overwhelming influence from Heemskerk's trip to Italy.

In ancient times the dancing and singing of the nine Muses were believed to inspire mortal singers and poets and to incite them to noble deeds. The Muses' harmonious tones and rhythmic singing purified the spirit and kept the human soul properly balanced. The association of Apollo gave a dimension of scholarship to this allegorical interpretation, and thus the Muses' activities came to exemplify the proper way of exercising scholarship. A product of this is that moral standards are improved and vices, notably lust, are avoided. Finally, a humanistic interpretation of Heemskerk's day designated the Muses as guardians of "honest and good knowledge." The musical aspect of Heemskerk's interpretation is emphasized by the prominent position of the organ. It is not a specific antique instrument, but instead acts as a symbol of *ars musica* in general. No doubt Heemskerk presents the harmony of this concert of Apollo and the Muses as an allegory of the ennobling virtues that proceed from a knowledge of the arts.

S.E.S.

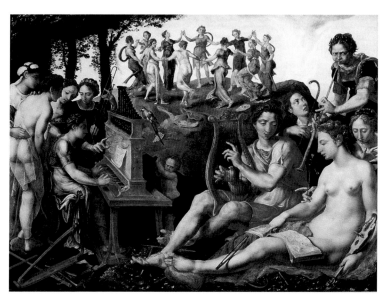

Abraham Bloemaert

Dutch, 1564-1651

Saint John the Baptist Preaching in the Wilderness. circa 1632

oil on canvas, 35 ½ x 51 in. (90.2 x 129.5 cm.)
Museum purchase and gift by exchange of
Mr. and Mrs. Frederick M. Stafford and
Dr. and Mrs. Richard W. Levy. 87.108

Abraham Bloemaert's long career encompassed several distinct stylistic phases. Beginning in the 1630s and for the remainder of his career, Bloemaert practiced his most personal style which combined elements from both international Mannerism and his Dutch artistic heritage. Although he abandoned much of the artifice of the Mannerist style in favor of more naturalistic observation, Bloemaert retained its academic standards of composition, draughtsmanship and modelling.

Saint John the Baptist Preaching in the Wilderness illustrates these dual tendencies of Bloemaert's mature vision. The theme enabled him to integrate the traditional academic elements of a religious subject and nude figure with the Dutch liking for a casual grouping in a landscape setting. While this setting allowed him to use the observational studies he had long made of landscape details, the landscape still bears the mark of aesthetic manipulation. An unexplained light source strikes two central figures who are emphasized also by their size and placement. But despite their apparent importance, the entire composition is subtly focused upon the figure of Saint John in the middle distance. Not only does the audience attentively lean toward him, so do the trees and the foliage that enclose him. Even the pink banner held aloft points toward Saint John. The figures are convincingly modelled and arranged in clear, sedate poses reflecting basic academic teachings derived from Italian Renaissance ideals. Bloemaert's personal response to the shifting aesthetic tendencies of his day is a unique, skillful synthesis of academic elements from the Mannerist tradition of Italy with the indigenous Dutch interests in genre and naturalistic description.

S.E.S.

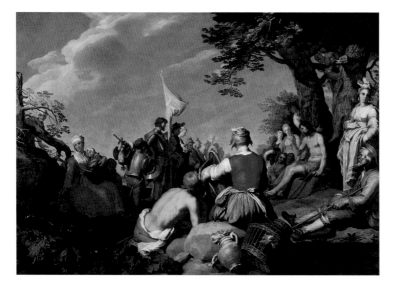

Jan Lievens

Dutch, 1607-16

Portrait of an Old Man. 1640

oil on canvas, 30 ½ x 25 in. (cm.)
Gift of Mr. and Mrs. Henry H. Weldon. 81.294

The proximity of Jan Lievens' career to that of Rembrandt has left Lievens remembered as the less accomplished associate of the great master. This is an unfortunate summation of a career that began with great promise. A year younger than Rembrandt, Lievens was a child prodigy who was already well advanced in his art studies when Rembrandt decided to become an artist. Both men studied with Pieter Lastman in Amsterdam and then returned to Leiden where they worked together closely from the late 1620s until 1631 when Rembrandt returned to Amsterdam. In Leiden the two artists shared a studio and worked in a style so similar that a picture listed in a 1632 inventory could be given to either "Rembrandt or Lievens." At this time, however, Lievens seems to have had the greater reputation as indicated by the longer entry given him in a 1641 description of the city of Leiden.

In 1635 Lievens moved to Antwerp where he worked until 1644. In Antwerp he was strongly influenced by his Flemish contempo-

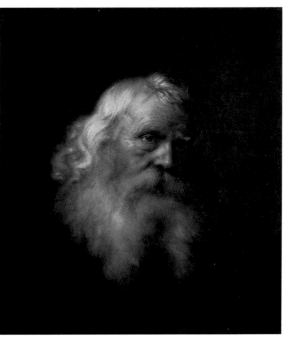

raries, including Rubens, Brouwer and Van Dyck. Throughout the remainder of his career Leivens, given to a variety of influences, produced an incredibly eclectic body of work that is difficult to assess.

Lievens' strongest paintings are those made during his association with Rembrandt. His *Portrait of an Old Man* reflects their close relationship. Although his vision was not as penetrating as Rembrandt's, Lievens has striven for an intense realism in facial characterization and the effects of age. But the influence of Flemish painters is apparent in his lighter palette and thin, almost transparent, application of paint, which specifically recalls Rubens.

S.E.S.

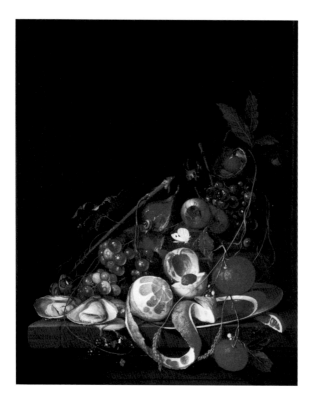

Cornelis de Heem

Dutch, 1631-1695

Still Life with Fruit on a Ledge

oil on canvas, 26 ¹/₂ x 21 ¹/₂ in. (67.3 x 54.6 cm.)
Gift of the Azby Art Fund in memory of
Herbert J. Harvey Jr. and Marion W. Harvey. 83.50

The hallmark characteristic of 17th century Dutch still lifes is a closely observed illusionism wedded to a moralistic content. An excellent example is provided by Cornelis de Heem's *Still Life with Fruit on a Ledge*, both a dazzling display of technical accomplishment and a rich repository of allegorical significance. The complex overlapping arrangement and consistent tonal quality produce an emphatically unified composition. Orange peels and wheat stalks spill over the ledge, lessening the gap between the pictorial space and the viewer's space, and thus beckoning the viewer to contemplate the significance of the message. Inviting on the outside but sour on the inside, the lemon is a symbol of the luxury which alienates man from God. De Heem has juxtaposed elements with good associations and those with bad to remind the viewer of the choice between earthly pleasures and heavenly reward. The oyster, long considered an aphrodisiac, is a symbol of lust while both the lemon and the orange may refer to original sin. The butterfly represents the human soul and its possibility for redemption, while the collection of fruits and nuts refers to the Passion of Christ which gave humankind this possibility. Finally, the grapes and wheat are symbolic of the Eucharist. A *vanitas* message, or reminder of the transience of human life, is conveyed by the perfectly ripe state of the organic objects which will soon decay, alluding to the erosive character of time. While de Heem's painting is an opulent display of luxurious objects, it reminds the viewer that these are ephemeral pleasures and thus admonishes moderation.

S.E.S

Aelbert Cuyp

Dutch, 1620-1691

Landscape Near Dordwyk. circa 1645

oil on panel, 11 ½ x 16 ½ in. (30 x 42 cm.)
Bequest of Bert Piso. 81.274

The name Cuyp belonged to three Dutch painters from the town of Dordrecht: Aelbert, his father, and his half-uncle; but it is Aelbert who has earned the greatest recognition for the family name. Aelbert studied with his father, Jacob Gerritsz Cuyp, a portraitist; and while Aelbert did paint several portraits, as well as still life and genre scenes, he is best known for his landscapes.

Cuyp's early landscapes emulate the tranquil style of fellow Dutch artist Jan van Goyen. The influence of van Goyen's subtle monochromatic technique gradually waned as Cuyp began to develop a personal style emphasizing tonal and atmospheric effects with greater detail and a cheerier palette. *Landscape Near Dordwyk* is a fine example of his early style and

of the many views Cuyp painted near his hometown. Dordwyk was an estate owned by Cuyp's son-in-law which was very near Dordrecht. Cuyp has placed the viewer on the bank of the river across from which are visible the rooftops of Dordrecht. The immediate foreground is occupied by cows, a trademark element of Cuyp's paintings, whose bulk interrupts the low horizon and enhances the sense of depth. The mellow, golden palette emphasizes the peaceful mood of the resting cows and reflects the influence of sunlit Italianate landscapes then fashionable. Despite never having seen the Italian countryside himself, Cuyp eventually became the greatest northern exponent of the Italianate landscape by bathing his Dutch scenery in a warm Italian sunshine. While his painting certainly displays the careful observation characteristic of the Dutch tradition, it is his ability to convey a moist, golden atmosphere, especially that of the late afternoon river, that has given rise to his posthumous renown.

S.E.S.

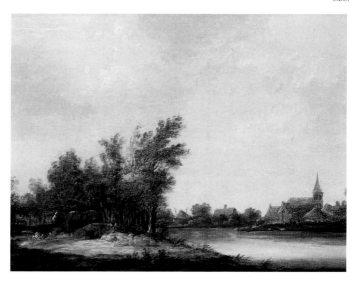

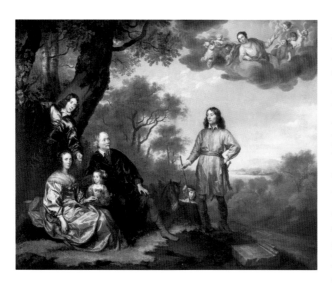

Jan Mytens

Dutch, 1614-1670

Portrait of the Martini Family. 1647

oil on canvas, 48 x 60 in. (121.8 x 152.4 cm.)
Museum Purchase. 79.216

Born at The Hague, Jan Mytens was the nephew and pupil of Daniel Mytens the Elder, who had absorbed the influence of Anthony Van Dyck in England. Jan, who also felt the court painter's influence, became a major Hague portraitist and genre painter. He is best known for pictures of elegant figural groups in pastoral settings.

Portrait of the Martini Family is an outstanding example of Dutch portrait painting, featuring six major figures in a landscape setting. These individuals have even been identified by name; each one is written in white ink on the back of the canvas. The elderly man is Jacques Martini, the Commissioner General for the Ammunition of War for the Netherlands; the woman seated near him is his second wife Adriana. This painting was executed the very same year that the two were married. Appropriately, the grapes offered to Adriana by two of the children, Eric and Magdalena, symbolize chaste love in marriage. The eldest son, Ambrosius, stands tall in the landscape. Of particular interest is the depiction of Jacques' first wife, Philippote van Sypesteyn, in the clouds surrounded by cherubs. The placement of cherubs in the clouds is a uniquely Dutch way of depicting children who have died during infancy. Jacques gazes solemnly heavenward in remembrance of these deceased family members. In the lower right corner Latin inscriptions on the stone record the ages of the principal figures in Roman numerals.

Jan Mytens was particularly adept at rendering faces. His compositions show a certain naive charm which, combined with exact visual reportage and unfailing accuracy of detail in costuming, decor and environment, furnish a valuable social document for mid-17th century Dutch life.

J.G.C./S.G.S.

Otto Marseus van Schrieck

Dutch, 1613-1678

Serpents and Insects.
circa 1650

oil on canvas, 38 x 28 ¾ in. (95.5 x 73 cm.)
Gift of John J. Cunningham. 56.30

The early training of Otto Marseus van Schrieck remains a mystery. It is known, however, that in 1652 he made a trip to Rome in the company of Matthias Withoos, a Dutch painter of still lifes, and there joined the Dutch Guild of Artists. Later he worked at the court of the Grand Duke of Tuscany and traveled throughout England and France. Documents record him in Amsterdam in 1664 when on April 25 of that year he married Margarita Gysels, the daughter of Cornelius Gysels, an engraver. In the second half of the 17th century van Schrieck's paintings were extremely popular in the Netherlands where several Dutch artists followed his style, including Christian Striep (1634-1673), Nicolaes Lachtropius (d. 1687), and Raphael Ruysch (1664-1750).

Marseus van Schrieck enlarged the definition of still life by painting living creatures composed entirely from nature. At first hand he copied lizards, snakes, frogs and rare insects that he raised in a small vivarium. These crea-

tures were the favorite and often repeated subjects for which the artist became well known. By concentrating on a small view and using a startling combination of zoological subject matter painted with extraordinary care and fidelity, as exemplified in *Serpents and Insects*, van Schrieck created bizarre and exotic imagery. His trip to Rome had little influence upon him, other than giving him a predilection for allegorical themes which appealed equally to the sensibility of the Dutch.

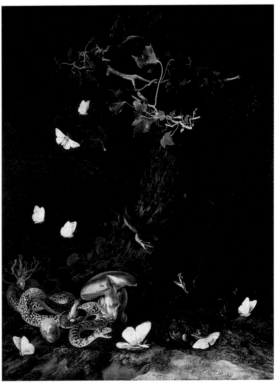

Accordingly, *Serpents and Insects*, which illustrates the brutality of the natural world, may convey a *vanitas* theme, the popular Dutch message concerning the brevity of life.

J.G.C.

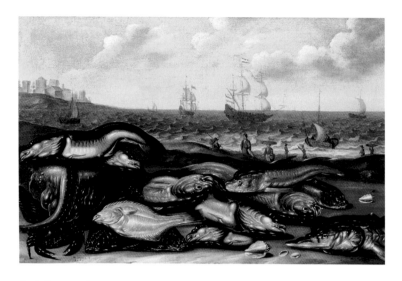

Willem Ormea

Dutch, 1611-1665

Adam Willaerts

Dutch, 1577-1664

Fish Heaped on the Beach. 1658

oil on canvas, 26 1/4 x 40 1/2 in. (66.6 x 102.8 cm.)
Gift of Bert Piso. 71.38

In this painting Adam Willaerts was responsible for the seascape, while Willem Ormea painted the still life of fish in the foreground. This collaborative effort was a fairly common working method of 17th century Dutch masters who became increasingly specialized as the century progressed. *Fish Heaped on the Beach* contains all the signature elements of its two artists. Willaerts was an important Flemish-Dutch sea painter whose earliest paintings depict historical sea battles, shipwrecks and harbors in the style of Hendrick Vroom. In his later paintings he concentrated on beach scenes which characteristically

include cliffs surmounted by castles. These beaches are populated with fishermen and seamen in the style of Jan Breughel and Joos de Momper. Also typical of Willaert's pictures are obliquely running, stylized waves in the background. Ormea, a well-known Utrecht painter of marine still life, acquired a reputation for depicting sea creatures and fish either in fish-mongers' stalls or on beaches. His work is characterized by the use of a plunging perspective which makes the foreground seem out of proportion to the background.

The beachscape and fish still life genres were popular in 17th century Dutch painting. This is accounted for by two national preoccupations, one with the sea as it was the basis for that society's livelihood, and the other with a scientific examination of the natural world. Pure science was valued for its own sake as well as for its technological applications. Artists such as Ormea delighted in the challenge of painting the silvery hues and anatomical details of these marine creatures which they regarded as natural marvels.

J.G.C.

Bartholomeus van der Helst

Dutch, 1613-1670

Homo Bulla: A Boy Blowing Bubbles in a Landscape. circa 1665

oil on canvas, 32 x 28 ³/₄ in. (81.3 x 73 cm.)
Gift by exchange of Edith Rosenwald Stern Fund. 95.188

Van der Helst was born to an innkeeper in Haarlem but moved in 1636 to Amsterdam where he remained throughout his career. Because so many painters were bringing their individual ideas and styles to Amsterdam at this time, the city claimed no distinct artistic style as could Haarlem and Delft. But among the variety Van der Helst perfected a style that made him the most fashionable and sought after portraitist in Amsterdam from the mid-1640s on. His subtle combination of formal flattery with a lively naturalism earned him fame that exceeded that of Frans Hals and even Rembrandt.

This charming painting demonstrates the elegant style that made Van der Helst the favorite portraitist of Amsterdam's elite patrons. The artist often used informal landscape or park settings for his sitters, a device seen here. Yet the treatment of the boy's apparel is characteristically luxuriant. Van der Helst rarely resisted this kind of virtuoso treatment of the rich textures worn by his sitter.

As might be expected with a Dutch painting, this is not merely a literal depiction of the young boy. Emblematic allusions are frequent in Van der Helst's portraits. In this one the presence of the bubbles indicates a *momento mori* significance, specifically the *homo bulla* theme: human life is as transient as a soap bubble. This theme has a long history with a classical origin. In 15th and 16th century Dutch paintings the *homo bulla* theme was depicted symbolically but by the 17th century it was shown naturalistically with playing children as the pictorial vehicle. The theme, which discourages material gain, acquires an ironic tone when juxtaposed with the oppulent luxury of this child's clothes.

S.E.S.

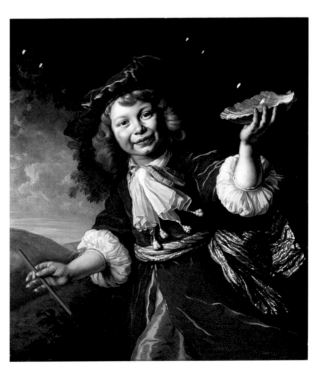

Claude Gellée, called Le Lorrain

French, 1600-1682

Ideal View of Tivoli. 1644

oil on canvas, 46 x 57 ⁷/₈ in. (117 x 147 cm.)
1977 Acquisition Fund Drive. 78.1

Little is known of the formative years of Claude, who would become one of the most renowned landscape painters in the history of European art. His birthplace is likely Champagne, in the duchy of Lorraine and he is known to have gone to Rome while still an adolescent as an apprentice to a pastry maker. Recent biographers have pointed out the influence on his work of the luministic effects visible in landscape painting from the German-born Goffredo Wals and the Fleming Paul Brill. Claude's first Roman works from the early 1630s were fresco cycles, but by the end of the decade he was the principal landscape painter in Italy, having received commissions from the highest ranking ecclesiastics and the King of Spain.

The subject here is pastoral: shepherds and their herd return home at the end of the day. Behind them rises the 1st century B.C. Temple of the Sibyl at Tivoli, rendered accurately in its ruinous state. Claude has changed the general topography of this location in the Roman countryside to accommodate his classic landscape construction: foreground area, subtle gradations of spatial recession with trees used as repoussoirs, a major land mass in the middle of the composition and an extended vista to one side. The temple, cascade and medieval fortification help set the scene of an idyllic past, while the small representation of St. Peter's on the horizon links the image to the actuality of 17th century urban Rome. The emotional quality of the landscape is brought forth by the atmospheric effects of the light and the colorful sky, brilliantly rendered in the golden sunset and in its reflections on the clouds.

E.P.C.

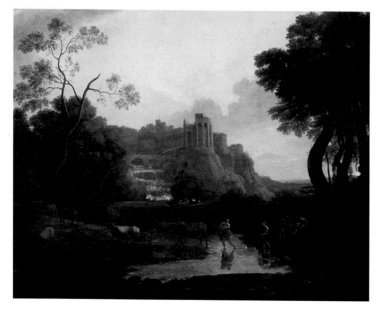

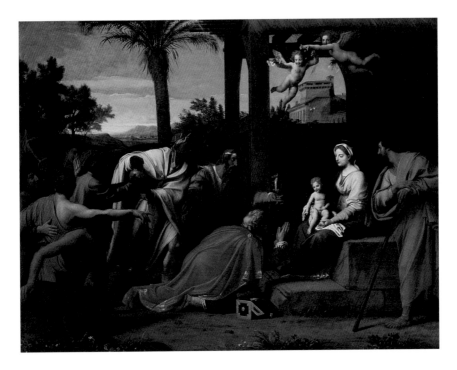

Nicholas Colombel

French, 1644-1717

Adoration of the Magi. 1693-1699

oil on canvas, 45 x 58 ¹/₂ in. (144.3 x 148.6 cm.)
Women's Volunteer Committee Fund. 73.209

Colombel was born near Rouen in 1644 and was in Rome by 1682 when he sent four large paintings to Paris. In 1686 he was made a member of the Roman Academy of St. Luke; sometime between then and 1693 he made his way back to Paris. In 1694 he was received at the Royal Academy and exhibited many works at the Salons of 1699 and 1704. Colombel's work includes mythological, Roman and biblical paintings executed in a classicizing style strongly influenced by the work of Nicolas Poussin.

Colombel has placed the Magi and their retinue in a relief-like arrangement, in a composition taken in reverse from Poussin's *Adoration* of 1633 (Dresden, Staatliche Kunstsammlungen), though he enlarged the size of the figures and limited their number. Realism and vivid colors are balanced with an emphasis on linear design, which many of Colombel's contemporaries had abandoned. Colombel evokes an animated feeling of wonder and adoration in which all movement is directed toward the Christ child; this movement is enhanced by a clear bright light that falls on the Madonna and child.

The painting may have been executed as long as ten years before it was first exhibited at the Salon of 1704. This practice of delayed exhibition was not unusual for Colombel who preferred to show his works in groups rather than individually at each Salon.

E.P.C.

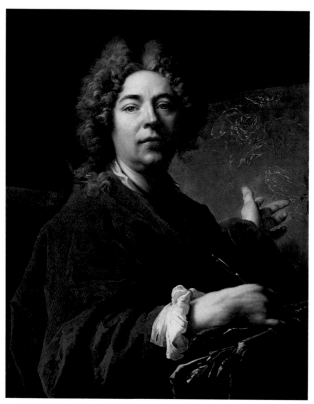

Nicolas de Largillière

French, 1656-1746

Self-Portrait. 1711

oil on canvas, 32 x 26 in. (81.3 x 66 cm.)
Women's Volunteer Committee Fund, in memory of
Frederick M. Stafford. 82.164

Largillière was born in Paris, the son of a hat merchant; the family moved to Antwerp when he was three years old. He served as an apprentice under the Flemish painter Antoni Goubau and became a master in the Antwerp Guild of St. Luke in 1673. Two years later he was in London, in contact with several Flemish artists and Sir Peter Lely, though he was not a member of the latter's workshop

as is commonly believed. Only still-lifes are documented from this early period; by the time Largillière returned to France in 1679 he had begun painting portraits, the genre for which he became celebrated. Largillière became the favorite portraitist of the Parisian upper class and executed several important commissions for Parisian municipal officials before his reception at the Royal Academy in 1699.

Largillière portrays himself here in an animated pose, pointing to a canvas in progress that depicts an Annunciation: its inclusion may refer to the academic hierarchy, which ranked history painting above portraiture. The loose treatment of the velvet coat, white shirt and wig and the accentuated foreshortening of the hand bespeak the artist's Flemish training. This realism is balanced with the tradition of formal artifice that marks the art of Hyacinthe Rigaud, the official court portraitist of the day. The painting thus exemplifies the characteristics of Largillière's style that secured success with his clients and denotes his importance in the history of French portraiture. As Myra Nan Rosenfeld has pointed out, this synthesis of the idealization of court portraiture and the realism of middle-class portraiture produced unique paintings with lasting visual appeal that herald the transition to the Rococo style.

E.P.C.

François Boucher

French, 1703-1770

The Surprise (Woman with a Cat).
1730-32

oil on canvas, 32 x 25 ³/₄ in. (81.5 x 65.5 cm.)
Women's Volunteer Committee Fund. 84.58

A fashionable painter embodying the frivolity and elegance of the aristocratic life that engendered the French Rococo, Boucher was the leading French artist of the middle of the 18th century. His manifold talent extended into stage design for the theater and ballet, interior decoration, tapestry design, graphic art and porcelain in addition to painting. Boucher's talent was acknowledged by the award to him in 1724 of the coveted prix de Rome, in 1765 of the title of First Painter of the King, a of professorship at the Royal Academy. A further honor was his standing as teacher and favorite artist of Madame de Pompadour, the mistress of King Louis XV and the great arbiter of artistic taste in France at that time.

Boucher's painting The Surprise parallels the amorous preoccupations of the Rococo age. Tension is introduced into this blissful world by the presence of the voyeur who occupies the shadows behind the young woman. The voluptuous figure of the woman is alluring to the interloper and fascinating to the child; the cat, however, remains indifferent to the scene unfolding before it. Examination of the expected features, the delight in contrast in surface patterns and textures and the broken, flickering touch of the brush, identify The Surprise as an early work in

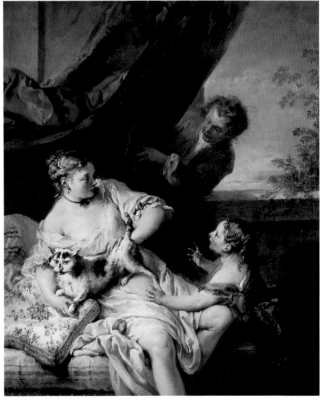

Boucher's oeuvre. His work signals a full retreat from the religious austerity of the Renaissance to the secular idealism of the Northern art world. Its sumptuousness at once embodies the spirit of the age while it appalled much of the liberal critical establishment and indeed heralded the demise of the ancien régime.

S.E.S.

Charles-André Van Loo, called Carle Vanloo

French, 1705-1765

Noli Me Tangere. 1735

oil on canvas, 25 1/2 x 19 1/4 in. (64.8 x 48.8 cm.)
Museum Purchase. 83.2

Born to a family of accomplished artists who had gained recognition throughout Europe, Carle must be viewed as the most successful and highly considered of them all in the 18th century. By 1735, the year of this painting and of his admittance to the Academy, his reputation was already considerable. He eventually filled every position at the Academy, was ennobled in 1751, directed the École Royale des Elèves Protégés and in 1762 attained the greatest artistic achievement in the realm, selection as First Painter of the King.

The subject is taken from the Gospel of John and the iconography is traditional. The scene represents one of the three appearances of Christ during the forty days between the Resurrection and the Ascension. Having gone to Christs' tomb to mourn in solitude, Mary Magdalene is startled by a man whom she mistakes for a gardener. As she reaches to touch Him, He halts her gesture saying, "Touch me not, for I am not yet ascended to my Father" (John 20:17).

Although Vanloo's iconography is traditional, his style is transitional indicating the development of the Baroque into Neoclassicism. Whereas the Magdalene's gesture of surprised adoration indicates her piety, it also carries the sensuous resonance of the Baroque. The precise delineation of the figures, though carefully modeled, do not yet exhibit the severity of the impending Neoclassical manner and a Baroque flavor lingers in the composition's dramatic lighting and theatrical character. While the secure power of his classicizing style does not stir the emotional response associated with the paintings of his peer Boucher, it does elicit the great respect Vanloo accrued in his own era.

S.E.S.

Charles Joseph Natoire

French, 1700-1777

The Toilette of Psyche. 1735-36

oil on canvas, 78 x 66 ½ in. (198 x 169 cm.)
Museum purchase with the bequest of
Judge Charles F. Claiborne. 40.2

Born in Provence, Natoire worked with his father, a sculptor, before going to Paris to enter the studio of François Le Moyne. He received the prix de Rome in 1721; from 1723 to 1729 he was active in Rome where he enjoyed an excellent reputation. Upon his return to Paris he received many commissions. In 1737 he became a professor at the Royal Academy. By mid-century he was considered one of the great artists, along with Carle Vanloo, Jean Restout and Boucher, who dominated painting in the earlier part of Louis XV's reign.

The story of Psyche, the personification of the soul, is based upon *The Golden Ass* of Apuleius, recounted again in 1669 by Lafontaine in *Les Amours de Psyche et de Cupidon*. In this painting, Psyche, whose attribute of the butterfly hovers above her head, has been transported to a new palace where her hand-maidens prepare her for her first meeting with her lover Cupid. Like his contemporaries, Natoire delighted in rendering the female nude with its accompanying col-oristic possibilities. Natoire uses an animated line in his design and the whole is bathed in a warm shimmering light. The sense of elegance and refined beauty in this work, similar to that of Boucher's, is a revealing indication of the artistic aspiration and taste of the French Rococo.

The work has been in America since 1815 when Joseph Bonaparte arrived in Philadelphia with an extensive collection of important paintings. Sold at auction in 1845 to James Robb, a prominent New Orleans banker and art collector, the painting has been in the city since that date. A subsequent owner, Randolph Newman, loaned the work to the Museum when it first opened in 1911. The painting was eventually purchased for the collection in 1940.

E.P.C.

Jean-Baptiste Greuze

French, 1725-1805

Portrait of Madame Gougenot de Croissy. 1757

oil on canvas, 31 1/2 x 24 3/4 in. (80 x 62.8 cm.)
Ella West Freeman Foundation Matching Fund,
Women's Volunteer Committee Fund and gift of
an Anonymous Donor. 76.268

To 18th century France the art of Jean-Baptiste Greuze appeared original, unique and morally superior to the gallant and pastoral themes painted in the Rococo style. Throughout much of his career he was the preferred portraitist of the upper classes, but his greater historical importance lies in the didactic genre scenes he painted. These images elicited acclaim from such notable figures as Diderot who praised Greuze's work as representing the highest ideal of painting in his day.

On a trip to Italy in 1755 Greuze was in close association with Natoire at the French Academy and met Louis Gougenot, the Abbé de Chezal-Benoît, who would become one his most important patrons. Two years later Greuze returned to France and painted portraits of Gougenot's brother Georges Gougenot de Croissy (Brussels, Musées Royaux des Beaux-Arts), future Conseiller-secrétaire to Louis XV, and the latter's twenty year-old wife, Marie-Angelique (née de Varennes), shown here.

This early portrait displays the straightforward interpretation Greuze gave his

sitters. Madame Gougenot de Croissy's personality is conveyed by her direct gaze, charming smile and subtle tilt of the head. Greuze's superb painterly technique is evident in the various textures rendered in her costume, especially that of the lace for which he was famous. The stylish young woman holds a navette or decorative shuttle around which she winds her knotted string. This activity was done in public by fashionable ladies and had no function other than to emblematically represent female diligence.

E.P.C./S.E.S.

Hubert Robert

French, 1732-1808

The Park of Saint-Cloud. 1768

oil on canvas, 31 x 39 ½ in. (78.7 x 99.7 cm.)
Gift by exchange of Edith Rosenwald Stern. 95.312

Robert's artistic direction was set during the eleven years he spent in Italy. He attended the prestigious French Academy in Rome and then traveled throughout the country making numerous studies of the landscape and architectural remains of classical Italy. This established his specialty and he became known as "Robert of the ruins." Within the year after he returned to Paris in 1765 Robert was received by the Royal Academy as a "painter of architecture." He went on to enjoy a highly successful official career as well as membership, with his beautiful wife, within the most fashionable social circles. These aristocratic associations eventually proved detrimental, however, when he was denounced to the Revolutionary authorities and imprisoned. But Robert continued his prodigious output from his cell, making paintings, watercolors, drawings, and even decorating plates that were then sold in town.

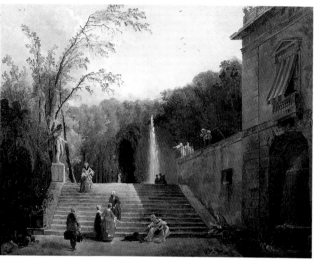

When Robert returned to France from Italy, he began to exhibit views of Paris and its environs, particularly park scenes. As the premier landscape painter of his time, it was perhaps inevitable that Robert become involved in landscape design. He was in fact in great demand in this capacity and after his innovative designs for the gardens at Versailles was named "landscape gardener to the king" in 1778.

Whereas his ruin paintings are calculated to evoke a nostalgic, melancholy mood, Robert's paintings of actual scenes succeed without artifice. These pictures command a freshness and vitality that is complemented by his free, feathery brushwork. *The Park of Saint-Cloud* precisely captures the clear atmosphere of a fine summer afternoon as fashionable Parisians stroll through the park of one of the royal palaces.

S.E.S.

Elisabeth Louise Vigée-Lebrun

France, 1755-1842

Portrait of Marie Antoinette, Queen of France. circa 1788

oil on canvas, 109 $^1/_2$ x 75 $^1/_2$ in. (278.1 x 191.8 cm.)
Women's Volunteer Committee and
Carrie Heiderich Funds. 85.90

Elisabeth Vigée-Lebrun was one of the most celebrated court portraitists of the late 18th century. In 1783 she received a rare honor for a woman at that time when she was admitted to the Royal Academy. At the outbreak of the French Revolution in 1789, Vigée-Lebrun fled France and travelled for several years throughout Europe. The portraits she painted during this exile strengthened her reputation and with the restoration of the Bourbon Monarchy in 1814, Vigée-Lebrun returned to France to continue her long career as portraitist of the aristocracy.

Of the at least twenty-five portraits Vigée-Lebrun painted of Marie Antoinette, the New Orleans painting is indeed a masterpiece. Her imperious bearing conveys an air of majesty that is reinforced by the various emblems of the monarchy: she wears a dress and toque of royal blue; the crown sits atop a pillow embroidered with gold fleur-de-lis; the arms of the Bourbon and Hapsburg families are imprinted on the leather cover of the book she holds on her lap and are embroidered upon the red velvet carpet covering the table. In Vigée-Lebrun's life size portrait, Marie Antoinette represents an ideal of regal power and authority.

The portrait is the second version of the same composition (the first is at the Chateau de Versailles). It was commissioned by Louis XVI's younger brother, the Comte d'Artois who eventually ascended to the throne as Charles X in 1824, the last Bourbon King of France. The portrait retains its original ornately gilded wood frame carved with the arms of the Comte d'Artois.

S.E.S.

Jean-Joseph Taillasson

French, 1745-1809

Coriolanus Beseeched by His Mother and Wife. circa 1791

oil on canvas, 45 x 57 in. (114 x 146 cm.)
George S. Frierson, Jr. Fund and gift by
exchange of Mrs. Charles Kohlmeyer,
Dr. and Mrs. Richard W. Levy, Mrs. Charles F. Lynch
and Mr. and Mrs. Moise S. Steeg Jr. 94.7

Taillasson was a product of the Neoclassical movement that dominated French art at the end of the 18th century. He studied with one of the most determined proponents of that movement, Joseph-Marie Vien, who also taught the artist most identified with Neoclassicism, Jaques-Louis David. The vogue for things classical had been spurred in part by the 1748 excavations in Italy at Herculaneum and Pompeii, but the

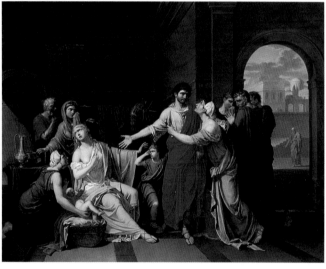

artistic manifestation was also a reaction against the frivolity of the Rococo. In opposition to the informal compositions, loose handling and decorative color of the Rococo, Neoclassicism presented an art of noble simplicity and calm grandeur, akin to ancient Greek and Roman art.

Taillasson's theme here is from early 5th century Roman history. Coriolanus was a one-time hero who had been banished. He then allied himself with the Volscians, a neighboring and enemy people, whom he led in an attack against his homeland. A heroic group of Roman women, including Coriolanus' wife, Vergilia, and his mother, Volumnia, met with Coriolanus to plead with him to call off the invasion. They were successful, but upon Coriolanus' return to Volsci, he was killed as a traitor.

This tragic tale provides a moralizing example of the strength of family ties and of patriotism, epitomizing the belief then current that art can be a tool to improve and uplift society. Taillasson has arranged the figures in a shallow, stage-like space parallel to the picture plane in a manner similar to ancient Greek and Roman relief sculpture. The clarity and force of the sculptural figures and their clear, dramatic gestures are typical of Neoclassicism and make the didactic message easy to read.

S.E.S.

Baron Antoine-Jean Gros

French, 1771-1835

Pest House at Jaffa. 1804

oil on canvas, 28 ½ x 36 ¼ in. (72.4 x 92.1 cm.)
Ella West Freeman Foundation Matching Fund. 67.24

Because the Royal Academy was dissolved before the ambitious and determined Gros was able to win the prix de Rome, he made the Italian trip on his own means. In Genoa he met Josephine Bonaparte whose influence with her husband assisted Gros in becoming a major artist to establish in paint the image of Napoleon Bonaparte as a military hero. Gros was one of the first French artists to be classified as a romantic because of the powerful emotional content of his works.

This oil sketch is a preliminary study for the monumental painting *Bonaparte Visiting the Plague-Stricken at Jaffa on March 11, 1799* (Paris, Musée du Louvre) that was an astound-ing success at the Salon in 1804. The sketch portrays the actual visit of Bonaparte to the hospital in Jaffa (near present-day Tel Aviv) where his troops stricken with the plague were housed. Contemporary accounts describe how the General actually held a dying man in his arms. Gros' turbulent brushstroke in this study becomes an effective vehicle to portray the emotional atmosphere of the scene of suffering and despair. Yet in the midst of the dying, Bonaparte appears quietly stoic.

The painting was originally commissioned as a propaganda piece; Bonaparte had faced much criticism for the massacre of civilians in the Syrian campaign and it was rumored that he poisoned his own soldiers dying from the plague to avoid further contamination of the troops. The preliminary version was rejected because Bonaparte felt his image was lacking in heroic qualities. The final version depicts the General almost as a Christ figure, bravely touching the sores of a plague victim.

E.P.C.

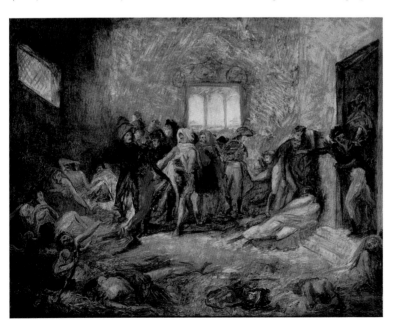

Jean-Auguste-Dominique Ingres

French, 1780-1867

Study for The Apotheosis of Homer.
1826

graphite and ink on paper,
9 7/8 x 12 3/4 in. (27 x 32.4 cm.)
Muriel Bultman Francis Collection. 86.225

Ingres was the leader of the Neoclassicists and the dominant figure in French art of his day. This study is one of an estimated 204 preliminary drawings related to his major painting *The Apotheosis of Homer* (Paris, Musée de Louvre). Indicating the final composition, the sketch depicts Homer enthroned at the apex of a pyramidal group of Homerides, both ancient and modern figures who have gathered to pay homage to him. These figures represent Ingres' opinion of history's most significant artists, writers, and philosophers including Pindar, Apelles, Phidias, Alexander the Great, Raphael, Dante, Virgil, Poussin, Molière, Racine, and Shakespeare. Also present at Homer's feet are allegorical figures representing his major works, the *Odyssey* and the *Iliad*. These illustrious figures are gathered to deify Homer, the single genius whom Ingres revered and to whom he believed all subsequent generations are indebted.

Ingres spent eleven years working out the final version of the composition of *The Apotheosis of Homer*. He made careful studies of individual figures, groups of figures, and of the entire image. The New Orleans drawing differs from the finished painting in several ways: Homer holds his staff out to his side rather than close to his shoulder; the figure of Victory crowning him carries a torch in her left hand whereas in the painting she uses both hands to hold the laurel crown; the figure of Odyssey rests her forehead rather than her chin against her hand; in the final composition Odyssey has an oar in her lap which symbolizes the sea journey of Odysseus and Iliad has a sword leaning against the steps.

S.E.S.

Gustave Courbet

French, 1819-1877

Rocky Landscape. circa 1858

oil on canvas, 21 x 25 in. (52.5 x 62.5 cm.)
Ella West Freeman Foundation Matching Fund. 69.16

Independent and obstinately self-assured by nature, Gustave Courbet ignored the traditional academic course of training to follow his own course of study by copying Dutch and Spanish Old Master paintings. Although his early works reflect the Romantic tradition, the 1850 exhibition of his paintings *The Stone Breakers* and *The Burial at Ornans* established Gustave Courbet as the leader of the Realist school of painting.

It is perhaps ironic that Courbet, the independent and rebellious artist who protested not only against academic teaching but against any organization of the art world, inspired a distinct school of artistic outlook. Courbet is acclaimed as an innovator on account of both his subject matter and his treatment thereof. His realist beliefs led him to choose themes from contemporary life, not excluding what was usually considered ugly or vulgar. Further, he eschewed idealization and romantic exoticism, preferring instead to treat his themes in an unemotional, straightforward fashion. He rejected the paint brush for the palette knife and so rather than draw his composition, he built it up in solid layers of paint. Courbet acknowledged the palpable reality of the pigment and exploited it to convey the material reality of his subject.

Painted in Dinant, Belgium, *Rocky Landscape* exhibits Courbet's usual dark palette, a characteristic he retained from his study of Old Master paintings. The surface texture betrays his confident wielding of the palette knife, particularly the strokes evident in the lower right corner. His use of impasto, thick layers of paint, emphasizes the materiality of the medium and thus is appropriate for this landscape as the paint itself evokes the dense, solid reality of rock.

S.E.S.

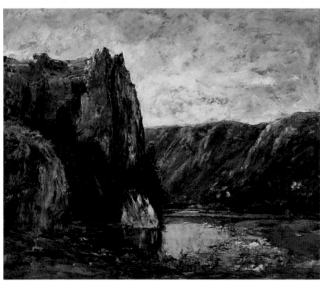

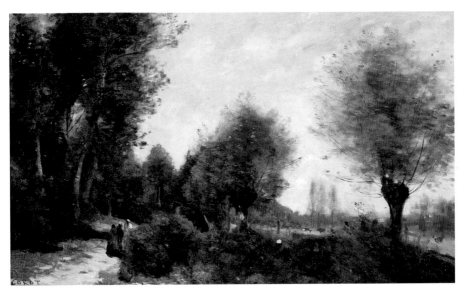

Camille Corot

French, 1796-1875

Woodland Scene. 1870-1873

oil on canvas, 14 $\frac{1}{2}$ x 23 $\frac{1}{2}$ in. (36.8 x 59.7 cm.)
Gift of Mr. and Mrs. Chapman H. Hyams. 15.8

Discouraged by his family from pursuing an artistic career, Corot did not begin painting until he was twenty-six. His first training was under traditional landscape painters, but in 1825 when in Italy he began working on plein-air sketches. By 1827 he was showing at the annual Salons and soon thereafter joined other artists at the village of Barbizon near the forest of Fountainbleau. Corot's name is invariably linked with the Barbizon School of landscapists who informed their canvases with a modern, fresh naturalism and a lyrical expression of their own love of the countryside; however, he actually spent relatively little time at the site. By the 1840s Corot's reputation had grown to such a point that the government acquired one of his history paintings. Financial success came in the 1850s and his popularity continued to grow, especially with the more affluent bourgeoisie.

Woodland Scene displays all the characteristics of Corot's late style: a matte surface, a cool palette of grays and greens and a soft atmospheric haze punctuated with spots of white and vibrant color. He creates a lyrical and nostalgic mood using a traditional landscape theme as a vehicle for personal expression. This painting may have been executed in 1872, as it bears many similarities to works such as *Landscape Near Arras* (Rouen, Musée des Beaux-Arts) of that date. In that year Corot traveled throughout France and southern Belgium, painting landscapes at nearly every stop on his itinerary.

E.P.C.

Narcisse-Virgile Diaz
de la Peña

French, 1808-1875

Autumn. 1872

oil on panel, 23 ³/₄ x 18 ³/₄ in. (60.3 x 47.7 cm.)
Gift of Mr. and Mrs. Chapman H. Hyams. 15.0

Diaz de la Peña was born in Bordeaux, the son of Spanish political refugees. His family moved to Sèvres where his first artistic endeavor was, like that of Renoir, painting porcelain. After brief formal training, Diaz was first accepted in the Salon of 1835 with a history painting entitled *Battle of Medina,* derisively called at the time the *Battle of the Broken Paint Pots.* Two years later he was at Barbizon where he avidly took up the new style of naturalism in landscape painting. His financial success was insured by the many small works readily accepted by the Salon and quickly purchased by his bourgeois clientele. At the time of his death Diaz had received every award that the Salon could bestow.

Diaz's work can be divided into two categories: small figural compositions of a fanciful nature that form part of the 19th century Rococo revival, and landscape views of the forest of Fountainbleau. *Autumn* belongs to

the second group and is typical of his works from the late 1860s and the 1870s. It is a pure landscape, executed in earth tones, with no intruding elements from the civilized world. The sunlight creates bold patches in the clearing of the dense wood and on the treetops; the shadows are then enlivened with yellow highlights. The resulting effect is one of an enchanted landscape that embodies a sense of mystery and the quiet solitude of a purely natural setting.

E.P.C.

Franz Xaver Winterhalter
German, 1806-1873

Young Woman in a Ball Gown. 1850

oil on canvas, 51 ¼ x 38 in. (127.8 x 90 cm.)
Carrie Heiderich Fund and gift by exchange of
Mr. and Mrs. Harris Masterson. 87.32

The preeminent portrait painter of European royalty, Winterhalter was born in Germany and studied engraving in both Fribourg and Munich before traveling to Paris in 1834. In Paris Winterhalter began painting portraits and quickly established his reputation. The long list of his illustrious and royal sitters includes King Louis-Philippe of France and the principal members of the Orleans family, King Leopold I of Belgium, Queen Victoria of Great Britain and Prince Albert and their family, and the Hapsburg Emperor Franz Joseph. His most important royal patron was the Empress Eugenie into whose personal service he was pressed when Louis Napoleon Bonaparte became Emperor of the French in 1851. The great favor his patrons showed him stemmed in part, no doubt, from his ability to capture a faithful likeness of his subjects while subtly enhancing their appearance at the same time. Winterhalter is credited with creating the exuberant style of the Second Empire by combining elements of both French academic painting and German romanticism.

Painted in Paris in 1850, *Young Woman in a Ball Gown* is a beautiful example of Winterhalter's version of the tradition of the Grand Manner inherited from Rubens and Van Dyck. The elegant figures who populated European courts and his paintings were the perfect vehicle for Winterhalter to indulge his skill in rendering a variety of sumptuous textures. His fluid brushwork conveys the young lady's soft, milky flesh as convincingly as it does her iridescent, silk taffeta ball gown. Winterhalter's fancifully extravagant style appropriately documents the splendor of the imperial pretensions of Napoleon's court.

S.E.S.

His paintings parallel French interest in the Arab world that began early in the 19th century with the publication of the fourteen volume *Description d'Egypte* (1808-1829) following Napoléon's campaign and French colonial expansion in the region. Because of this popular interest Gérôme and other Orientalist artists made numerous trips to North Africa, particularly to Egypt, to depict scenes both alien and exotic to Western European eyes. This fascination with the exotic is noteworthy as one of the offshoots of the Romantic movement.

A number of paintings reveal Gérôme's distinct preference for groups of colorful figures in realistic settings. Turkish mercenaries, known as Bashi-Bazouk, appear in paintings as merrymakers, shot casters, or, as in this painting, chess players. While an earlier depiction of *Chess Players* exists in the Wallace Collection, London, a black and red chalk drawing of the same figures can be found in the Clark Art Institute, Williamstown, Massachusetts. Of the three versions, New Orleans' *Chess Players* is the most complex.

J.G.C.

Jean-Léon Gérôme

French, 1824-1904

Chess Players. circa 1867

oil on canvas, 25 ¼ x 21 ¼ in. (64.1 x 53.9 cm)
Gift of Mr. and Mrs. Chapman H. Hyams. 15.14

Specializing in the realm of realistic history painting, Jean-Léon Gérôme was one of the most popular artists of the 19th century. Until recently, however, he has been neglected and often denigrated for his realistic depictions of the oriental world of the Near East.

Jehan Georges Vibert

French, 1840-1902

The Cardinals' Friendly Chat.
circa 1880

oil on canvas, 29 x 32 ½ in. (73.7 x 82.6 cm.)
Gift of Mr. and Mrs. Chapman H. Hyams. 15.27

Vibert was one of the most popular French artists of the late 19th century in both France and America. He was greatly admired for his mocking wit, equally evident in his short plays, and his detailed realism, the precision of which was facilitated by his frequent use of panel for a picture's support. Vibert's academic training began at age sixteen and his first Salon exhibition was in 1863. His early paintings were of historical and religious themes, but he soon turned to a gentle satirical tone, often focusing on ecclesiastics in comical genre situations.

Cardinals' Friendly Chat depicts two ecclesiastics enjoying an animated conversation over wine and elegant cakes. Vibert makes an intentional ironic reference to the eucharist with the biscuit being soaked in the wine. This comic mode creates a theatrical feeling that is clearly related to Vibert's stage productions. The playful mockery of the princes of the Church is taken further by the setting of their intimate afternoon party; it is the Turkish Boudoir of Queen Marie-Antoinette in the castle of Fountainebleau. The furnishings in the Empire style were added by the Empress Josephine in 1805.

E.P.C.

William-Adolphe Bouguereau

French, 1825-1905

Whisperings of Love. 1889

oil on canvas, 62 x 36 ¹/₂ in. (157.5 x 92.7 cm.)
Gift of Mr. and Mrs. Chapman H. Hyams. 15.6

Bouguereau's name, like that of Gérôme, has become synonymous with French academic painting of the second half of the 19th century. He was one of the most powerful figures in official French art circles, but after his death his name fell into relative obscurity, his work considered too sentimental for the emerging modern age. Only in the past thirty years has interest been revived in Bouguereau as the supreme academician in the great age of the Paris Salon.

Had Bouguereau followed his parents' wishes, he would have remained in the world of commerce. Through the kind offices of an uncle and his own efforts as a portrait painter, Bouguereau was able to study at the École des Beaux-Arts in Bordeaux. He arrived in Paris in 1846 and entered the Beaux-Arts as a student of Picot. In 1850 he won the prix de Rome; by 1859 he was made a member of the Legion of Honor.

Most of Bouguereau's Salon pictures are nudes, religious subjects and figures from classical history or mythology. *Whisperings of Love* is more of a genre piece, executed in the highly finished, realistic style of the "Neo-Greeks." Historical authenticity is attempted with the Greek chiton and the protogeometric amphora. The reduced color range and the idealized beauty of the young woman are noted characteristics of Bouguereau's later style. The sentimentality of the artist, so highly regarded by some and harshly criticized by others, is expressed here through the large, searching eyes of the maiden. She appears vulnerable, yet somehow receptive, to the amorous stirrings aroused by the whispers of the playful cupid.

E.P.C.

Edgar Degas

French, 1834-1917

Portrait of Estelle Musson Degas.
1872

oil on canvas, 39 3/8 x 54 in. (100 x 137 cm.)
Museum Purchase by Public Subscription, 1965. 65.1

Perhaps the most well-known French painting of the New Orleans collection, Degas' portrait of his sister-in-law (and first cousin) was painted in New Orleans in December 1872, during the artist's stay in his mother's native city. Degas had come to New Orleans to visit his uncle Michel Musson, who was prominent in the cotton business, and his brothers Achille and René, who were wine importers.

In New Orleans Degas painted about fifteen portraits of family members, all portrayed in interiors on account of his weakened vision. Degas felt a particular sympathy for the nearly blind Estelle (1843-1909), wife of his brother René, portrayed here immediately before the birth of her fourth child. His description of her in a letter relates her brave acceptance of the handicap, though it ends "she is almost without hope." Two other portraits of Estelle were produced during this short visit (Washington, National Gallery of Art and Paris, Musée d'Orsay); the New Orleans picture is the largest and most monumental in conception.

Estelle is depicted arranging flowers in a shaded room. The sketchy ground of reds and browns creates an aura of darkness emanating from her form, probably a reference to her blindness. Degas also emphasizes the sense of touch with the woman's hands tentatively arranging the flowers. Her face is silvery grey and is illuminated not from the window, but from a source of light to the left, creating a sense of ineffable mystery. The surface is then enlivened with the greens, whites, reds and yellows of the bouquet. The portrait's unfinished state reveals how Degas' painting process was more closely approaching the Impressionist aesthetic in the early 1870s.

E.P.C.

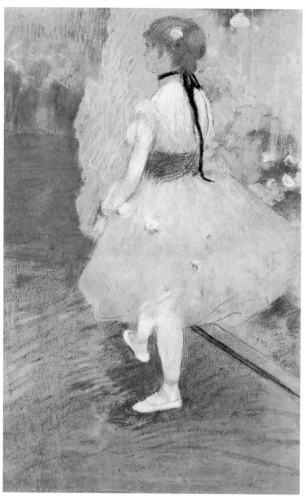

Edgar Degas

French, 1834-1917

Dancer in Green. circa 1878

pastel on paper, 18 ¼ x 11 ½ in. (48.3 x 29.2 cm.)
Gift of Charles C. Henderson in memory of
Nancy S. Henderson. 74.282

During the first decade of his artistic career Degas painted portraits and historical themes. Eventually, however, he turned to contemporary life to find the subject matter for his paintings. He studied people in action going about their work; jockeys, milliners, laundresses, opera singers and dancers. Gradually as Degas' interest in the opera and theater grew, dancers assumed a background position similar to that allotted to landscape in his earlier painting. Then, with the picture *Musiciens de l'Orchestre*, the dancer suddenly occupied center stage. This subject became a major concern of the artist in the years between 1875 and 1890 during which time he began experimenting with pastels as a primary medium. Degas spent many hours attending ballet classes in order to observe the struggling young dancers of the Paris Opera and to sketch them in class and on stage.

Dancer in Green shows a young girl waiting in the wings during a performance. In depicting this dancer, Degas has employed several of his favorite devices including averting the face in half-profile; positioning the figure high up in the picture plane; using back lighting and selectively viewing empty space as an important part of the composition. He also executed an oblique view with exaggerated recession, which he learned from a study of Japanese woodblock prints.

J.G.C.

Edgar Degas

French, 1834-1917

Walking Horse. circa 1880

bronze, 5 ¹/₄ in. (13.3 cm.)
Gift of the Musson Family. 50.4

Degas first began to make sculpture in the early 1860s when he modeled a small horse as a study for a painting. It is difficult to accurately date his sculpture because he exhibited only one during his lifetime. His initial horse sculptures were smooth and finished. As he grew older, his obsession with movement and anatomy grew, and his forms and modeling became freer. His ceaseless concern with the expression of movement is perhaps the dominating characteristic of Degas' work.

Walking Horse was among the earliest sculptural expressions of this theme. The artist also recorded pastel sketches of horses, simultaneously working in two media. Often Degas chose poses from real life which he had previously committed to memory while viewing famous works of art. *Walking Horse* is clearly related to large Italian equestrian monuments such as Verrocchio's *Colleoni* and the bronze horses of San Marco in Venice.

After Degas' death the bronze foundry A.A. Hebard cast twenty-two sets of seventy-two of the one hundred and fifty sculptures found in his studio. Each bronze bears an Arabic number (1-72) and a letter designating the set to which it belongs. The New Orleans bronze is number 10, set D, and is one of ten bronzes given to the Musson family in New Orleans in the settlement of René Degas' estate.

J.G.C.

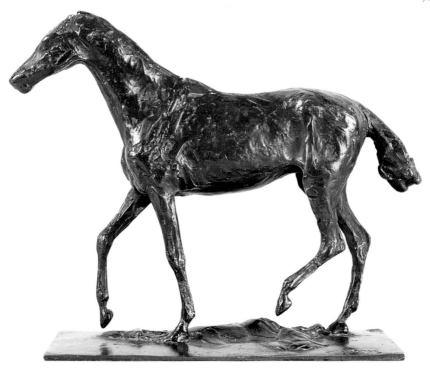

Edgar Degas

French, 1834-1917

Dancer Adjusting Her Stocking.
circa 1880

bronze, 16 3/4 in. (42.5 cm.)
Ella West Freeman Foundation Matching Fund. 72.21

From about 1875 Degas devoted as much time to modeling in wax and clay as he did to painting. The artist's methods were totally unorthodox. Most of his sculpture was executed on wire armatures using a combination of wax and plastilene. This media gave the artist a desirable, flexible system. Nevertheless, the mixture of materials with different drying rates encouraged crackling while the movement of the arms and legs caused breakage.

The pose of *Dancer Adjusting Her Stocking* is related to an earlier Degas drawing of a classical figure and resembles the stance of an antique faun. The pose, inherited from the 18th century, was handled before Degas in a slightly different manner by the sculptor Pierre Philippe Thomire (1751-1846). Stylistically Degas strove in sculpture as in painting to capture motion.

During the final year of his life the artist was occupied almost exclusively with sculpture, since near blindness prevented his working in paint or pastels. At his death in May 1917 his studio was filled with over one hundred sculptures, many of them in bad condition. None of the sculptures was ever cast in bronze by Degas and he publicly exhibited only one wax model during his life.

J.G.C.

August Rodin

French, 1840-1917

The Age of Bronze. 1876

bronze, 72 in. (182.9 cm.)
Gift of Mr. and Mrs. A.Q. Peterson. 64.21

Soon after Rodin entered the Imperial School of Drawing and Mathematics, he discovered his affinity for sculpture. Thereupon he enrolled in the Ecole des Beaux Arts in Paris. During his stay in Belgium several years later, he was enormously influenced by Flemish Baroque art. In a similar manner, his travels to Rome and Florence introduced him to another great influence of his career, Michelangelo. *The Age of Bronze* was executed soon after his return from Italy and is Rodin's first life-size work to survive.

The Age of Bronze was one of Rodin's most significant early works and the scandal which ensued after its first exhibition established his artistic reputation. It was shown first in Brussels and later in Paris in 1877. The sculpture was admired for its life-like appearance but condemned for the same reason because some critics mistakenly believed that Rodin had cast it from a living model. In 1880 it was cast again in bronze and exhibited at the Salon des Artistes Français. The New Orleans sculpture is one of twenty-seven known full-sized bronze made, cast during the artist's lifetime.

J.G.C.

Claude Monet

French, 1840-1926

Houses on the Old Bridge at Vernon.
circa 1883

oil on canvas, 23 ³/₄ x 32 in. (59.4 x 80 cm.)
Promised and Partial Gift of Mrs. John N. Weinstock in
memory of Mr. and Mrs. B. Bernard Kreisler. 95.387

Water is a recurrent motif in Monet's compositions and appears in *Houses on the Old Bridge at Vernon*. In previous landscape painting water was depicted in a fixed and regularized manner as a mirror-like reflective area. In Monet's pictures, however, water no longer has a fixed, unvarying character, but rather, assumes a variety of appearances. This appearance is dependent upon Monet's other major concern, depicting the atmospheric conditions of the landscape at the time during which he was painting it.

In this work these concerns are used to convey the impression of a stormy day. The palette is dark; the colors are muted and almost muddy. The overcast sky is dominated by dense, grey cloud masses. The body of water appears to be quite agitated with white-crested waves stirred up by an impending storm. Although a broken brushstroke is characteristic of Monet's work and is used throughout the image, the strokes composing the area of water appear to have been dragged or slashed through very thick pigment. Rather than acting as a reflective surface, this water is dark and opaque. Monet's working method was one based upon observation rather than invention. In respecting his perceptions and refusing to embellish or idealize, Monet has captured that moment before the onslaught, when the storm is yet but a threat.

S.E.S.

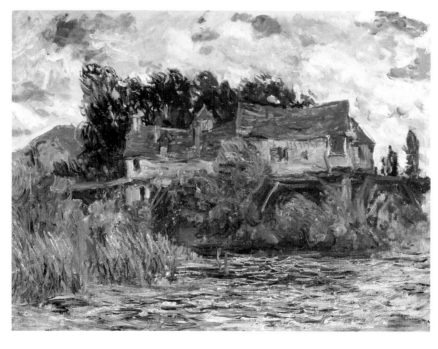

Gustave Caillebotte

French, 1848-1894

Bouquet of China Asters and Sunflowers in a Vase. circa 1887

oil on canvas, 24 ³/₄ x 19 ³/₄ in. (62.8 x 50.2 cm.)
Gift of Dr. and Mrs. Richard W. Levy. 77.48

Caillebotte was raised in an affluent Parisian family, studied law and served in the military before entering the Ecole des Beaux-Arts in 1873 through the influence of the academic painter Léon Bonnat. In 1874 he associated himself with the Impressionists who were then under intense criticism from academic circles. He exhibited with that group several times and was an avid collector of their more daring works. His own paintings of urban subject matter were consistent with the Impressionist style. His plunging perspectives of Parisian streets are his most innovative works. After the Impressionists split up in 1882, Caillebotte spent most of his time at his country home in Petit-Gennevilliers, near his friend Monet at Giverny. Caillebotte's collection of Impressionist works was eventually given to the state and is now housed in the Musée d'Orsay in Paris.

Caillebotte was an amateur horticulturist and floral still-lifes became important in his work after his departure from Paris. At this time his technique loosened, though here his flowers appear densely arranged over a large portion of the picture field. The painting pul-

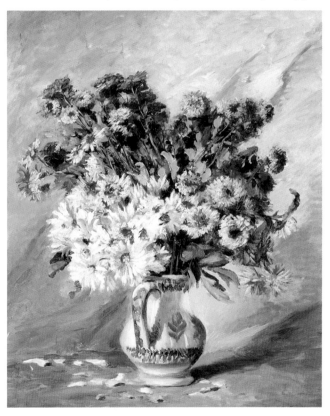

sates with life and color harmonies and demonstrates the artist's firm mastery of the Impressionist style. This still-life is dated about 1887 when most of Caillebotte's painting focused on his house and garden at Petit-Gennevilliers.

E.P.C.

Pierre Auguste Renoir

French, 1841-1919

Seamstress at Window. circa 1908

oil on canvas, 25 $^1/_2$ x 21 $^1/_2$ in. (64.8 x 54.6 cm.)
Gift of Charles C. Henderson in memory of
Margaret Henderson. 80.179

In 1862 Renoir was enrolled at the Beaux-Arts as a student of Charles Gleyre in whose studio he met the other painters who would become central to the Impressionist movement. He was soon attracted to the colorism of Delacroix, the modernism of Courbet and the painterly qualities of Edouard Manet. In the 1860s Renoir was most interested in painting light and his work is almost indistinguishable from that of Monet with whom he

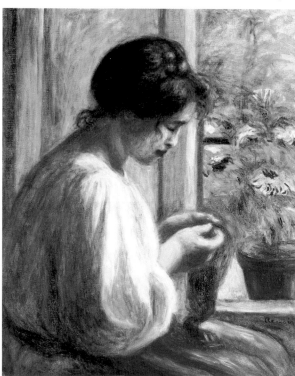

worked quite closely. But he is more often remembered for the sensuality and vibrancy of his colors, especially of his blues and reds. Renoir was the most instrumental of the Impressionists in creating the new image of the urban, middle-class society happily enjoying its leisure time.

Renoir began to break from the Impressionists around 1881 when he came in contact with classical art. He felt that their predominant interest in color and light over line and composition threatened a loss of the basic human qualities inherent in the classical tradition of art. His own painting came to rely more upon line and descriptive detail with a corresponding emphasis on the human form. Renoir's oeuvre, more than that of any of the Impressionists, included a great deal of monumental figures, especially women.

Seamstress at Window is a late work and falls into the category of a genre painting. The model is undoubtedly Gabrielle Renard, the young woman who became Renoir's housekeeper in 1895. The reds and oranges of his palette give the image a warmth and glow. Renoir's purpose here seems to be the creation of a sense of domestic tranquility, most likely reflecting the aging artist's home life.

E.P.C.

Pierre Bonnard

French, 1867-1947

La Revue Blanche. 1894

gouache on paper, 31 ¹/₄ x 23 ¹/₂ in. (79.4 x 59.7 cm.)
Gift of Mr. and Mrs. Frederick M. Stafford. 76.421

A generation younger than the Impressionists, Bonnard, while studying law in Paris, began painting at the Académie Julian, where he met the other young artists who would found the Nabis group. They took their name from the Hebrew word for prophet and held a common admiration for Gauguin and the highly decorative quality of line and color in his more abstract works. Bonnard spent much of his earlier career designing posters and book illustrations, using bold, two-dimensional designs in black against a neutral ground. He later developed a painting style resplendent with bright hues and a magical, colored light.

In 1891 Bonnard created a design for a commercial poster advertising *France Champagne*. It was an immediate success and helped popularize what was to become known as the Art Nouveau style. When Alfred and Thadée Natanson took over the publication of the avant-garde literary and art magazine called *La Revue Blanche*, they called upon Bonnard for illustrations and in 1894 the

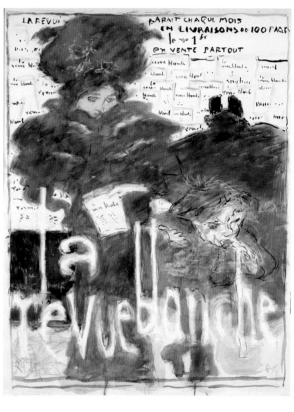

design for a poster. This gouache is the study for the lithographic poster. A street urchin, bent over, distorts his face as he loudly hawks his journal. He points behind himself where a woman stands, her large eyes coquettishly peering out from her stylish belle époque costume. The model is believed to have been Marthe Meligny (née Maris Boursin), Bonnard's mistress and later his wife. A third figure, seen from behind, is a man wearing a top hat and bending over to read or buy an issue of the magazine at the newsstand. Few changes appear in the resulting poster, though the image is flattened and the newsboy's cravat becomes patterned.

E.P.C.

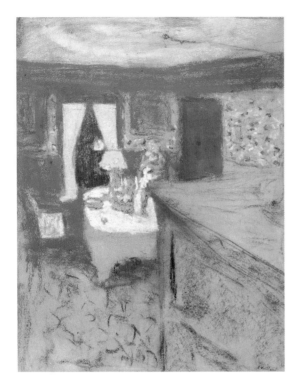

Edouard Vuillard

French, 1868-1940

Interior Scene. circa 1900

pastel on paper, 23 ½ x 18 ¼ in. (58.7 x 46.4 cm.)
Muriel Bultman Francis Collection. 86.312

The work of Edouard Vuillard is domi-
nated by small-scale, evocative depictions
of his family and friends in familiar surround-
ings, almost always interiors. It is in these
intimate interiors of the decade between
1890 and 1900 that Vuillard's artistic sensibil-
ity and pictorial construction manifest
themselves at their most sophisticated
and complex.

These interiors evoke Vuillard's
life in a visual shorthand. Not
only do they depict familiar
rooms, they also convey his feel-
ings towards the characters who
inhabit them. The interior scene
was the subject through which
Vuillard could best explore the
complex emotional and intellec-
tual issues central to a beginning
painter's development. It became
a metaphor for his own interior
life, an inner space at once self-
controlled and removed from
the world as well as fecund
with possibility.

The space in this, as in most of
Vuillard's interior scenes, is
crowded, almost claustrophobic,
and difficult to decipher. The
image explores a concept that
was central to the psychological scrutiny of his
art, the relationship between form and color
and their power to convey meaning. The psy-
chological impact of this image upon the
viewer is certainly jarring. The viewer's access
to the space is both directed and denied by the
form of the bureau jutting in from the right.
Dominated by a single tonal character, the
space appears ambiguous. It does, however,
indicate Vuillard's usual sense of structure
through contrasts as the background wall is
formed by a series of rectangles varied in pat-
tern and color. Such elusiveness of structure,
form, and thereby meaning, ultimately creates
an enigma of Vuillard's intimate interiors and
thus makes them irresistibly compelling.

S.E.S.

Odilon Redon

French, 1840-1916

Beasts at the Bottom of the Sea.
circa 1900-1905

pastel on paper, 24 x 19 ³/₄ in. (60 x 49.5 cm.)
Muriel Bultman Francis Collection. 83.69

Although he was their exact contemporary, Redon was distinguished from the Impressionists by his strong imaginative bent. His belief that an art of broader reference was needed led him during the 1870s to develop a pictorial language which epitomizes Symbolism. Symbolism was a loosely organized movement of artists both visual, Puvis de Chavannes, Gustave Moreau, and literary, Stephan Mallarmé, J. K. Huysmans, who shared a similar attitude of protest. Their revolt was against the scientific rationalism and materialism that had

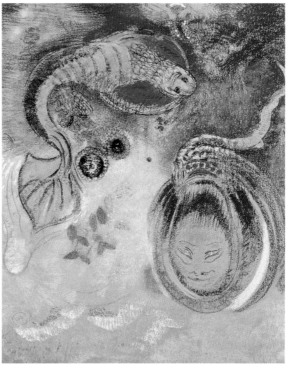

developed throughout the 19th century. Redon's visionary images sprang from the Symbolist belief that a picture is neither simply an arrangement of lines and colors, nor a direct transcript from nature, but is the manifestation of another order of meaning.

Beasts at the Bottom of the Sea allowed Redon to combine his love of brilliant, jewel-like color and his continuing fascination with the animal world. Using variegated textures and directional movements of shimmering pastels ranging from blues to greens to yellows, Redon has evoked a mysterious aqueous world. Suspended in it are fanciful imaginary creatures who playfully twist and turn in arabesques that animate the composition. Using such playful forms and alluring colors, Redon has transformed the cold, alien underwater depths into an enticing and attractive environment whose appeal is strengthened by the presence of the smiling anthropomorphic-zoomorphic creature.

S.E.S.

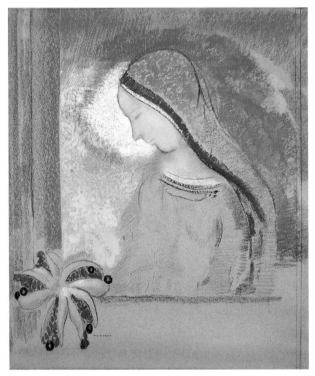

Odilon Redon

French, 1840-1916

The Dream. circa 1905

pastel on paper, 26 1/4 x 22 1/2 in. (66.6 x 57.2 cm.)
Muriel Bultman Francis Collection. 86.283

In the 1890s color began to illuminate Redon's formerly anguished and apocalyptic vistas and transform the mood of his subject matter. No longer somber or violently tragic visions, his dreams now occupied a tranquil and serene universe characterized by a silent beauty and enigmatic charm. A leitmotif that spanned nearly thirty years of Redon's career and became particularly prominent in 1905 is that of the pensive young woman. These women are always shown in profile facing a flower or group of flowers. They are frequently framed by a window or an arch, a favorite compositional device of the artist. Creating an illusion of a picture within a picture, this device delineates for these young women a removed and timeless environment marked by an air of mystery.

The Dream is from this series of depictions of women in profile. Her head bowed and eyes closed, the young woman's private reveries are symbolized by the swirling, iridescent colors of the background. In this series Redon's lustrous background colors become progressively independent of contour until, as here, they are fully autonomous areas, an extension of dream reality. A single, exotic blossom provides a link between the more somber realm without the illusionistic frame and the luminous one within. The nature of the flower bursting with seeds to suggest fertility is ambiguous: does it belong to the mundane realm or to the dream realm? The classic simplicity of the profile and the reference to Marian iconography in the woman's draped head, evoke the sense of quasi-religious spirituality that pervades many of Redon's pictures. It is a non-specific mysticism asserting the victory of the spirit over darkness, of serenity over anguish, won by a soul at inner peace.

S.E.S.

Kees van Dongen

Dutch, 1877-1968

Woman in a Green Hat. 1905

oil on cardboard, 18 x 14 ³/₈ in. (45.7 x 36.5 cm.)
Gift of Mr. and Mrs. S. J. Levin. 63.39

Kees van Dongen was one of the so-called "heroic" generation of painters who helped make Paris the fascinating hub of artistic life before and after the First World War. Although he was one of the original Fauves who burst onto the Parisian art scene with the 1905 *Salon d'Automne*, Van Dongen's position among the Fauves was never central. It was limited by his Dutch background and relatively independent artistic stance. Both his emotionality and his darker palette are ascribed to his Northern European background. Yet his natural inclination for a free use of color, rich in contrasts, his thick impasto, and his use of Impressionist and Neo-Impressionist precedents demand his designation as a Fauve.

Unusual for Fauve work is the eroticism of van Dongen's personal iconography. His favorite theme was the image of woman, often nude. After 1905 he began to concentrate upon portraits of prostitutes, circus performers, actresses and singers. These images portray independent women with a strong sense of immediacy and presence conveyed through vibrant color as in *Woman in a Green Hat*. In his usual fashion van Dongen has translated this woman's face into a broad, simplified shape dominated by schematically indicated eyes. The deep, ultramarine blue, oblong eyes are a trademark of his broad, stylized heads which often evoke ancient Greek sculpture. Compared to that of the face and hat, the color scheme of the woman's dress seems reserved. The intensified color and

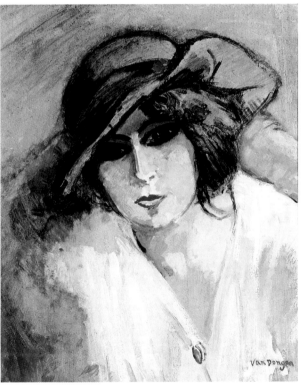

rhythmic lines of this image, characteristics of his work, were considered suggestive of a scandal-causing sensuality. It is this type of stylish portrait that was the source of van Dongen's fame during the first half of the century.

S.E.S.

Maurice de Vlaminck

French, 1876-1958

The Seine. 1905

oil on canvas, 18 ¹/₂ x 22 in. (46.4 x 55.9 cm.)
Promised and Partial Gift of Mrs. John N. Weinstock in
memory of Mr. and Mrs. B. Bernard Kreisler. 95.393

Maurice de Vlaminck, born in Paris of a Belgian father and a French mother, had practically no artistic training. He took up painting after meeting André Derain in 1900, but felt no great inspiration until seeing the 1901

Vincent Van Gogh retrospective with Derain and Henri Matisse. Passionate and headstrong, Vlaminck was a painter of instinct who would boldly apply intense colors almost directly from the tube. He and Derain shared an impoverished studio on the island of Chatou in the Seine where they pushed their art beyond the objectivity of Post-Impressionism.

Their first important exhibition was the famous *Salon d'Automne* of 1905 that so shocked the public because of the artists' intense colors, violent brushwork and simplified forms. In reviewing the Salon a critic called these painters the Fauves, or wild beasts, because of their bright surfaces and revolutionary aesthetic. The Fauve movement lasted only three years, but paved the way for further experimentation in modern painting.

The Seine depicts the bridge that crosses the river at Chatou (Hauts-de-Seine, between Nanterre and St. Germain-en-Laye). Vlaminck's long parallel and perpendicular brushstrokes are an extension of the divisionist style with no color modulation, though the color choice is purely subjective and reference to natural light is minimal. Vlaminck often wrote that he painted his heart and that color was an expressive vehicle for his emotions. This is most apparent here in the red trees and in the white, marine blues and reds of the water's surface. Comparison with a similar, but large, work of the same view painted in the same year, (Los Angeles, formerly William Goetz collection) shows how Vlaminck would arbitrarily distort and rearrange observed landscape elements.

E.P.C.

Georges Braque

French, 1882-1963

Landscape, l'Estaque. 1906

oil on canvas, 20 x 23 ³/₄ in. (50.8 x 60.3 cm.)
Bequest of Victor K. Kiam. 77.284

Born in Paris and raised in Le Havre, Braque left the painter-decorator's trade to move to Paris to study art, though he spent only a few months at the Ecole des Beaux-Arts as a student of Bonnat. Along with Picasso, he is remembered as one of the most important figures in the development of 20th century art because of his role as a founder of the Cubist movement in 1908. In the very first years of the new century, however, Braque worked in a Neo-impressionist style, but later destroyed most of his work from before 1905 or 1906. When his interest turned toward Cézanne in 1907 and when he began his association with Picasso in Paris, the pictorial freedom he had won during his Fauve period manifested itself in the formal experiments of his early Cubist pictures.

Braque's first significant paintings date from 1906, when his affinity with the Fauve movement was strongest. In the summer he painted landscapes near Antwerp and in the fall traveled south to paint at l'Estaque, near Marseilles. Like Derain's landscapes of this period, the horizon of *Landscape, l'Estaque* is near the painting's edge. The painting shines with warm sunlight and the pale greens, roses, blues and orange-yellow combinations produce an effect close to iridescence. Besides the typical Fauve emphasis on colored outlines of forms, Braque confers a sense of movement through the landscape by the bold dashes of color reminiscent of Neo-impressionism. The composition as a whole typifies the gentle lyricism and controlled balance of all Braque's work that marks his important place in the tradition of French painting.

E.P.C.

André Derain

French, 1880-1954

Landscape at Cassis. 1907

oil on canvas, 24 x 20 in. (60.9 x 50.8 cm.)
Gift of William E. Campbell. 53.6

Along with Matisse and his close friend Maurice de Vlaminck, André Derain developed a new style in which pure colors were used subjectively rather than descriptively to depict abstracted natural forms. The aim of these Fauve painters was not to produce traditional images of objects, but to represent pictorial equivalents to those objects. By the end of World War I Derain felt obliged to express his individuality and abandoned the avant-garde in favor of a personal neo-classicism that allied his painting to the naturalism of post-medieval art.

Derain spent the summer of 1906 at l'Estaque in southern France. It was once thought that this landscape was painted on that trip. But in 1906 Derain's brushwork was still related to the divisionist style and closely resembled the work of Vlaminck and even Braque's Fauvist landscapes. The next summer Derain was at Cassis where this landscape was painted. The palette is still bright, but is dominated by a more somber green and color areas are now flatter and larger. Forms have been simplified and the flat planes of the house, hills and trees reveal a concern for formal structure that is related to the work of Cézanne. The vertical strips of color on the canvas' right edge may refer to a tree trunk or a window frame from which Derain viewed the landscape, but their real pictorial function is to sustain the painting's dominant color tension. It is known that later in 1907 Derain destroyed some recently finished canvases. There are, however, three extant Cassis landscapes (New York, The Museum of Modern Art; St. Petersburg, The Hermitage; and Troyes, Musée d'Art Modern Pierre Levy) that were painted immediately after the New Orleans picture.

E.P.C.

Ernst Ludwig Kirchner

German, 1880-1938

Sawmill in Königstein. circa 1913

oil on canvas, 19 ³/₄ x 29 in. (50.17 x 73.66 cm.)
Partial and promised gift of Eleanor B. Kohlmeyer. 90.200

Kirchner was a founding and dominant figure of *Die Brücke* (The Bridge) group of German Expressionist artists. These artists put great emphasis upon the instinctive, spontaneous and subjective, and sought to express in a forceful manner the strong emotional attitudes they had towards their subject matter. Kirchner was especially drawn to late Gothic art from which he derived the jagged forms and harsh contrast of planes considered characteristic of his work.

During the years 1912 and 1913 Kirchner produced the work considered not only among his best, but also the most representative of German Expressionism. Through his direct approach to his subjects, Kirchner attempted to express the pace and emotional atmosphere of modern life. With his *Sawmill in Königstein*, an area outside of Dresden, Kirchner directed his characteristic vision, with its simplified drawing and contrasting color, to a scene less frenzied than those depicted in his images of the feverish atmosphere pervading Berlin before and during World War I. Yet because of his familiar techniques even an apparently calm, rural landscape may convey the anxiety of modern life. The canvas is weighted in the middle ground where the slashing, sometimes writhing brush strokes create an almost abstract pattern of color, texture and shape. Kirchner has constructed the image using his combination of Gothic distortion and brilliant fauvist color which creates a scene of heightened visual intensity and emotional vibrance.

S.E.S.

Antoine Bourdelle

French, 1861-1929

Hercules the Archer. 1907

bronze, 98 x 94 ³/₄ in. (248.9 x 240.7 cm.)
Museum Purchase. 49.17

Winning a prize at the Ecole des Beaux Arts in Toulouse and the acclaim of his teachers resulted in Antoine Bourdelle's receiving a scholarship to the Ecole des Beaux Arts in Paris. There he studied briefly with Falguiere, then with Dalou and finally with Rodin. Aside from his work as a sculptor,

executing such major public commissions as the Franco-Prussian War Memorial for Montauban, Bourdelle gained fame as a teacher after 1900.

From 1900 to 1907 Bourdelle worked on the model for *Hercules the Archer* which is his most famous work. Hercules is depicted in the fifth of his labors, the shooting of the Stymphalian birds. As a model for the body, the artist used an athlete, Commandant Doyen Parigor, who was later killed at the Battle of Verdun during World War I.

The New Orleans bronze cast of Hercules was made after the sculptor's death. It is the tenth and final cast from the second edition of the original by Bourdelle and was made under the supervision of his widow in 1947. Other casts can be found in such diverse collections as the Musée National d'Art Moderne, Paris; National Gallery, Prague; the Metropolitan Museum of Art, New York; and the Public Gardens of Buenos Aires.

J.G.C.

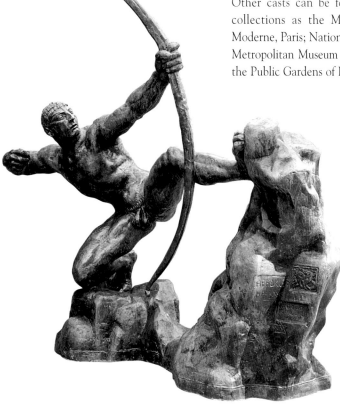

Pablo Picasso

Spanish, 1881-1973

Table with Bottle and Violin. 1913

black chalk and newspaper
on paper, 24 x 28 ½ in.
(61 x 46.5 cm.)
Muriel Bultman Francis
Collection. 86.275

From the beginning Pablo Picasso's art was characterized by continuous, radical change. After his Blue and Rose Periods of 1901-1907 Picasso collaborated with Georges Braque to develop a wholly new artistic style called Cubism. Throughout its reign Cubism addressed the relationship between the reality of nature and the reality of art. In autumn of 1912 a second phase of Cubism emerged that was based upon the techniques of *papier collé* and collage. Instead of reducing real objects to abstract components, the method of Analytical Cubism, the Cubists now used real components to construct art objects. This process, one of construction rather than analysis, was called Synthetic Cubism.

The two primary elements in this 1913 collage, the violin and bottle, are recurrent features in Cubist still lifes composed as they are of elements from the artist's daily environs, the studio and the cafe. The bottle is constructed from a fragment of a daily newspaper which refers to a nonartistic context. With its inclusion, Picasso has revitalized the contact between his art and external reality which had grown ever more distant during the initial phase of Cubism. The clipping, however, retains the ambiguous nature now expected from Cubism. Whereas the bottle should be transparent, it is constructed of opaque newspaper, while the violin, which should be opaque, seems incorporeal. In this manner Picasso has again used his art to confound our assumptions and provoke our renewed consideration of reality.

S.E.S.

Jacques Lipchitz

French/American, born Lithuania, 1891-1973

Bather. 1916-1917

bronze with gold patina, 27 in. (68.6 cm.)
Anonymous gift through The American
Federation of Arts. 60.38

Because of his handling of symbolic themes in an expressive manner and his preference for modeling over carving, Jacques Lipchitz was considered the successor to Rodin. Initially influenced by Archipenko, Lipchitz later met Pablo Picasso, Diego Rivera, and, most importantly, Juan Gris, whose acquaintance along with a natural proclivity for African tribal sculpture led him to accept the tenets of Cubism. He later began producing allegories like *Prometheus Strangling the Vulture* of 1937 which reflected the political situation in Germany then. In 1941 he escaped to New York where he lived and produced the romantic and lyric works of his old age until his death in 1973.

At first Lipchitz accepted Cubism only grudgingly. By 1915, encouraged by Gris, he began to experiment with a series of extremely rectilinear figures partially inspired by the Dogon art of Africa. The *Bather* of that year, now in the Hirshhorn Collection, exemplifies this early linear tendency. More successful three-dimensional figures composed of interwoven planes, partially curvilinear and partially angular, were produced by 1917 in the *Bather* and *Harlequin* series. His use of this subject matter reflected the interest of the Cubists in pathetic figures of clowns, acrobats and nudes, all outside the mainstream of society.

The New Orleans *Bather* is a bronze version of a figure which was executed in marble in 1917. Conceived completely in the round, it may be read equally well from a number of vantage points.

J.G.C.

Jean Metzinger

French, 1883-1956

Still Life with Box. 1918

oil on canvas, 20 ½ x 28 in. (52.2 x 71.2 cm.)
Gift of Richard M. Wise and Mrs. John N. Weinstock in
memory of Madelyn C. Kreisler. 80.180

When Braque and Picasso jolted the artistic world with the introduction of Cubism, Metzinger was quick to follow. In 1912 when Cubism was approaching total abstraction, Metzinger and the painter Albert Gleizes co-authored a defense of the new style entitled *Du Cubisme*, one of the first art manifestos of the 20th century. Both men aimed at abstraction in their paintings, but in their treatise they made allowance for natural forms which they stated could not be "absolutely banished, at least not yet." Metzinger became one of several Cubists associated with the *Section d'Or* (Golden Section), a group that sought a theoretical foundation to painting through pure number and proportion.

Toward the end of the teens, despite their belief in the theory and practice of abstraction, modernist painters in France began to re-integrate a sense of the natural object into their work. This was particularly the case with Metzinger around 1918, when he painted *Still Life with Box*. The table top has been tilted toward the picture plane, in emulation of the style of Juan Gris. Reference to recognizable elements such as a tablecloth, the wood grain of the table, a teapot and playing cards, make up the still life elements that surround an open box. Thus, despite the overlapping shapes carefully arranged according to abstract, geometric relationships to the picture's edge, the center of the composition is a small space represented in perspective. The variety of color used by Metzinger enhances the painting's legibility and adds a bright jovial note to the tone of the technically complex composition. As a theorist Metzinger was quite capable of intellectualizing the Cubist movement; ironically, however, as a painter he was reluctant to wholly reject the appearance of nature.

E.P.C.

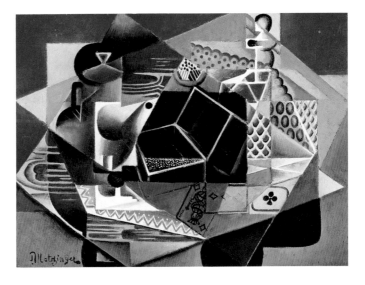

Juan Gris

Spanish, 1887-1927

Still Life with Cut Lemon. 1926

oil on canvas, 13 ³/₄ x 10 ⁵/₈ in. (34.93 x 27 cm.)
Muriel Francis Bultman Collection. 86.197

Juan Gris' personal interpretation of Synthetic Cubism was quite unlike what the other Cubists were producing. More than the other Cubists, Gris retained an attachment to the simple, everyday objects of his still-lifes for their associative qualities; he believed these metaphorical qualities gave art its spiritual value. His pictures look noticeably different from other Cubist pictures because of their architectonic structure and richly tactile and colored surfaces. Gris' participation with the *Section d' Or*, a group of artists who put great emphasis upon mathematical theory and proportion, nurtured his methodical and measured approach which he based upon a combination of rational proportions and abstract schemes. He never turned toward pure abstraction, however, but always retained respect for the real world. Gris was largely instrumental in bringing light and color back into Cubism. He used strong, local color descriptively, as well as mono-chromatic shading to delineate form and differentiate the spatial planes inhabited by these forms.

Still Life with Cut Lemon is indicative of Gris' austere working manner at the end of

his life. The lemon and other objects are reduced to stark, simple, elemental color shapes separated by spatial intervals that have become as tangible as the solid forms. Using a thick paint application and matte surface, Gris acknowl-edges the material nature of paint and thus reinforces the sense of rigorous structure. The subtle patterns of interlocking abstract and solid forms are at the basis of Gris' ambiguous pictorial space which reflects the Cubist change of attitude from analysis to pictorial construction. What remains constant is the questioning of two-dimensional versus three-dimensional reality.

S.E.S.

Georges Braque

French, 1882-1963

Still Life with Flowers. 1927

oil on canvas, 17 x 28 ³/₄ in. (43.2 x 73 cm.)
Bequest of Victor K. Kiam. 77.285

The first phase of Cubism, known as Analytic, lasted until about 1912, when the complex pictorial language of Braque and Picasso exploited the tension between the reality of nature and the reality of art. The subsequent phase of this style, in which Braque and Picasso took more individual direction, is called Synthetic Cubism. Recognizable objects begin to appear within the cubist grid, with additions of color, texture and collage. The outbreak of war brought an abrupt interruption to Braque's painting career; a serious wound prevented him from taking up his brush again until 1917.

Throughout the 1920s Braque's art focused mainly on still lifes which reveal a typically French balance and sense of proportion. In *Still Life with Flowers*, the use of a black ground is apparent , a technique he used often in the twenties to give a richer resonance to the overlaid colors. The table top is distorted and placed parallel to the picture plane; this same view point is used for the petals and leaves on the table. The pitcher with the floral arrangement, however, is viewed in profile. These simultaneous angles of vision are all that remain of Analytical Cubism. While the painting exhibits the typical austerity of cubist pictures its surface is nevertheless enlivened with quick touches of ocher and a variety of textures created by the addition of sand to the paint.

E.P.C.

Maurice Utrillo

French, 1883-1955

Place du Tertre and the Sacré-Coeur, Montmartre. 1913

oil on canvas, 23 x 31 in. (60 x 81 cm.)
Gift of Janet Kohlmeyer in memory of
Charles Kohlmeyer, Jr. 89.296

Utrillo was associated with the Maudits, an expressionist subgroup of the School of Paris, whose members were noted for their poverty, alienation and disorderly bohemian lifestyle. He did not begin to paint voluntarily but only as a result of the disciplinary efforts imposed by his mother, Suzanne Valadon, a popular artists' model. An unruly child, Utrillo was expelled from school, dismissed from several jobs, and by the age of eighteen in a sanatorium for alcoholics. His mother pressured Utrillo to paint, hoping it would have some remedial, calming effect upon her incorrigible son. Instead, Utrillo used his paintings, which he produced at a furious pace, to finance his drinking habit. His work gradually attracted critical attention and appreciation, however, and in 1909 he exhibited at the Salon d'Automne and in 1913 had his first one-man exhibition.

Utrillo's work is often referred to as "primitive" due to his lack of formal training. Despite this, he had an instinctive and sophisticated feeling for the relation of color values and pictorial composition. His best known works are the urban snow scenes and chalky white buildings of Montmartre that he painted from 1908 through 1914, his "white period." Dating from this period, Place du Tertre illustrates his pictorial interests at this time. The buildings standing beneath the leaden sky, although white, are bathed in the soft red, green and blue hues of their roofs and shutters. Utrillo claimed to be too shy to paint human figures and so they rarely appear except in the background as here. The figures, however, do little to counteract the air of solitude and emotional emptiness that pervades so many of Utrillo's street scenes.

S.E.S.

Amedeo Modigliani
Italian, 1884-1920

Portrait of a Young Woman.
1918

oil on canvas, 24 x 18 in. (61 x 45.7 cm.)
Gift of Marjorie Fry Davis and Walter
Davis, Jr., through the Davis Family Fund.
92.68

Amedeo Modigliani, the subject of much romantic mythologizing, has come to represent the epitome of the carefree, left-bank artist of the School of Paris. Born in Italy, Modigliani moved to Paris in 1906 and there immersed himself in bohemian life, attending artists' gatherings at the Bateau-Lavoir, frequenting the cafes, and enthusiastically participating in Parisian nightlife. This erratic existence exacerbated his already tubercular condition which ultimately led to his early death. In a manner contrary to his self-destructive and turbulent lifestyle, Modigliani's sculptures, drawings, and paintings are marked by a cool sureness, a firmness of line and a controlled design. His individually mannerist mode was unique in the Parisian art world preoccupied with Fauvism and Cubism.

Modigliani, more than anything else, was a portrait painter. His intent, however, was not so much to capture the psychological character of the sitter as it was to transpose the sitter's physical and physiognomical features into the pictorial dimension. Painted during the last few years of his life, Modigliani's *Portrait of a Young Woman* illustrates the diagnostic elements of his mature style. Although more naturalistic and organic than his earlier work, his later portraits still bear formal modifications that indicate his desire to create a stable and autonomous image. The figure has been subjected to Modigliani's mannerist elongations. The face is simplified and flattened, almost mask-like, with the button mouth, spatulate nose, and almond-shaped eyes characteristic of his portraits. The opaque indication of the eyes is another recurrent feature of Modigliani's portraiture. By so alienating the woman he emphasizes the autonomy of his image and forces the viewer to relate to it as a painting rather to the individual depicted.

S.E.S.

Wassily Kandinsky

Russian, 1866-1944

Sketch for Several Circles. 1926

oil on canvas, 27 ⁵/₈ x 27 ⁵/₈ in. (70.2 x 70.2 cm.)
Gift of Mrs. Edgar B. Stern. 64.31

Russian-born, German-trained, Wassily Kandinsky was the initial practitioner of non-objective art and a founder of the *Blaue Reiter* (Blue Rider), the second expressionist group movement in Germany.

The New Orleans painting is a study sketch for Kandinsky's large painting *Several Circles* now in the collection of the Guggenheim Museum, New York. It was made in Dessau when Kandinsky, influenced by the Bauhaus where he was working and teaching, began experimenting with geometric figures superimposed on dark backgrounds. In Kandinsky's work colored backgrounds became increasingly opaque in the middle of the 1920s as line surrendered to the explicit geometric configuration of the circle. Haloes around the circles, a feature of Kandinsky's paintings in the middle and late 1920s, serve to separate the circles from the background. The halos lend a spatial quality to the composition, a quality enhanced by the cloud-like effects of the background and the transparency of the intersecting circles. From 1923 through 1929 the circle was the single motif which the artist explored exhaustively in ten major paintings.

Sketch for Several Circles supports and forms the basis for Kandinsky's own statement of October 12, 1930, in which he describes his fascination with the circle and its relation to the cosmos: "...Of the three primary forms... the circle points most clearly to the fourth dimension."

J.G.C.

Georges Rouault

French, 1871-1958

Crucifixion. 1937-1939

oil on canvas, 26 ¹/₈ x 20 ¹/₈ in.
(66.3 x 51.1 cm.)
Gift of William E. Campbell. 53.13

Georges Rouault was apprenticed to a stained-glass designer at the age of fourteen and studied briefly at the Ecole Nationale des Arts Décoratifs until his entry into the Ecole des Beaux-Arts as a student of Gustave Moreau in 1891. He spent little time painting in the style of Symbolists and was associated with the Fauves from the inception of their movement. But Rouault stood apart from all his contemporaries, not only in his style, but also in his conservative and emotional interpretation of religious images. His pictures are usually somber in mood, though his color tones are rich and highly impasted, with forms delineated by thick, expressive black lines. Rouault's early works treated themes of moral indignation, but this developed into a gentler and more personal form of mysticism in his later years.

Following the advice of the dealer Ambroise Vollard, Rouault put most of his creative energy into making prints from 1918 to 1928.

In the 1930s he returned to painting and concentrated on his images of clowns, landscapes and religious pictures. This *Crucifixion* was probably painted around 1938 and is a variation of a repeated theme in Rouault's work. This composition has changed little since the 1918 version (Philadelphia Museum of Art), though in this painting the cross extends to all four edges of the design and Rouault includes a painted frame within the painting. The paint is opaque and the surface generally matte, but the colors cry out with an emotional energy befitting the tragic event.

E.P.C.

Georges Rouault

French, 1871-1958

Miserere. 1948

etching and aquatint on paper.
27 x 20 ¼ in. (68.6 x 51.4 cm.)
Gift of Mr. and Mrs. Frederick M. Stafford. 77.323

Miserere, the most significant and sensitive series of Rouault's graphic work, is probably the most monumental suite of prints produced in the 20th century. Conceived during the years 1914 through 1918 when Europe was convulsed by World War I, these distressing and tragic images were inspired by the profound suffering of mankind. A deeply religious man, Rouault used the image of Christ throughout the suite as both a symbol of suffering and the promise of hope. His use of rich blacks and a variety of tones and textures was a natural means for him to achieve a strong and tragic mood in every image.

At first Rouault envisioned a publication of one hundred plates in two volumes, one to be titled *Miserere* and the other *Guerre*. The artist first executed the images as drawings

in india ink and later transformed them into paintings. His dealer and publisher Ambroise Vollard then had the images photographically transferred to copper plates on which Rouault worked directly for many years. Fifty-eight plates were finally completed in 1927 but they were not printed until 1948 when Editions de l'Etoile Filante of Paris published an edition of 450 with the title *Miserere*. The image illustrated here, from New Orleans' complete copy, was titled by the artist *Nous croyant rois* (We think ourselves kings.)

J.G.C.

Henri Matisse

French, 1869-1954

Jazz. 1947

stencil prints in colors on paper,
26 ¼ x 17 ½ in. (66.7 x 44.4 cm.)
Gift of Mr. and Mrs. Fritz Bultman. 66.13

Henri Matisse was one of the giants of 20th century art, ranking with Picasso both in the quality and quantity of his production. Not only did he produce hundreds of paintings, he also created sculptures, drawings, and prints in considerable numbers. During the 1940s Matisse spent much of his time and energy in the creation of eight illustrated books, which rank among his outstanding achievements of that decade. Of these publications *Jazz* was unique in that it heralded the series of large *papier découpés* (cut-and-pasted papers), which occupied his last years.

To create the images for *Jazz*, Matisse cut forms out of sheets of brilliantly painted paper, which he then arranged until he achieved a dynamic composition of pure color. Stencils were then made by the printer from the completed *papier découpés*. As Matisse wrote in the text for *Jazz* under the heading "Drawing with Scissors," "To cut to the quick in color reminds me of direct modeling in sculpture. This book has been conceived in that spirit."

Two editions of the book were published in 1947 by E. Tériade in Paris. One edition of 250 copies included twenty stencil prints and 130 pages of original text written by Matisse, while another smaller edition of 100 copies included only the twenty stencil prints. The bulk of the artist's text is composed of philosophic or poetic thoughts on various subjects. Matisse summarized the inspiration of the book when he wrote, "The images presented by these lively and violent prints came from crystallizations of memories of the circus, of popular tales, and of travel." The example illustrated here from New Orleans' complete copy of the smaller edition (number 98 of 100) is titled *Le Cirque*.

J.G.C.

Joan Miró

Spanish, 1893-1983

Lady Strolling on the Rambla in Barcelona. 1925

oil on canvas, 51 ¼ x 38 ⅜ in. (132 x 97 cm.)
Bequest of Victor K. Kiam. 77.293

Joan Miró, one of Spain's greatest artists, was born in Montroig near Barcelona in 1893, the son of a goldsmith and watchmaker. During his years as an art student in Barcelona from 1907 through 1915, Miró was inspired by medieval Catalan art as well as the avant-garde Fauve and Cubist painters. In 1919 he began a series of annual visits to Paris where he immediately met Picasso. Miró's paintings of the early 1920s, primarily landscapes and still lifes, were executed in a precisely rendered style, inspired by the Cubists. In 1924, however, under the influence of Surrealist writers and painters in Paris he radically altered his style and began to experiment with hallucinatory and dream-inspired imagery.

The most original and radical result of this experimentation was a series of freely organized and relatively abstract works. *Lady Strolling on the Rambla in Barcelona* is a fine example of these loosely brushed, improvisational paintings. From the Surrealists Miró adopted the technique of automatic drawing, which allowed a free association of images to emerge from the artist's subconscious and appear on the canvas.

The title refers to the fashionable main boulevard of Barcelona, La Rambla, on which the ladies of the city promenaded. Using only red, blue, black and white against a variegated brown background, Miró has humorously abbreviated the figure of a woman to a few undulating curves and lines. The accidental staining and dripping on the raw, unprimed canvas is typical of Miró's free, automatic technique.

J.G.C.

Joan Miró

Spanish, 1893-1983

Portrait of a Young Girl. 1935

oil with sand on cardboard,
41 3/8 x 29 2/8 in. (104.6 x 74.6 cm.)
Bequest of Victor K. Kiam. 77.294

After producing an extraordinary series of abstractions in 1925 and 1926, Joan Miró moved toward a more recognizable surreal fantasy in his subsequent work. In 1928 and 1929 he produced two series of paintings inspired by the works of earlier artists: *Interiors*, after 17th century Dutch genre paintings; and *Imaginary Portraits*, after portraits of women by such diverse artists as Raphael and George Englehart, an 18th century English miniaturist. While in the past it was part of the academic teaching method for students to copy the old masters, 20th century avant-garde artists, such as Miró and Picasso, often used an earlier painting as inspiration for an original and transformed work of their own.

Portrait of a Young Girl recalls Miró's earlier Imaginary Portraits, although in this case he did not use the work of another artist as a starting point for his own composition. In comparing this 1935 painting to *Lady Strolling on the Rambla*,

made ten years earlier, the evolution of Miró's style is evident in the crisper contours of the figure, silhouetted against the bright yellow background. The artist's lively wit is seen here in the reduction of a pretty young girl, with her huge picture hat and blushing cheek, to a few sinuous lines and simple biomorphic shapes—she seems a parody of Mae West. Miró, a master colorist, has used a few prismatic hues —red, yellow, orange—with black as a dramatic foil to create an image of considerable power and monumentality.

J.G.C.

Joan Miró

Spanish, 1893-1983

Persons in the Presence of a Metamorphosis. 1936

egg tempera on masonite,
19 3/4 x 22 5/8 in. (50.2 x 57 .5 cm.)
Bequest of Victor K. Kiam. 77.295

While Joan Miró had always been apolitical, he could not remain unmoved or neutral toward the disastrous events of the 1930s: world depression, the rise of fascist dictatorships, and the Spanish Civil War. Between October 1935 and May 1936 he created a series of twelve paintings, which he called *tableaux sauvages* (wild paintings), that express his personal fears and anxiety. In these works his whimsical bestiaries are transformed into fantastic monsters, roaming through a barren, desolate landscape.

Persons in the Presence of a Metamorphosis, painted at Montroig, between January 20 and 31, 1936, is the largest work in this important series. Its palette is not unlike *Portrait of a Young Girl* with red, green, orange, yellow, white, and black predominating. Here, however, Miró has abandoned the flatness and simplicity of the earlier work to create a strange landscape with unlikely plains and knolls. The figures, rendered in three-dimensional chiaroscuro style, are elemental, organic forms, suggesting bare skeletons with exposed viscera. It appears that the two monsters on the right are casually watching a third creature disintegrate into its component parts.

In his definitive study of Miró's work Jacques Dupin wrote that in his "wild paintings" the artist raised, "...his voice in protest —a protest soon to be that of Spain and the whole planet, progressively more haunted by the specter of coming disaster. A world filled with the screams of madmen, the curses of murderers, and the groans of tortured men, women, and children — a living hell where bestiality takes possession of the human body..."

J.G.C.

Max Ernst

German, 1891-1976

Gulf Stream. 1927

oil on canvas, 25 1/4 x 20 1/2 in. (64.14 x 52.07 cm.)
Muriel Bultman Francis Collection. 86.183

One of the most significant figures of the Surrealist movement, Max Ernst distinguished himself from his associates by his innovative style and approach. His fascination with textures and the associations they evoke led him to develop creative rubbing techniques that are considered his most original contribution to Surrealism. The textures achieved in this way aroused unpredictable associations through their new context. Because of the element of chance inherent in these procedures, the techniques are uniquely appropriate for achieving the pure psychic automatism Surrealists thought necessary to express the real processes of thought and thereby convey knowledge of reality.

The autonomy and mystery of the natural world are prominent ideas in Ernst's work and are dominant in *Gulf Stream,* one of a series of evocative landscapes Ernst created using his rubbing techniques. The composition is divided horizontally into two fields. The upper half is a blazing field of intense yellow and white, representing the sky and conveying the awesome and inescapable power of the sun. The bottom of the canvas represents the invisible current of the Gulf Stream which is suggested by a *frottage* pattern. Although the swirling current is itself delineated in a controlled and ordered manner, it is submerged in the black, mysterious depths of the sea and therefore becomes uncontrollable.

Ernst had previously expressed his fascination with the irrationality and power of the natural world of the Gulf Stream in a work of 1925 in which he used the same motif of the current swirling within an impenetrable field.

S.E.S.

Max Ernst

German, 1891-1976

Everyone Here Speaks Latin. 1943

oil on canvas, 18 x 21 ¹/₂ in.
(45.7 x 54.6 cm.)
Gift of Mr. and Mrs. Isaac S. Heller. 52.31

Ernst acquired fame as the creator of *frottage*, or texture rubbings, and as an important painter in the Dada and Surrealist movements. As an artist he was largely self-taught. After establishing a Cologne branch of Dada in 1919, he moved to Paris in 1922 and joined the Surrealist movement two years later. An alien in France at the outbreak of the Second World War, Ernst was interned three times before he escaped to the United States in 1941. After the war he lived in Sedona, Arizona, with this fourth wife, Dorothea Tanning. He returned to Paris in 1951.

While living in New York during the years 1941 through 1943, Ernst made paintings that reflect the decaying situation in Europe. A number of remarkable paintings of the 1940's capture a certain catastrophic feeling of revulsion: *Europe After the Rain* (1940-1942), *The Eye of Silence* (1943), *Vox Angelica* (1943) and *Everyone Here Speaks Latin* (1943). The latter's title is perhaps a personal reference to Ernst's situation in a foreign country.

All of these paintings are executed in *decalcomania*, a technique invented and practiced by the Spanish painter Oscar Dominguez in 1937. It is a process by which a tacky or sticky painted surface is compressed between two layers of canvas or paper which are then peeled apart. The resulting spongy surface is intended to evoke visions of ruin and decay.

J.G.C.

René Magritte

Belgian, 1898-1967

The Art of Conversation. 1950

oil on canvas, 20 ¼ x 23 ¼ in. (51.4 x 59 cm.)
Gift of William H. Alexander. 56.61

Although ostensibly a Surrealist, Belgian painter René Magritte made wit and fantasy his trademark until his death in 1967. After studying at the Brussels Academy from 1916 to 1918, he went through Cubist and Futurist phases before joining the Surrealists in the 1920s. Rather than focusing upon the unconscious, which concerned the other Surrealists of his generation, Magritte juxtaposed seemingly unrelated objects to create his startling images.

From 1950 to 1961 Magritte, fascinated with the effects of stone, began to use this effect in an unusual manner by painting stone people, stone tables, stone fruit and even a stone coat. In some of these works the wit lies in the application of a rock-like texture to normally fragile objects such as birds, feathers and leaves. During these same years Magritte's concern with stone was echoed in a particular group of paintings in which the word *rêve*, French meaning illusion or dream, frequently appears as a colossal stone monument. *The Art of Conversation* is one of these paradoxical images in which the fleeting, illusory concept, *rêve*, is expressed as an enduring rock.

The title *The Art of Conversation* was used by Magritte for several other paintings of this period. In the others two small figures not only provide a reference to scale, but also offer a possible explanation for the title: they stand at the base of the monumentalized objects which have stimulated conversation.

J.G.C.

Pablo Picasso

Spanish, 1881-1973

Still Life with Candle. 1937

oil on canvas, 15 1/4 x 18 1/2 in. (38.7 x 47 cm.)
Bequest of Victor K. Kiam. 77.297

The last painting in a series of three, *Still Life with Candle* is Picasso's most expressive analysis of this theme. As an arrangement of inanimate objects the still life has been the standard vehicle by which an artist demonstrates illusionistic skill. In the 20th century the still life genre has been conducive to the mod-

ernist conception of a picture as an arrangement of form and color upon the surface plane. As such a pictorial construct the still life was very appropriate for Picasso's continual interest in the analysis and synthesis of form.

Although he had betrayed no previous political sympathies, Picasso responded to the eruption of the Spanish Civil War with rage and horror. His emotions inspired by the atrocities wrought in his home country were vent in full force in his huge cathartic image of 1937, *Guernica* (Madrid, Museo Nacional Centro de Arte Reina Sofía). Painted several months earlier, *Still Life with Candle* represents a more restrained expression. The three mundane objects on the table exude the quiet and yet monumental dignity present within simple everyday things. As a measure of the beauty inherent in such objects of modest form, this juxtaposition represents Picasso's plea to halt the senseless destruction of war.

Picasso's appeal to humanity is embodied by the eye-like form of the candle flame. The conflation of the eye with a source of light is an established historical tradition symbolic of the human spirit and of intelligence. The perceptive faculty of the eye represents a spiritual act and, when perceiving light, symbolizes understanding. Through the thick impasto and vivid colors, the eye-flame is endowed with an animated light, both literal and spiritual, and radiates Picasso's plea for reason and humanity.

S.E.S.

Pablo Picasso

Spanish, 1881-1973

Woman with Tambourine. 1938

etching and lithograph,
28 x 20 in. (71 x 52.7 cm.)
Muriel Bultman Francis Collection.
86.278

Picasso once stated, "I am always a Cubist," and, indeed, he never ceased to explore the pictorial possibilities that had emerged during the Cubist revolution. He did, however, forsake the intellectual purity of early Cubism to invest its formal idiom with a new and increasingly shrill psychological tenor. As the horrors of the Spanish Civil War and the Second World War stunned the world, themes of violence, mystery, and magic invaded Picasso's previously measured and rational Cubist universe.

Although Picasso's preoccupation with anguish and despair found its most complete expression in his 1937 painting *Guernica* (Madrid Museo Nacional Centro de Arte Reina Sofía), his horror at the cruelty and destructive nature of war continued to affect his vision as is evident in this great print. The image of "woman" is central to Picasso's work, but in the 1930s he began to take a perverse pictorial liberty with her anatomy. *Woman with Tambourine* illustrates Picasso's manner of exploiting the Cubist idiom to new and forcefully expressive ends. He has manipulated the human form into exaggerated and angular distortions with almost bestial qualities. The woman's body has been ripped apart; her limbs have been violently twisted and dislocated in a torturous version of the Cubist simultaneous vision as every view—frontal, rear and profile—of her body has been flattened across the surface of the canvas. Even her facial features have been mercilessly rearranged, her face split down the middle and pulled in either direction. The seemingly playful gesture of waving the tambourine does little to soften the impact of such a nightmarish image, as much a dissection of the artist's mental state as it is of the female figure.

S.E.S.

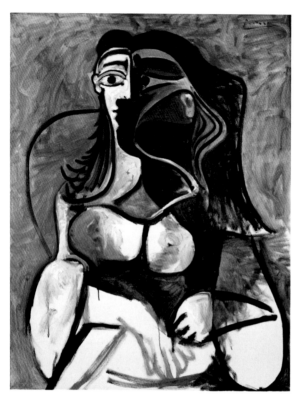

Pablo Picasso

Spanish, 1881-1973

Woman in an Armchair. 1960

oil on canvas, 45 ¹/₂ x 34 ³/₄ in. (115.5 x 83.3 cm.)
Bequest of Victor K. Kiam. 77.299

The female figure occupies a central place within Picasso's oeuvre. His paintings of women are extraordinarily varied in form and in interpretation. They include the first Cubist faceted forms in the 1907 *Demoiselles d'Avignon* (New York, The Museum of Modern Art), the ponderous, classically-inspired goddesses and mothers of the 1920s and the distorted and simultaneous views, especially of the faces, of female subjects from the 1930s on. During the last years of his life Picasso painted and repainted the female form with his second wife, Jacqueline Roque, as his principal model. She is the model in this picture, painted on April 1, 1960 at Picasso's villa, La Californie, in Cannes.

The woman seated in an armchair is a common iconographic element in Picasso's paintings. He first treated the theme in the 1930s and particularly concentrated on it in Paris during the Occupation, when he was virtually cut off from the world, totally immersed in his painting. The subject becomes prevalent again around 1959 and 1960, the year of this painting. The latest of the series can be interpreted as an homage to Jacqueline whose large, dark eyes and black hair play a dominant role in this composition. Her face is seen in both profile and frontal views, a stylistic element derived from Picasso's earlier Synthetic Cubist style. His palette is here reduced to black, white, grays and browns, reminiscent of the earliest phase of Cubism. The image of Jacqueline looms before us, half a recognizable portrait and half a specter from Picasso's vivid imagination.

E.P.C.

Joan Miró

Spanish, 1893-1983

The Red Disk. 1960

oil on canvas, 51 ¹/₄ x 63 ³/₈ in. (130.2 x 161 cm.)
Bequest of Victor K. Kiam. 77.296

Throughout his life, whether his work was purely abstract or had figurative implications, Joan Miró remained faithful to the basic Surrealist goal of releasing the creative forces of the unconscious mind from their control by logic and reason. Through his insistence on "pure psychic automatism" Miró became "the most surrealist of [them] all." He rejected traditional pictorial representation and composition and instead built his work on spontaneous expressions of alogical fantasy. By fusing this with the reality of experience, Miró hoped to make pictorial representations of a higher reality, a sur-reality. Although his usual automatic mode was briefly interrupted by a period of increased realism, growing out of his reaction to the political situation of the 1930s, by 1940 Miró had resumed his more usual, automatic means of access to this sur-reality.

The Red Disk illustrates a complete realization of Miró's automatic idiom. Although he had always indulged in freely composed configurations of color, this image represents a further dissolution into abstract stains and splashes. His greater spontaneity of pictorial expression is attributed to the influence of Jackson Pollack's gestural freedom. Miró had attended Pollack's first one-man exhibition in Paris in 1952 and called it a "revelation." As in Pollack's drip paintings, The Red Disk denies the traditional pictorial device of a compositional focus. Discrete form is subservient to an all-over spotting and animated flickering of form and color. In the midst of this field of chaos exists the germ from which the cosmos will emerge. Thus The Red Disk alludes to a mechanism which transcends the control of human logic and reason and inhabits a realm of higher reality, of sur-reality.

S.E.S.

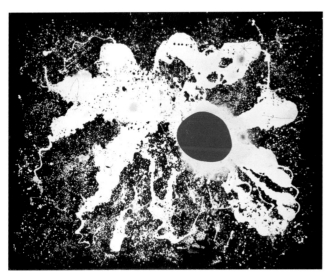

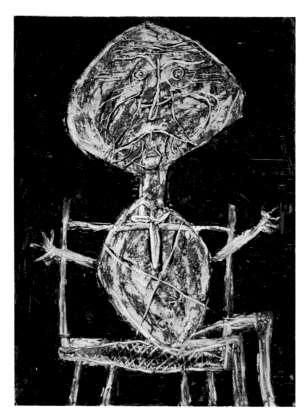

Jean Dubuffet

French, born 1901

Paul Léautaud in a Caned Chair. 1946

oil, with sand, on canvas,
51 1/4 x 38 1/8 in. (130.1 x 96.8 cm.)
Bequest of Victor K. Kiam. 77.287

Born into a middle-class family in Le Havre in 1901, Dubuffet went to Paris in 1918 to study painting at the Académie Julien. After only six months he withdrew and from then on was entirely self-taught. A copy of Dr. Hans Prinzhorn's book, *The Artistry of the Mentally Ill*, provided Dubuffet with his introduction to the aesthetic importance of psychopathic art and its relationship to children's art and to primitive cultures. The book was a catalyst for Dubuffet's work and philosophy as well as his anti-cultural, anti-art position.

Dubuffet resumed his artistic career in 1942 by painting portraits of famous friends in Paris. By 1945 he was using an astonishing combination of ashes, dust, sand and cinders bound together with a tar-like varnish. Into this mixture he inscribed suggestions of human features. Raw and purposefully depersonalized, these paintings display an inventive and deliberately child-like approach to the human physiognomy. Only a few accessories appear in this series of so-called portraits, painted between 1945 and 1947. More significantly, hats, neckties, watches and buttons are assigned the importance these appurtences assume for children. In this way the paintings are singularly mocking in their irony and in their universalization of the human condition.

Paul Léautaud in a Caned Chair is a portrait of one of Dubuffet's intellectual friends who was a writer, critic, anthologist and editor of the periodical *Mercure de France*. As in all of the portraits of these years, a resemblance is not sought but, instead, an image is created to stimulate the imagination of the viewer.

J.G.C.

Jean Dubuffet

French, born 1901

Gas Stove, III. 1966

vinyl paint on canvas, 45 ³/₄ x 35 in. (116.2 x 88.9 cm.)
Bequest of Victor K. Kiam. 77.289

Dubuffet's historical importance arises from his unique position in French art since World War II. Around 1920 he associated himself with well-known painters such as Léger and Dufy. But he twice abandoned painting for commercial enterprises before seriously beginning painting in 1942. His work engendered much criticism because of his theories; he thought that art could be anti-cultural, based on the vision of children and the insane. As such, Dubuffet's art fits into no school or movement and continually challenges the traditional aesthetic of the beautiful. Dubuffet came to create what he called *l'art brut* or raw art in which the ordinary and the banal are exploited to shock the viewer out of accepted aesthetic responses.

In 1962 Dubuffet began his *Hourloupe* series, drawings and paintings begun from doodles with a felt-tipped pen and

stripped of almost all associative content. *Gas Stove, III* is one of seven variants of that theme that belong to the series. The common object is wrenched from all its ordinary connotations and presented as a distorted and hermetic image, eternally locked in a black void. The form is compartmentalized into cellular segments, the outlines of which create what Dubuffet called his "uniform meandering script." The painting of the stove thus becomes a "mental derivative" of the object, endowed with its own independent and forceful physical presence.

E.P.C.

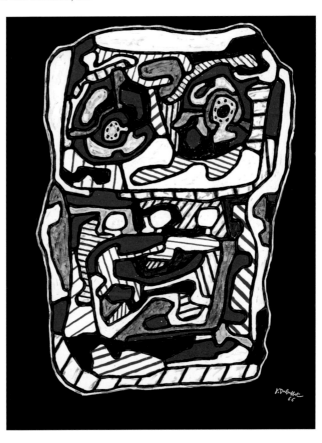

Alberto Giacometti

Swiss, 1901-1966

The Studio. 1953

oil on paper mounted on canvas,
27 ³/₄ x 19 in. (70.5 x 48.4 cm.)
Bequest of Victor K. Kiam. 77.291

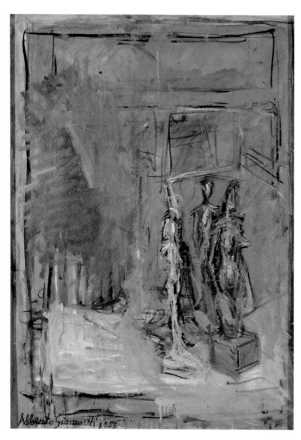

had sculpted a series of busts of his brother Diego by age fifteen. In 1919 Giacometti studied art at the Geneva School of Arts and Crafts and during 1920 through 1921 he toured Italy where he was impressed by the work of Tintoretto and Giotto. In Paris he studied for three years with the sculptor Antoine Bourdelle.

In the late 1920s and early 1930s Giacometti experimented with Cubist formations and with Surrealist themes. Although he began to paint and draw pointillist works as early as 1922, the majority of his paintings date from after 1947. Along with still-lifes and portraits, human beings were the painter's favorite subject matter. In his paintings, usually executed in a technique closer to brush drawing than to actual painting, Giacometti's palette is serene, limited to grays, browns, blacks and whites.

The Studio was executed during the artist's most productive period of the 1950s. The enframing lines at the sides and top of the painting suggest a large, empty space. In actuality this painting is a study of three Giacometti sculptures, treated as still-life in a corner of the studio. The studio was one of Giacometti's favorite subjects, handled in various media from the 1930s until his death in 1966.

The most important sculptor working in Europe after the Second World War, Alberto Giacometti is best known for his attenuated human figures. Having a precocious talent, he

J.G.C.

Alberto Giacometti

Swiss, 1901-1966

Standing Woman. circa 1953-1955

painted bronze, 22 1/4 in. (56.5 cm.)
Bequest of Victor K. Kiam. 77.292

During his early years Alberto Giacometti experimented with Cubism and Surrealism; and these movements continued to occupy his artistic attention until 1935 when he broke with Surrealism. From that time forward he worked both from nature and from his imagination and created the elongated, attenuated figures for which he became world famous.

Shortly before 1960 he concentrated on skeletal figures in motion. By using the technique of dripping plaster he covered his figures with a rough, craggy surface. He also startled the spectator with the exagger-

ated scale, some five to six feet, as well as the increased fragility of the pieces.

A change in Giacomettei's style emerged about 1953, when his figures not only became smaller, but increased in plasticity and roundness. Surfaces became eroded, sharply scratched and pitted. The New Orleans *Standing Woman* belongs to this period. She stands on a slanting base, her ankles formed by the scoop of the sculptor's tool. Her well-developed, though pitted torso, rises to a small head set upon a scrawny neck. Until the end of his life Giacometti continually vascillated between the more volumetric, full figure and the extremely attenuated type, sometimes shrinking, sometimes increasing the scale of the human figure, his favorite subject. On rare occasions, such as with this piece, Giacometti painted the bronze figure, simulating natural flesh tones.

J.G.C.

Jean Rustin

French, born 1928

Two Persons. 1992

oil on canvas, 38 ¹/₄ x 51 ¹/₄ in. (97.16 x 130.18 cm.)
Gift of the Foundation Rustin. 92.773

Despite a considerable critical reputation, Jean Rustin has yet to earn broad popular recognition. Undoubtedly this may be attributed to the disturbing quality of his work. Rustin initially rejected the traditional training he received in Paris at the Ecole des Beaux Arts from 1947 to 1953 for a brilliantly colorful, abstract style. But even in his abstract work there were vestigial figurative elements. The turning point for Rustin came in 1970-71 when a personal crisis precipitated a complete shift in his work. The figurative suggestions lost their ambiguity and became completely specific, albeit distorted. For a long time his paintings depicted figures who were usually nude and radically distorted with sexual and violent implications. These isolated figures appear to have been abandoned in anonymous institutions for geriatrics or the insane.

While the figures in Rustin's recent paintings have regained their integrity and are often clothed, his work remains difficult. Nonetheless he has been compared to several luminaries in the artistic tradition: his rapid yet delicate stroke, scumbling and restricted color scheme are similar to those elements in the work of the Baroque artists Frans Hals, Rembrandt and Velasquez; his arrangement of figures in a shallow arc across the canvas with breaks suggesting psychological isolation is reminiscent of the compositions of the 17th century French artist Louis Le Nain. Rustin's disturbing subject matter also has been compared to the work of such contemporaries as the English painters Francis Bacon and Lucien Freud.

It is the psychological state that is most relevant in Rustin's work. Lacking a narrative or even the explicit grotesqueries of his earlier work, the NOMA painting gives the viewer little to contemplate but the psychological character of old age. Indeed the figures confront the viewer with their blank expressions, slumped posture, and grayed sagging flesh, as if for that purpose alone.

S.E.S.

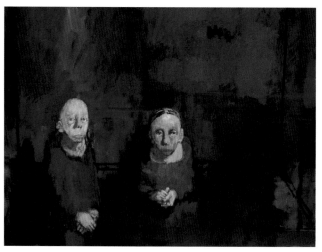

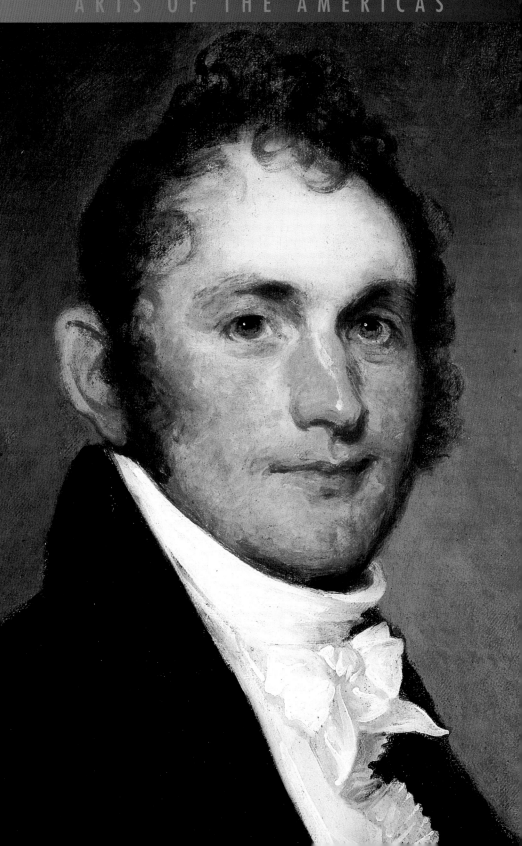

John Wollaston

English, born circa 1710, worked in America 1749-1767

Portrait of Staats Long Morris.
circa 1749-1752

oil on canvas, 50 x 40 in. (127 x 101.6 cm.)
Gift of Mr. and Mrs. Prescott N. Dunbar. 76.101

Upon his arrival in the American colonies about 1749, English-born John Wollaston became one the of the most active painters on the Atlantic Seaboard. His handsome, richly colored portraits were highly regarded by the colonial gentry and by American artists whom he influenced, including Benjamin

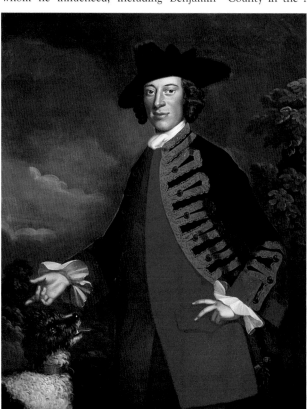

West, Matthew Pratt and Gustavus Hesselius. After painting for nearly a decade in America, Wollaston went to Bengal for the East India Company, returned to the American colonies for a brief six months, settled in Charleston and in 1767 returned to London, never to be heard of again. Of approximately three hundred extant paintings seventy-five are of New York sitters, the New Orleans portrait among them.

The subject of the painting, General Staats Long Morris, is portrayed as he appeared in his early twenties. Born in 1728, he was a member of one of the oldest families in Westchester County in the New York colony. Later one of his brothers, Lewis Morris, was a signer of the Declaration of Independence. Staats Long Morris, on the contrary, remained loyal to the British crown all his life. After attending Yale University he left for England in 1755 and soon after entered the British Army. He reached the rank of Major-General in 1777 and General in 1778. A member of Parliament from 1774 to 1784, Morris was appointed Governor of Quebec in 1797, where he died in 1800.

J.G.C.

John Singleton Copley

American, 1738-1815

Portrait of Colonel George Watson. 1768

oil on canvas, 50 x 40 in. (127 x 101.6 cm.)
1977 Acquisition Fund Drive and gift by exchange of
Isaac Cline, Herman E. Cooper, F. Julius Dreyfuss,
Durand Ruel & Sons and Lora Tortue. 77.37

John Singleton Copley was the most skillful artist practicing in the American colonies before the Revolution. He had two careers, one in the colonies and one in England where his loyalist sympathies led him to settle in 1774. By the middle 1760s Copley had secured a reputation as a portraitist of the elite of Boston. His artistic growth can be traced through the steady development of an ability to achieve a softer, more rounded modeling of the human figure and an increased use of chiaroscuro.

By 1768 the *Portrait of Colonel George Watson* indicated a change in Copley's style toward a more somber palette and was accompanied by a shift in the level of his patronage. As the impending Revolution became increas-

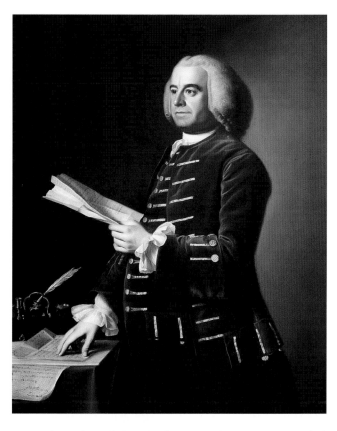

ingly apparent, Copley began to paint a new breed of men: politicians, professionals and financiers.

Watson, like Copley, was a loyalist, an elected member of His Majesty's Council in the colonies. Six years after the Watson portrait a midnight crowd appeared at Copley's house demanding to see the loyalist "villain" Colonel George Watson whom they believed to be visiting the painter. Watson had left Boston a few hours earlier so Copley's home was spared destruction by the rebellious mob, but the incident helped confirm Copley's decision to move to Royalist England.

J.G.C.

James Claypoole, Jr.

American, circa 1743-circa 1800

Memorial to E.R. 1774

oil on canvas, 47 x 39 in. (117.5 x 97.5 cm.)
The Rosemonde E. and Emile N. Kuntz
Collection. 79.426

Originally from Philadelphia where he had a successful painting career, James Claypoole, Jr. eventually settled in Kingston, Jamaica. *Memorial to E.R.* is the only signed work known from the time Claypoole spent in Jamaica. It depicts a dark haired young woman, E.R., being led through a funerary grove by the allegorical figure of Fame. The striking effect of the juxtaposition of bright, clear colors and deep shadows provokes con-templation of Claypoole's image and its meaning. The poem inscribed upon the monument, and to which E.R. gestures, clarifies the painting's commemorative con-tent. These stanzas reproach the Fates for their cruelty in having ended the promising life of one so beautiful as E.R.

Its memorial content makes this painting rather unique. While portraits of the dead were often painted, such images usually follow the same pictorial conventions dictating those of the living and so are indistinct. Claypoole's image not only makes E.R.'s death explicit, but does so in a sophisticated and inventive manner. E.R.'s classical dress, the amorini, and the allegorical figure refer to the antique and thus enhance the portrait genre with elements of history painting. The image contrasts the brevity of young E.R.'s life, the youthful purity of which is emphasized by the striking white of her garment, with the timeless character of the antique. This juxtaposition implies the maxim that while human life is ephemeral, art is eternal. These sophisticated allu-sions, complemented by a rich and coherent deco-rative character, make Claypoole's painting an impressive achievement of American colonial painting.

S.E.S.

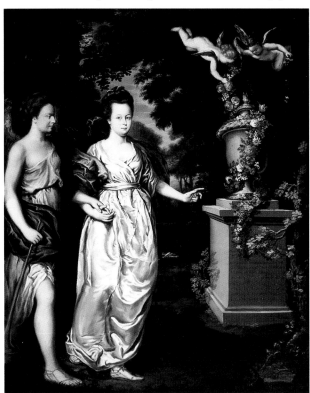

Benjamin West

American, 1738-1820

Romeo and Juliet. 1778

oil on canvas, 50 x 44 ¼ in. (149.8 x 112.4)
Women's Volunteer Committee Fund. 73.33

A trend-setter, West forecast both the Neo-Classic and Romantic movements in his painting. Beginning as a portrait painter in colonial Philadelphia, he studied briefly in Italy and then spent the remainder of his extraordinarily successful life in England, serving as historical painter to King George III, as President of the Royal Academy of Art, and as teacher and benefactor to young American artists like Gilbert Stuart and Thomas Sully.

In the 1770s at the height of his career West painted three categories of subjects: English history, the Bible, and Shakespeare. Exemplifying this last interest, *Romeo and Juliet* may be viewed against the background of nationalism and dramatic literary subjects which were part of the Romantic movement. West's interest in Shakespearean subjects precedes the formation in 1786 of Alderman John Boydell's famous Shakespearean Gallery in London for which the best artists of the country depicted famous scenes from the Bard's plays.

Romeo and Juliet was commissioned by the Duke of Courland, who in 1781 presented West with a gold medal and rewarded him handsomely for the painting. The artist chose a moment of action in Act III, Scene 5 of the play. At dawn the embracing lovers are interrupted by the nurse who runs to warn the couple of the awakening household: "Your lady mother is coming to your chamber. The day is broke; be wary, look about." Juliet then laments, "Then, window, let day in, and let life out." Romeo hastily leaves saying, "Farewell, farewell! One kiss, and I'll descend."

J.G.C.

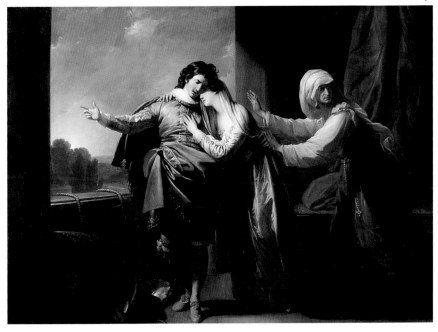

Charles Willson Peale

American, 1741-1827

Portrait of Robert Morris. 1782

oil on canvas,
50 ¹/₂ x 40 in. (128.2 x 101.6 cm.)
1977 Acquisition Fund Drive. 78.2

Peale was born in Maryland and received his first artistic training under John Hesselius. As in the case of Benjamin West, a group of Maryland gentlemen sent Peale to London for further training. He spent two years in England, studied with West, then returned to America. Subsequently, he worked in Annapolis, Baltimore and Philadelphia, where he settled permanently. A sound draftsman, Peale's sympathetic and penetrating observation of his subjects made him an excellent portraitist.

The subject of this portrait, Robert Morris (1734-1806), was the most able financier in the colonies at the time of the American Revolution and the chief founder of the Bank of North America. Since Morris was a conservative and Peale was a radical, the two became bitter political enemies. Ironically, Peale filled the Assembly seat vacated by Morris in the November elections of 1779. However, after a year's service in the Assembly Peale, disillusioned and disappointed with politics, retired to paint exclusively.

Later, Peale's optimism and enthusiasm in founding the Peale Museum and Morris' pleasure in being considered for its portrait gallery led Morris to commission a three-quarter length portrait of himself and a replica, several smaller portraits of himself and Mrs. Morris, miniatures from the heads of both portraits, and a double portrait of Robert Morris and Governor Morris. The New Orleans portrait is the three-quarter-length replica version, formerly in the collection of the Pennsylvania Academy of the Fine Arts.

J.G.C.

Thomas Sully

American, born in England,
1783-1872

Portrait of Chester Sully. 1810

oil on panel, 25 x 21 ³/₄ in.
(63.5 x 55.2 cm.)
Gift of Mrs. Dudley
Rogers West. 71.1

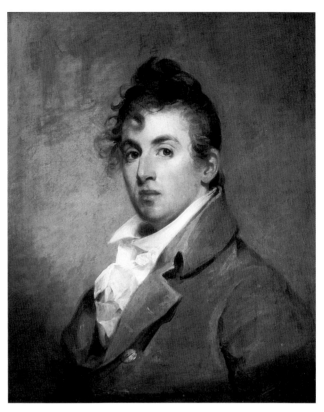

Although Sully was born in England, he came to America at an early age with his parents and settled in Charleston, South Carolina. His first introduction to painting consisted of lessons, first from a brother-in-law, Jean Belzons, and later from his brother Laurence Sully. In 1808 he settled permanently in Philadelphia where he was considered the leading portrait painter until his death at the age of ninety. During his lifetime he made two trips abroad: the first to study under Benjamin West and other painters in London from 1809 to 1810, and the second to paint the portrait of Queen Victoria in 1838.

Sully's romantic portrait of his brother Chester seems to reflect the immediate influence of the English portrait painter Sir Thomas Lawrence, with whom Sully is said to have studied in 1809. Chester Sully, born in England in 1781, was living in Norfolk, Virginia, when this portrait was painted between May 16 and May 28, 1810, according to Sully's journal. Later in life Chester lived in New Orleans where he imported mahogany from Santo Domingo.

The portrait was given by the artist to his nephew George Washington Sully who left it to his son Thomas Sully, the well-known New Orleans architect. In turn, he gave it to his daughter Jeanne Sully West, who donated it to the Museum in 1971.

J.G.C.

Jean Hyacinthe Laclotte

American, born in France, 1766-1829

The Battle of New Orleans. 1815

oil on canvas, 29 ¹/₂ x 36 in. (74.9 x 91.4 cm.)
Gift of Edgar William and Bernice
Chrysler Garbisch. 65.7

Although Laclotte was trained as an architect in his native France, he did not receive much attention through his practice. Instead, he gained fame through one oil painting, *The Battle of New Orleans*, executed from sketches on the battlefield. During the War of 1812 Laclotte was an assistant engineer in the Louisiana Army and was able to render the battle from a first-hand panoramic view. This view is the only one believed to be authentic; other known paintings of the subject seem to be fantasized versions.

Laclotte's painting depicts Jackson and his militia on the left, entrenched behind the Rodriquez Canal. The British General Packenham is shown leading his troops in a direct frontal attack on the Americans. This action occurred on the grounds of the Chalmette Plantation, east of the city, on January 8, 1815.

Laclotte painted this original and one copy of *The Battle of New Orleans*, known in the 19th century as *The Eighth of January 1815*. The painter shipped the copy to France, intending to have it engraved by Philibert O. Debucourt (1755-1832), but the copy was lost in transit. This forced Laclotte to send the original, then in Philadelphia, to France in its place. Although 1818 is the generally accepted date for the publication of the engraving, an announcement for its sale first appeared in the October 31, 1817, edition of the *Louisiana Courier*, a New Orleans newspaper.

J.G.C.

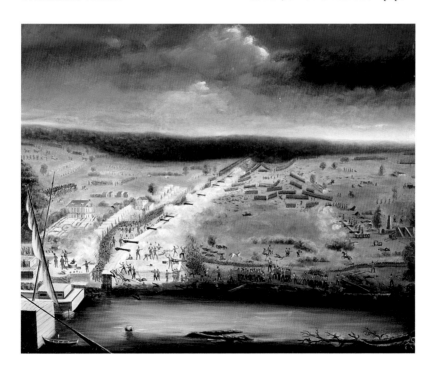

Gilbert Stuart

American, 1755-1828

Portrait of
Major Peter Fort.
1818

oil on board,
28 ¹/₂ x 24 ³/₄ in. (72.3 x 62.8)
City of New Orleans
Capital Fund. 76.23

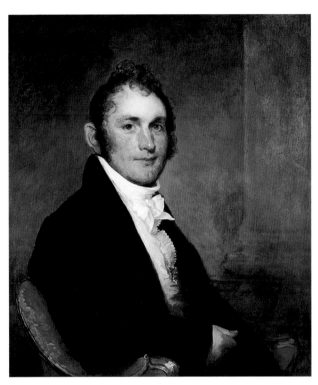

After Gilbert Stuart's long Scottish and English training he returned to America in 1792 as a mature, Europeanized artist. With the success of *The Skater* Stuart became the most prominent portraitist in America during the Federal period. Five presidents as well as many lesser personages sat for Stuart, and these portraits played a vital role in shaping American imagery for the new republic. His easy mastery of European painterly conventions made him ideally suited to introduce these techniques to America.

The *Portrait of Major Peter Fort* was painted during Stuart's Boston period, late in the artist's life. The Yankee qualities of his sitters interested him, so the dashing nature of his earlier European brushwork was toned down to realize a more authentic American style in his work. Although the artist was a less powerful artistic influence in Boston than he had been earlier in New York or Washington, he remained a guid-

ing force for other artists and befriended Washington Allston and Thomas Sully at the beginnings of their American careers.

The subject of the New Orleans painting, Major Peter Fort, was a man with close connections to New Orleans. Born in Poughkeepsie, New York, in 1783, Fort lived in New Orleans from 1808 to about 1816. A local newspaper account of 1810 records that he worked for his brother John A. Fort, a wholesale grocer. From contemporary documents it is also known that Peter Fort fought with the City Riflemen on the extreme right of the American line during the Battle of New Orleans.

J.G.C.

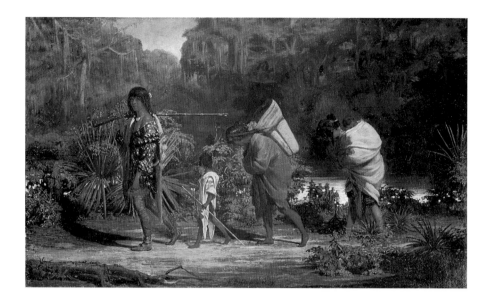

Alfred Boisseau

American, born in France, 1823-1901

Louisiana Indians Walking Along the Bayou. 1847

oil on canvas, 24 x 40 in. (61 x 101.6 cm.)
Gift of William E. Groves. 56.34

Following the example of a number of well-trained European artists who were lured to New Orleans in the 1830s and 1840s, Parisian artist Alfred Boisseau arrived in the city in 1845. Before that date he studied at the Ecole des Beaux Arts from 1838 until 1842 and also had been a pupil of Paul Delaroche. During his two years in New Orleans he exhibited in 1845 and again in 1847 at the Paris salon where *Louisiana Indians Walking Along the Bayou* was first shown. Thereafter, Boisseau

lived in other parts of America: he worked first in New York City until 1852 and then in Cleveland from 1852 to 1859 and finally moved to Montreal where he was active as a portrait painter.

Boisseau was a better genre painter than portraitist though he worked as both. Attracted by the exotic, he was able to endow a native scene with great freshness and perceptive vision. In this painting details of the hair and basket styles indicate that the Indians depicted are Choctaws. The locale is thought to be somewhere along the Tchefuncta River on the north shore of Lake Pontchartrain. Choctaws were frequently seen in the markets of New Orleans, where they sold baskets, goods woven from palmetto leaves and filé, a root condiment used in the preparation of Creole foods.

J.G.C.

Asher B. Durand

American, 1796-1886

Forenoon. 1847

oil on canvas, 60 ¼ x 48 ¼ in. (153 x 122.5 cm.)
Gift of the Fine Arts Club of New Orleans. 16.4

As a young man Durand first gained fame as an engraver, but by 1830 he began painting genre, history, portraiture and landscape. After making the Grand Tour of Europe in 1840, he decided to devote himself exclusively to landscape painting, recording scenery along the Hudson River, in the Catskills and Vermont.

In addition to being one of the first artists in America to concentrate on painting landscapes outdoors, he was a leading member of the Hudson River School and President of the National Academy of Design from 1845 to 1861. He preferred the "unadorned landscape," exemplified by the inter-relationship between man and nature, the real as opposed to the idea.

Forenoon is closely related to Durand's 1845 painting, *The Beeches* (New York, Metropolitan Museum of Art). In both paintings the bare tree

trunks lead the spectator into the painting. Throughout the 1840s Durand continued to experiment with the composition of beeches and to emphasize the trees' trunks as a special feature of his paintings.

Forenoon was one of a pair of paintings commissioned by the wealthy New Orleans

banker James Robb. After first being exhibited at the National Academy of Design in 1847, the painting hung in the entrance hall of the Robb mansion on Washington Avenue until 1859, when it was sold with the estate.

J.G.C.

Thomas Birch

American, born in England, 1779-1851

Rocky Coast with Shipwreck. 1849

oil on canvas, 29 x 36 in. (73.7 x 91.4 cm.)
Gift of Dr. and Mrs. Nathan H. Polmer. 76.459

Born in England in 1779 and reared in Philadelphia, Thomas Birch was America's first marine artist. Initially trained as an engraver and then as a portrait painter, he made a fortuitous visit in 1807 to the Delaware Cape where his interest in marine painting began. Influenced by the marinescapes of 17th century Dutch artists and the stormy seascapes of the French painter Claude-Joseph Vernet, Birch later made his reputation with a series of paintings based on the naval engagements of the War of 1812. These paintings included both Perry's victory on Lake Erie and McDonald's conquest on Lake Champlain. Patriotism combined with the drama of the sea made such paintings popular.

Although Birch is also noted for his winter landscapes, he is best known for his seascapes, whether dramatic renderings of storms at sea or ships wrecked and breaking on the rocks along the shore. Following the romantic tradition of the clash between man and nature, Birch conceived of the wild power of the sea as a pitiless elemental force beyond the control of mere man.

During the last years of his life the artist continued to paint harbor views and marine scenes like the *Rocky Coast with Shipwreck.* Recent cleaning has revealed large areas of clear blue sky and atmospheric light for which Birch was well known.

J.G.C.

Richard Clague

American, 1821-1873

Spring Hill. 1872

oil on canvas, 16 x 24 in. (40.6 x 60.9 cm.)
Ella West Freeman Foundation Matching Fund. 71.2

Clague's early life and training were divided between New Orleans and France. Before returning to New Orleans to settle permanently in a studio on Camp Street, he registered at the Ecole des Beaux Arts in Paris where he frequented the studios of Horace Vernet and Ernest Hebert.

While Clague's cultural and artistic heritage was French, his work is very much part of an American naturalistic landscape tradition. In particular, he was the first landscape painter in Louisiana to understand in aesthetic terms the character of the Mississippi River Delta region, the swamps and forests of Louisiana, Mississippi and Alabama. Clague made extended visits to Alabama where he painted *Waterworks at Mobile* and made a number of sketches and paintings including *Spring Hill*. The Museum owns the artist's sketchbook which includes a pencil drawing of this scene, inscribed "Spring Hill, March 16, 1872."

The New Orleans painting illustrates Clague's ability to characterize the atmosphere and geography of the locale he was painting. Here he includes the low horizon line, the cluster of rural buildings, the inevitable fence, and the roadway leading into the distance. This is the only Clague landscape in which water is not introduced along with woods, either in the foreground or background.

J.G.C.

Marshall Joseph Smith, Jr.

American, 1854-1923

Bayou Plantation. circa 1870-1880

oil on canvas, 17 x 36 ¼ in. (43.18 x 92.08 cm.)
Gift of William E. Groves. 66.22

Marshall J. Smith was one of the most thoroughly trained Louisiana artists of the 19th century. After the death of his mentor Richard Clague, New Orleans' foremost landscape painter, Smith embarked upon an extended tour of Europe during which he visited Italy, Germany, France, and England. Before his journey Smith's paintings had been dependent upon the compositional formulae of Clague and the brilliantly colored atmospherics characteristic of luminist painters. Upon his return, however, his style began to develop more independently and his images became more naturalistic and controlled, carefully constructed with dense yet subtle brushwork.

As Smith's personal vision began to evolve toward a greater naturalism, this same tendency began to ebb within the larger Southern cultural currents. Rather than conjuring genteelly idealized visions of the South, Smith's paintings truthfully document the economic desolation left in the wake of the Civil War. *Bayou Plantation* is representative of Smith's mature work which is devoted largely to images of rural Louisiana that often reflect the lives of the poor area farmers and fishermen. His European influence is evident in the veils of subtle color he has used to convey the atmosphere. The dilapidated shanty in the foreground, whose unsteady look is enhanced by Smith's minute brush strokes, illustrates the privation and decay of the Reconstruction South. Appropriate to the often desperate mood pervading Smith's landscapes is the moss-hung live oak tree that appears in *Bayou Plantation* and is a recurrent motif in his work. While no overt symbolism can be ascribed to it, the connotations of this motif, traditionally associated with mourning portraits, cast a melancholy pall over the ruined landscape.

S.E.S.

Achille Perelli

American, born in Italy, 1822-1891

Blue Crab and Terrapins.
circa 1880

gouache on cardboard,
24 ³/₄ x 15 ¹/₂ in. (62.8 x 39.4 cm.)
Gift of the Samuel Weis Estate. 56.90

While studying sculpture at the Academy of Arts in Milan, Italian-born Achille Perelli temporarily abandoned his career to serve with Garibaldi, the Italian patriot, in the Revolution of 1848. When Garibaldi was defeated and fled to the United States, Perelli followed and came to live in New Orleans in 1850. For the rest of his life he was active as a sculptor, teacher and painter. He worked to promote Louisiana art, helped organize the Southern Art Union, and was an important member of the Artist's Association of New Orleans.

Perelli, Louisiana's first sculptor in bronze, executed a bust of Dante for the Tomb of the Dante Lodge of Masons in St. Louis Cemetery #3, the statue of Stonewall Jackson in Metairie Cemetery, and the Confederate Monument in Greenwood Cemetery. Although such commissions were the basis of his livelihood, Perelli's true interest lay in the portrayal of Louisiana wildlife. The artist is best known today for these deli-cate and precise studies, which compete with Audubon in their minute naturalism.

Perelli painted in the *trompe l'oeil* (fool-the-eye) tradition. In *Blue Crab and Terrapins*, the nail protruding out into space and the shadows cast by the still life create a feeling of three dimensionality. According to one critic this study of Louisiana marine life adds a new and unusual contribution to the subject matter of American still life painting.

J.G.C

John Singer Sargent

American, 1856-1925

*Portrait of Mrs. Asher B.
Wertheimer.* 1898

oil on canvas, 58 x 37 ¹/₂ in. (147.3 x 95.2 cm.)
1977 Acquisition Fund Drive in memory of
William Henderson. 78.3

Sargent was born in Florence, Italy of wealthy
expatriate New England parents and remained
in Tuscany until the age of nineteen, when he
left for Paris to study with the academic por-

traitist, Emile-Auguste Carolus-Durand, from
1874 through 1876. In 1877 he began exhibit-
ing at the Paris Salon, but the scandal created
by his *Portrait of Madame X* as well as the lack
of French patronage forced Sargent to move to
London to seek commissions. By 1897 the artist
was a famous figure on the London art scene
and the preeminent portraitist of his period.

Included in his list of eager sitters was
Asher B. Wertheimer, a wealthy London
art dealer, who commissioned the artist
to paint portraits of himself and his wife
to commemorate their silver wedding
anniversary in 1898.

A standing saturnine ren-
dering of Asher Wertheimer
with his black poodle is the
pendant to this portrait of his
wife. Both paintings were
shown at the Royal Academy
in 1898 and created an enor-
mous sensation. Thereafter,
Sargent painted ten more por-
traits of members of the family,
including a second portrait of
Mrs. Wertheimer seated at a
tea table dressed in black.
With the exception of the
1898 New Orleans portrait
and two others the rest of the
Wertheimer family portraits
were bequeathed to the British
nation by Asher B. Wertheimer
and now hang in the Tate
Gallery, London.

J.G.C.

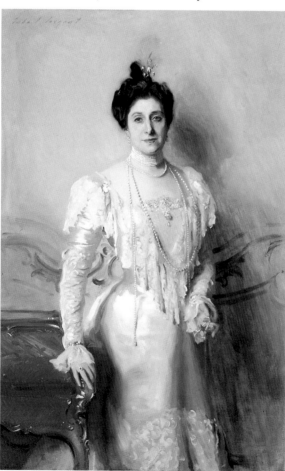

Mary Cassatt

American, 1845-1927

Mother and Child in the Conservatory. 1906

oil on canvas,
36 1/8 x 28 3/4 in. (90.31 x 71.88 cm.)
Gift of Mr. and Mrs. Harold
Forgotston. 82.124

This mother's embrace of her child and their interlocking hands evoke the emotional relationship of love and security felt by both mother and child. The image illustrates Cassatt's tendency to depict moments that, while dramatically uneventful, are replete with the psychological nuances that characterize the development of an intimate relationship;

Cassatt was an Impressionist artist distinguished by being an American expatriate completely versed in the most avant-garde theory in Paris at that time. Not only did she differ by being the only American painter of her generation to enthusiastically embrace the Impressionist style, but she was a woman artist whose talent was recognized and acknowledged by her male peers, a rare occurrence before the 20th century.

Like the other Impressionists Cassatt depicted moments distilled from Parisian middle-class leisure activities. Her paintings, however, are concerned specifically with the theme of mother and child, a theme which accounts for nearly one third of her total production and for which she is best known. The pyramidal structure of Mother and Child in the Conservatory conveys the solidity and endurance of this mother-child relationship. Cassatt frequently used hand gestures to convey the intimacy and tenderness inherent in the moments she depicted.

the binding gestures convey the close interdependence of the mother and child. Cassatt's images are a fluent expression of the duality of the maternal relationship; she captures the most elusive instant, the momentary glance, gesture, or movement, yet synthesizes it with an evocation of the permanent, universal character of the relationship.

S.E.S.

Marsden Hartley

American, 1877-1943

The Ice-Hole, Maine. 1908

oil on canvas, 34 x 34 in. (86.3 x 86.3 cm.)
Ella West Freeman Foundation Matching Fund. 73.2

Hartley was born in Lewiston, Maine, lived in New York City and first exhibited in 1909 at Alfred Steiglitz's 291 Gallery in New York. Although the exhibition was not a great critical success, the connection with Steiglitz and subsequent trips to Europe between 1912 and the 1930s kept Hartley in the vanguard of American art. A prolific artist, he produced hundreds of paintings and drawings during his lifetime in a number of varying styles, which reflect a willingness to experiment with a whole gamut of European artistic movements from Post-Impressionism to Cubism.

Hartley's earliest style of 1907 and 1908 has been termed Impressionist, but his rhythmic slashing brushstrokes and rugged paint surfaces have all the qualities of the German Expressionists with whom he was later associated.

Maine was a source of constant renewal for Hartley. The Ice-Hole, Maine is a forecast of the painter's life-long interest in his native state, despite a life of constant wandering. In 1908 he executed a group of paintings of the Maine landscape all influenced by the stitch-like brushstroke of the Post-Impressionist Swiss painter, Giovanni Segantini. This painting is one of several utilizing the "Segantini stich," and just predates his discovery of the somber, romantic canvases of Albert Pinkham Ryder in 1909.

J.G.C.

Robert Henri

American, 1865-1929

The Blue Kimono. 1909

oil on canvas,
77 x 37 in. (195.6 x 94 cm.)
Ella West Freeman Foundation
Matching Fund. 71.16

Robert Henri was a leader of the artistic world in Philadelphia and New York from the turn of the century until his death in 1929. The artist organized the first exhibition of The Eight, the famous group of New York realists whose show in 1907 created a sensation and helped to reform the standards of the National Academy of Design. As a teacher he exerted enormous influence first at William M. Chase's School and then at the Art Students League of New York. Henri was an artistic rebel, fighting against all aesthetic restriction. He helped to organize the Independents Exhibition of 1910 and the important Armory Show of 1913.

Trained in Paris at the Académie Julien, Henri was influenced first by the Impressionists and then by the bravura brushwork of Velasquez, Hals and Manet. In *The Blue Kimono* the artist returned to an interest in oriental subjects, first kindled in Paris in 1890 and at the Chicago World's Columbian Exposition in 1893. Henri's inspirations from Japan were a passing interest which sometimes were reflected in his work.

The Blue Kimono, a full length portrait of a Miss Kaji, a model of American and Japanese heritages, was among the works shown in 1911 at the inaugural exhibition of the Isaac Delgado Museum of Art, now the New Orleans Museum of Art.

J.G.C.

Ellsworth Woodward

American, 1861-1939

Paradise Wood, Breaux Bridge, Louisiana. circa 1910

oil on canvas, 32 3/4 x 44 1/2 in. (83.19 x 113.03 cm.)
Museum Purchase from the Art Association
of New Orleans. 29.1

Ellsworth Woodward dedicated himself to making art an integral element of daily life; his long career as an arts activist in New Orleans encompassed the roles of teacher and administrator in addition to artist. Having studied art in Europe as well as in the United States, Woodward arrived in New Orleans in 1885 to become the founding Dean of the Newcomb College Art School and Pottery. He introduced the latest Northeastern and European trends to the New Orleans art community. While based upon the landscape and architecture of the South, his works were enhanced by the more cosmopolitan character of international art.

Woodward's paintings exemplify the Southern adaptation of the Impressionist idiom. The atmospheric concerns and suggestive, rather than defining, structure of Impressionism make it well suited to convey the liquid atmosphere and lush vegetation of the Louisiana landscape. Using the vibrant colors and lively brushwork, in *Paradise Wood*, Woodward has depicted an idyllic haven shaded from the intense Southern sunlight. The contrast between the shadows and the light that filters through the canopy of moss-swathed oak trees creates a tonalist effect and suggests a German influence from the time Woodward spent studying at the Munich Academy. While his devotion to the rural Louisiana landscape may be seen as another Impressionist element, or perhaps attributed to his love of nature, it also derives from the strong sense of place infusing Southern culture. It was this notion, that the artist had to draw inspiration from his or her native area in order to achieve artistic honesty and spiritual fulfillment, that nourished Woodward's efforts to forge a strong Southern art tradition.

S.E.S.

Henry Ossawa Tanner

American, 1859-1937

The Good Shepherd. circa 1914

oil on canvas,
20 ⅛ x 24 ⅛ in. (51.1 x 61.3 cm.)
Museum Purchase. 30.3

Tanner was the foremost African-American artist of the late 19th/early 20th century period. At twenty-one he began his artistic training under Thomas Eakins at the Pennsylvania Academy of the Fine Arts. Hoping to find the personal freedom and artistic success denied him in America, he moved to Paris in 1891 and returned only once to the United States in 1902. The rest of his career was essentially French. In Paris Tanner studied with Benjamin Constant and Jean Paul Laurens at the Académie Julien and regularly exhibited at the Paris Salon.

As Tanner violently rejected the Post-Impressionist influence of his time, he remained firmly affiliated with French Post-Romantic movements. The painter's life-long interest in biblical subjects may have been strengthened by his association with Laurens, who specialized in forgotten themes from ecclesiastical history. *The Good Shepherd* is a subject repeated several times in Tanner's work, from the first version in 1914 to a study made on a visit to the Atlas Mountains, Morocco in 1930. The silhouetting of white forms in a dark space and the mystical content of Tanner's paintings owe something to the French artist, Eugène Carrière, who painted melting, gauzy figures seen at dusk. While Tanner's thick impasto style has been compared to that of his contemporary American Romantic Albert Pinkham Ryder, this development seems to have been the painter's own contribution, as was his preference for a palette of blue-violet tones.

J.G.C.

Josephine Marien Crawford

American, 1878-1952

Her First Communion. 1935

oil on canvas, 39 x 24 in. (99.06 x 60.96 cm.)
Gift of Mr. and Mrs. Richard B. Kaufmann
in honor of E. John Bullard. 93.167

Josephine Crawford's family had a long history in New Orleans; her mother's family was one of the first to settle in the city. As the family mansion in the French Quarter was her home throughout her life, Crawford had an intimate

knowledge of the Old Quarter way of life that tourists rarely glimpse. She made this the subject of her art. Crawford did not begin to study art until she was in her mid-forties when she began attending classes at the recently established Arts & Crafts Club. But once she had begun Crawford pursued her studies with true commitment, even traveling to Paris to study with André Lhote. In this heady avant-garde atmosphere of 1920s Paris, Crawford met many of the most important artists of that period including Dufy, Gleizes, Léger, Metzinger, Picabia and Picasso.

When she returned to New Orleans Crawford focused again upon her quiet life, but painted it in a manner marked by her experience abroad. *Her First Communion* illustrates Crawford's facility with the decorative tendencies popular in Paris while she was there. She restricted detail and simplified form. The picture is constructed with minimally modulated planes of color. But whereas one tendency of the French avant-garde was to use color structurally, Crawford's use of color emphasizes the flatness of the picture. Also emphasizing the two-dimensionality is the outline that encloses the thinly applied planes of delicate color. Pursuing it solely for the personal fulfillment it afforded her, Crawford created a quiet art that chronicles the dignity of private life.

S.E.S.

Georgia O'Keeffe

American, born 1887

My Back Yard. 1937

oil on canvas, 20 x 36 in. (50.8 x 91.4 cm.)
City of New Orleans Capital Fund. 73.8

O'Keeffe was born in Sun Prairie, Wisconsin, in 1887. After studying at The Art Institute of Chicago and the Art Students League of New York, she spent the winters of 1912 through 1918 as a teacher in the Texas Panhandle where the vast spaces of the western landscape became a major theme of her painting. The artist first exhibited at Alfred Steiglitz's 291 Gallery in New York in 1915. This exhibition marked the beginning of a thirty-year artistic and personal relationship with Steiglitz, whom she married in 1924.

Although O'Keeffe developed a highly individualistic style, her painting is closely related to the American Precisionists of the 1920s. Like two other protagonists of this group, Charles Demuth and Charles Sheeler, her work is characterized by semi-abstraction, impersonality, hard edges and areas of even color. Whether O'Keeffe paints an unfolding flower or a sprawling desert landscape, her work is distinguished by her unique ability to distill the essence of natural forms through the use of simplification and soft color.

In 1929 O'Keeffe began spending her summers in New Mexico, returning there each year until 1949, when she moved permanently to a remote ranch outside the village of Abiquiu, New Mexico. My Back Yard, painted in 1937, depicts the mountains behind the artist's Ghost Ranch near Abiquiu.

J.G.C.

Will Henry Stevens

American, 1891-1949

Abstraction. 1940

oil and tempera on masonite,
40 ¹/₂ x 34 ¹/₂ in. (102.9 x 87.6 cm.)
Harrod Fund. 46.1

The work of Will Henry Stevens, a long-time professor at the Newcomb Art School, embodies the same paradox that pervaded the larger American culture of the pre-World War II era. As society itself struggled between advancement and parochialism, so did art oscillate between experimental modernism and defensive conservatism. Initially working in an objective mode, Stevens painted landscapes that suggest the influence of Cézanne in their vibrant, limpid colors and planar organization.

This tendency to schematize his images into intersecting fields of color and form seems to be the impulse which moved Stevens into abstraction in which he quietly, almost secretly, began to work in the late 1930s and early 1940s.

Evident in *Abstraction,* and characteristic of all of his abstract work, are strong influences from the European artists Wassily Kandinsky and Paul Klee, whose work Stevens could have seen as early as 1936. Their tendency to divide a picture plane into distinct but interacting abstract forms encouraged Stevens' own inclination to do so. His interests were not strictly formal but also encompassed spiritual and universal themes. He was preoccupied with the emotional and psychological implications of abstract pictorial elements which led him "gradually to depart from the representation of surface appearance and to develop symbols expressive of cosmic values..."

Caught in the uncertainty of transition, however, Stevens' abstract work is not wholly non-objective. Landscapes provided the inspiration for his abstract works which invariably suggest objects or aspects of nature. Indeed, *Abstraction* evokes the intensity of southern sunlight filtering though a window, a remnant of the architectural motifs that often occupied his earlier work.

S.E.S.

John McCrady

American, 1911-1968

Our Daily Bread. 1941

oil and tempera on canvas,
32 x 46 in. (81.28 x 116.84 cm.)
Harrod Fund. 47.1

From a childhood steeped in the rich folk cultures of rural Louisiana and Mississippi, John McCrady grew to be an artist aligned with the Regionalist movement. During the 1930s many American artists rejected the abstract course of modernism in favor of a naturalist depiction of American life. The Regionalists, including Thomas Hart Benton and Grant Wood, were one such group of these American Scene Painters who concentrated upon scenes of the land, people, customs and activities common to the rural Midwest and deep South. Their choice was motivated both by a patriotic desire to establish a legitimate American art,

independent of European styles, as well as by a nostalgic desire to record and celebrate small town America before it was absorbed into industrial urbanization.

When McCrady returned to Louisiana to paint the myths and realities of his home region, he found of particular interest the African-American life in the South. The strong narrative content implied in *Our Daily Bread* is characteristic of McCrady's work. While one man continues his work into the dusk, two others return home to enjoy the rewards of their labor, a home that beckons with warmth and comfort. The plowed fields in the background indicate the close connection in this region between the land and its inhabitants. This connection gives the painting an agrarian theme, referring to the belief that the soul of the South lies in the soil, which has been prominent throughout the history of the South and was an influential aspect of the ideological foundation of Regionalism.

S.E.S.

Dorothea Tanning

American, born 1913

Guardian Angels. 1946

oil on canvas, 48 x 36 in. (121.9 x 91.5 cm.)
Kate P. Jourdan Fund. 49.15

While growing up in a small town in Illinois, Tanning had two overriding ambitions: to be a painter and to see Paris. To achieve these goals she started her artistic training at the Chicago Academy of Arts. In New York a lecture on Picasso's *Guernica* by Arshile Gorky and the exhibition *Fantastic Art, Dada, Surrealism* dramatically influenced her career, but it was Tanning's fortuitous meeting in 1942 with Max Ernst that helped to form her style. In 1946 she married Ernst and moved to Sedona, Arizona, where they lived until they moved to France in 1952. Tanning developed two consecutive styles: the first was completely surrealist and lasted until about 1954, while the second and current one, developed in France, is abstract.

Guardian Angels has proved to be one of the most popular of Tanning's works. In her surrealist phase, to which this painting belongs, Tanning specialized in erotic imagery involving adolescent girls. In *Guardian Angels* the headless innocents, once lying on their crumpled beds, seem ravished by the saving angels who bear them aloft. The atmosphere is troubled and brooding, yet the colors are pastel in tone, applied with an iridescent shimmer. The meticulous renderings of Tanning's imagery have been compared to the more grotesque qualities of early German landscape painting.

J.G.C.

Ralston Crawford

American, 1906-1978

Wharf Objects, Santa Barbara. 1948

oil on canvas, 26 x 36 in. (66.04 x 91.44 cm.)
Gift of Paul J. Leaman, Jr. 91.447

Ralston Crawford's childhood was spent in close proximity to the sea which left an indelible mark upon his art. He was born in Ontario where his father was the captain of a cargo ship. When he was ten his family moved to Buffalo where water remained a ubiquitous presence. He and his father often sailed the Great Lakes and Crawford later spent time as a seaman on a cargo ship. His preoccupation with the sea is most obvious in Crawford's choice of motifs but it has also been noted as a source for his flat, hard edged style which could be derived from the strong, clear light of an ocean environment.

While undeniably influenced by European artistic tendencies, Crawford was a notable participant in the development of American modernism, which emphasized the two dimensionality of the canvas. His radically simplified paintings related to the American art movement called Precisionism which is itself derived from the flattened forms of European Synthetic Cubism. Precisionists, such as Charles Sheeler and Charles Demuth, reduced the forms of the American industrial landscape to regularized, schematic forms established by flat color shapes. In his early work Crawford, like the Precisionists, obeyed the demands of visual recognition, but in his post-World War II work; which is considered his strongest, optical realism gave way to greater simplification and abstraction. His emphasis upon rigorous structural order and the use of color as a building block is related to the American brand of non-representational geometric abstraction. Yet Crawford's work is always based upon observation and so never truly non-representational. It is this exquisite balance, indeed tension, between abstraction and representation that makes Crawford's best works, such as *Wharf Objects, Santa Barbara*, so powerful.

S.E.S.

Hans Hofmann

American, born Germany, 1880-1966

Abstraction with Chair and Miró.
1943

oil on canvas, 58 x 44 in.
(147.32 x 111.76 cm.)
Murial Bultman Francis Collection. 86.200

Despite the profound impact of his own work, Hans Hofmann is more often recognized for his role as a teacher; significant members of both the first and second generations of the New York School studied with him, and even the eminent critics Clement Greenberg and Harold Rosenberg attribute to him an important impact on the formation of their influential theories.

Abstraction with Chair and Miró summarizes the influences generative of Hofmann's style. He has chosen a theme, the artist's studio, prevalent in the work of both Picasso and Matisse, artists whose work he greatly admired. Also from Matisse he adopted the manner of constructing an ambiguous space, the floor and walls painted in the same hue, and of delineating the objects within by a black outline. Hofmann refers to another source of artistic inspiration, Joan Miró, by including his own version of a Miró painting he held in his personal collection. Hofmann's solution to the Cubist quest to resolve three dimensional reality with the two dimensional picture surface resides in the quality of "plasticity" he achieved through counterbalancing the "push and pull" forces of two dimensional color. In this way the vibrant fauve colors of *Abstraction* are not simply decorative, but through their interrelationships they have an integral effect upon the entire pictorial structure. The colors and their forms are chosen to create an harmonious and proportionate balance throughout the composition.

S.E.S.

Jackson Pollock

American, 1912-1956

Composition (White, Black, Blue and Red on White). 1948

casein on paper mounted on masonite,
22 ⅝ x 30 ½ in. (57.8 x 77.5 cm.)
Bequest of Victor K. Kiam. 77.300

The most famous Abstract Expressionist or "action painter" of his generation, Jackson Pollock exerted a tremendous influence in the New York art world from his first one-man show in 1943 until his tragic death in an automobile accident in 1956. After a peripatetic childhood spent in Arizona and California, he began his painting studies in Los Angeles and then continued at the Art Students League of New York under Thomas Hart Benton. In an interview in 1944 Pollock listed Albert Pinkham Ryder, Joan Miró and Pablo Picasso as the three painters who most influenced his work.

Pollock began the 1940s by creating paintings with mytho-poetic themes, but by 1946 he had begun experimenting with descriptive imagery which soon filled the entire canvas with rhythmic movement. Through experimentation Pollock gradually began painting on huge canvases stretched and tacked to the floor. In this manner he could interact with all four sides of the canvas at will. Pollock dripped and flung different kinds of paint, including oil, aluminum and enamel, on the canvas. Because he worked in frenzied movements, the paintings evolved through the action of the artist's own body motion. This action or process of frenetic creation became the theme of the painting.

Composition is one of over two dozen drip works on paper, all of which are approximately the same dimensions, painted in 1948 and 1949. These lyrical smaller works are to his mural-sized drip canvases what chamber music is to symphonies.

J.G.C.

William Baziotes

American, 1912-1963

Sleep. 1952

oil on canvas, 24 x 30 in. (60.9 x 76.2 cm.)
Gift of Muriel Bultman Francis. 55.27

Baziotes, along with David Hare, Robert Motherwell and Mark Rothko, founded the "Subjects of the Artist School," a major center and rallying point for Abstract Expressionism in the 1940s and 1950s in New York City.

Born in Pittsburgh of Greek descent, Baziotes differed from most of the Abstract Expressionists in his ability to create a personal, surreal mythology, inspired largely by Picasso and especially by Miró. Generally, Baziotes limited the forms in his compositions, employing nebulous, amorphous shapes which drift across the canvas surface. By this means and through the skillful manipulation of several thematic, formal repetitions, used emblematically, he created a mood of mystery and vague fear.

Sleep contains playful linear forms reminiscent of those found in works by Paul Klee. *Sleep* is closely related to other paintings created by Baziotes in the early 1950s in the use of two or three basic forms juxtaposed on the picture plane. The artist was fascinated with the primeval geological world and its prehistoric animals. The strange, reclining creature in *Sleep* is reminiscent of *Primeval* of 1952 and *Primeval Landscape* of 1953. Scarlike or wavy vertical additions appear as an extra element in all three of these paintings. In the New Orleans painting the strange eye mysteriously added to the sleeping creature in the lower half of the canvas seems to hark back to Baziotes' earlier works such as *Cyclops, Night Mirror* and *Dwarf* of 1947.

J.G.C.

Fritz Bultman

American, 1919-1985

Sun Figure. 1955

oil on canvas, 72 x 36 in. (182.88 x 91.44 cm.)
Muriel Bultman Francis Collection. 86.157

Although he exhibited regularly with such New York School luminaries as Baziotes, de Kooning, Gottlieb, Motherwell and Hofmann, and is represented in the collections of most major museums, New Orleans-born Fritz Bultman is generally omitted from the legendary group of Abstract Expressionists. His unfortunate absence from the famous 1951 *Life* magazine photograph of the Irascibles, the group from which the list of Abstract Expressionists has been compiled, forever plagued his career.

The affinity of Bultman's heavily painted canvases with the spirit of those by recognized Abstract Expressionist masters is illustrated in *Sun Figure*, a painting Bultman considered one of his most important. Its exuberant physical handling of pigment is as representative of Bultman's personal style as it is of the sensuous manipulation of materials associated with Abstract Expressionism. The subject of Bultman's images also corresponds with an interest prevalent in Abstract Expressionist painting, the interest in mythic content as a more valid means of giving expression to that era's social, psychological and moral concerns. In designating the highly abstracted yet figurative form, at once dense yet buoyant, delineated by his brush handle as 'sun figure,' Bultman

refers to an ancient mythical tradition. Manifest in cultures throughout history, solar symbolism has established a varied heroic language. The Swiss psychiatrist Carl Gustav Jung, often a source for Abstract Expressionist artists, recognized the sun as a symbol of the source of life and of the ultimate wholeness of man. Bultman's expressed interest in developing a universal artistic idiom, one based upon magical signs, is well illustrated by this image which reverberates in the collective psyche.

S.E.S.

Joseph Cornell

American, 1903-1972

Radar Astronomy. 1952-1956

mixed media,
13 x 19 ¹/₄ x 4 ¹/₄ in. (33.02 x 48.90 x 10.80 cm.)
Muriel Bultman Francis Collection. 86.174

Joseph Cornell, one of the most enigmatic figures of 20th century art, lived an hermetic existence with his mother and disabled brother in a spectacularly ordinary house in Queens, New York. Yet through his miniature but magical creations, Cornell escaped the boundaries of his mundane, domestic existence in the small house appropriately located on Utopia Parkway.

Cornell was inspired by the Surrealist concept of poetry that is created through the juxtaposition of incongruous objects or images. Using the media of collage and construction, Cornell created gently compelling arrangements contained within small-scale shadow boxes. The disparate elements of his intricate assemblages are divorced from their rational functions, yet acquire fantastic significance through associative evocation. This significance is enhanced by the formal power of the enframing box which confers dignity upon Cornell's mundane oddments.

Cornell frequently explored a single theme throughout several boxes; *Radar Astronomy* is one of several on the theme of space in which he tried to capture some of the spirit of the scientific discoveries of the modern era. The cork ball is symbolic of the sun, and the metal rings refer to the orbit of the planets around the sun. These elements also allude to a type of game in which the ball is rolled through a ring. Also suggested, as the rings slide along the bar, is the progress of time. The clay pipe is a personal symbol recurrent in Cornell's work and which he associated with memories of New York. Transformed by his orchestration into new relationships, these elements transcend the disparity of their quotidian reality as Cornell himself transcended his own ascetic existence.

S.E.S.

Richard Diebenkorn

American, 1922-1993

Woman on Porch. 1958

oil on canvas,
72 x 72 in. (182.9 x 182.9 cm.)
National Endowment for the Arts Matching Fund
and Women's Volunteer Committee Fund. 77.64

During the last three decades of his career, California artist Richard Diebenkorn moved from Abstract Expressionism to the figurative and back again to abstraction, as evidenced in his final *Ocean Park* series. In the late 1940s at the California School of Fine Arts in San Francisco he was influenced by David Park and was introduced to the Abstract Expressionist paintings of Clyfford Still. In addition, Diebenkorn responded strongly to two major figures in a painterly tradition: Bonnard and Matisse.

In figural painting Diebenkorn constructed a new world through the use of balanced geometric elements, unequal bands of bright color and implied space. Typical of his earlier experience with abstract art, he also composed his figures in settings and landscapes that convey a pervasive mood of reverie.

These distinguishing features can be found in *Woman on Porch*, the largest and one of the most important of his figurative paintings. Characteristically, the artist has isolated a solitary faceless creature in a light filled architectural space and packed the canvas with planes of brilliant color. Instead of painting directly from the posed model, Diebenkorn usually worked from a number of drawings which served as part of a reintegration process, linking the single figure to the larger spatial environment.

J.G.C.

Lee Krasner

American, 1908-1984

Breath. 1959

oil on canvas, 60 x 49 in. (152.40 x 124. 46 cm.)
Gift of Mrs. P. Roussel Norman. 87.270

Though long overshadowed by her husband, Jackson Pollock, Lee Krasner has now garnered the recognition appropriate to her accomplishments. As well as being a pioneering member of the "heroic first generation" of Abstract Expressionism, she was one of only two American artists to work in a wholly abstract style prior to World War II. Krasner found her lifelong direction under the influence of Hans Hofmann, the legendary teacher who was such an influential force in the New York art world. Hofmann taught her that color, and its interaction to produce purely optical spatial illusions, may be a subject in itself. In her own work Krasner combined Hofmann's theories with influences from two other artists whose work she admired: the airy, unrestrained sensuousness of Matisse, and the severely intellectual structure of Mondrian. Yet she wished to temper these influences with a more active, spontaneous, improvisational style. From this synthesis emerged the relationships that have since informed Krasner's work: those between thought and feeling, color plane and line, and tectonic structure and baroque dynamism.

Characteristic of Krasner's work is the dynamic, abstract rhythm that animates *Breath.* Though securely anchored at the edges of the canvas, linear arabesques gyrate across the canvas in a fluid, all-over patterning identified with Abstract Expressionism. These calligraphic notations are made dramatic by variations of line and rhythm. The critic William Rubin has described Krasner's images as being marked by a "sustained pneuma or breathing." This observation was inspired by the dappled, rather than solid and opaque, quality of her thinly applied pigment as is seen here. This leaves areas of the white canvas exposed which evokes the openness and lightness acknowledged by the title.

S.E.S.

Sam Francis

American, 1923-1994

White Line I. 1959

oil on canvas,
71 ³/₄ x 47 ⁷/₈ in. (182.2 x 121.6 cm.)
Bequest of Victor K. Kiam. 77.290

Sam Francis, born in San Mateo, California, studied medicine for three years at the University of California, Berkeley. During a period of convalescence from a spinal injury he began painting as a diversion. After his release from military service he studied with David Park at the California School of Fine Arts in San Francisco, returned to Berkeley to receive his Masters in Art and then trained in Paris, where he studied briefly at the Académie Fernand Leger.

Francis developed a mature style, which encompassed some measure of abstraction, within three years after his first instruction. His earlier medical training could have influenced the organic, corpuscular nature of his work from 1949 to about 1955. By the mid 1950s Francis' painting changed drastically, as his color range grew wider and changed from red and black to blue, purple, yellow and red.

Beginning in 1957 the white areas of canvas became increasingly important to Francis. White implied endlessness to the artist. It can also denote silence, death, or a new beginning. Four paintings of the late fifties demonstrate this new use of white: *The Whiteness of the Whale* (1957); *White Line* (1958-1959); *White Line II* (1959); and the New Orleans painting, *White Line I* (1959). In some cases Francis' use of white has been compared to a white river floating between clusters of color islands. In *White Line I* he retains the separation of color areas by driving a wedge of white vertically down the center of the canvas.

J.G.C.

David Smith

American, 1906-1965

Swan. 1959

welded and painted steel,
35 x 31 ½ x 5 ¾ in. (89 x 80 x 14.7 cm.)
Muriel Bultman Francis Collection. 86.295

David Smith has been posthumously recognized as the most important post-World War II American sculptor. Generally represented as an inspired genius, Smith is credited with liberating American sculpture from European domination and, in the course of his short but brilliant career, rocking the aesthetic foundations of his medium.

Paradox is central to Smith's work. Because of its three dimensionality, sculpture is usually the most physical of art objects. Smith denies the physical presence to make his works purely visual. The elusive physical presence of *Swan* illustrates this paradox. *Swan* lacks a generating core or even an enclosing contour that bounds a comprehensible volume of air; it is diffuse. Smith neither articulated the swan's exterior as a solid block, nor stereometrically examined its interior structure. Instead, the work asserts the fluctuating and elusive quality of appearances. The figurative activity of this sculpture dances around its perimeter at the center of which is an open field, a transparent membrane. The surface of this transparent membrane fluctuates continually according to the object's

environment and thus upsets the viewer's habitual systems of knowledge and control. It is at once a surface and not a surface. Because of the two-dimensional, linear character of Smith's sculptural draftsmanship the contour is as ambiguous as is the substance of this object which disappears as the viewer moves around it. By upsetting the traditional relationship between the sculpture and its viewer Smith revolutionized both the formal and the ideological convictions of the 20th century sculptural tradition.

S.E.S.

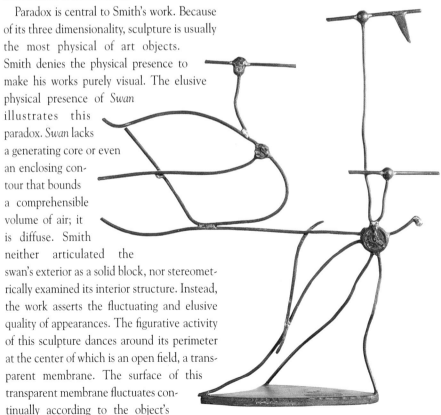

Larry Rivers

American, born 1923

Portrait of Sunny Norman: Parts of the Face. 1963

oil on canvas,
30 x 30 in. (76.2 x 76.2 cm.)
Gift of Mrs. P. Roussel Norman.
91.235

Rivers' first artistic excursion was in the realm of music. During his early 20s he supported himself as a professional saxophone player in various jazz bands. His interest in the visual arts was awakened by several personal friends, one of whom encouraged Rivers to become a student of Hans Hofmann, the renowned painter/teacher who exerted such a profound influence upon the second generation of the New York School. He continued his formal training at N.Y.U. where he studied under William Baziotes and other New York School luminaries. Even before he finished his degree in 1951 Rivers had been noticed by the powerful art critic Clement Greenberg who, in distinguishing him as an "amazing beginner", launched Rivers' career.

Rivers established his reputation by forging a viable alternative to Abstract Expressionism. He returned to recognizable subject matter but with gestural nuances left over from action painting. His references to tradition were initially scoffed at by an avant-garde already outraged by his figurative approach, but the irony of these references prefigured the coolness of Pop.

This *Portrait of Sunny Norman*, a prominent New Orleans art patron and a longtime NOMA trustee, is part of a series that Rivers began with a portrait of his second wife in 1961. The common device in this series of portraits is his use of stencilled labels for the sitter's features and anatomy. On this picture Rivers wrote the labels in French but he used a variety of languages throughout the series. The contrast between the bold, graphic character of the words and the loose, sketchy rendering of the figures in this series alludes to the dichotomy of human experience in the split between perception and conception. Whereas every individual is comprised of the same component parts, the sum of those parts is always unique and knowledge of that individual is more elusive than the identification of the component parts.

S.E.S.

Milton Avery

American, 1893-1965

The Artist's Daughter Reading. 1963

oil on paper, 22 ³/₄ x 30 in. (57.79 x 76.2 cm.)
Gift of Mrs. P. Roussel Norman. 91.236

Milton Avery began his career as a commercial artist, but a course in lettering led him to a course in charcoal drawing which stirred his desire to become a serious fine artist. But while his work influenced and earned respect from his fellow artists, it initially elicited only confusion from the public. In the light of an historical perspective, Avery takes his place among those American artists, such as Dove, O'Keeffe and Hartley, who bravely forged an indigenous modern American artistic idiom.

Avery's work was unusual for both its content and its style. It was an entirely personal art made from the minutia of the domestic life he shared with his wife, artist Sally Michel, and daughter, March. His use of personal and idiosyncratic rather than recognizable subject matter was at the time an extremely renegade choice. And so his daughter March was an obvious, indeed inescapable, motif as his widow remarked: "Every aspect of the growing child was noted...all found equivalents in color and form radiating the father's delight in discovering new harmonies inspired by the growing child."

But because these "equivalents" were not fully detailed recreations of the visual world, Avery's work was criticized for being sloppy and unfinished. He simplified and reduced his motifs into interlocking planes of color, creating a balanced two-dimensional design. But while this approach was extremely economical, he never sacrificed the motif to his aesthetic concerns. Thus in his best work, the work of the 1950s and 60s, Avery achieves an equilibrium between the evocative rendering of his motif and a balanced construction of line, color, form and space.

S.E.S

Alex Katz

American, born 1927

Ada in Aqua. 1963

oil on canvas, 50 ¹/₄ x 80 in. (127.64 x 203.20 cm.)
Gift of the Frederick R. Weisman Foundation. 93.15

Curiously enough, Katz's aesthetic sensibility was nurtured in the milieu of Abstract Expressionism in New York City. He studied at the Cooper Union and frequented The Cedar Street Tavern, The Club, and other bastions of the New York School. But while Katz adopted the energy, physicality and flatness of Abstract Expressionism, he never gave up his direct perception of nature. By faithfully depicting three-dimensional reality while maintaining the integrity of his two-dimensional painting surface, Katz hopes to reconcile representation with the pictorial strategies of modernism.

Using the monumental scale associated with Abstract Expressionism, Katz depicts his subjects in frozen, iconic poses. In thus transferring them from the mundane world to the remote, ideal realm of pictorial exis-

tence he transforms his subjects into symbols with "multiple meanings." A portrait of Ada, Katz's wife and perhaps most frequent subject, represents beauty, motherhood, charity, and sexuality in addition to her person. In *Ada in Aqua* the pictorial field is filled by a close up view of Ada's face but, characteristically, Katz has included only the detail required to create a convincing illusion. While recognizable as Ada, the image is generalized by the regularization of contours and surfaces. The close cropping is typical of his images as Katz rarely portrays his subjects within a context that conveys narrative. Ada exists in an eternal and private reverie. This remove is strengthened by her sunglasses which completely deny the viewer access. Through Katz's emphasis upon high style, his images become neutral and detached. His portraits are simple, indisputable pictorial facts, dependent not upon narrative or emotional baggage for their validation, but upon their assertive design achieved through his resolution of abstraction and realism.

S.E.S.

Robert Gordy

American, 1933-1986

Rimbaud's Dream, # 2. 1971

acrylic on canvas, 82 x 64 in. (208.3 x 162.5 cm.)
Museum Purchase. 71.23

During the 1970s a number of contemporary artists living and working in Louisiana, such as Robert Gordy, Ida Kohlmeyer, Jim Richard, and Robert Warrens, achieved national prominence. Born on Jefferson Island and raised in New Iberia, Louisiana, Robert Gordy received degrees from Louisiana State University, did graduate work at Yale University and studied with Hans Hofmann. Beginning in the mid-sixties Gordy exhibited extensively throughout the United States, and his work was acquired by the Whitney Museum of American Art, the Corcoran Gallery of Art, and the Metropolitan Museum of Art, among others.

In his paintings Gordy was preoccupied with the female figure in a two dimensional decorative landscape. Inspired by the work of Paul Cézanne and Henri Matisse, his figural compositions continue a Western tradition of the nude. Rendered in flat, bright colors, Gordy's abstracted, anonymous figures are placed in a tight, densely packed

environment, integrating positive and negative space in an overall pattern. *Rimbaud's Dream, # 2*, one of a series of paintings made on a black ground, was inspired by the French poet Arthur Rimbaud's abortive attempt to seek his fortune in Africa. Gordy described the picture as "a treasure in a dark tomb," the poet's dream of riches in an exotic, foreign land.

J.G.C.

Jim Nutt

American, born 1938

Sliding, Slowly, Softly.
1972

acrylic on canvas, 50 $^1/_2$ x 38 $^1/_2$ in.
(128.2 x 97.7 cm.)
Museum Purchase. 74.158

Jim Nutt was born in Massa-
chusetts and studied at the
School of the Art Institute of
Chicago, where he began to
develop his characteristic
style. An original member of
the Chicago Hairy Who, his
work was influenced by
"junk" advertising and comic
strips, both source materials
used by other members of the
group. In his work Nutt fa-
vors shapes that are clear cut,
unmodelled, yet rubbery and
that are executed in crisp, hard-edge line. His
two central themes are the single, human fig-
ure, usually a female, portrayed as a salacious
dream image and the double figures, usually
male and female, confronting each other in
erotic or comic scenes. In many paintings
parts of the human anatomy are grotesquely
exaggerated or wildly cut up and spread
around the surface of the canvas. Often terri-
fying anxieties are depicted in a style
paradoxically rich in playful decoration and
brilliant color.

Sliding, Slowly, Softly seems to be a satiric
treatment of the traditional mother and child
theme carefully concealed by the title.
Visceral texture, slick handling and neon
color characterize the artist's style. The tex-
tured face of the mother is repeated in the
woman's face of *He Might Be a Dipstick But
They Are a Pair*. The typical device of doodling
on the frame of a painting again appears in
other works and serves as a kind of sponta-
neous extension of the painted surfaces.

J.G.C.

Sister Gertrude Morgan

American, 1900-1980

The Revelation of Saint John the Divine. circa 1965-70

acrylic, pencil, ink on vinyl plastic,
47 7/16 x 83 7/8 in. (120.5 x 213 cm.)
Gift of Lee Friedlander. 84.90

Sister Gertrude Morgan's artistic career is inextricably linked to her spiritual career as a prophetess and missionary. Although long active in the Baptist church, Morgan did not begin preaching until 1934 when instructed to by a divine revelation. In 1939 she moved to New Orleans where she embarked upon intensive missionary work beginning as a street preacher. Again by divine command, Morgan began supplementing her biblical teachings with painted illustrations in 1956. She readily acknowledged the origin of her motivation and always gave the credit for her artwork to the Lord who she believed guided and nourished her talent.

Although Morgan usually worked on traditional pictorial surfaces, she sometimes used unconventional ones culled from whatever was available. *The Revelation of Saint John the Divine* is painted on both sides of a window shade. Often inspired by the Book of Revelation, Morgan here combined the text of the Revelation with somewhat unusual but nearly literal illustrations of its content. The use of written text, whether biblical passages, original sermons, or auto-biographical notes, is a recurrent device in Morgan's work.

This composition indicates the increasing exuberance of Morgan's style following her more subdued and muted pictures of the late 1950s and early 1960s. Morgan's compositions are typically quite vibrant and complex resulting from her loose, agitated brushwork, bright palette, and variety of shapes arranged across a flat space. Enhancing this liveliness is the rhythmic pattern created by the black written words on the white field punctuated by the bright shapes of her illustrations. Though certainly unconventional, Morgan's pictorial expressions are always forceful and embody her determination to celebrate the teachings of the Lord.

S.E.S

David Butler

American, born 1898

*Windmill with Man Riding
Flying Elephant.* 1975

painted tin, wood and plastic,
47 x 30 in. (119.38 x 76.20 cm.)
Gift of the Artist. 76.259

The whimsical and imaginative constructions envisioned by "the wildest and most fantasti-cated eye" of David Butler may have their origin in the wooden boats and animals he carved in his spare time as a boy in rural Louisiana. His creations range from small, simple, flat shapes to quite large, complex wood and metal kinetic assemblages. This *Windmill* is typical of Butler's more ambitious works which usually incorporate other moving parts. He has used old tin roofing, his preferred medium, cut into shape with a large knife and hammer. Butler mounted many of his constructions onto wooden stakes which he then drove into his yard. Gradually, his yard became home to a menagerie of real and imaginary animals including flying elephants, cockatrices, sea monsters, as well as elaborate whirligigs, biblical scenes, and even Santa Claus and his reindeer.

Butler uses his constructions as spirit shields to keep unfriendly spirits at bay. This use of his works as charms or mojos refers to the African heritage which influences many Southern self-taught, African-American artists. This heritage is often manifest in the use of protective symbolism derived from Haitian *voudun* (commonly called voudou) which itself is derived from a mixture of older African traditions. In this symbolic tradition, certain colors have protective con-notations and are used to fight against all sorts of disturbing elements. The same colors that dominate Butler's palette, red, white, black, silver, and blue, are those colors associ-ated with a protective function. A protective function is also ascribed to asymmetrical designs and multiple patterns which serve to distract elements of evil.

S.E.S.

Jacob Lawrence

American, born 1917

Builders #4. 1973

gouache on paper, 21 ¹/₂ x 30 ¹/₂ in. (54.5 x 77.4 cm.)
National Endowment for the Arts Matching Fund and
Women's Volunteer Committee Fund. 73.251

Born in Atlantic City in 1917, Lawrence studied at the Harlem Art Workshop and the American Artists School. By 1941 he had his first one-man show in New York. In addition to being the recipient of numerous fellowships and grants, his work is represented in many collections, including the Metropolitan Museum of Art, New York City; the National Gallery of Art, Washington, D.C.; and The Museum of Modern Art, New York.

In his work Lawrence has felt the need to rediscover the heritage of African-Americans and to present it to the world in visual terms. The artist has been categorized as a social realist, but he moves in a much larger time frame. He is a painter of history working in a simplified, yet powerful and realistic style, which expresses a deep concern for the human condition in general.

Through the years the artist has preferred to work in series, presenting heroic subjects such as the lives of Frederick Douglass, Harriet Tubman and John Brown in episodic sequence. *Builders #4* is from a similar series begun in 1971 which celebrates the satisfaction and dignity of creative labor.

J.G.C.

David Bates

American, born 1952

Grassy Lake. 1982

oil on canvas, 90 x 72 in.
(228.60 x 182.88 cm.)
P. Roussel Norman Purchase Fund
and gift of Mr. and Mrs. Claude C.
Albritton, III. 83.27

As a participant in an independent study program at New York's Whitney Museum in 1976/77, Bates learned that the figurative style he preferred was considered passe in an artworld then enthralled by minimal and conceptual work. Yet upon returning to his Texas home, Bates pursued his folk-based, figurative inclinations, tempering them, however, with sophisticated pictorial mechanisms.

A dominant theme in Bates' work is the relationship of man to nature, often that of the inhabitants of the remote lake areas of Texas, Arkansas and Louisiana to their environment. Bates pictorially communicates the harmony he finds there by a complex rhythmic structure of repetitive patterns and shapes that integrates figure and landscape.

Depicted in this painting is Ed Walker, one of the men who lives and works by Grassy Lake which is located in a remote western Arkansas wildlife preserve. Walker imparted to Bates much of the wisdom gained from life on the lake and is shown here, in the rear of the canoe, as guide to Bates, who sits in the bow. The two figures create a central axis which, with the cypress trees on either side of the boat, stabilizes the animated composition. The rhythm characteristic of his compositions is established by the slanting oars, which unite foreground and background, and by the spots of bright white punctuating the overall brown and green palette. The lush foliage of the swampy area is given an intense, almost visionary character by his exaggerated style, luminous, clear colors, and precisely rendered details. Grassy Lake is exemplary of Bates' style which combines populist motifs and a simplified, descriptive approach with an aesthetic astuteness.

S.E.S.

Louise Bourgeois

American, born France 1911

Female Portrait. 1962-82

marble, 23 ³/₄ x 17 x 11 ¹/₂ in.
(60.4 x 43.2 x 29.2 cm.)
Museum Purchase. 82.165

Born in France, Bourgeois' aesthetic was nurtured in the vibrant avant-garde circles of Paris in the early 1930s. Although Surrealism was a dominant force in Paris then, Bourgeois did not begin to investigate its possibilities until after her 1938 move to New York. The psychological motivations and exploration of the unconscious embodied by her early work correspond with Surrealism, yet the subsequent evolution of her work has brought it closer to pure expressionism in its focus upon elemental states of being.

Female Portrait is a variation of a motif, a human head protruding from a coiled mass, which began to appear in Bourgeois' work in the 1960s. Characteristic of these pieces is the cluster of highly polished, rounded forms perched atop a rough hewn base. Many of her works address the

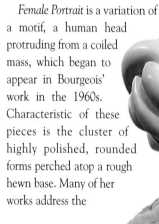

inescapable dualities of human existence which are evoked here by the contrast of the highly polished marble with the rough, unfinished base. The arrangement of the head protruding from the writhing mass of tubular forms suggests the birthing process or perhaps grasping tentacles or fingers. The simultaneous sensations evoked complement the formal suggestions of duality. The work inspires a fascination and visceral attraction to its surfaces, but a horror at its form. On a universal level the work communicates the experience of the human mind trapped within its body, but at a more specific level it indicates the powerlessness of women in a patriarchal society. While in general Bourgeois' work addresses universal themes, such as basic emotions, instincts and needs, her dominant theme concerns the reality of female identity, psyche and sexuality.

S.E.S.

Elizabeth Catlett

American, born 1919

Mother and Child. 1983

mahogany, 53 x 13 x 13 in. (134.62 x 33.02 x 33.02 cm.)
Women's Volunteer Committee Fund. 83.71

Elizabeth Catlett believes that art should be a way of speaking both to and for those who cannot speak for themselves. This affects her work both thematically and stylistically; her work has a strong emotional content and is always figuratively-based so that ordinary people can relate to it. Her belief is part of an over-all concern for social justice born of her experiences as an African-American woman. This interest in social justice was nurtured by her participation in New York's Harlem Renaissance of the 1940s and was further aroused by her work with peasants in Mexico, where she has been a long-time resident.

As Catlett explains, the mother and child theme has appeared regularly in her work: "Many of my sculptures and prints deal with maternity for I am a mother and a grand-mother." This mother's strength, stability and pride in her role as nurturer and protector are conveyed by squarely planted feet and an upright stance. At once expressive and simpli-fied, the interplay of solid masses and voids, surfaces and contours, alludes to both Western and non-Western traditions. The combination of abstract and figurative principles indicates the Western love and respect for pure form, while Catlett's willingness to adapt empirical information to her own symbolic and commu-nicative ends reveals a non-Western, African influence. Yet Catlett does not allow this expressive synthesis to become inaccessible, but rather achieves a universal statement by stripping form to its essential structure. Catlett's respect for her material is evident in her meticulous craftsmanship. She emphasizes the nature of the wood as an aesthetic element by manipulating its grain to follow the con-tours of the figures, to respond to the rhythm and beauty of the form.

S.E.S.

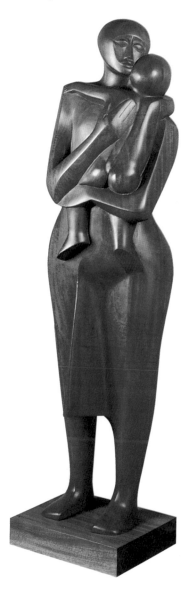

Tony Smith

American, 1912-1980

Lipizzaner. 1976-78

fabricated steel, 9 x 7 x 9 ft. (274.3 x 213.4 x 274.3 cm.)
Gift in honor of P. Roussel Norman from his wife. 78.145

Tony Smith is one of the foremost sculptors to emerge from the Minimalist movement of the 1960s. Born in South Orange, New Jersey in 1912, he studied at the Art Students League of New York and trained as an architect at the New Bauhaus in Chicago in 1937 and 1938. After Smith worked as an architectural apprentice to Frank Lloyd Wright from 1938 to 1940, he was active as a practicing architect until 1960 and taught at New York's Cooper Union and Pratt Institute in the 1950s. He suddenly emerged as a sculptor in the 1960s and his huge, geometrically simple sculptures, painted black, made his reputation almost overnight.

Lipizzaner marks a departure for the artist since it is painted white. The sculpture is made of 1/4 inch thick steel plates and is the result of Smith's interest in tetrahedra and octahedra modules. It was fabricated at Industrial Welding in New Jersey, shipped to New Orleans, sandblasted on the site and then spray painted with white auto enamel.

Lipizzaner grew rather arbitrarily out of an earlier experimental piece called Crazy Horse. While playing with the pieces of Crazy Horse, which fell apart several times, Smith conceived New Orleans' Lipizzaner. The title of the piece is a reference to the white stallions of the Spanish Riding School in Vienna because the complex surface of the modular forms in Smith's sculpture suggests a prancing horse.

J.G.C.

John T. Scott

American, born 1940.

Alanda's Dream Tree. 1985

painted steel, brass, and stainless steel cable,
76 ½ x 36 x 78 in. (194.3 x 91.44 x 198.1 cm.)
Muriel Bultman Francis Collection. 86.292

As an African-American and native New
Orleanian, John Scott makes an art resonant
with allusions to those two larger cultural
spheres. His work did not assume its current
direction until 1983 when two seminal
events occurred. The first was a cov-
eted invitation to work with the
kinetic sculptor George Rickey. The
other was his discovery of an African
hunting ritual: early African hunters
would honor the soul of the animals
they killed with a kind of dirge played
upon the strings of their overturned
hunting bows. In time this instrument
came to be called a diddlie bow. Since
1983 the diddlie bow has had a strong
presence in Scott's work, referring
both to his African-American heritage
and to the strong musical culture of
New Orleans. Although he had long
wanted to add a kinetic element to his
sculpture, Scott had been wary of
appropriating the vocabulary of another
sculptor. But through his conversa-
tions with Rickey and his research into
his heritage, Scott's own individual
vocabulary emerged.

Alanda's Dream Tree is one of the
first tall pieces in this diddlie bow series.
Scott has made a visual love poem for
each of his children and this piece is

the one he made for his youngest daughter,
Alanda. Characteristic of his kinetic sculp-
tures is the contrast between the gestural
application of the paint and the precision of
the metal structure. Also typical of his kinetic
pieces is the upward thrust from heavy, solid
elements to lighter, more thread-like ones. In
the commentary his work provides on his
cultural heritage, this upward movement is a
metaphor for ideas such as aspiration, hope,
freedom, and triumph.

S.E.S.

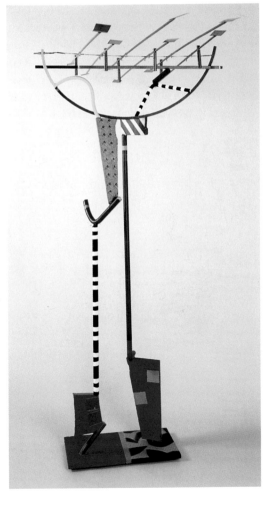

James Rosenquist

American, born 1923

Hybiscus and Woman. 1987

oil on canvas, 62 x 54 ¹/₂ in. (157.48 x 138.43 cm.)
Bequest of Elise Newman Solomon. 88.322

Rosenquist's budding talent was recognized already when he was only twelve and was given a scholarship to the Minneapolis Art Institute. He later won a scholarship to the Arts Students League of New York. During his student days Rosenquist supported himself by painting billboards and designing department store window displays. Elements of this consumer culture of advertising media and billboard and sign painting eventually appeared in his work which placed it in the category of Pop art. Yet because his work also challenges that classification, Rosenquist is called the "dark horse of Pop art."

The beckoning female face, commanding colors, even the large scale and sliced juxtaposition of imagery in *Hybiscus and Woman*, which suggests the experience of painting one billboard sign over another, all refer to industrial sign painting. Yet the painting subverts its Pop classification as readily as it inspires it. Although slick, its illusionistic modeling contradicts the Pop principle of flatness. Whereas the realistic pictorial elements imply a narrative, any such cohesion is denied by the lack of any apparent relationship. His image further disrupts our expectations and habits of recognition through the disconcerting close-up view of the female face, the unexplained juxtaposition of the face and flower, and the illogical scales of these two images.

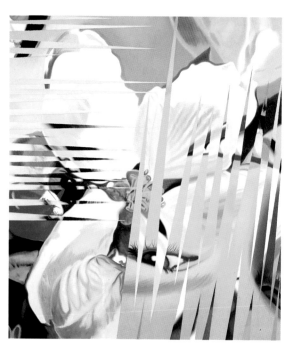

Hybiscus and Woman is one of a group of images Rosenquist painted in the 1980s depicting women whose faces are inexplicably slashed. Whether formal, in the arrangement of the segments as abstract elements, or humorous, in the conflation of downy female skin with the dewy petals of the hybiscus, or even misogynistic, as some have accused, the intent is maddeningly elusive. It is this very elusiveness that makes Rosenquist's work so irresistibly mesmerizing.

S.E.S.

Roger Brown

American, born 1941

California Hillside. 1988

oil on canvas, 72 x 48 in. (182.88 x 121.92 cm.)
Robert P. Gordy Fund, by exchange. 89.9

Brown belongs to a generation of Chicago artists referred to collectively as "Chicago Imagists." Stylistic traits this generation shared include strong patterning, vivid color, manipulated spatial relationships and the use of recognizable imagery that is in some way personally transformed.

Since the late 1960s, Brown's work has been dominated by landscapes that are inhabited or otherwise altered by modern civilization. Inspiration for these landscapes is often collected from cross-country drives, one of his favorite pastimes. Though Brown rejects its elitism and self-referential, art-for-art's sake stance, he does retain some of Modernism's stylistic elements such as its emphasis upon the two dimensional picture plane and an abstract composition. The spatial reality of *California Hillside* has been transformed into a schematic pattern with repeated plant and animal motifs depicted as flat silhouettes lit from behind. Typical of Brown's paintings is this simplified outline style with uninflected planes of flat color and abrupt transitions from dark to light as seen in the edge of this hill. Also characteristic of his work is the ominous

mood of this painting here conveyed by the heavy, brooding sky. The radical shift in scale between the large clouds and the landscape below emphasizes this mood, while the schematized character of the landscape creates an enigmatic but haunting stillness. Simultaneously accessible and complex,

this work embodies our ambivalent response to the American landscape, one of both boredom and awe. And while he refrains from didacticism, Brown implies a troubled view of the way in which this response is codified by contemporary culture.

S.E.S.

Lin Emery

American, born 1928

Wave. 1988

polished aluminum,
168 x 180 x 108 in. (426.72 x 457.20 x 274.32 cm.)
Gift of Frederick R. Weisman Foundation. 88.365

The work of New York-born New Orleanian Lin Emery is largely influenced by the ideas of Ossip Zadkine who first taught her about sculpture. In Paris to pursue a writing career, Emery was sidetracked by her interest in Zadkine's work and became his apprentice. It was not his stylistic but his philosophical approach that had the most profound influence upon the development of Emery's own aesthetic convictions. Zadkine's interest in the multiple perspectives offered by one object, and the modes of space and time consciousness by which sculpture is perceived, are given their ultimate exercise by Emery's addition of a kinetic element to the sculptural object.

Another influence from her time spent in Paris is seen in the crescent motif that is characteristic of Emery's work. She explains it as having evolved from the examples of Christs in Romanesque sculpture. She believes she was drawn to Romanesque sculpture by a common goal, to give visual shape to spiritual values. The crescent motif is ideally suited to *Wave* as it evokes the physical configuration of a wave. Yet Emery intends the dip and swoop of these sleek elements to refer beyond the variant specifics of the natural movement and to express the spiritual harmony, resulting from the union of matter and energy in nature. It has always been her concern to convey this harmony or unity which she believes makes nature "ordered, consistent, coherent, in constant flux but also in equilibrium" and gives it "progression, rhythm, and pattern." Indeed, her description of nature would serve equally well to describe the elegant and graceful movement of her sculpture.

S.E.S.

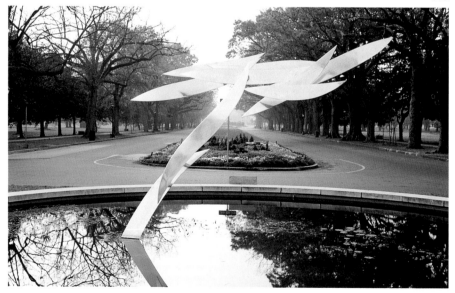

Purvis Young

American, born 1943.

Angels Over the City.
1989

housepaint and acrylic on
windowshade, formica and wood,
57 x 45 in. (144.78 x 114.3 cm.)
Museum Purchase. 92.509

Born in the Liberty City section of Miami, Young has spent his entire life within the street subculture of Overtown, an African-American neighborhood. While incarcerated for armed robbery from the age of eighteen to twenty-one, Young was encouraged to draw by a prison attendant. He was inspired to express his ethnic and community pride by the mural movement then emerging in the urban neighborhoods of Chicago and Detroit. Creating public and private works, he finds both his subject matter and materials in the streets of Overtown.

Young's forcefully expressionistic style and abstract imagery transform his experiences into mythic emblems of urban street life. Like many self-taught artists he eliminates detail from his pictures to convey his subject matter by its most essential formal elements. Thus the human figure becomes a thick, twisted line which embodies the physical and emotional energy of city inhabitants. The turbulent energy of Young's street life is also conveyed by his gestural paint application. This gestural stroke and the squiggle figures are as distinctive of Young's personal style as are the skewed buildings and floating heads. He identifies these heads as the angels or "good people" without whom he could not make his art. Young has taken to constructing frames out of discarded objects found in city streets. From the hours he has spent in the library pouring over art books, one of his favorite activities, Young is aware of the traditions of art history. He compares his frame constructions to the elaborate frames of older altarpieces and says, "I want to make it look old-fashioned. . . To me that's beautiful art."

K.N./S.E.S.

Anasazi Culture

St. John's region, New Mexico,
United States of America

Bowl. circa 1175-1300

terra cotta, pigment, 5 x 11 ⁵/₈ in. (12.7 x 29.54 cm.)
Gift of S. Thomas Alexander. 93.359

Possibly Snowflake region, Arizona,
United States of America

Oval Bowl or Scoop. circa 1000-1200

terra cotta and pigment, 8 x 9 ¹/₂ in. (20.32 x 24.13 cm.)
Friends of Ethnographic Art Fund. 93.107

Socorro region, New Mexico, United States of America

Seed Jar. circa 1100-1300

terra cotta, pigment, 10 x 13 ¹/₂ in. (25.4 x 34.29 cm.)
Friends of Ethnographic Art Fund. 94.147

The Southwestern United States has been the homeland of indigenous peoples for over 10,000 years. Over the millennia drastic changes occurred in the natural environment; these produced the semi-arid desert and mountainous terrain of today. Important inno-

vations introduced from Mexico made life in this harsh environment easier, three of the most important being agriculture, weaving and ceramics.

By 1000 A.D. many of the prehistoric communities in this vast southwestern area shared unique cultural traditions, independent of their southern neighbors. By 1100 A.D. the northern area, now referred to as the "Four Corners," was experiencing a dramatic florescence. The population increased and migrated to ceremonial and administrative centers where ambitious building and agricultural projects were focused. Painted pottery for ceremonial as well as utilitarian use became an important aesthetic medium and was produced in abundance. These great builders and artists are now commonly referred to as the Anasazi culture.

The Anasazi painted pottery tradition from 1100-1300 A.D. for the most part consisted of stylized geometric patterns and lines defined with black paint on a white slip. In some regions a less common black-on-red style developed. The Anasazi built the bodies of their vessels with ropes of clay which were scraped smooth before firing. This technique is still used today by the Pueblo Peoples, descendants of the Anasazi.

P.J.T.

Acoma Pueblo Peoples

New Mexico, United States of America,
Rose Stevens, maker

Storage Jar. circa 1970

terra cotta, polychrome, 15 x 14 1/$_2$ in. (38.1 x 36.8 cm.)
Gift of High J. Smith, Jr. 86.384

New Mexico, United States of America

Water Jar (olla). circa 1920

terra cotta, polychrome, 10 x 12 1/$_2$ in. (25.4 x 31.8 cm.)
Gift of Emerson Woelffer in memory
of his wife Dina. 91.368

New Mexico, United States of America

Water Jar (olla). circa 1940

terra cotta, polychrome,
4 1/$_2$ x 6 1/$_2$ in. (11.4 x 16.5 cm.)
Gift of Emerson Woelffer in memory
of his wife Dina. 91.370

Occupied since prehistoric times, the Acoma Pueblo provides a direct link to the ancient Anasazi culture. While most of the residents live in modern homes below the mesa on which Acoma sits, the old village is still kept up and appears much the same way it did centuries ago.

Before the arrival of the Spanish, Acoma potters had developed a glazeware using mineral-based paints mixed with lead. This glazeware was discontinued around 1700, about the time the Spanish had reconquered the area. Among the theories for this cessation of production is that the Spanish barred the Acoma from the mines so they could use all of the lead for ammunition.

Acoma potters have been considered some of the finest creators of matte-painted polychrome pottery. Fine, thin walls, concave bases, and a flaring mid-body are characteristics of Acoma water jars. These functional features were originally meant to facilitate the portage of water and goods on the head. No longer necessary for utilitarian purposes, Acoma pottery is still produced in its many traditional forms due to great demand from collectors.

P.J.T.

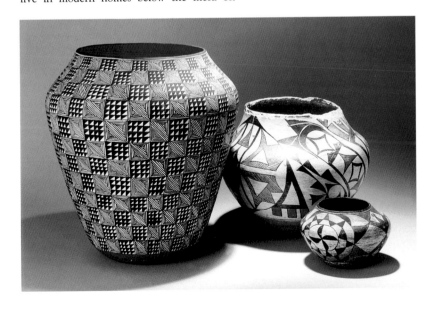

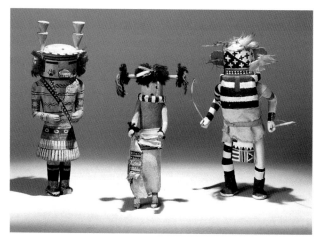

Hopi Pueblo Peoples

Arizona, United States of America

Yucca Kachina (Movitkuntaqa).
circa 1920

cottonwood, natural fibers, string and pigment,
13 ¼ x 4 ¼ x 3 ⅜ in. (33.6 x 10.8 x 8.6 cm.)
Bequest of Victor K. Kiam. 77.252

Zuni Pueblo Peoples

New Mexico, United States of America

Wood Carrier Kachina (Yamuhakto).
circa 1920

pine wood, commercial cloth, leather,
feathers, wool and pigment, 12 ½ x 6 x 6 in.
(31.75 x 15.24 x 15.24 cm.) Gift of Mr. and
Mrs. William Christovich. 94.6

Hopi Pueblo Peoples

Arizona, United States of America

Warrior Kachina (Ewiro). circa 1950

wood, pigment, feathers, cotton,
natural fibers and leather, 12 x 6 x 3.5 in.
(30.48 x 15.24 x 8.89 cm.) Gift of Emerson Woelffer
in memory of his wife, Dina. 91.326

In the middle of the 16th century Spanish expeditions entered the southwestern United States. In northern New Mexico and Arizona they encountered the descendants of some of the ancient southwestern peoples. The Spanish called these people the Pueblos because of the towns or villages in which they lived. Of the one hundred or more pueblos encountered, nearly one third are still occupied. Despite centuries of domination and repression by foreigners, many ancient Pueblo beliefs, customs and ceremonies continue.

From prehistoric times to the present the Pueblo peoples have influenced one another while maintaining linguistic and cultural differences. The ceremonies referred to as Kachina dances vary greatly from pueblo to pueblo. The Hopi and Zuni have been the most open to allowing outsiders to view the public part of the elaborate ceremonies which start at the end of December and continue through July. During the dances male initiates wear sacred masks which permit them to impersonate the Kachina spirit beings who are the benefactors of the Pueblo peoples.

The tradition of carving Kachina dolls has evolved rapidly since the late 19th century and is now a serious commercial enterprise with Hopi artists being the most prolific carvers. The traditional function of the dolls has been interpreted as an educational and potent gift for children learning to identify the many Kachina spirits.

P.J.T.

Tilingit Peoples

British Columbia, Canada

Chilcat Blanket. circa 1870

wool, cedar bark and native dye,
51 x 66 in. (129.5 x 167.6 cm.)
Gift of Mrs. Nellie W. Nolte. 52.0

Well before the arrival of Europeans in the late 18th century, the Native Americans of the Pacific Northwest coast had developed an elaborate and distinctive culture. Despite the existence of a number of distinct language groups, a cultural unity prevailed. A rich mythology was shared and celebrated in spectacular ceremonies, grand architecture and elaborate sculptural objects and costumes.

The Tlingit peoples are well-known for their production of woven robes commonly referred to as Chilcat blankets. The robes were traded throughout the region and were highly prized by their owners. Used at important ceremonial functions and dances, the robes were worn over the shoulders like a cape, allowing the long fringes at the bottom to sway with the rhythmic motions of the wearer.

The creation of such a robe was a complex process that entailed periods of fasting by the weaver and could take many months to complete. The design for the robe was painted by men on a pattern board. A female weaver then constructed the robe on a loom using the board as a guide. Natural dyes were used to produce the only three colors used in traditional patterns, bluish-green, yellow and black. The finished robe is highly abstract, decorated with geometric designs and stylized animal crest symbols.

P.J.T

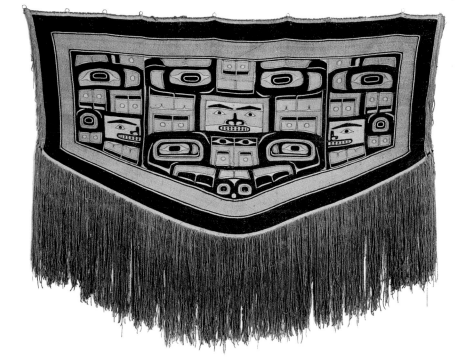

Nuxalt Peoples

British Columbia, Canada

Frontlet Headdress. late 19th century

wood, pigment, red haliotis shell,
ermine pelts, woven cedar bark, sea-lion whiskers,
ferrous metal, mirror, yarn, and printed cloth,
22 x 11 x 10 in. (55.9 x 27.9 x 25.4 cm.)
Anonymous Gift. 79.345

Masks were an important part of the regalia worn during many of the different dances and initiation ceremonies which are the heart of the traditions of Northwest Coast peoples. The interrelationship between people and nature, in particular animals, provides the foundation of an elaborate mythology based upon legends of a distant past when supernatural beings with both animal and human characteristics shaped the world. When this time passed, animals retained the power to live in both the supernatural and natural worlds while humans did not. The ability to trace their ancestry to this mythic time granted some individuals powerful economic rights and social responsibilities. Artists were employed to create objects that incorporated images, or crest symbols, of the animal beings belonging to the descendants' supernatural legacy.

A family chief would sponsor a feast or ceremonial dance to display inherited power and wealth and to reenact important legends. This frontlet, made by a Nuxalt, formerly known as the Bella Coola, was meant to be worn like a headdress during a Sisaok ceremonial dance. The central figure is that of a thunderbird. The little faces poking out from the rim and the abalone inlay are characteristic of Nuxalt frontlets. The blue pigment is not of Native manufacture; it was made by mixing a commercially available laundry blueing with a traditional salmon egg medium.

P.J.T.

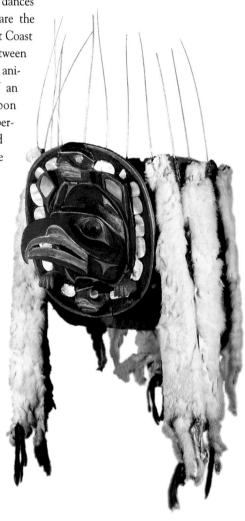

Cuzco School

Peru, Unidentified Artist

Archangel Michael Triumphant. 17th century

polychrome on wood, 78 in. (198.1 cm.)
Museum Purchase and gift of
Mr. and Mrs. Arthur Q. Davis and
the Stern Fund. 74.279

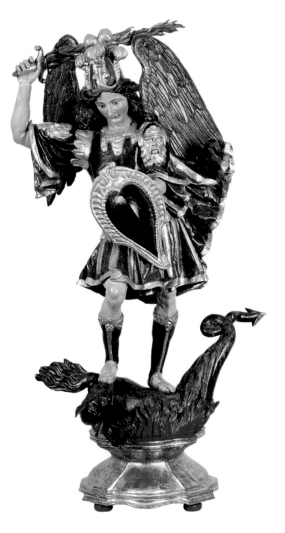

Archangels were perhaps the most admired images in Spanish Colonial America. The source of the imagery for these archangels was chiefly Antwerp, where a series of engravings representing the Seven Archangels of Palermo was produced by Hieronymous Wieriex and published by the Plantin Press. Recognized by the Council of Trent in the late 16th century, three of these archangels, Michael, Gabriel and Raphael, were given sainthood and symbols.

Archangel Michael was particularly admired in South America, where he often appears as a winged Renaissance warrior, dressed in a costume which combines a corselet, leather greaves and the short skirt of a Greek warrior. Arrayed in plumed headgear which seems to be 17th century in origin, Michael wields a flaming sword and treads the dragon beneath his feet. Figures of this type frequently stood on the high altar of Latin American churches in the midst of a retablo and probably guarded, along with the Archangel Gabriel, an image of the Madonna.

This statue was carved from mahogany and, as Pal Keleman noted, "the wood was covered with a fine coat of gesso and sheathed in silver leaf, so that the translucent dyes used in the coloring glowed iridescently. The breastplate is a cold blue-green, as if of oiled steel, and much brilliant cochineal red was used in the garments. The wings are silver, now tarnished with age. Glass eyes were often applied, as here both to the archangel and the demon, to heighten their realism."

J.G.C.

Cuzco School

Peru, Unidentified Artist

The Immaculate Conception.

late 17th century

mixed media over silver leaf on linen,
60 x 36 in. (152.4 x 91.4 cm.)
Museum Purchase and gift of Mr. and Mrs. Arthur Q.
Davis and the Stern Fund. 74.265

During the 17th and 18th centuries Cuzco was the leading Spanish Colonial art center in South America. Just as uncounted numbers of

canvases were painted in Cuzco during this period, so it is believed 10,000 pictures have been removed from Cuzco since that time.

Even more isolated than the Mexican colonial school of painters, the Cuzco School in the Peruvian Andes acquired a unique and indigenous flavor. In general, Cuzco painting is characterized by brilliant color, an emphasis on elaborate costume, the reproduction of gilt brocade as surface decoration, the use of native birds and flowers in religious scenes and a naively flat depiction of space.

The Virgin in this *Immaculate Conception* is represented as she is described by St. John in Revelation XIII: clothed in the sun and surrounded by twelve stars standing atop a crescent moon. The two putti holding the jeweled crown are a later addition to the usual iconography and imply that Mary is the Queen of Heaven in this depiction. Many Spanish masters, notably Estaban Murillo (1617-1682), portrayed the Virgin in a similar fashion.

The Virgin's dress and garment are covered with brocaded gold stamps in two different patterns. Avoiding the soft folds of the robe, the stamps are applied to the garment as though it were a flat surface. Attached to the canvas is a real earring in the figure's left ear and real rings on the fingers of her right hand. Votive offerings hung on paintings like this one were so heavy that they constantly threatened the durability of the canvas.

J.G.C.

Circle of the Master of Calamarca

Lake Titicaca School, Bolivia

Archangel with a Matchlock Gun, Salamiel Paxdei (Peace of God).
late 17th century

oil on cotton, 42 ¹/₂ x 31 in. (107.9 x 78.7 cm.)
Museum Purchase and gift of Mr. and Mrs. Arthur Q. Davis and the Stern Fund. 74.278

The motif of archangels with firearms seems to be unique to Alto Peru (Peru and Bolivia). New Orleans' archangel is one of a number, shown either loading, carrying, aiming, firing or cleaning his musket. Usually in the Christian depiction of the Archangel Michael he holds a flaming sword of supernatural power. However, in Peruvian colonial art this equivalent power is expressed by the musket, the frightening weapon of the conquering Spaniards.

It is now believed that the positions or activities of these archangels can be directly attributed to a Dutch military manual, *An Exercise of Arms*, written by Jacob de Gheyn and published in 1607. The New Orleans archangel approximates the position of carrying arms described by de Gheyn, "First of all is shewed to every Musketeer,

how he shall handsomely carye his Musket...and the matche kindled at both ends between the two smallest fingers of the left hand...". A later manual, printed in France in 1660, illustrates a musketeer of the French Palace Guard dressed in an elaborate surcoat, pantaloons, bowed shoes, wig and plumed hat, a costume closely resembling that of the New Orleans archangel. Under the rule of the Bourbons, French influence in Spain was disseminated throughout Latin America, resulting, no doubt, in this unique depiction of an archangel.

J.G.C.

salamiel Paxdei

Cuzco School
Peru, Unidentified Artist

Our Lady of Cocharcas Under a Baldachin. 18th century

oil on fabric, 46 $^1/_2$ x 38 $^1/_2$ in. (118.1 x 97.8 cm.)
Museum Purchase and gift of Mr. and
Mrs. Arthur Q. Davis and the Stern Fund. 74.267

The village of Cocharcas in Peru acquired its reputation as a miracle-working site in Latin America according to a strange legend. It seems that an Indian boy, having sustained a hand injury in his native village of Cocharcas, set out to receive the aid of the miraculous Virgin of Copacabana on Lake Titicaca. When the journey was only half completed, the young man's hand was healed by a miracle.

Nevertheless, he continued his pilgrimage in order to give thanks to the Titicaca shrine and to beg for alms to provide a statue to duplicate the original shrine in his own village. On his return journey the new statue was greeted with music and dancing while flowers miraculously sprang up along its path.

At first the shrine, founded in 1598, was small. Finally, about 1673 the church at the site was finished. This church and the outdoor narthex are visible in the background of the painting on the upper right hand side. The Virgin stands in the center under a baldachin supported by silver posts interwoven by roses. In the foreground pilgrims carrying knapsacks approach the shrine along both sides. Contrary to the usual motifs, the entrances to the silver mines appear as horseshoe shapes in the distant background.

This rustic painting is a splendid example of the naivete of the Indian tradition in Spanish Colonial painting.

J.G.C.

Haiti

Unidentified Artist

Voudun Processional Flag. circa 1970

colored sequins on cloth,
33 x 28 ¹/₂ in. (82.5 x 71.25 cm.)
Gift of Perry E. H. Smith. 82.83

The flags of *voudun* shrines embody the unique fusion of African and European sensibilities that comprises Haitian culture. These flags are kept in the *voudun* sanctuary with other ceremonial objects and are intended to communicate respect and honor for the deities which they represent.

Voudun flags are fabricated from a European-looking media, shiny silk or other expensive cloth, but are then decorated with beaded and sequined patterns clearly derived from the sacred *vèvè* signatures of *voudun* gods and goddesses. *Vèvè* signatures are ceremonial designs drawn with flour or ashes on the earthen floors of voudun shrines. They take their structure from older African Fon and Kongo traditions of sacred ground painting. A cross is the usual starting pattern, around which are symmetrically arranged various sub-motifs such as hearts, snakes, crosses, phallic forms, flags, stars or circles.

Over the centuries the African roots of the *voudun* religion have become tempered by the pervasive influence of European religious thought and tradition. Catholicism, imported by French and Spanish colonials, has had such a profound impact upon Haitian thought that many *voudun loas* have become associated with Catholic saints. The loa heralded by this flag seems to be Maitresse Erzulie, the goddess of love, who is sometimes associated with the Virgin

Mary. The Maitresse Erzulie identification for this flag is suggested by the dominance of the heart motif which is her symbol and by the letter "M" incorporated into the design. However, the black and purple color scheme of the design suggests a connection with Grande Brigitte, the wife of the *voudun* lord of death and cemeteries.

S.E.S.

Michel Obin

Haitian, born 1949

Famille Royale. 1979

oil on panel, 23 ¹/₂ x 29 ¹/₂ in. (59.69 x 74.93 cm.)
Gift of Perry E. H. Smith. 89.348

The artistic accomplishment of the Obin family has been so profound that their surname now refers to a particular stylistic school of Haitian painting. Philome Obin was the progenitor of an artistic dynasty which has been continued by many of his sons, grandsons, and nephews as well as by numerous other artists, all of whom have developed an individual style within the Obin canon. Michel Obin, one of the venerable patriarch's nephews, has concentrated upon depicting the picturesque streets of Cap Haitien, a seaport in Northern Haiti, as well as Haitian historical subjects in the Obin manner.

The Obin style has been described as a kind of magical realism, a realism more conceptual than optical. Obin artists painstakingly depict detail in a stylized and patterned fashion. A cool, subdued atmosphere is conveyed by thin washes of soft pastel colors. The magical, almost otherworldly, mood of Obin compositions is conjured by this atmosphere and is emphasized by the seemingly arrested motion of the figures and the precise linear perspective of the scene.

The European influence upon Haitian culture is far more apparent in urban than in rural areas. Because city-bred artists generally concentrate upon representations of urban life, their paintings often include evidence of this European heritage. Michel Obin's painting, Famille Royale, illustrate the manner in which Haitian upper classes adopted the customs of European aristocracy.

S.E.S.

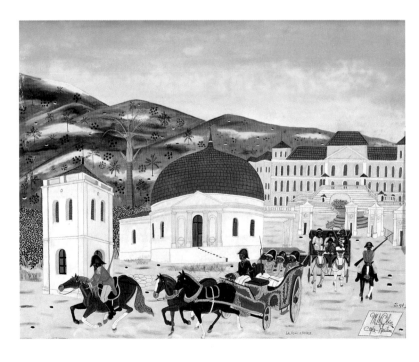

Olmec Culture

Xochipala area, Guerrero, Mexico

Pathological Figure. circa 500-100 B.C.

terra cotta, 15 $^1/_2$ x 8 $^1/_2$ x 3 $^3/_4$ in. (39.4 x 21.6 x 9.5 cm.)
Ella West Freeman Foundation Matching Fund. 71.50

Long before the Spanish Conquest, advanced civilizations flourished in Central and South America. The term "Mesoamerican" is used to distinguish unified cultural traits of peoples located in what is now the region of Mexico, Guatemala, El Salvador, Nicaragua, Costa Rica and Honduras. These people, Olmec, Maya, Zapotec, Aztec, Totonac and Toltec, were characterized by the development of the step pyramid, ball courts, hieroglyphic writing, a solar calendar and a theocratic government. Artistically productive at varying times during the Precolumbian era, Mesoamerican peoples were skilled in the creation of sculpture, painting, pottery, wood carving, gold, jade and featherwork.

The pathological features represented by this figure are repeated throughout Olmec stone sculpture. The plump infantile body, baby face and lack of genitalia may indicate a glandular disease such as dystrophia adiposo-genitalis, or Frölichs's Syndrome. This disease produces an abnormality in growth due to the disturbance of the endocrine glands. Or the characteristics may simply represent an aesthetic ideal.

New Orleans' *Pathological Figure*, a free-standing, hollow figure, demonstrates the Olmec's extremely fine technical control of the difficult medium of terra cotta. Particularly remarkable in this figure are the heavy, hanging jowls. Another interesting feature is the cap-like headdress with standing ears which has only been found in one other Olmec figure, also discovered in the Xochipala area of the Mexican state of Guerrero.

J.G.C.

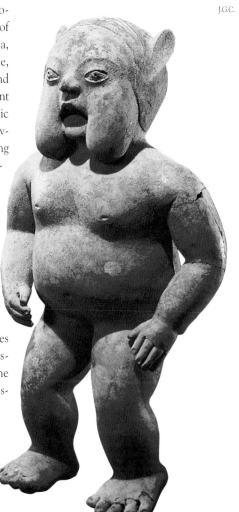

Maya Culture

Campeche, Mexico

Lidded Bowl Depicting the Water Bird on the Waters of the World.
circa 200-600

terra cotta with polychrome,
10 $\frac{1}{4}$ x 8 $\frac{5}{8}$ in. (26 x 21.9 cm.)
Ella West Freeman Foundation Matching Fund. 68.15

Maya quadruped or tetrapod bowls with zoomorphic-effigy lids were produced in the Campeche-Tabasco area during the Early Classic period. This particular example is a rare Early Classic Tzakol 3 type. Movement seems to play an important part in the bowl's function for the tall legs are filled with pebbles which rattle when the bowl is moved.

A water bird head that rises from the lid of the vessel serves as a handle. In its beak the bird holds a fish. Probably the bowl served as an incense burner, since the hollow neck and open beak would have allowed smoke to escape from the bird's bill. A "sky dragon" with wings is painted on either side of the lid while winged serpents decorate each side of the bowl. On the legs glyph signs, resembling the day sign Imix, could symbolize the terrestial world. In that case the "sky dragon" would symbolize the celestial realm.

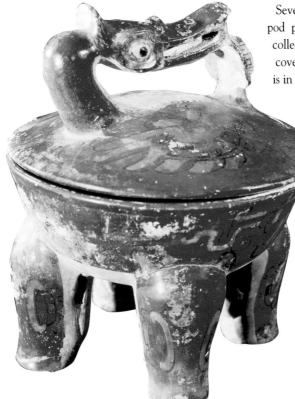

Several other versions of the tetrapod pots can be found in various collections in this hemisphere. A cover with an almost identical bird is in the Jorge Castillo Collection of the Popul Vuh Museum in Guatemala City, while an earlier tetrapod bowl with incised decoration from Tabasco is in the Brooklyn Museum.

J.G.C.

Maya Culture

Yucatan, Mexico

Cylindrical Vessel Depicting Four Ballgame Players. circa 600-900

terra cotta, polychrome,
7 1/4 x 4 3/4 in. (18.42 x 12.1 cm.)
Ella West Freeman Foundation Matching Fund. 68.16

The four figures depicted on this vessel are wearing hip and knee pads as well as arm mits, all protective garments associated with the ballgame. The vertical bands behind the first and last figures frame a glyphic text and suggest the parallel walls that define the playing ground of many ballcourts. The ballgame was one of the integrating elements of the varied Precolumbian cultures. As a game it resembled soccer, with the ball kept in motion by the player's elbows, knees and hips. But as a ritual, the ballgame was a deadly serious affair rooted in the mythical manuscript, the *Popol Vuh*. The game probably symbolized the balance of movement between the sun and moon, or between the celestial and terrestial spheres. Ballgame art suggests that after the game selected players were ceremonially sacrificed.

Two of the players here wear the same derby-like hat and confront each other striking identical poses. The player on the left is wearing his mit on his outstretched arm while the figure facing him is holding what appears to be his mit in his hand as if he were presenting it to the other player or even receiving it from him. Ballgame art indicates that the game was played by two teams of two players each. But while the difference in costume suggests that the figures observing are the team opposing the figures facing one another, this is not certain. Missing from the scene is the black rubber ball itself which is usually depicted in ballgame art. The players must be enacting a pre- or post-game ceremony.

P.J.T.

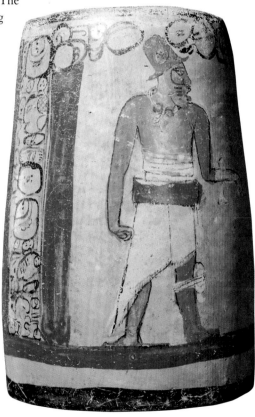

Maya Culture

Jaina Island, Yucatan, Mexico

Ballplayer as a Royal Captive.
circa 600-900

terra cotta with polychrome,
9 7/8 x 3 x 2 1/4 in. (25 x 7.6 x 5.7 cm.)
Women's Volunteer Committee Fund. 74.211

Jaina figurines, basically local in character, are restricted to the island of Jaina and a few inland sites. Unlike the great ceremonial centers of the Peten Maya of the mainland, the objects from this island are not carved in stone, but are delicately modelled in clay. In all known cases these figurines, fully three dimensional, were made as mortuary objects for burials.

This delicately fashioned ballplayer stands frontally on splayed feet, a characteristic Jaina pose.

Although he grasps a ball, he wears the simple clothing of a penitant or a captive rather than the standard ballgame costume, which included a yoke, *hacha*, and long, hide hipcloth. The beads of blood on his face indicate that he has undergone bloodletting rituals as does the cloth draped over his left arm. His bruised and swollen face and his short hair also suggest that this figure represents a royal captive.

The New Orleans figurine has only the belt and loincloth worn by most male figures of his type. Note the remnant of a collar visible on the right side of the neck, a minor feature added to some models.

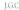

J.G.C.

Maya Culture

El Peten, Guatemala

Cylindrical Vessel Depicting Enthroned Lords and Attendants.

circa 600-900

terra cotta with polychrome,
6 ⁵/₈ x 5 ³/₄ in. (16.8 x 14.6 cm.)
Ella West Freeman Foundation Marching Fund. 69.33

This polychrome vase from the Northern Peten in Guatemala depicts two enthroned rulers, each with an attendant figure on a lower level. Such double-throned rulers can be found on a vase from the Placeres region of southern Campeche, Mexico, formerly in the Leff Collection, Uniontown, Pennsylvania. Similar scenes are also inscribed on Late Classic Maya pottery from Tikal. The accumulated evidence from pottery of this class suggests that dual kingship may have existed among the Maya as among the later Aztecs of Mexico.

Broad headdresses and heavy necklaces distinguish the rulers from the attendant figures. Some evidence has led to the supposition that the attendant figures are women. The names and titles of all four figures seem to be inscribed on the vertical columns of glyphs on the vase. Closer examination shows that an animal head with a protruding tongue, identified as *Manik* (glyph 671), occurs in the names of all four personages on the vase.

J.G.C.

Maya Culture

Waachtun site, El Peten, Guatemala

Plate with Dancing Figure.
circa 600-900

terra cotta with polychrome,
2 ¹/₂ x 16 ³/₄ in. (6.4 x 42.6 cm.)
Ella West Freeman Foundation Matching Fund. 69.2

The general area of the Northern Peten in Guatemala and the nearby provinces of Campeche and Quintana Roo in Mexico have produced painted Maya ceramic ware of extraordinary quality.

The design and movement of the male dancer in the center of this plate are very similar in style to the famous polychrome tripod plate from Structure A-1 at Uaxactun, Guatemala. This suggests that the New Orleans piece may have come from the same area and may even have been created by the same artist.

Since the dancing male wears a headdress with the head of the "Zip Monster," it has been suggested that the figure is engaged in the Maya Dance of Death. The elegant pose is also reminiscent of two other dancing figures, one found on Pier D of House A from Palenque and the other found on another Palenque relief now in the Dumbarton Oaks collection, Washington, D.C.

Six of the nine glyphs in the margin, which surrounds the edge of the plate, are repeated irregularly in pairs around the circumference.

J.G.C.

Maya Culture

Chiapas, Mexico

Cylindrical Incensario Depicting a Sun God.

circa 600-900

terra cotta, polychrome,
26 3/4 x 13 1/8 x 6 in.
(67.95 x 33.5 x 15.24 cm.)
1965 Museum Auction Fund. 67.32

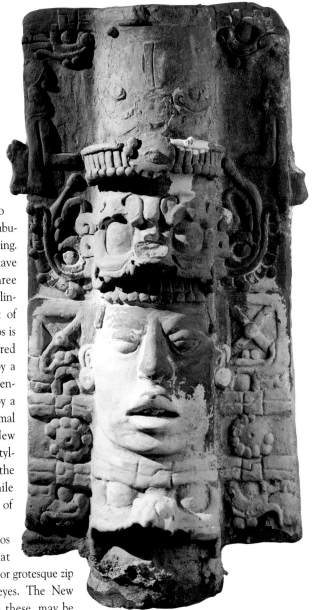

Incense burners from Palenque in southern Mexico are distinguished by an open tubular form and exquisite modeling. Their wide x-marked flanges have protruding tabs located three quarters of the way up the cylinder. Usually the arrangement of decoration for these incensarios is a series of four or five tiered grotesque heads, dominated by a realistic human head in the center. These heads are topped by a bird and one intervening animal which is missing in the New Orleans piece. In addition, stylized serpent heads decorate the corners of the flanges while rosettes appear at either side of the principal head.

The majority of incensarios from the temple complex at Palenque portray a jaguar god or grotesque zip monster with round, open eyes. The New Orleans head, differing from these, may be related to a realistic piece from the Zopo cave, twenty-five miles west of Palenque, on the Tabasco-Chiapas border. Such a piece was reported by Franz Blom and Oliver Lafarge in 1925-1927.

J.G.C.

Maya Culture

Placeres, Campeche, Mexico

Architectural Ornament in the Form of a Bearded Man's Head.

circa 600-900

stucco, polychrome,
10 ³/₄ x 8 x 7 ¹/₂ in. (27.3 x 20.3 x 19.1 cm.)
Ella West Freeman Foundation Matching Fund. 67.40

The Maya decorated their architecture with sculpture in the upper zones of facades and along roof combs at the tops of temples. The most renowned stone sculpture carved in the full round is from Copan. However, by Late Classic times sculpture from the Chiapas-Campeche area at sites such as Palenque, Comalcalco and Edzna was made of stucco, not stone. Recently, although large quantities of stucco heads have been found in the southern Yucatan Peninsula, they are of uncertain provenance.

By contrast, the stucco *Architectural Ornament in the Form of a Bearded Man's Head* was found in Placeres on the Guatemala-Campeche border. The portrait-like face is unusually realistic. The nose is less prominent than the usual Maya stylization. The deeply furrowed forehead and cheeks seem to indicate a mood of quiet but sorrowful emotion. A large amount of the original red and blue polychrome still remains in the deeper crevices of the sculptured head which is slightly larger than life-size.

The function of the New Orleans piece is still uncertain. A broken hole in the rear of the head may indicate that it once held a tenon and therefore served as part of an architectural facade or temple closure.

J.G.C.

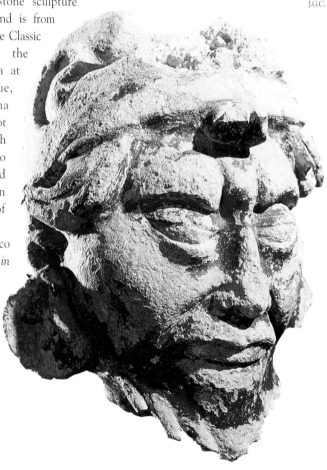

Maya Culture

Copan, Honduras

Tenoned Architectural Ornament Depicting the Head of a Sun God. circa 600-900

greenish andesitic tuff,
18 7/8 x 12 x 14 in. (47.9 x 30.5 x 35.6 cm.)
Gift of Mr. and Mrs. Richard McCarthy, Jr. 72.29

Head of a Priest or Ruler. circa 600-900

greenish andesitic tuff,
18 x 12 x 11 in. (46 x 30.5 x 27.9 cm.)
Ella West Freeman Foundation Matching Fund. 70.17

The ruins of Copan lie in a valley in the westernmost part of the Republic of Honduras. Discovered and conquered originally by the Spaniards, the area lay forgotten until the first authentic archaeological expedition in the Americas, conducted by John Gallagher in 1834.

The amount of stone sculpture at Copan is unrivaled, for no other New World site was so lavishly adorned. Baroque in style, the sculptures covered the entire surface of altars, stelae, temples and stairways. In place of limestone Copan sculptors used a greenish, fine-grained trachyte or andesite, a volcanic soft stone which hardens upon contact with air.

Once functioning as part of an architectural decoration, the *Head of a Priest or Ruler* is over life-size in scale. Although it is cut cleanly at the neck, it has a rugged stone support in the back where it was formerly attached. Above the hairline there is a hole, no doubt the result of an old repair, where the stone was originally carved with a knot of sculptural hair.

The *Head of a Sun God* was also probably attached to a temple wall as architectural decoration, placed higher than the height of a man and carved to be seen from below. Although almost all Mayan architectural sculpture was painted, few known pieces with such surface decoration exist in modern collections. The traces of polychrome decoration on the surface of the New Orleans *Head of Sun God* has been verified as original.

J.G.C.

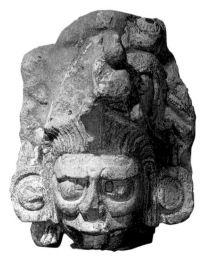

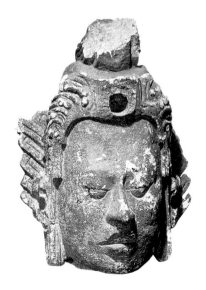

Maya Culture

El Cayo, Chiapas, Mexico

Wall Panel Commemorating a Military Victory by a Warrior King.

circa 600-900

limestone, 32 x 25 3/4 x 2 in. (81.3 x 65.4 x 5 cm.)
Ella West Freeman Foundation Matching Fund
and the 1965 Museum Auction Fund. 67.31

An elaborately dressed priest is seen here stretching his hand toward a kneeling devotee or ruler, while a woman on the right witnesses the ceremony. According to recent opinion this scene may represent a transfer of power through a bloodletting ritual. In such ceremonies figures draped with cloths and holding sharp instruments are depicted humbling themselves at the moment they are invested with power.

The El Cayo stele seems to follow this pattern. The kneeling left hand figure, wearing a scarf, probably holds a perforator between the thumb and index finger of his right hand. A "drum major" headdress, similar to that worn by the woman on the right, was found at Palenque and Negras and was worn by rulers at Yaxachilan, areas where the bloodletting ritual was practiced.

No doubt faces on the panel have been willfully destroyed. This could have occurred at the end of the Classic period during a time of revolt. On the other hand, faces on reliefs were sometimes effaced to indicate the death of the person represented, at which time the carving was buried.

J.G.C.

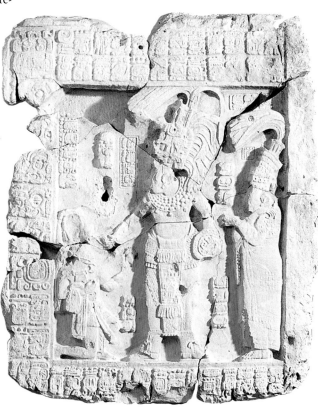

Maya Culture

El Caribe, El Peten, Guatemala

Commemoratory Stele Portraying a Warrior King and Captive. dated 780

limestone, 59 ½ x 37 ¼ x 2 ½ in. (151.1 x 94.6 x 6.4 cm.)
Edith Stern Birthday Fund and Ella West Freeman
Foundation Matching Fund. 69.9

This Stele No. 1 was found at El Caribe, located in a bend of La Pasión River, by A. Ledyard Smith, H.E.D. Pollock and E.M. Shook of the Twentieth Central American Expedition on May 28, 1937. At that time it was located in the middle of the stairway leading to the terrace of Mound 1.

The sculpture is executed in low relief, a technique characteristic of monuments from San Pedro Martir and La Pasión. Both the figure of a standing warrior and a captive seated crosslegged in profile adorn the front. The warrior is depicted sideways to the waist and frontally from loincloth to feet. This profile-frontal representation was a favorite stylistic trait of the Maya.

The warrior wears a loincloth, decorated waistband and high wristlets. On his head is a huge skeletal headdress, possibly a representation of the Death God A, *Au Puch.* This headpiece is wrapped by a turban and decorated with a long-feathered, sweeping tassel. In his right hand he carries a tasseled spear while in his left hand he holds a shield. Many warlike figures represented on Maya monuments carry similar shield with sun faces.

Inscribed on the left and right are twelve glyphs, part of which are date glyphs. According to the Goodman-Thompson correlation, these can be computed to correspond to 780 A.D. on the modern calendar.

J.G.C.

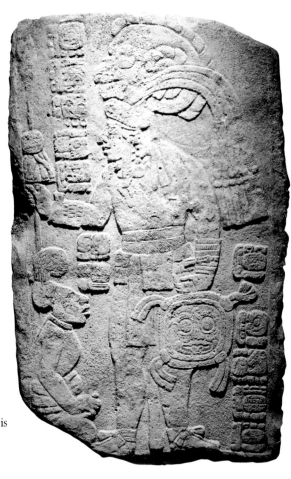

Veracruz Culture

Gulf Coast, Mexico

Hacha in the Form of a
Severed Head. circa 200-900

limestone, pigment,
8 ³/₄ x 7 x 1 ³/₄ in. (22.2 x 17.8 x 4.5 cm.)
Gift of Mr. and Mrs. P. Roussel Norman. 74.292

From 200-900 the cultures inhabiting the Gulf Coast of Mexico produced a rich variety of carved stone and modelled clay sculpture. During the Classic period three distinctive kinds of stone sculpture were produced, referred to as *hachas*, *palmas* and yokes. It is generally agreed that these objects are associated with the ballgame, possibly as the paraphernalia worn by the players, but their exact purpose is not known.

Hachas are narrow stone wedges that are carved on both sides and usually depict a human head in profile. One theory suggests they represent the decapitated heads of ballplayers ritually sacrificed at the conclusion of the game.

There is not one stylistic formula for hachas but instead they seem

to represent individual characters. Consequently the New Orleans *hacha* can easily be read as a portrait of a decapitated individual. Traces of red pigment remain on the surface.

A unique feature of this *hacha* is the tenon which could imply that it was part of an architectural panel although most theories consider them to be portable sculptures, intended to be carried or displayed in an upright position.

P.J.T.

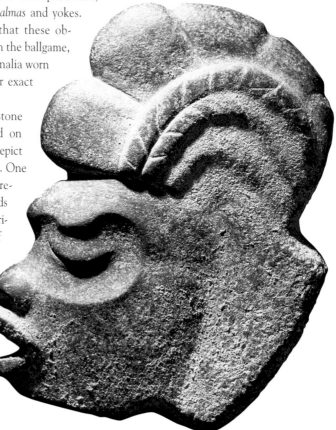

Veracruz Culture

Gulf Coast, Mexico

Articulated Figure. circa 700-900

terra cotta, polychrome,
11 ³/₈ x 9 ¹/₂ x 7 ³/₄ in. (28.9 x 24.1 x 19.7 cm.)
Gift of Mr. and Mrs. P. Roussel Norman. 68.3

Smiling children with subtly rounded bodies are among the best-known types of clay figurines from the Veracruz area. Skillfully made of thin-walled clay, they are composed of two parts: a hand-modelled body and mold-made face. The movable limbs are attached to the body by strings, a device which permits the arms and legs to move to different positions. As a rule these smiling children are modelled in a standing position with their legs apart and with their arms raised or stretched out in an attitude of joy. Certainly the smile is a typical feature in the artistic expression of the Totonac-speaking people along the eastern Gulf of Mexico around Veracruz. The most interesting feature of this piece is the combination of the articulated limbs and a movable head, which is held in place by a cone-shaped but invisible neck.

The precise function of these jointed figurines is un-known. It has been suggested that these smiling children represent *Xochipilli*, God of Dance, Music and Joy. According to another source, they might have been sacrificial victims of the gods, kept in a good humor with inebriating potions or drugs. Still another source claims they were used as puppets or dolls. Whatever their function, they are the most expressive attempt by New World artists and artisans to represent a mood rather than a god or activity.

J.G.C.

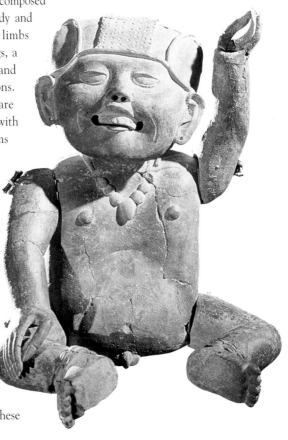

Colima Culture

West Coast, Mexico

Seated Warrior. 300 B.C.-A.D. 500

burnished terra cotta,
14 x 8 x 7 in. (35.6 x 20.3 x 17.8 cm.)
Gift of Mr. and Mrs. Richard McCarthy, Jr. 73.1

Colima figures have been found in an area on the West coast of Mexico bounded by the Rio Grand de Santiago to the north and the Colima-Michoaca border to the south; at one time they reached as far as Chupicuaro, Guanajuato in central Mexico. Figurines of the Classic period retain many traits from the earlier Formative period including a display of nakedness, the practice of handmodelling and the use of applied clay or fillets. Typical of the region are moderate-sized clay figures made of polished red ware such as this *Seated Warrior*.

Colima sculptors were interested primarily in portraying the daily life of the people. For the most part, they depicted both handsome and ugly people who were usually engaged in everyday activities. Their enormous range of subject matter included normal men and women, either standing or sitting, as well as hunchbacks, prisoners, dwarfs and warriors. Even though the sculptors' interest extended further to animals, plants and shells of the region, they seldom portrayed gods.

Archaeologists have demonstrated that Colima hollow vessels were used as grave offerings. The fact that the New Orleans warrior has a spout also suggests service as a liquid container in addition to funerary use.

J.G.C.

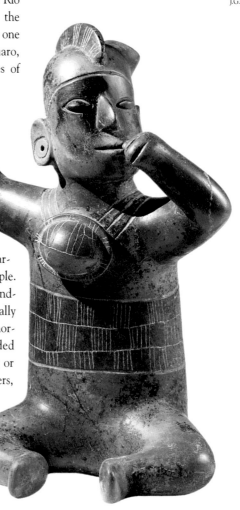

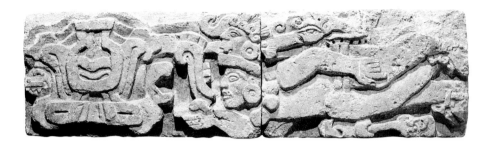

Zapotec Culture

Atoyac Valley, Oaxaca, Mexico

Lintel from a Tomb Chamber.

circa 300-500

limestone, 10 $^1/_2$ x 37 $^1/_4$ x 5 $^1/_4$ in.
(26.7 x 94.6 x 13.3 cm.)
Ella West Freeman Foundation Matching Fund. 67.33

This limestone lintel depicts a swimming fig-ure with his right hand pointing to an urn-shaped glyph which symbolizes water sur-mounting the numerical bar "5." The glyph, a Day-Sign "Z" from the Zapotec *Book of Days*, resembles an urn-shaped sign from Stele 12 at Monte Alban, Oaxaca. The figure wears an elaborate anthropomorphic headdress, while a speech scroll issues from its mouth. Similar horizontal figures in "swimming" positions appear on a Oaxaca pottery vessel in the British Museum, London.

The sculpture on the lintel bear an even closer resemblance to a group of eighteen highly fired clay tiles, eleven of which are in St. Louis and the rest in a private collection in Oaxaca. All of the tiles were found in the remote southern part of the Atoyac Valley, a district known as the "Zaachila arm," an area with a high population level during the Classic Zapotec period.

Stylistically, the low, flat, even carving is characteristic of both the ceramic tiles and the New Orleans stone lintel. Also, glyphs, numerals, horizontal and plumed human fig-ures appear in a similar manner in both the tile group and the New Orleans lintel. These stylistic and iconographic resemblances sug-gest that the Atoyac Valley, the site where the terra cotta tiles were found, may also have been the locale where the New Orleans lime-stone lintel was carved.

J.G.C.

Mixtec Culture

Teotitlan del Camino region, Mexico

Pair of Brazier Lids. circa 1300-1500

terra cotta, polychrome,
13 1/4 x 10 x 5 3/8 in. (33.7 x 25.4 x 13.7 cm.)
14 3/4 x 9 1/4 x 7 (37.5 x 23.5 x 17.8 cm.)
Gift of Mrs. P. Roussel Norman. 79.196-197

In Post-Classic times the Mixtecs produced a civilization of great artistic skill and introduced a complex cosmology and theology into the Valley of Mexico.

The city of Teotitlan del Camino played a key role in the development of religious ideas that were synthesized and used by the Aztecs who also flourished during the same period. In addition, Teotitlan del Camino on the Oaxaca-Puebla border was the center of production for xantils or brazier lids. These hollow figurines were constructed of terra cotta to be set over braziers so that smoke was emitted through the open mouth and chest holes. A great number of these squatting xantils represented the Aztec god *Macuilxochitl* or Five Flower, the God of Pleasure, Feasting, Frivolity, Music and Dance.

The majority of these figurines are yellowish-buff ware covered with red, white, yellow and blue paint. In most cases the rosettes, earrings, necklaces, wristlets and anklets are painted blue. All the figurines of this type show the pointed beard with painted facial hairs along the chin. Generally the headdress is pointed while three blue feathers protrude in file behind it. In the New Orleans pair of brazier lids the beard of one figure is partially broken; in the second example, part of the headdress and right earring are missing. The pendant necklaces, wristlets and the rosettes of the headpieces clearly indicate that the figures indeed represent *Macuilxochitl*, the frivolous god of festivals and merriment.

J.G.C.

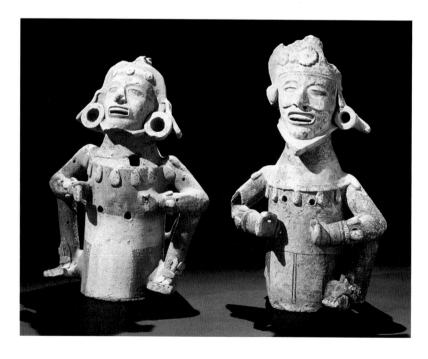

Aztec Culture

Valley of Mexico, Mexico

Maize Goddess. circa 1350-1520

volcanic schist,
25 7/8 x 10 3/4 x 6 in. (65.7 x 27.3 x 15.2 cm.)
Anonymous Gift. 74.212

This female figure, created in the Valley of Mexico during the late period of Aztec civilization, embodies the best characteristics of Aztec sculpture: frontality, compactness, angularity and a hieratic appearance.

In the pantheon of Mexican mythology, goddesses connected with fertility were extremely important. They were frequently represented in codices, ritual calendars, and sculpture. This particular figure, like other goddesses of this type, was representative of the earth or the production of corn and probably was revered as a household deity.

In her left hand this goddess once held a double corn cob, one of which is now missing. In her outstretched clenched right fist a hole would have held a rattle staff or *chicahuaztli*. She wears a skirt and draped over her shoulders is a poncho-like article of clothing that is called a *quechquemitl*. The drilled hole in the top of the chest probably contained a decorative piece of obsidian. This could have been substituted for the stone relief necklace that often appears in similar depictions of the goddess. In this figure, as in others of this class, the eye sockets are hollow; they too were once filled with mother-of-pearl or obsidian. Characteristic of other Aztec maize goddesses is her headdress with its big ear spools and large oversized tassels.

J.G.C.

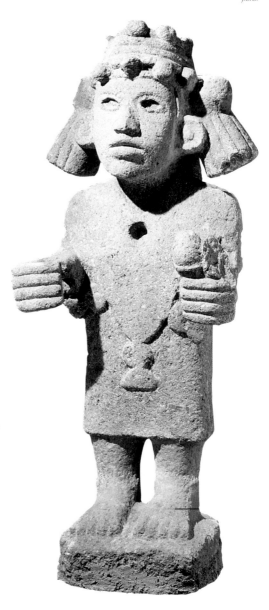

Costa Rica

Diquis region

Pendant with Anthropomorphic Figure and Surrounding Crocodile Heads. circa 700-1400

gold, 1 $^5/_8$ x 1 $^5/_8$ x $^1/_2$ in. (4.1 x 4.1 x 1.3 cm.)
Anonymous Gift. 76.132

Diquis region

Eagle Pendant (Ceremonially Killed). circa 700-1400

gold and copper alloy,
3 $^3/_8$ x 2 $^3/_4$ x 1 $^5/_8$ in. (8.6 x 6.9 x 4.1 cm.)
Anonymous Gift. 76.124

Diquis region

Pendant with Anthropomorphic Figure Wearing Headdress. circa 700-1400

gold, 2 $^3/_8$ x 1 $^1/_2$ x 1 $^5/_8$ in.
(6.01 x 3.8 x 4.1 cm.)
Anonymous Gift. 76.131

Diquis region

Pendant with Standing Male Figure Holding Hand Rattles. circa 700-1400

gold, 2 $^5/_{16}$ x 1 $^3/_8$ x $^1/_2$ in.
(5.9 x 3.5 x 1.3 cm.)
Anonymous Gift. 76.129

Linea Vieja, Atlantic Watershed region

Pendant with Standing Male Figure Holding Rope. circa 700-1400

gold, 2 $^1/_8$ x 2 x $^1/_2$ in. (5.4 x 5.1 x 1.3 cm.)
Anonymous Gift. 76.106

As is the case with mankind throughout the ages, the Precolumbian Indian cultures, from Peru and Colombia through Panama and Costa Rica to Mexico, did not escape the enigmatic lure of gold. Obtained almost exclusively by placer mining in river beds, gold was smithed in various ways by the ancient Americans. Besides the methods of simple mold, lost wax, and hollow core casting, the annealing process, in which the metal is hammered into shape with the application of heat to make it soft and malleable, was popular.

The great majority of gold objects from Precolumbian times which have survived are comparatively small in size, including various types of jewelry, implements, vessels and funerary masks. Some pendants, such as the large eagle shown here, were most probably not made to be worn, but were made to be "ceremonially killed" and placed in burials with the dead. Generally they represent cult deities taking the form of frogs, alligators, birds, lobsters, sharks, bats, jaguars, serpents, monkeys and anthropomorphic figures.

J.G.C.

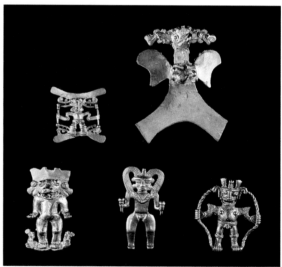

Costa Rica

Vereh, Atlantic Watershed region

String-Cut Multifigure Pendant.
circa 800-1200

jade, 3 x 1 ¹/₂ x 2 in. (7.6 x 3.8 x 5.1 cm.)
Jeunesse d'Orleans Acquisition Fund. 73.4

Linea Vieja, Atlantic Watershed region

Spiral-Beaked Bird or Jaguar with Curled Tail Pendant. circa 1000-1500

jade, 2 ³/₄ x 1 ³/₄ x ¹/₄ in.
(6.99 x 4.5 x .64 cm.)
Women's Volunteer Committee Fund. 73.6

Guacimos, Linea Vieja,
Atlantic Watershed Region

Earth Monster and String-Cut Deer Medallion.
300 B.C.-A.D. 600

jade, 2 ¹/₂ x 2 x ¹/₂ in. (6.4 x 5.1 x 1.3 cm.)
Ella West Freeman Foundation Matching Fund. 71.27

Nicoya region

Double-Headed Crocodile Bar Pendant. circa 1000-1200

jade, 3 ¹/₂ x 1 ¹/₂ x ³/₄ in. (8.9 x 3.8 x 1.9 cm.)
Women's Volunteer Committee Fund. 73.5

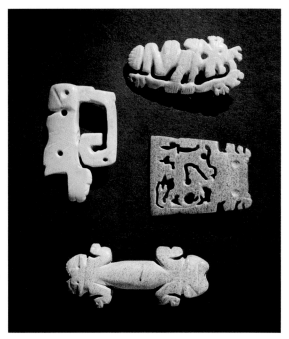

Stemming from the Spanish *piedra de ijada*, or loin stone, the word jade originated in the New World. This word identified the semi-precious stone used by most Precolumbian cultures of Central America even before it was applied in Asia to describe Chinese objects of the same material. The original Spanish term referred to its medicinal qualities for it was thought to cure ailments of the loin and kidneys.

As jade is harder than steel, it was necessary to use abrasive powders with tools of metal, soft stone, wood, bone, fiber and leather to work the jade into objects. While the process of drilling was commonly utilized, knowledge of the wheel and rotary devices was unknown. One particularly ingenious process devised by the early Olmecoid lapidaries in Costa Rica was that of string sawing. By using taut cords with abrasion powders, extremely intricate openwork designs, seen in two of these examples, could be executed. To achieve the smooth matte or highly reflective finishes, fine powdered abrasives, various woods and hard stone burnishes were used in combination.

J.G.C.

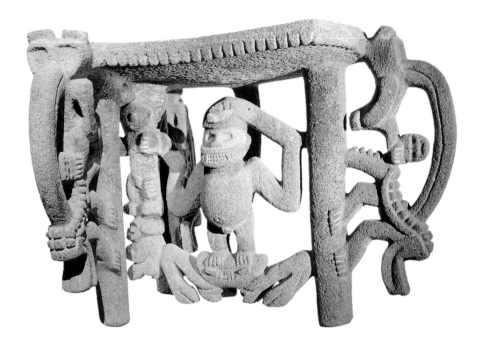

Costa Rica

Atlantic Watershed region

Flying Panel Ceremonial Metate.
circa 900-1000

volcanic stone, 23 ¹/₂ x 35 x 32 in.
(59.7 x 88.9 x 81.3 cm.)
1965 Museum Auction Fund. 67.34

Large scale ceremonial grinding stones, or metates, of this type are found in the Atlantic Watershed region of Costa Rica. Carved from a single block of volcanic stone, metates from this area derived from a South American, rather than Meso-American, prototype. The edge of the grinding stone appears serrated, but these serrations represent stylized human or effigy heads which appear in greater clarity on other metates of eastern Costa Rica and Panama.

The tripod base of this exceptionally fine metate combines a range of animal forms. The central figure or "flying" support beneath this metate depicts a monkey braced by a crab. In turn, the monkey holds a humanoid above a jaguar head. Since the figure of the crab is unique, it seems to supply evidence of a Pacific influence. On each of the leaning tripod legs there appear huge beaked birds with long bills pecking crocodiles. This prominent beak-bird, associated with fertility, reflects a Precolumbian procreation myth.

Flying panel altars of this type have also been discovered further south in Veraguas, Panama.

J.G.C.

Moche Culture

North Coast, Peru

Stirrup Spout Vessel in the Form of a Frog. circa 200-50 B.C.

terra cotta, polychrome,
7 ¹/₂ x 5 ¹/₂ x 8 in. (19.1 x 13.97 x 20.3 cm.)
Gift of Barbara Smith Miller. 93.245

The first major Andean culture, known as Chavin, began to dominate much of present day Peru around 900 B.C. Chavin art and architecture developed quickly, motivated by a vibrant religion. As the end of the 1st millennium B.C. approached, Chavin control of the area diminished. Smaller regional cultures began to develop across Peru and they adopted elements of the rich iconography of Chavin culture. On the north coast a spectacular culture known today as the Moche emerged and prospered for almost a thousand years until it was conquered around A.D. 800.

Among the outstanding achievements of the Moche culture was its ceramic arts. The favored

form of the Moche potter was a modelled and painted effigy pot referred to as a "stirrup spout vessel." These vessels depict all kinds of plants, animals, human figures and individual portrait heads. The skill of the Moche potter is evident in this finely sculpted frog. The cream and brownish red colors are typical of many Moche ceramics. The vessel itself was most likely made from a mold, another important Moche innovation, while the body of the frog and the spout may have been made separately and then joined together.

It is not known if there is any symbolic importance given to frogs in Moche iconography. By virtue of their habitat, frogs often symbolize water, that most precious resource for farmers in an arid climate.

P.J.T.

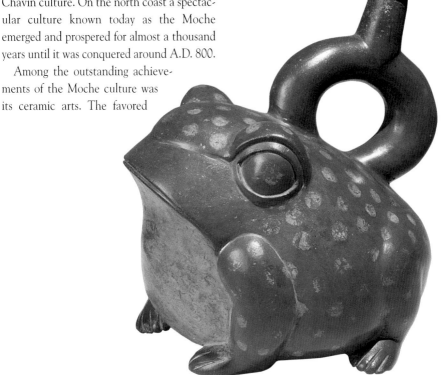

Nazca Culture

South Coast, Peru

Ceremonial Drum. circa 400

llama hide, pigment,
14 x 11 x 4 ¹/₂ (35.6 x 27.9 x 11.4 cm.)
Gift of Mrs. P. Roussel Norman. 91.476

The Nazca culture flourished from roughly 200 B.C. to A.D. 600 on the southern desert coast of Peru. Like the Moche, their northern neighbors, the Nazca survived by cultivating the river valleys that provided fresh water in their dramatically arid environment.

Among the aesthetic objects Nazca artists created are beautiful textiles and extraordinary ceramics. But to many the Nazca culture is synonymous with the large enigmatic drawings, or "Nazca Lines," which they carefully constructed on the desert surface.

Nazca artists combined representational and geometric motifs to create a highly stylized iconography. Mythological beings and animals were common themes.

Religious ritual was most likely an impor-
tant part of Nazca culture, and music was an integral element of ritual ceremonies. Panpipes, rattles, ceramic trumpets and drums would have been played. The drum here is rare, having survived many centuries in a tomb in the dry desert climate. The drum was designed to be held by its strap with one hand. One side is undecorated and is obviously the one meant to be struck. It retains bits of llama fur on its surface and does not appear to have been used often. The creatures depicted on the drum appear to have the body of a snake and a feline head. Perhaps the drum was made to be used in one specific ritual or in a funeral procession and was buried with the deceased.

P.J.T

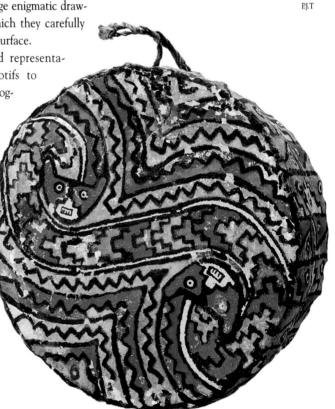

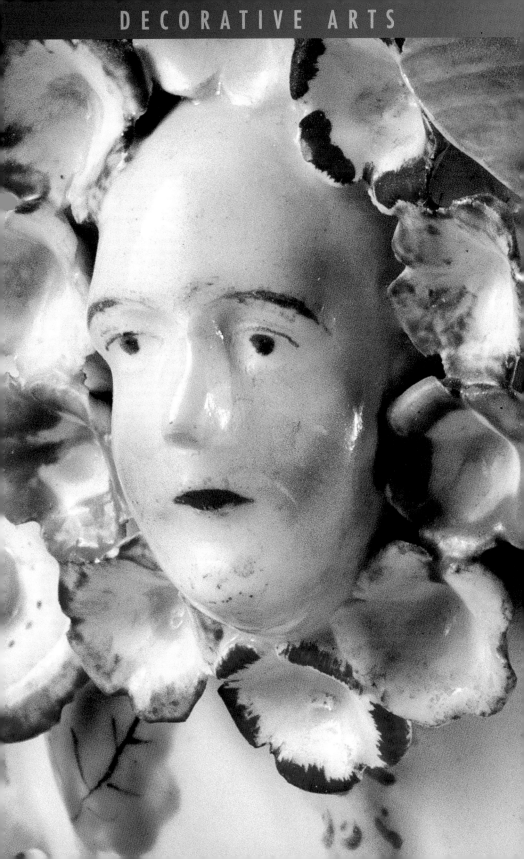

Egypt

18th Dynasty, 1546-1350 B.C.

Flask in the Form of a Column

core-formed, threaded, tooled and applied
non-lead glass; opaque blue matrix with thread
decoration in yellow, pale blue and white,
3 1/4 in. (8.26 cm.)
Gift of Melvin P. Billups in memory of
his wife Clarice Marston Billups. 64.86

Glass was first produced in Mesopotamia over four thousand years ago. The oldest known examples of glass have been found at such Middle Eastern sites as Tell-al-Rimah, Assur and Egypt. The ancient Egyptians began to produce vessels such as this unguent flask during the reign of Tuthmosis III (r. 1504-1450 B.C.) in the 18th Dynasty.

The Egyptian name for glass was *iner en wedeh* or *aat wedhet*, meaning appropriately "the stone of the kind that flows." The ancient world viewed glass as a kind of mystical gem and valued the substance as highly as it did sapphires, emeralds and other precious stones. This flask, the oldest example of glass in the New Orleans collection and reproduced here in its actual size, was formed by the core technique. Having not yet developed the mouth-blowing method, the ancient glassworker applied a wet core of mud, straw and decayed vegetable matter to a cylindrical rod which was then dipped in a cauldron of molten glass. The glass conformed to the shape of the core and rod. Then threads of colored glass were trailed on the matrix and "combed" with a pointed stylus. The refined scallops at the neck of the flask were also added at this time. When the vessel cooled completely, the dried core could be removed.

Creating vessels this sophisticated by such primitive methods required great skill. The final objects were greatly prized by their royal and aristocratic owners.

C.E.G.

Syro-Persian area

"Dromedary" Flask. circa 500-799

colorless non-lead glass; freeblown, applied
and tooled, with weathering and irridescence,
4 ½ in. (11.4 cm.)
Gift of Melvin P. Billups in memory
of his wife, Clarice Marston Billups. 59.29

Already a thriving culture, Islam spread
rapidly after the death of Mohammed in
632 A.D. The period of
Islam Conquest (632-
1453) caused Islam to
replace the Roman Empire
as the unifying force in
Mediterranean and Near
Eastern civilization. This
period of relative stability
also witnessed the rise of a
sophisticated Court cul-
ture. Although early Islamic
glass was merely a con-
tinuation of the Late
Antique tradition, these
courts caused the expres-
sion of a typical Arabic
love of nature in a wealth
of floral ornament and
animal forms.

Islamic glass craftsmen
exploited their skills in
applying lavish pinched
and trailed decoration to
freeblown shapes. One of
the most distinctive forms to evolve from this
exploitation was the whimsical "dromedary"
flask, a diminutive, highly stylized quadruped
bearing a blown vasiform element upon its

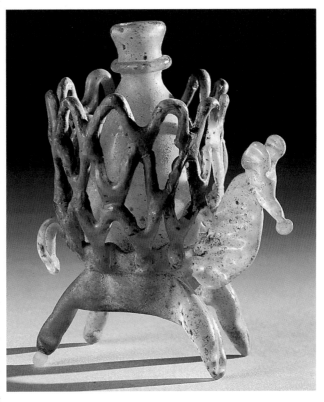

back. Camels and dromedaries were, of
course, central to Islamic desert life, so the use
of their form for these elaborate flasks was
highly appropriate.

Such highly embellished and vigorously
three-dimensional flasks probably contained
the unguents and cosmetics of their well-placed
owners. It is highly unlikely that they were
intended for dining or table use, particularly
since Islamic religious principles forbade the

use of alcoholic beverages. Today these flasks
are eloquent reminders of the strength of
Islamic Conquest culture and its highly sophis-
ticated Court life.

J.W.K.

Syria or Egypt

Mosque Lamp. circa 1250-1360

transparent pale amber non-lead glass; freeblown,
applied, tooled, polychrome-enamelled and parcel-gilt,
10 $1/2$ in. (26.67 cm.)
Gift of Melvin P. Billups in memory of his wife,
Clarice Marston Billups. 69.78

The primary contributions of the Islamic world to the history of glassmaking were the development of the freeblown technique until it was able to realize objects of an unprecedented size, superb polychrome enamelling and accomplished gilding. All of these Islamic characteristics may be observed in this large mosque lamp.

Mohammed's poetic concepts of Creation in the Koran and an express forbidding of portraits or representations of the human form caused Islamic decorators of glass to turn to elegant script and stylized depictions of flowers, leaves and vines. All of these succinctly expressed a deep Arabic love of nature. The enamelled script decorations frequently took the form of laudatory dedications to rulers or patrons or quoted the Koran, as is the case with this lamp.

The monumental shape of the lamp, with its sophisticated symmetry, was admirably suited to receive the opulent overall decoration seen here. The applied loops on the body of the vessel permitted it to be suspended from the traditionally lofty ceilings of the mosque. Usually these prestigious pieces of glass were presented to a particular mosque by noble members of the congregation. The form of these lamps and their interlaced enamelling and gilding display a superior sense of design and a superb mastery of the skills of the glassblower.

J.W.K.

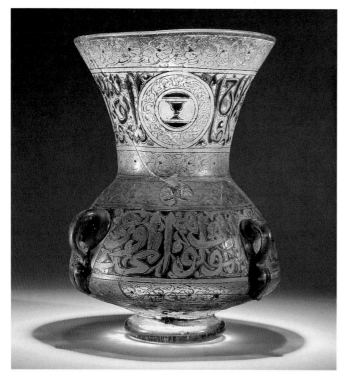

Italy

Island of Murano, Venice

Ewer. circa 1500-1550

colorless non-lead glass; freeblown, applied,
tooled and polychrome-enamelled, 12 in. (30.5 cm.)
Gift of Melvin P. Billups in memory of his wife,
Clarice Marston Billups. 69.84

The Republic of Venice was not only a major
Adriatic and Mediterranean trading power
during the opening years of the 16th century,
she was also a flourishing center for the man-
ufacture of glass. The fame of Venetian
cristallo, a transparent, nearly colorless soda-
lime glass of great ductility that recalls the
appearance of the purest natural rock crystal,
had spread throughout Europe.

Through their extensive trading contacts
with the Islamic world, Venetian glass artists
were aware of the large scale achieved by
the glassblowers of Islam as well as their
spectacular enamelling and gilding.
These Islamic advancements were soon
absorbed and reinterpreted by the
Venetian artisans in a thoroughly
Western, Renaissance mode. How well
the Venetians had observed these
Islamic refinements may be observed in
this handsome ewer. The size of the ewer
is large by 16th-century standards, and
the form itself is immensely refined. Islamic
calligraphy has been transformed into com-
plicated strapwork punctuated by small
grotesque masks ,and this ornament is suited
perfectly to the form of the piece. It should be
of little wonder that such extraordinarily
sophisticated glass objects were among
the greatest status symbols of the
Renaissance. Ownership of such an art
object immediately conveyed a resounding

message of wealth, taste and refinement. That
the force of this message was undiluted later
is indicated by the ownership of the ewer by
two of Europe's most sophisticated 19th cen-
tury Viennese collectors of glass, Baron Gustav
von Rothschild and Oskar Bondy.

J.W.K.

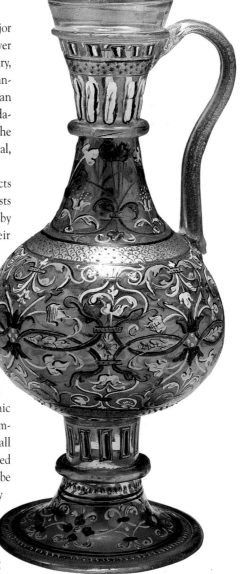

Probably Bohemia

Reichsadlerhumpen. dated 1629

colorless non-lead glass: freeblown, applied,
tooled and polychrome-enamelled, pewter,
9 ³/₈ in. (23.9 cm.)
Gift of Melvin P. Billups in memory
of his wife, Clarice Marston Billups. 57.112

The force of the 16th-century Venetian tradition may be observed in this characteristic Northern European, Germanic beaker, or *Humpen*. Its large magisterial form and its

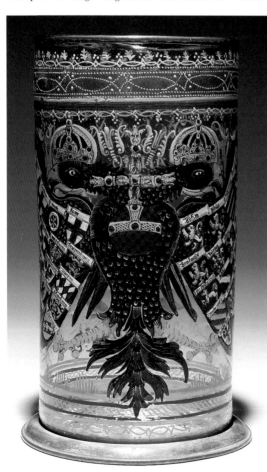

brilliant polychromy are derived from earlier Venetian refinements absorbed from the Islamic world.

Venetian enamelled glass was extremely popular and fashionable in Northern Europe of the 17th century but its exorbitant cost restricted ownership to royal and aristocratic persons. Added to the obstacle of expense were the problems of extreme fragility and the duress of travel. Germanic glass artists therefore absorbed the lessons of scale and enamel decoration from their Venetian colleagues but adapted both to suit Northern taste. One of the results of this were broadly, brightly enamelled *Humpen* of simple cylindrical form whose plain surfaces carried allegories of the Holy Roman Empire, its Electors, family histories and trade or guild insignia. The most esteemed of these were the *Reichsadlerhumpen*, or "Imperial Eagle" beakers. The primary surface of this example is dominated by the double-headed imperial eagle derived from Byzantium and the surrounding shields of the fifty-six member states, principalities and duchies of the Empire. This decoration patently intended to impress the beholder with the wealth and power of the state.

Such majestic Northern European glasses thus form a bridge between the northern *waldglas*, or "forest glass," tradition and that of the equally distinctive Southern enamelling.

J.W.K.

Attributed to George Ravenscroft

English, 1618-1681

Ewer. circa 1673-75

lead glass: freeblown, applied and
tooled in "diamond-nipt waies,"
8 ¹/₂ in. (21.59 cm.)
Gift of Melvin P. Billups in memory of
his wife, Clarice Marston Billups. 64.176

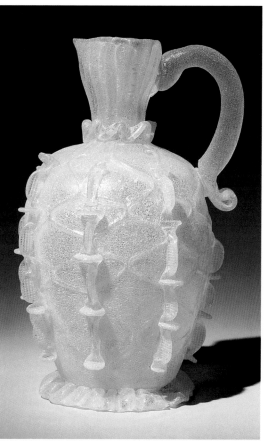

A successful entrepreneur with commercial ties to the Venetian glass trade, George Ravenscroft (1618-1681) was the founder of the so-called "lead glass revolution" which gave England domination of Western glass markets and contributed to the slow decline of Venetian primacy in glass manufacture.

Ravenscroft successfully substituted crushed and calcined flint, or lead, for the traditional sand in his formula. The result was a soft, more brilliant and durable glass than that permitted by the Venetian soda-lime formula. In addition to these eminently desirable properties, the new lead glass was slow to cool, which allowed it to be worked extensively, took color well and could easily withstand the stresses of engraving and cutting. An enthusiastic Charles II awarded Ravenscroft a seven-year patent for his spectacular new glass; however, the secret of its recipe proved impossible to keep. By 1696 there were twenty-seven glasshouses in London alone producing lead glass.

The difficulties Ravenscroft encountered with his formula are reflected in the clouded appearance of this ewer. Early customers, who paid Ravenscroft up to five times more for his already expensive glass, complained that it crizzled and lost transparency after only a few months. The problem was overcome by 1675-1676 although the crizzling observed here permits the latter-day scholar to date this ewer between the opening of the Savoy Glasshouse in 1673 and Ravenscroft's stabilization of the revolutionary lead formula in 1675.

J.W.K.

Bohemia and probably Holland

"Ariadne at Naxos" Charger.

circa 1685

colorless potash-lime glass: freeblown,
tooled, and copper wheel-engraved, d: 14 3/8 in.
Gift by exchange of the Heirs of Judge Emile Rost. 87.25

The invention of lead glass in 1675 by the English entrepreneur George Ravenscroft (1632-1683) revolutionized the history of glass-making. The addition of lead oxide to the traditional formula resulted in a soft, limpid slow-cooling glass capable of taking color well and of being elaborately cut and engraved. Continental glassmakers quickly recognized the technical and aesthetic potential of the new formula and rushed to develop a similar one. Their solution was the potash-lime recipe which closely replicated the appearance of the Ravenscroft lead formula.

This superb charger is among the most important examples of Baroque glass in the New Orleans collection. It is thought that the piece was crafted and the cavette engraved in Bohemia; the engraved cavetto carries the legend of Ariadne on the island of Naxos. Theseus was aided in his access through the Labyrinth to the Minotaur by the enamored Ariadne. After slaying the Minotaur, Theseus carried Ariadne off and she fell asleep on the island of Naxos. While the smitten princess slept, Theseus abandoned her. However, Dionysius discovered her, fell in love with the sleeping maiden and married her when she awoke. Through this marriage Ariadne was raised to the status of a goddess.

The elaborate lace-like engraving of the rim is thought to have been executed in the Netherlands where lace had become an important costume accessory and a status symbol. Dutch engravers specialized in elaborate engraved effects of this type to the unabashed delight of their affluent merchant patrons. It is consistent with 17th century burgher taste that the popular dramatic legend of Ariadne be embellished with finely detailed Dutch engraving.

J.W.K.

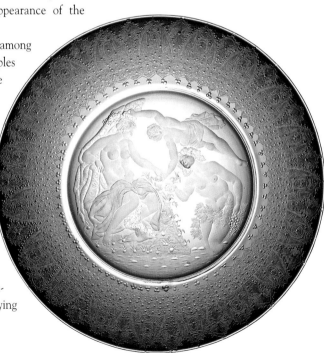

Probably the Boston and Sandwich Glass Company

Sandwich, Cape Cod, Massachusetts, United States (active 1825-1888)

Bowl. circa 1825-1835

colorless lead glass: lacy-pressed, d: 12 in. (30.5 cm.)
Museum Purchase. 89.285

Although the manufacture of glass in America had been attempted as early as 1608 in the Jamestown colony of Virginia—and later at Salem, Massachusetts, New Amsterdam, and Philidelphia—it was not until the 1820s that American glasshouses became major industrial forces.

Part of the reason for this rise to prominence was the development of the technique of pressing glass in a mold to impart both form and pattern. Credit for perfecting this method is usually given to the American glass entrepreneur Deming Jarves, founder of the New England Glass Company (1818) and the Boston and Sandwich Glass Company (1825).

Early pressed glass objects were often cloudy or rippled due to the difference in temperature between the molten glass and the mold. Jarves and his contemporaries soon realized that a stippled—or lacy—background for the glass would disguise these imperfections. Lacy pressed glass also had the aesthetic advantage of reasonably imitating the appearance of the more expensive cut glass wares of the day. Although most lacy pressed objects, such as cup plates, salt cellars and small dishes, were necessarily of small size, this impressive bowl represents an extremely ambitious use of the technique. As the size of the mold increased, so did the difficulties of filling it evenly, maintaining an even overall pressure and obtaining a uniform pattern. Bowls of this scale were therefore rare and were the pride of their middle-class American owners in the early 19th century.

J.W.K.

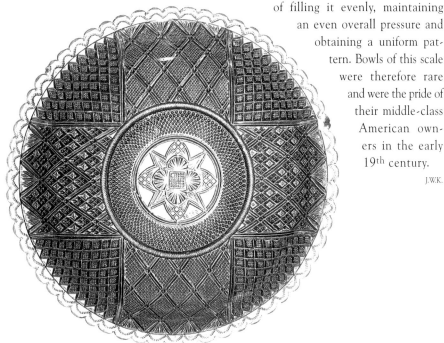

Either the Redwood or Redford Glassworks

Upstate New York, United States.

Pitcher. circa 1825-1850

transparent aquamarine lead glass: freeblown,
applied and tooled in the "Lilypad" technique,
8 $^7/_{16}$ in. (21.44 cm.)
Gift of Melvin P. Billups in memory of his wife,
Clarice Marston Billups. 60.51 a

The characteristically American "Lilypad" technique emanated from the Germanic decorative vocabulary that had so strongly influenced the earlier South Jersey glassmaking tradition. Many glass historians maintain that this decorative device is the only wholly original American contribution to the long history of glassmaking.

Lilypad ornament was achieved by superimposing a gather of glass on an already-formed object and then drawing up portions of the edges of that gather into stems around the body of the object. The space created between the drawn-up elements resembled a lilypad and imparted a rich three-dimensionality to the particular object. Variations on the theme quickly developed; one finds a combination of the Lilypad on a tall stem, referred to by glass historians as "Type II." Two large pads on swirling stems are referred to as "Type III."

The glassblowers of early 19th-century upstate New York particularly favored this technique. This bold and vigorous example was undoubtedly created at either the Redwood or Redford glassworks. Pitchers were particularly well-suited to Lilypad decoration although it is also seen on sugar basins and their covers. Only rarely does it occur on tankards.

The Billups Collection is particularly rich in examples of this distinctive American technique.

C.E.G.

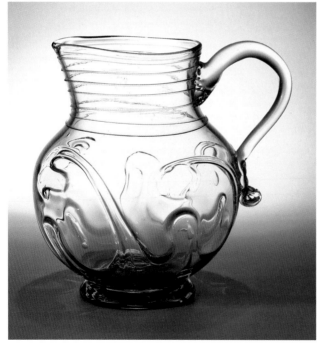

Louis Comfort Tiffany

American, 1848-1933

Morning Glory Vase. circa 1915

colorless, transparent green, yellow and red lead glass: "Favrile" type; blown, cased, millefiore in Paperweight technique, 9 in. (22.86 cm.) max d: 5 ¹/₄ in. (13.34 cm.) Gift of Mr. and Mrs. Prescott N. Dunbar. 91.568

Scion of the illustrious Tiffany family, founders of Tiffany and Company jewellers and silver-smiths, Louis C. Tiffany determined to clear a new path for himself in the art world.

Tiffany began his career as a painter and studied under George Inness and Samuel Colman. From them he learned to value the opulent color and kaleidoscopic detail found in nature and which came to be the hallmarks of his work in glass. Tiffany's glasswork is linked to the European Art Nouveau move-ment (characterized by organic, nonconforming lines and forms) with its painstaking perfection in rendering so elegantly in glass what nature effortlessly and bountifully gives forth.

The exceptional baluster-shaped Morning Glory Vase was made by the Tiffany Studios in Corona, Long Island, New York for display at the 1915 Panama-Pacific Exposition in San Francisco. Tiffany used the word "Favrile" to describe his trademark iridescent and lustrous hand-blown glass. The work is derived from the Old English "fabrile," meaning "handwrought." Favrile glass, first used by Tiffany for windows, later came to be used to create superb lamps, vases and bowls.

The vase is a variation of the millefiore (a thousand flowers) technique called "Paperweight glass." The vase was created by layering glass over decorative floral glass designs embedded in an inner layer. This layering over the lus-trous inner surface created a reflective, shimmering look. "Paperweight glass" is among the most uncommon of the Tiffany techniques and such vases are exceedingly rare.

C.E.G.

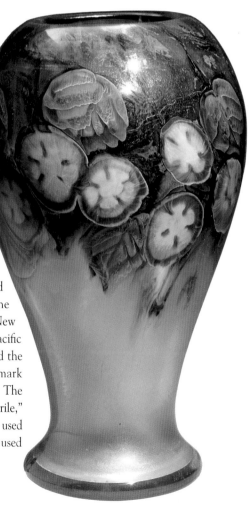

René Lalique

French, 1860-1945

"Albert" or "Deux têtes de faucon" Vase, designed in 1925

transparent dark topaz glass: press-molded, cut and polished, 6 3/4 x 8 1/4 x 5 1/2 in. (17.15 x 20.96 x 13.97 cm.) Gift of Dr. and Mrs. Siddharth K. Bhansali. 91.575

There is no doubt that René Lalique was one of the most talented designers of glass of the entire 20th century. Lalique began his distinguished career as an Art Nouveau jewelry designer and took up the manufacture of glass only after a 1907 commission from the parfumeur François Coty for scent bottle labels, then stoppers and finally the complete bottles. The designs for Coty were so successful that other perfume manufacturers flocked to Lalique's Paris studio, and a career in glass was born.

In 1919 the ambitious Lalique purchased a second factory site at Wingen-sur-Moder and expanded his production on a grand scale, manufacturing vases, bowls, bar and toilette wares, lighting fixtures and architectural elements. Of these the vases are generally considered by connoisseurs and collectors to be the most important single body of objects within the Lalique oeuvre. Lalique designed between 150 and 200 of them between 1919 and his death. The overall diversity of his forms, decorative motifs, colors and sizes is vast and remarkable.

The celebrated 1925 International Exposition of Modern Decorative and Industrial Arts in Paris marked the supremacy of the Art Deco as the reigning international style. Lalique designed this sleek and sophisticated vase in that year, thus demonstrating his mastery of the decorative vocabulary of the new style. This is all the more astounding when one reflects that he had been hailed as a leading exponent of the Art Nouveau style a quarter of a century earlier.

C.E.G.

Robert Willson

American, born 1912

Fabricated by the glassworks of Pino Signoretto, Venice

Polar Bear Fetish.
circa 1986

glass: translucent white, opaque red, black, and
turquoise; gathered, applied, and tooled,
15 3/8 x 16 3/4 in. (15 3/8 x 16 3/4 cm.)
Museum Acquisition. 89.138.42

Although Robert Willson is a contemporary
glass sculptor, his work lies slightly outside the
parameters of the American studio glass
movement. The basic tenet of this movement
is that the designer and the executor of a piece
are the same person. Willson, however,
designs his pieces for fabrication in Venice,
Italy, by Italian *maestri.*

A trip to Venice in 1952
drew Willson's attention to its
traditional diminutive sculp-
tures in glass. He realized that
sculpture was a natural applica-
tion of the glass medium and
that glass was eminently applic-
able to large-scale sculpture.
With its long history of glass-
making, Venice was a perfect
location in which to realize
Willson's designs for large,
weighty sculptures. Since 1956
Willson has made an annual
trip to Venice to work with
such established masters as
Alfredo Barbini, the Toso
brothers, Pino Signoretto, and
the consortium Ars Murano.
This collaboration produces
about twenty original sculp-
tures per year, with each piece

taking approximately a week to complete.

Although the setting of Venice initially
stirred Willson's imagination, he remains
firmly attached to his native Texas and the
sweeping romance of the American West. His
sense of the land is active, and he is an avid
student of Native American culture as seen in
this vigorously three-dimensional large-scale
interpretation of a Southwestern bear fetish.
Such fetishes are traditionally small scale and
eminently portable. Here the entire image has
been trebled, made heavy and permanent and
given a subtle list, making it an engineering
tour de force as well.

New Orleans has the premier American
collection of sculpture by Willson, of which
the *Polar Bear Fetish* is a prime example.

J.W.K.

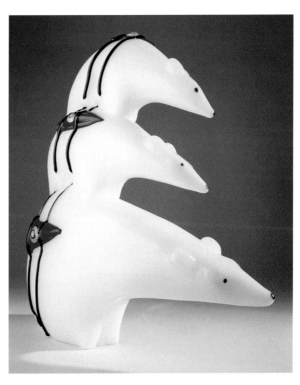

Paul Storr

English, 1771-1844

Centerpiece. 1810

raised, cast, soldered and chased sterling silver,
16 x 8 ¼ in. (40.64 x 20.96 cm.)
Promised Gift of Elinor Bright Richardson.

It is a matter of consensus that Paul Storr was the greatest English silversmith of the 19th century. He was also a leading proponent of the emergent Regency style, a superb craftsman and an astute businessman.

Storr registered his own mark with the Worshipful Company of Goldsmiths in 1793 and shortly thereafter began to acquire such highly placed patrons as the dukes of Bedford, Dorset, Manchester, Portland and Wellington, King George III and the Prince Regent. Storr's works have gracefully withstood the merciless test of time and remain among the most sought after of period silver.

Centerpieces of this antique brazier type figured prominently in Storr's work no doubt because their patently architectonic design appealed to a fashionable affluent clientele. The superb detail and finish of such centerpieces ensured the delight of the most critical patron. Of particular interest here are the superbly cast and chased shell finial of the cover and the wreath of applied ivy leaves on the underside of the lip. This last refinement prevented those seated at table from gazing upon an unadorned surface.

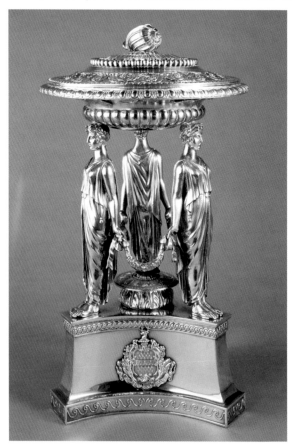

Storr was born into an old Yorkshire family of artisans some of whose members had moved to London in the early 18th century and prospered in the watchmaking and silverchasing trades. Storr's father was a silverchaser, a trade that may account for the jewel-like finish the son achieved on such monumental pieces as this handsome centrepiece.

J.W.K

Elkington, Mason and Company

Birmingham, England (active 1842-1856)

Candelabrum-Centerpiece and Plateau. circa 1850-1855

cast, soldered and chased silverplated
nickel and cut and mirrored glass, 33 in. (83.82 cm.)
Anita Nolan Pitot Fund. 91.400 a&b

The process of electroplating silver was patented by George Richards Elkington (1800-1865) in 1840. It revolutionized the silversmithing industry and set the Elkington firm at the forefront of the leading English silversmiths. It became company policy to stress quality and aesthetic content while reaping profits from its lucrative electroplating patents.

This monumental candelabrum-centerpiece represents both a zenith of Rococo Revival design and a triumph of the intense elaboration sought by the Elkington designers. The Rococo Revival was the reigning international decorative style from circa 1850 to 1865; it sought to reinterpret the Court style of Louis XV for use in the modern world. This reinterpretation caused the 19th century designer to become interested in foliate motifs, richly textured surfaces and a contrast of materials all of which may be observed here.

The centerpiece originally formed part of the furnishings of the distinguished Southern statesman, Duncan Farrar Kenner (1813-1887) at his great River Road house Ashland (a.k.a. Belle Hélène) near Geismar, Louisiana. The estate was fabled in the antebellum era for its stylish appointments and lavish entertaining.

J.W.K.

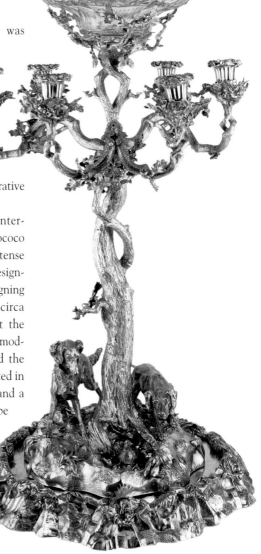

Bow Factory

Stratford, Essex , England (active circa 1747-1776)

Pot-pourri Vase. circa 1760-1765

soft-paste porcelain: raised, pierced, applied, and poly-
chrome glazed, 5 $1/2$ x 4 in. (13.97 x 10.2 cm.)
Bequest of William MacDonald Boles and
Eva Carol Boles. 95.113

The Bow manufactory was, with the Chelsea
Works, one of the earliest English porcelain
producers. It commenced production about
1747. The Bow proprietors were the first to
add bovine ash to their porcelain formula,
thereby making Bow the progenitor of the
renowned English "bone china."

The manufacture of porcelain in England
happily coincided with the development of an
English taste for the imported Rococo style. A
prosperous and fashionable native clientèle
demanded objects fabricated of costly porce-
lain in this new mode. However, the English
porcelain factories at the mid-18th century dif-
fered significantly from their Continental
counterparts in that they did not enjoy royal
or noble patronage. Established as commercial
ventures, they were required to operate at a
profit. Given this factor, the wide range of
articles produced by the Bow factory is yet
more extraordinary.

This large example of Bow porcelain accu-
rately reflects the English interpretation of the
imported French Rococo taste. Of note are
the exuberantly applied flowerheads,
and foliage, masques, and the
whimsically painted insects.

J.W.K.

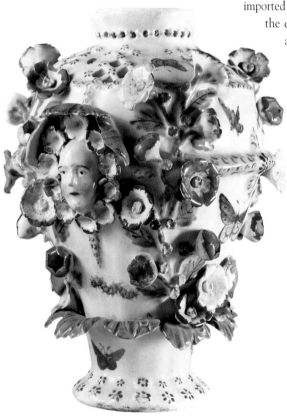

Darte Frères manufactory

Paris, France (active 1801-1833)

Mantel Clock (horloge de cheminée).
circa 1825

hard-paste porcelain; Vieux Paris type:
cast, gilt, contrast-burnished; steel, iron and enamel,
11 x 9 5/16 x 6 7/8 in. (27.94 x 23.65 x 17.48 cm.)
Mrs. Seymour Katz Fund. 92.812

Contrary to popular opinion, Vieux Paris, or "Old Paris," porcelains were not produced by a single manufactory but by some thirty-seven different firms operating from about 1772 to circa 1875. These factories were surrounded by a galaxy of independent decorators, decorating firms and luxury goods retailers. The Vieux Paris manufacturers supplied porcelains for the newly rich bourgeoisie and were therefore required to closely follow changes in fashion in order to maintain the interest of this notably fickle market.

Reticulated vasiform mantel clocks were the height of fashion during the French Restauration (1815-1830). At that time the showy architectonic qualities of the Napoleonic Empire style were scaled down to accommodate middle class taste. Neoclassicism remained in fashion as can be seen in the military trophée, fleurettes, lion masques and dolphin handles of this example. However, this was a Neoclassicism stripped of the formality of the 18th-century Louis XVI style or the chilly splendor of the First Empire manner. From the relatively small number of such clocks extant, it would appear that the prestigious firm of Darte Frères specialized in their manufacture. The firm was one of the most fashionable porcelain manufacturers of the Restauration and kept a shop at the expensive Palais du Tribunat.

Such examples of Vieux Paris porcelain reflect Parisian porcelain manufacture at its height long before competition from Limoges and distant Bohemia forced this long tradition into decline after the fall of Napoleon III's Second Empire.

J.W.K.

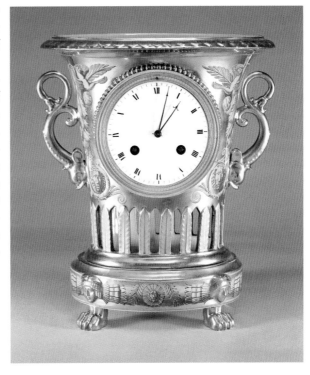

Attributed to the Jacob Petit manufactory

Paris, France (active 1796-1868)

Pair of Candelabra Bases.

circa 1846-1850

hard-paste porcelain; Vieux Paris type: cast, glazed, polychrome-overglazed and parcel-gilt, each: 21 3/4 in. (55.25 cm.)
Bequest by exchange of Isaac Delgado. 86.436.1-.2

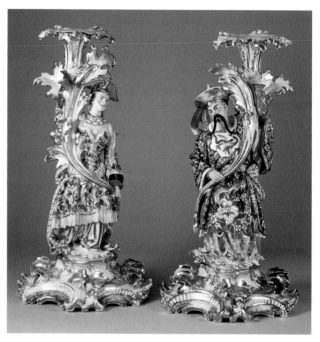

Because the manufacturers of Vieux Paris porcelain depended upon the newly affluent bourgeoisie, they were impelled to stay abreast of the latest developments and changes in fashion. One of these manufacturers was Jacob Petit, a wily businessman and an adventuresome designer who boldly combined elements of the Gothic, Rococo, *chinoiserie,* and Louis XVI styles in his production.

Petit excelled in the manufacture of complex ornamental pieces although he also produced table and toilette wares. His understanding of the 18th-century *chinoiserie* mode may be seen in this pair of vigorously modelled, richly decorated candelabrum bases in that style. Originally, the floriform elements held aloft by the figures were fitted with gilt-bronze candle-arms, and it is possible that the bobeches were dressed with cut-glass prisms. However, Petit has here greatly enlarged and enriched his 18th-century *chinoiserie* inspiration; the figures are at least three times the size of their prototypes. The palette employed on the costumes of the figures is also typically Petit in its elaboration and vivacity. Petit had reintroduced the bright colors of the mid-18th century to porcelain manufacture. However, the combination of these hues is distinctly 19th-century French in character.

These tour de force porcelains originally formed part of the lavish appointments of statesman Duncan Farrar Kenner's (1813-1887) great house, Ashland, on the River Road in Geismar, Louisiana. At the time of its furnishing it was widely regarded as one of the most opulent residences in the entire South. This fact would no doubt have pleased the creator of these whimsical yet impressive pieces of porcelain.

J.W.K.

Manufacture Nationale de Sèvres

France (active 1756-present)

Pair of Garniture Vases. dated 1848

hard-paste porcelain: cast, glazed, polychrome-
overglazed and parcel-gilt, with gilt-bronze mounts.
14 $1/2$ in. (36.83 cm.)
Gift of John J. Agar in memory of his father,
William Agar. 15.76 a&b

The elegant products of the Sèvres porcelain manufactory have long attracted the interest of American collectors. The association of the factory with the *ancien régime* Kings Louis XV and Louis XVI and such fashion-setters as the accomplished Madame de Pompadour and Queen Marie-Antoinette has imbued it with a fascinating glamour and appeal.

Although the 18th-century wares of Sèvres have enjoyed nearly universal international acclaim, it is its 19th-century examples which are presently attracting favorable critical and aesthetic reevaluation. This handsomely decorated pair of Louis-Philippe Sèvres vases is

typical of the type of ware enjoying this renewed attention. They were produced at the end of the brilliant Sèvres directorship of Alexander Brongniart (1770-1847) whose forceful leadership assured that the factory wielded a profound influence upon the manufacture of European porcelain throughout the 19th century.

Brongniart oversaw the switch away from soft-paste, or artificial, porcelain and was responsible for greatly improved methods of manufacture. He introduced casting (used from 1819) and a two-chamber kiln in 1842. However, he also clung to principles introduced at the beginning of the 19th century. This imposed an essential conservatism on Sèvres products throughout the reign of Louis-Philippe (1830-1848).

The Louis-Philippe purchaser of porcelain preferred lush, dense arrangements of flowers contrasted with dark ground colors, both of which may be observed here. This rich decoration was ideally suited to the large monumental Neoclassical form of these vases.

J.W.K.

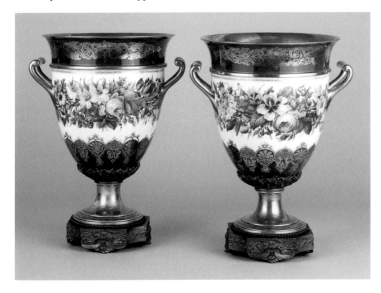

W. J. Copeland and Sons, Ltd.

Stoke-on-Trent, England (active 1847-present)

Pair of "Bacchic Revels" Jugs.
circa 1850-1855

Parian porcelain: cast and interior-glazed,
each: 10 ¹/₂ x 9 x 7 in. (26.67 x 22.86 x 17.78 cm.)
Gift of Mrs. Eugenia U. Harrod in memory of her
husband, Major Benjamin Morgan Harrod. 13.42

The Victorian era (1837-1901) was charac-
terized by great technological innovation in
the decorative arts. Accompanying these
advances was an avid interest in the reinter-
pretation of historic styles for use in the
modern world. These highly sculptural jugs
are a lively reflection of this phenomenon
since they were executed in the new interna-
tional Rococo Revival style using the novel
medium of Parian, or statuary, porcelain.

Parian porcelain was developed by the promi-
nent Saffordshire firm of Copeland and Garrett,
successors to the Spode works, around 1844.
The new body was an instant public success

since its composition rendered it capable of
producing intricate detail while its surface was
considered to duplicate successfully the
appearance of marble. The very name "Parian"
reflected this affinity with marble since it
recalled the ancient Greek marble from the
island of Paros. Other manufacturers eager
to cash in on the fashion for Parian called it
"Carrara," again stressing the medium's relation-
ship to marble. The Copeland firm was soon
joined by Charles Meigh, Mintons, Coalport, T.
and R. Boote, and Wedgwood in the manufac-
ture of the new Parian wares. So popular did the
medium become that decorative sculpture was
quickly followed by table wares; by 1860 intri-
cate brooches of Parian porcelain were retailed.

The Rococo Revival style was inspired ini-
tially by the 18th-century Court style of Louis
XV with its emphasis upon serpentine curves
and foliate ornament. To this the Victorian
designers grafted a lively interest in leaves,
vines, bark, flowers and other botanical forms
as well as marked contrasts of texture, light,
and shadow. These motifs and contrasts may
be observed in these jugs.

C.E.G./J.W.K.

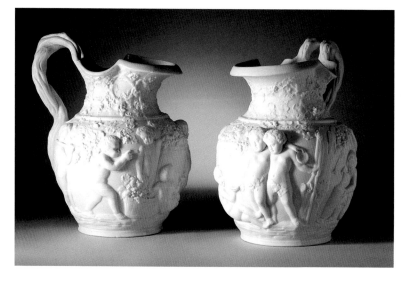

Worcester Royal Porcelain company, Ltd.

Worcestershire, England (active 1751-present)

"Moon" Garniture Vase.
circa 1875-1880

bone porcelain: cast, glazed, poly-
chrome-overglazed and parcel-gilt,
13 ³/₈ x 11 ³/₈ in. (34 x 28.9 cm.)
Françoise Billion Richardson Fund.
94.17

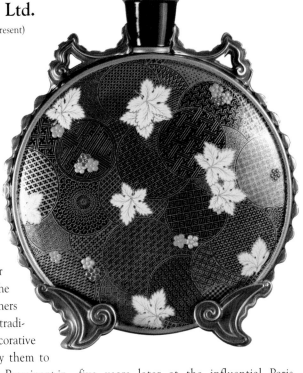

The opening of Japan to the Western world by the American Commodore Matthew Perry in 1853 inaugurated an inter-national vogue for objects either truly Japanese or created in the Japanese taste. Western designers and artists began to look at tradi-tional Japanese forms and decorative vocabularies in order to apply them to objects created in the Occident. Prominent in this phenomenon was the English Worcester Royal Porcelain Company, which had been founded in 1751. In 1862 the famous manu-factory was reorganized by R. W. Binns as the firm which exists to this day. Binns was an admirer of Japanese porcelains and collected them avidly; he often utilized the collection to instruct his company designers on Japanese motifs and techniques.

Under the Binns leadership the Worcester factory moved from triumph to triumph; it received enthusiastic notices at the prestigious Vienna International Exhibition of 1873 and five years later at the influential Paris Exposition Universelle. This stylish garni-ture vase reflects the Japanese taste advocated by Binns; the Orientalist moon shape was frequently employed by Worcester although it was not exclusive to it. The rich segmented gilt "brocade" patterning of the surface and the two-color gilding of the han-dles and the feet reveal the opulent decorative treatment favored by Worcester's designers.

Such vases were not only stylish but also represented the highest and most sophisti-cated contemporary Western taste in the decades of the 1870s and 1880s.

J.W.K.

The Mintons Pottery

Lane Delph, Staffordshire, England
(active 1783-present); decorated by Henry Sanders

Monumental Covered Vase.
circa 1880-1885

Parian porcelain: cast, glazed, decorated in the
pâte-sur-pâte technique and parcel-gilt,
17 $7/_8$ in. (45.4 cm.)
Gift of Dorothy Shushan in memory of her husband,
Shepard H. Shushan. 91.585 a-b

The costly and labor-intensive *pâte-sur-pâte*, or paste-on-paste, technique was ideally suited to Late Victorian taste since it was complex and highly ornamental, luxurious in appearance and requisitely expensive. *Pâte-sur-pâte* was a combination of ceramic painting and sculpture. Layers of slip were built up and carved or modelled. The density and relief of these layers therefore varied from total opacity to near transparency and created in effect a ceramic cameo.

The technique was developed at the Sèvres manufactory in the 1850s and brought to England by the decorator Louis-Marc Solon (1835-1913). Solon was employed at the Mintons Pottery and trained a cadre of decorators in the extraordinary technique. Among them was Henry Sanders, the decorator of this monumental covered vase. Sanders specialized in the depiction of figures in neoclassical dress and pose.

The Parian porcelain body was ideally suited to *pâte-sur-pâte* decoration. It also permitted the development of large complex shapes. In the case of this vase the striking handles were formed separately and bolted to the primary form.

The popularity of elaborate *pâte-sur-pâte* pieces waned by 1900 although Mintons continued to produce objects in the technique until 1937. This monumental covered vase represents the heyday of the technique's use and stands as a valid reflection of an opulent late 19th-century taste in ceramics.

J.W.K.

Newcomb College Pottery

New Orleans, Louisiana, United States.
Decorated by Harriet C. Joor.

"Chinaberries" Vase. 1902-1903

earthenware: raised, incised and
polychrome, glass-glazed,
7 7/8 x 8 3/8 in. (20 x 21.3 cm.)
Gift of Newcomb College through
Pierce Butler, Dean. 38.29

Newcomb College pottery is arguably the most renowned of all Southern art wares. The college, the women's division of Tulane University, was founded in 1886, with its celebrated pottery commencing a decade later. Its primary organizer Ellsworth Woodward (1861-1939) was much influenced by earlier English Arts and Crafts thinking and therefore supported vocational education for women. Such training, it was reasoned, would provide a source of income for educated women who wished to continue working. Even if they married and left the work force, they would appreciate the arts and would thus support a market for the fine and decorative arts.

Native flora and fauna were emphasized in the decorative motifs of Newcomb College pottery, often in stylized versions. The familiarity of such designs no doubt helped to sell the wares. The chinaberry, or Indian lilac, was imported from Asian but quickly became naturalized in the American South, where it was cherished for its decorative flowers and berries, quick growth and propensity to form deep shade.

This excellent example was decorated by Harriet Coulter Joor (circa 1876-1965), one of the nine members of the first ceramic art class at Newcomb College and one of the most proficient early decorators. At the prestigious 1900 Exposition Universelle, Paris, Joor's work was among those awarded a bronze medal.

The Newcomb College Pottery enjoyed artistic success from its earliest days and went on to garner awards at the prestigious international exhibitions of the day. It has passed the crucial test of time and is greatly admired today.

J.W.K.

Louis Comfort Tiffany

American, 1848-1933

Bowl. circa 1905

stoneware: cast and carved with tulips;
glazed in ivory and overglazed in shaded green,
5 $^1/_8$ x 8 $^3/_8$ in. (13.03 x 21.29 cm.)
George S. Frierson, Jr. Fund. 91.28

Louis Comfort Tiffany was undoubtedly the most famous American proponent of the Art Nouveau style. The basic tenet of this Franco-Belgian decorative mode was "art in nature; nature in art." In creating a wholly original, non-historicizing style designers were inspired by such natural motifs as flowerheads, roots, vines, leaves, and stems; these could be abstracted rather than replicated.

Tiffany concurred with the Art Nouveau concept that all of the arts should be practiced as one thereby eliminating the historic but artificial distinction between the fine and decorative arts. Painters were to become furniture and jewelery designers and vice versa. Trained as a painter and immensely successful as an avant-garde interior designer, Tiffany began to experiment with pottery in 1898, intending to make it part of his famed "Favrile" line of glass and metalwork. None of the new Favrile pottery was exhibited until the 1904 Louisiana Purchase Exposition in St. Louis, where it was critically acclaimed.

Brilliantly eclectic in his designs, Tiffany has here utilized a traditional Chinese brush washer form but has greatly enlarged it and then overlayed the form with relief patterns of abstracted drooping tulip blossoms and leaves. The pale earth tones of the glazes are also fully in accord with the Art Nouveau preference for unobtrusive lyrical hues.

J.W.K

France, perhaps Paris

unidentified cabinetmaker

Table (table de milieu). circa 1690-1700

carved and gilded oak,
33 $^1/_2$ x 65 x 30 in. (85 x 165 x 76 cm.)
Museum Purchase in honor of the 75th Anniversary
of the Museum. 85.89

It is generally agreed that French furniture of the late 17th and 18th centuries represents the highest achievement of Western decorative arts. This splendid table is testimony to the verity of that premise, exhibiting the architectonic clarity, Baroque detailing and grandiloquent presence associated with the style of the Sun King, Louis XIV (reigned 1661-1715).

After he succeeded to the French throne in 1661, the twenty-three year old Louis XIV spent the next half-century making France first in the arts, military might and statesmanship. Versailles, the obsession of the young king, became the standard by which all proper royal residences were judged. The fine and decorative arts with which it was furnished were, in fact, at the service of the state in order to glorify and enhance it.

Eagerly sought were such elements as dramatic presence, contrasts of line and surface, elegant movement, and a heroic, grand symmetry. French designers turned back to the Classical world for such motifs as shells, husks, *rinceaux*, masks and console brackets but reinterpreted them with such refined discipline that a quiet formality was established. In spite of its opulent gilded surface and elaborate detailing, this table retains architectonic clarity and reads as a stately unit. The eye of the observer flows freely over the involved design without interruption or abrupt pauses. The best examples of this type of Louis XIV giltwood furniture display this balanced interplay between straight and curved lines.

In design and execution, the restraint and balance of this superb table tell us much about the grandeur of the French state at the turn of the 18th century.

J.W.K.

France

Movement by Claude-Siméon Passement
(1702-1769)

Mantel Clock (horloge de cheminée).
circa 1775-1780

cast, chased and gilded bronze, steel, iron,
glass, enamel and white marble,
20 1/2 x 15 3/4 x 6 7/8 in. (52 x 40 x 17.5 cm.)
Gift of Dr. and Mrs. Richard W. Levy in honor of
the 75th Anniversary of the Museum. 85.67

France during the 18th century achieved a pinnacle of production in the decorative arts that has yet to be surpassed. Patrons demanded a high level of aesthetic and technical excellence and were eager to pay for such quality. The strictly enforced guild system of France ensured that high standards were maintained in spite of a clamorous demand for objects in the latest mode. The result was that the best of these, such as this superb mantel clock, speak eloquently of the most refined and sophisticated of European cultures.

The case of the clock conforms to the tenets of fashionable Louis XVI taste through a classical-inspired vocabulary of laurel swags, urns, console brackets and Roman garlands. Less apparent to the modern eye are the elaborate references to either marriage or anniversary. The dial is surmounted by a heart-centered bowknot, a symbol of union, while the blossoms of the pinks and the laurel branches around the dial symbolize betrothal and purity, respectively. An ivy and acanthus guilloche at the base of the clock signifies the entwining of two purities or souls. Similarly, the oak leaf-and-acorn pendants at the sides of the case are symbols of faith and endurance against adversity.

The maker of the movement, Claude-Siméon Passement, was appointed clockmaker to King Louis XV and was awarded with artisan's quarters in the Louvre. He remains famous today as a maker of superb clock movements. The maker of the case is, thus far, unidentified.

J.W.K.

Attributed to
Thomas Affleck

American, born Scotland, 1740-1795

Chest on Chest. circa 1770-1790

mahogany, mahogany veneers, gilt-brass,
90 $^1/_2$ x 47 $^1/_2$ x 22 in. (229.87 x 120.65 x 55.88 cm.)
The Rosemonde E. and Emile N. Kuntz
Collection. 79.425

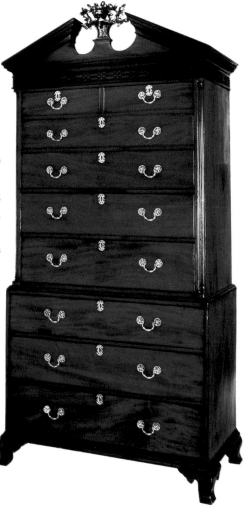

American furniture design of the 18th century was remarkably sophisticated, neatly assimilating Restoration, William and Mary, Early Georgian, Chippendale, and Neoclassical influences from England. Furniture-making shops flourished in Salem, Newport, New York, and Baltimore, with the greatest refinement occurring in Philadelphia.

A center of Colonial wealth, Philadelphia boasted an affluent merchant class eager for expensive, fashionable decorative arts. One of the English-trained cabinetmakers attracted by this situation was the Scottish-born Thomas Affleck. Arriving in Philadelphia in 1763, Affleck became a prominent proponent of the Philadelphia Chippendale style and exerted a broad influence upon Philadelphia taste.

Thomas Chippendale's 1754 publication of *The Gentleman and Cabinet-Maker's Director* introduced the English Rococo taste to America. In turn, Affleck interpreted this taste for his affluent Philadelphia clients. In this impressive chest-on-chest, employing a quantity of imported mahogany, one sees such features as a broken pediment, flute-carved side columns, ogee bracket feet, and gilt-brass hardware. The skillfully carved basket of flowers centering the pediment is a feature of Philadelphia Rococo taste. It is known that Affleck owned a copy of Chippendale's famed *Director* and therefore not at all surprising that he would have been thoroughly acquainted with the most advanced of Chippendale designs.

C.E.G.

Attributed to Alexander Roux

American, 1813-1881

Center Table. circa 1865-1870

Brazilian rosewood, mahogany, walnut burl,
ebonized cherry, holly and exotic wood veneers
on an oak carcase, gilt-bronze and iron,
31 5/8 x 51 1/4 x 31 1/4 in. (80.33 x 130.18 x 79.38 cm.)
Decorative Arts Discretionary Fund. 85.11

American furniture of the Renaissance Revival mode unites Renaissance, Baroque and Mannerist approaches to architectural design of 16th-and 17th-century France. In the construction of such furniture, the borrowed elements are used only decoratively and not structurally. This separates Renaissance Revival furniture from that of the Louis XVI Revival style, the sole mid-19th-century style that revived form as well as decorative motifs. Such architectural elements as balustrades, brackets, columns, pediments, pilasters, and volutes are employed freely in the Renaissance Revival style—as are such features as acanthus scrolls, classical busts, masques, fruit and foliage carved in high relief painted on porcelain or set in marquetry. The structure of such pieces tends to a blocky architectonic quality.

This boldly executed center table is a quintessential, high-style New York version of the Renaissance Revival style. It exhibits the expected Louis XVI 18th-century-inspired motifs of a rectangular top with demilune ends, a central marquetry *trophée* surrounded by interlaced banding, scrolls, foliage, and tendrils. The square-section legs are also derived from Louis XVI design as are the stretchers of addorsed scrolls centered by a handled covered vase.

The table is attributed to the shop of Alexander Roux, a New York émigré producer of luxury furniture in the Gothic, Rococo, and Renaissance Revival styles. It also has been suggested that the piece might be the work of Pottier and Stymus, successors to the decorating firm of Rochefort and Skarren in 1859. The Pottier and Stymus firm also produced elaborate high-style furniture in the Renaissance Revival manner.

J.W.K.

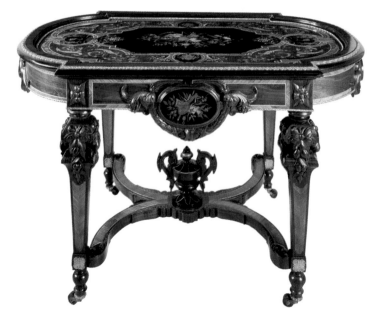

Bror Anders Wikstrom

American, born Sweden, 1854-1909

Cabinet. circa 1900

mahogany, 67 x 47 $^3/_4$ x 13 $^1/_2$ in.
(170.18 x 121.28 x 34.29 cm.)
Gift of Mr. and Mrs. G. R. Westfeldt.
14.98

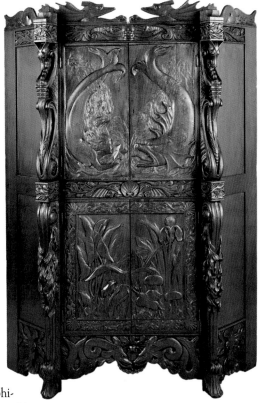

The regnant international decorative style at the turn-of-the last century, the Art Nouveau, sought to breakdown the cumbersome traditional distinctions between the fine and the decorative arts. Swedish-born Wikstrom epitomized this thinking since he was a portrait and landscape painter, an etcher and illustrator, a designer and the founder of a literary and artistic journal as well as a cabinetmaker.

A major tenet of the Art Nouveau philosophy was "Art in nature; nature in art" by which its proponents emphasized the development of a new modern style having no historical precedents and based upon motifs taken from nature. In this lively representation of calla lilies, irises, mushrooms, seaweed and aquatic creatures Wikstrom adhered to this philosophy. Art Nouveau thinking also emphasized that natural motifs should be sensitively stylized into sinuous, curving motifs such as the crisply carved clumps of kelp pendant from the softly modelled console brackets at either side of the lower half of the cabinet.

Such vigorously fanciful representations as the mermaid confronting a fierce dolphin and the elaborate silhouette of the pediment recall Wikstrom's career as the most renowned New Orleans pageant designer of the late 1880s and 1890s. He was repeatedly commissioned for Carnival designs by the Krewes of Rex and Proteus with an eager public awaiting his parade floats.

The modernity of the design of the cabinet is emphasized by its dramatically canted sides. The angle at which these are set thrusts the fancifully carved facade at the viewer while the relative simplicity of the side panels contrasts effectively with the elaborately worked facade.

J.W.K.

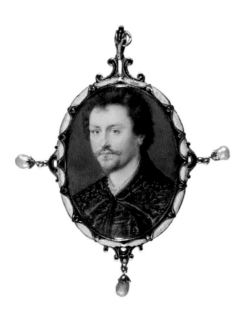

John Hoskins

English, circa 1595-1665

Sir George Wentworth

watercolor on parchment, 2 1/4 x 1 5/8 in.
(5.63 x 4.5 cm.)

Richard Cosway

English, 1742-1821

P.P. 1790

watercolor on ivory, 2 3/4 x 2 1/4 in. (6.88 x 5.63 cm.)
The Latter-Schlesinger Collection, gift of Shirley
Kaufmann, in memory of Harry and Anna Latter.
74.344 & 74.381

A portrait miniature is a small portable paint-
ing designed as a memento, portraying for
the owner an admired or beloved person. The
history of this art form began in the 16th
century in England and continued to be
fashionable, both in England and on the
Continent, throughout the next three cen-
turies. In the mid-19th century the four

hundred year tradition met its decline with
the invention of photography.

The portrait of *Sir George Wentworth* by
John Hoskins displays a quiet charm which
demonstrates Van Dyck's influence in
England. Here Hoskins' palette is subdued to
give a simple yet dignified effect. Using water-
color on parchment, the artist painted the
eyes in his typical manner: the pupils are clear
and round with light reflected in them. The
complexion is worked with a shading tech-
nique using a greenish stippling or dotting,
which was to be copied by other artists in
later years.

The portrait of P.P. by Richard Cosway, con-
sidered the dominant figure of 18th-century
English miniaturists, shows the artist's prefer-
ence for using quick, short gray brushstrokes
to model the figure with keen delineation. His
broad application of watercolor enhances the
luminosity of the ivory and at the same time
imbues the portrait with vitality and elegance.
Avoidance of dark backgrounds allows the
lighter colors to surround the figure, resulting
in a warm and balanced tonality.

J.G.C.

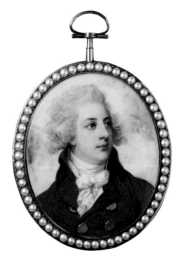

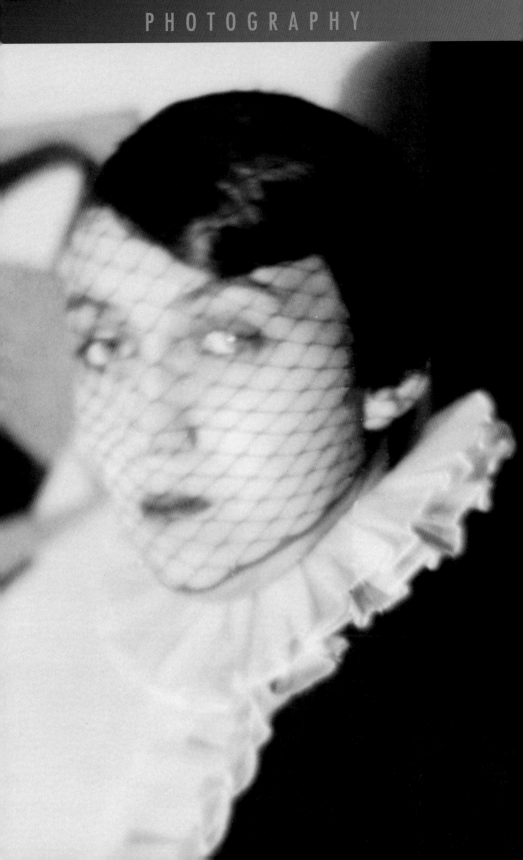

William Henry Fox Talbot

English, 1800-1877

View of the Paris Boulevards from the First Floor of the Hôtel de Louvais, Rue de la Paix. 1843

calotype, 6 $^{17}/_{32}$ x 6 $^{25}/_{32}$ in. (16.6 x 17.2 cm.)
1977 Acquisition Fund Drive. 77.66

William Henry Fox Talbot was a man of science who was instrumental in the creation of a new form of art. He was a noted mathematician, a leading historian, a well-published linguist, as well as a member of Parliament, the Royal Astronomical Society, and the Royal Society of British Scientists. Talbot also found time, beginning in 1833, to conduct a series of experiments which are now recognized as the foundation of modern photographic processes.

By 1835 Talbot had produced his first photograph, yet he did not publicize his remarkable achievement until 1839, after he had learned that a Frenchman named L.J.M. Daguerre had released his own photographic inventions. Although each of these two men is sometimes referred to as the inventor of photography, the first permanent recordings of images rendered onto a light sensitive medium were created by Daguerre's early partner, Joseph Niépce in 1824. Unlike his competitor's "daguerreotypes," Talbot's "photogenic drawings" were prepared by a negative/positive process which allowed the simple reproduction of an unlimited number of photographic prints. In 1841 Talbot patented an improvement of his technique, the "calotype," which required shorter exposure times and yielded more detailed results.

This calotype was taken in Paris where Talbot had travelled to promote his paper-based photography. Like the millions of tourists who have followed, Talbot photographed the view outside his hotel window. Yet Talbot, the scientist, had a purpose which transcended the ordinary inclination towards itinerant reportage. Pointing his camera at a world which had never been photographed, Talbot explored the capabilities of a new technology and the essence of an emerging form of art.

S.V.M.

Julia Margaret Cameron

English, 1815-1879

Study of Beatrice Cenci (May Princep). 1866

albumen print,
12 ¹⁵/₁₆ x 10 in. (32.9 x 25.4 cm.)
Women's Volunteer Committee Funds.
73.225

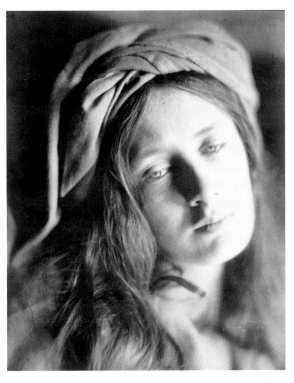

Julia Margaret Cameron was in many ways a conventional Victorian lady. She was also, however, a member of an elite and unusual intellectual circle. Cameron discussed poetry and literature with Tennyson and Longfellow, art and painting with Rossetti and Whistler, and science with Darwin and Sir John Herschel, an astronomer and a pioneer in the field of photographic chemistry.

Cameron's career in photography did not begin until she was forty-eight years old when her family gave her a camera as a gift. By that time there were already thousands of professional photographers throughout Europe who were all producing standardized, sharply focused *carte-de-visite* sized photographs of their clientele. These portraits were competent but hardly artistic. They were easily reproduced, shared and collected amongst friends and relatives.

Cameron's approach to photography and portraiture was artistically, and perhaps accidentally, iconoclastic. Working with beginner's equipment, large glass-plate negatives and lengthy exposures, Cameron's portraits have a soft-focus style which some of her contemporaries found romantic but others decried as amateurish. The composition of her portraits was also unusual. Just the head might fill the entire frame, and the eyes rarely confronted the camera. Although she produced many portraits of friends and family, Cameron also placed her sitters in flowing robes and beatific poses to represent religious or literary figures. In this photograph Cameron's niece, May Princep, is portrayed as Beatrice, the tragic character of Shelley's play *The Cenci* (1819).

Julia Margaret Cameron intuitively demonstrated that the photographic portrait, though mechanically produced, could be imbued with personal and even spiritual significance. She was one of the first artists to understand that the photograph could record more than mere appearances.

S.V.M.

Charles Hippolyte Aubry

French, 1811-1877

Histoire Triste (Sad Story). 1866

albumen print. 14 ¹⁵/₁₆ x 10 ⁷/₈ in. (37.9 x 27.6 cm.)
Museum Purchase. 79.131

Though portraiture was the obvious milieu for a Parisian photographer in 1864, Charles Aubry had other ideas. He opened a business that year to sell his photographs of leaves, plants, floral arrangements, and sculptures to decorative and fine arts students and professionals. He envisioned that they would use his images to create wall paper or fabric designs,

and as models in their drawing classes. Unfortunately, Aubry misjudged his market's acceptance of photographs as templates for more standard modes of artistic production. His business went bankrupt after only one year.

In 1866 Aubry employed his under-utilized skills in arranging objects in front of his camera to produce this eerie and unusual photograph. Along with bones and scalpels, and a small photograph of the deceased (near the lower edge), this image reproduces Aubry's excoriating letter to the Parisian newspaper *Le Courrier Français*. In it, Aubry recounts the "sad story" of his neighbor, Monsieur C. Jodon, who fell ill and sought

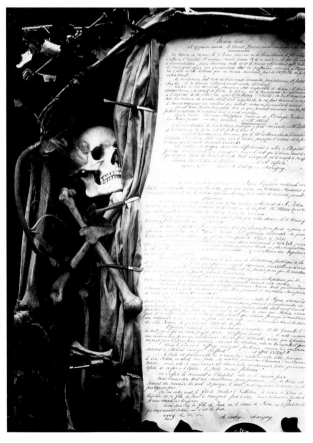

treatment at a public hospital. After being ignored for many hours, M. Jodon went home. Returning to the hospital the next day, he was again neglected by the hospital staff and soon died. Aubry's letter condemns the French health care system and the press for failing to report the tragic and negligent incident.

Aubry struggled throughout the rest of his life to find a niche for his work. This photograph, as a potent *memento mori*, a poignant piece of political and media criticism, a nimble linkage of image and text, and a tableau photograph of macabre beauty, suggests that Aubry was ahead of his time.

S.V.M.

Ernest James Bellocq
American, 1883-1949

Untitled (Young Woman in Undershirt and Black Stockings).
1911-13

gold toned silver print (p.o.p.),
19 7/8 x 8 in. (25 x 20.2 cm.)
Women's Volunteer Committee and
Dr. Ralph Fabacher Funds. 73.112

E.J. Bellocq worked as a commercial photographer in New Orleans during the first three decades of the twentieth century. Little else is known about his life. Besides the fact that he was hardly ever seen without his Bantam Special Camera he did little to distinguish himself in the eyes of his contemporaries. It was not until some twenty years after his death that Bellocq's photographic legacy was discovered.

In 1966 Lee Friedlander, the important contemporary photographer, purchased a fat box of old, deteriorating glass plate negatives from an antique dealer just off Bourbon Street in New Orleans' French Quarter. The prints Friedlander produced from these negatives disclosed a curious collection of portraits of prostitutes from Storyville, the red-light district of old New Orleans. They were photographs which Bellocq had taken around 1912 and 1913, but had kept hidden in his desk.

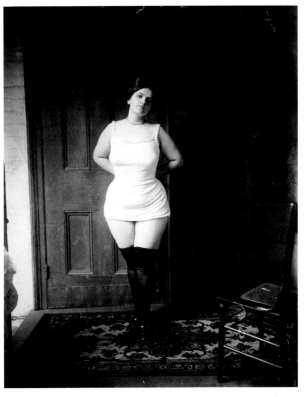

These images are unique as an historical record, and they offer explicit testimony to the inscrutable nature of the collaboration between a photographer and his model.

These portraits were not purloined from a peep show, rather they were crafted in a managed atmosphere of only mildly articulated indecency, in which the women, it seems, were free to interact with Bellocq to defy their objectification. Whereas in their professional and nocturnal lives these women were examined with languor and lasciviousness, their portraits possess the modesty of the day before, or the prudent intimacy of the morning after.

S.V.M.

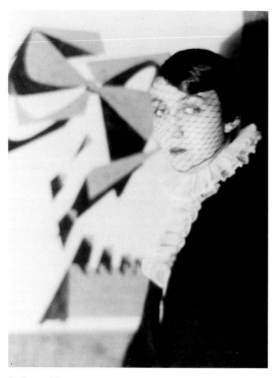

Man Ray
born Emmanuel Rudnitsky
American, 1890-1976

Portrait of Berenice Abbott in Front of Man Ray Composition. 1922

gelatin silver print, 8 ¹/₈ x 6 ³/₁₆ in. (20.6 x 15.7 cm.)
Museum Purchase. 87.40

Man Ray began his creative pursuits in New York City, but it was his move to Paris in 1921 that inaugurated the most seminal period of his artistic career. There he interacted with the most prominent members of the European avant-garde, including Picasso, Marcel Duchamp and André Breton. As a contributor to the Cubist, Dada and Surrealist movements, Man Ray experi-mented with innovative and unusual artistic strategies and techniques. In his paintings he created new languages of geometric abstraction. His sculptures and assemblages incorporate found objects as diverse as violins and hand-guns which helped define a new category of art for which selection, juxtaposition and wit were creative components as essential as form, color and expertise. Yet Man Ray's contributions to photography were even more varied and profound.

By placing various objects on top of photographic paper and then exposing his arrangements to light Man Ray was one of the first artists to explore abstract photography. These compositions, which he called rayographs, illustrate that light and shadow can be controlled without the assistance of a camera to produce images of whimsical yet formal beauty. His use of other techniques including solarization and photomontage was equally progressive and his portrait photographs were revolutionary in their unnerving blend of intensity and informality. In this portrait the photographer Berenice Abbott (who began her career as Man Ray's assistant) is posed against a striking geometric background provided by one of Man Ray's own compositions. This collage, completed in 1922, is also an important work in the New Orleans Museum of Art's permanent collection.

S.V.M.

André Kertész

American, born Hungary,
1894-1985

Théâtre Odeon, Paris. circa 1926

gelatin silver print, 3 x 3 ¹/₈ in. (7.6 x 7.9 cm.)
Women's Volunteer Committee Fund. 73.170

André Kertész once said, "Everybody can look but they don't necessarily see." With the camera as his notebook Kertész recorded the transient luster of everyday experiences through an eclectic blend of intuition and expertise.

Though many of his photographs had been published in Hungarian magazines, Kertész emigrated to Paris in 1925 to more assiduously pursue a professional photographic career. This endeavor had humble beginnings as Kertész first sold his photographs in postcard form to the cosmopolitan customers of bustling Parisian cafes. This miniature and splendid photograph is one of Kertész's original Parisian efforts, one of eighteen such vintage prints in NOMA's collection.

Kertész was one of the first artists to exploit the potential of the modern, small and manageable camera which enabled him to swiftly and instinctively capture imagery that caught his eye. Despite the spontaneity of his methods many of Kertész's photographs display a consistent style. This photograph exemplifies the angular and geometric sense of composition with which Kertész often ordered the world through his camera's viewfinder.

Kertész traveled to the United States in 1936 where initially he struggled to gain professional acceptance. His idiosyncratic style of reportage did not meet the more didactic demands of the photo-editors of popular American magazines such as *Life, Look* and *Harper's Bazaar.* Although Kertész published thousands of photographs working under an exclusive contract with Condé Nast publications from 1949 through 1962, it was not until a retrospective of his work at New York's Museum of Modern Art in 1964 that he was recognized as a seminal figure in the history of photography. André Kertész was more of a picture taker than a picture maker. As an artist and a photo-journalist he developed a unique, poetic and influential synthesis of documentation and subjectivity.

S.V.M.

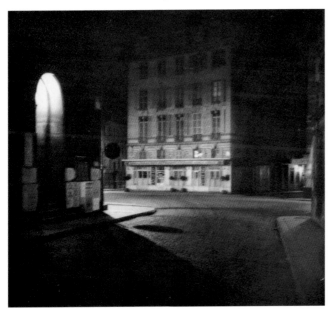

Clarence John Laughlin

American, 1905-1985

Elegy for the Old South (No. 6).
1946

gelatin silver print, 10 ⁷/₈ x 13 ³/₈ in. (27.2 x 33.4 cm.)
Museum Purchase. 73.30.8

New Orleans has had a long and rich history of photographic activity. One of the earliest daguerreotype studios in America was established in the French Quarter in 1840 by Jules Lion. Throughout the 19th century hundreds of commercial photographers including Edward Jacobs, J.D. Edwards, and George F. Mugnier produced well executed portraits and picturesque views. During the first half of the 20th century a few New Orleans photographers began to create less pedantic images. The most prominent and influential of these expressive artists was Clarence John Laughlin.

Born in rural Louisiana and raised in New Orleans, Laughlin made his first photographs in 1934, initiating a career that would last over fifty years. Analyzing his photographs, Laughlin explained that he had "attempted to transcend the customary recording usage of the camera....The imagination's creative power can at times be projected, despite popular misconceptions to the contrary, through the searching eye of the camera's lens."

In Louisiana's deserted and decrepit plantation houses Laughlin located the ideal subject with which to explore his poetic vision. In his photographs of these abandoned estates Laughlin illustrates not only architectural and historical significance, but also the broader metaphysical concerns and surrealist sensibility which so inspired his work. Describing this photomontage of the Woodlawn Plantation Laughlin wrote: "Looking with the eye of the mind, which, driven by memory and desire, recombines the elements of the natural world, we see the inner essence of the tragedy of Woodlawn....The house seems to be receding from us as though it were moving back into the shadows of the past....And the moss falls, in a ghastly rain of intolerable grieving."

S.V.M.

Diane Arbus
American, 1923-1971

A Young Brooklyn Family Going for a Sunday Outing. 1966

gelatin silver print, 14 $^{15}/_{16}$ x 14 $^9/_{16}$ in. (37.9 x 37.5 cm.)
Ella West Freeman Matching Fund. 73.29.4

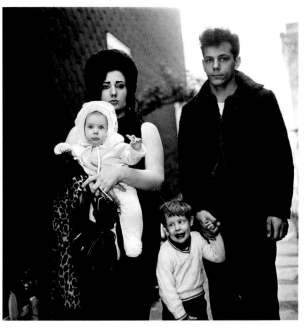

We rarely make eye contact with strangers. While walking down a crowded city street we often pretend to be more interested in the tops of our shoes than the hundreds of individuals who pass by. Yet our desire to examine other people is irresistible, if not innate. So our eyes are constantly searching the shuffling landscape of faces for someone or something extraordinary.

This practice of people watching is usually an incidental and undemanding hobby. As amateur observers we are content to steal a glance while maintaining a safe distance of insular detachment. But for Diane Arbus people watching was a professional, confrontational, and emotional occupation.

Not content with casual surveillance, she looked long and hard at strangers and recorded her findings through the lens. Like other photographers of her era Arbus created her images through a searching and ambulatory method which exposed unprecedented and aberrant subject matter to artistic and critical interpretation.

Arbus found many of her subjects outside the mainstream of social interaction. She photographed dwarfs and giants, nudists and transvestites, and the physically or mentally handicapped. Yet many of her photographs reveal less obvious, but equally noteworthy characters and predicaments.

By illuminating some of the discreetly unconventional persons within our midst, Arbus' pictures compel us to acknowledge the vulnerability of our own sense of the meaning and appearance of normality.

S.V.M.

David Levinthal
American, born 1949

Untitled, from the series The Cowboy and the Western Frontier. 1988

unique polaroid print, 20 x 24 in. (50.8 x 61 cm.)
Gift of H. Russell Albright, M.D. 93.548

David Levinthal is one of many contemporary photographers who suspect that the world has already been sufficiently photographed. Instead of seeking to record primary experiences, these artists seek their inspiration from other, less personal sources. Turning their critical attention to newspapers, magazines, television, film, advertising and all other aspects of popular culture, these "post-modernists" acknowledge, satirize, and exploit the pervasive influence that the mass media asserts on our society.

Since 1973 David Levinthal has been photographing toys and dolls which he has arranged before his camera in dramatic tableaux. In this photograph Levinthal uses these childish materials to illustrate the visually idiomatic components of a familiar genre. The saturated sunset colors and the figure of a man controlling a spirited horse are so emblematic of the Western, as it has been defined in mass media, that one is apt to neglect the obvious plastic artificiality of Levinthal's presentation.

Levinthal's photographs are empowered partly by the legacy of our preadolescent inclination to invest our dolls and other playthings with dynamic and melodramatic lives. Their plastic bodies are resilient to mistreatment and in vast dioramas created in playrooms or backyards these figurines are constantly facing abandonment, dismemberment, death, or the happily-ever-after. Though miniature characters, they play much larger and stereotypical grown-up roles.

As children we maneuvered these toys in childish games while busily creating acculturated expectations of our adult lives. As an adult and sophisticated artist Levinthal exploits their magical and anthropomorphic qualities to create reverberant "false realities," which disarmingly illustrate that photographs and consumers are equally prone to manipulation.

S.V.M.

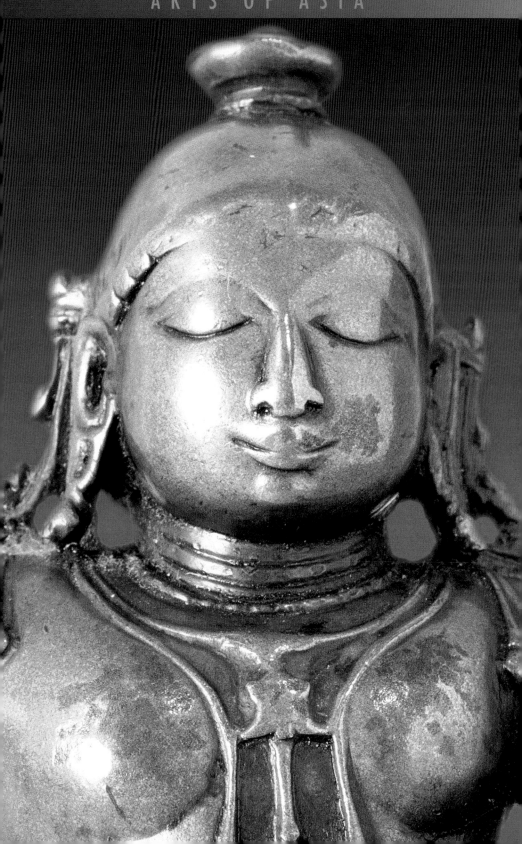

Yangshao Culture

Gansu Province, China, 3000-1850 B.C.

Storage Jar

red earthenware, painted in black and red,
15.6 in. (40 cm.)
Gift of Mr. and Mrs. Moise S. Steeg, Jr.
in honor of the 75th anniversary of the Museum. 86.56

The Yellow River valley is commonly regarded as the birthplace of Chinese civilization. The Yangshao culture, the earliest known Neolithic civilization of this area, was discovered in the 1920s by the farmers of Yangshao Village. This village and other related sites have been subject to excavations ever since, as archaeologists seek to understand the chronology and characteristics of the Neolithic peoples who inhabited this area. The picture that has emerged is one of settled farmers whose principal crop was millet, although hemp and silkworms were also cultivated. They used a variety of implements and had domesticated animals. Hunting and gathering supplemented their diet.

In terms of ceramics Yanghsao culture is characterized by a red pottery painted with black decorative designs. Large jars, such as this one, were used as storage vessels indicated by the remains of grains and other food stuffs found inside many. However, the presence of children's bones in some of these large jars also indicates that they were, at times, used for burial.

The New Orleans jar comes from Gansu province in the far northwest of China, and was produced by an off-shoot of the Yangshao culture called Machang. Machang artifacts are the most recently produced of the excavated Yangshao material and are found at the westernmost edge of the Yangshao region. The storage jar is made of red earthenware coiled in carefully prepared strips and then beaten smooth with a paddle. It was fired in a relatively sophisticated kiln, after which it was burnished and decorated with intricate and graceful designs executed in black and red earth pigments.

L.R.M.

Western Zhou Dynasty

China, 1027-771 B.C.

Zun (Ritual Wine Container)

bronze, 11 5/8 in. (29.5 cm.)
Gift of Jun Tsei Tai. 90.398

An indigenous bronze culture flourished during the Shang (circa 1850-1100 B.C.) and Zhou (circa 1100-221 B.C.) Dynasties in China and created works of great technical and aesthetic brilliance. Most bronzes appear to have been made for rituals performed by Shang and Zhou kings. Some vessels held food; others, wine or water. Within each type there is a great variety of individual shapes, which are seldom exactly duplicated. This Zun, a broadly flared vessel, was a wine container used during court rituals. In the earliest records of bronze and oracle bone inscriptions the term zun denotes not a shape, but rather a function: it applies to any sacrificial wine receptacle. It was not until the Song period (960-1279) that specific shapes were designated zun.

In Shang bronzes the animal mask, or taotie, is a prominent decorative motif. Created of zoomorphic and human features, this enigmatic motif was gradually replaced during the Zhou by a sweeping curvilinear bird design. This tall, cylindrical Zun is decorated with both the taotie and bird motifs. The flanges have been omitted on the upper third of the vessel and thereby draw attention to the lower sections. Below the trumpet-shaped upper section is a steeply shouldered mid-section decorated with four snub-nosed ram's heads. The mid-section is decorated with two taotie masks and with the eyes at either side of the flanges. The lower section, above a rather high footrim, is decorated with paired birds facing each other across the flanges.

L.R.M.

Han Dynasty

China, 206 B.C.-A.D. 220

Standing Female Figure

earthenware with polychrome, 26 ¹/₂ in. (67.3 cm.)
Gift of Mr. and Mrs. Frederick M. Stafford. 80.193

Most Han period grave goods represent items used by the occupant of the tomb before death. This allowed the deceased to continue, in the netherworld, the lifestyle to which he or she had become accustomed. Such items also proclaimed the status of the deceased. Attendants, most often the female members of the household, soldiers, horses and farm animals were interred in the form of replicas.

The use of such replicas has a long history in China. The interment of terra cotta and wooden figures gradually replaced the early practice of human sacrifice and gained popularity during the Zhou and Qin periods.

The best known example is the burial of over six thousand terra cotta soldiers in pits near the tomb of the first emperor of the Qin dynasty (d. 209 B.C.).

Here a female attendant is seen clothed in a three-layered robe that flares out in a trumpet shape at the bottom. Long inner sleeves cover her clasped hands. While the upper part of her body is relatively flat and stiff, the face of the figure has been given an emotive expression. Figures such as this have been found in many locations in China including Shaanxi, Shandong and Hubei provinces. All are dated to the Western Han period and most were made during the 2nd century B.C.. Although considerably larger, the New Orleans *Standing Female Figure* is quite similar in shape and form to figures excavated in 1953 from a tomb in Xi'an, Shaanxi province, which date to the Western Han (206 B.C.-A.D. 8).

L.R.M

Eastern Han Dynasty

China, 25-110

Tomb Relief with Procession of Horsemen and Chariots

carved gray limestone,
17 3/4 x 54 1/2 x 4 1/2 in. (45.1 x 138.4 x 11.4 cm.)
Gift of Mrs. Ping Y. Tai. 93.364 a

This relief formed part of a typical 2nd century A.D. tomb-shrine complex. In ancient China ritual practice enabled the living to communicate with the dead. Descendants expressed their filial piety by making offerings, by paying homage, and also by receiving teachings from their ancestors. A partial inscription at the far left of this relief confirms its place in a ritual setting: in the inscription the spirit is invited to partake of the sacrifice.

This work is carved in extremely low relief. Two horizontal registers comprise the scene: the upper, scroll-work and animal heads; and the lower, a procession of attendants, equestrian figures, and figures in chariots. Silhouetted against a vertically striated ground, thin incised lines create the forms' internal definition.

In most extant Eastern Han tombs specific conventions dictate the location of subject matter: ceilings, for celestial scenes or omens; and walls, for historical, legendary or mythological narratives and processions. Processions are an almost ubiquitous theme in Eastern Han funerary art and may reflect actual components of ancient Chinese funeral ceremonies. Also, the number and type of chariots, horses, and attendants are indicative of status, both of the mourners and of the deceased.

Although the motifs and decorative schemes of Eastern Han funerary art are conventionalized, there are identifiable regional styles. The technique and style of this carving reflects a style prevalent in Shandong province in the 2nd century A.D. Recent excavations in Jiaxiang county, home of the *Wu Liang Shrine*, the most famous example of this relief style, have unearthed fragments similar to this relief.

L.R.M.

Eastern Wei Dynasty

China, 534-550

Buddhist Stele

stone, 35 x 22 ¹/₄ in. (89 x 56.6 cm.)
Gift of Mr. and Mrs. Frederick M. Stafford. 76.422

Buddhism was imported from India in the 1st century A.D., but did not gain widespread popularity in China until the end of the 4th century. The offer of salvation and the possibility of a blissful life after death were tremendously appealing to Chinese in all walks of life. Stelae such as this one were commissioned by devout Buddhists as acts of piety and placed within temple precincts.

Carved in high relief, the central figure sits under a stylized canopy. He is identified in the inscription as Amitabha, the Buddha of Infinite Light. Amitabha had vowed that all who believed in him would be reborn in the Western Paradise where they would listen to his teachings of compassion. As usual an aura of tranquil repose emanates from the Buddha. Stylistically the round proportions of his head, sloping shoulders, and fluidly curving folds of his robe relate this image to others executed around the year 545 in Henan Province.

Flanking Buddha are simply incised figures representing the donors of the stele identified by the adjacent calligraphy. In respectful poses they face the center. On Amitabha's left are five females each carrying a lotus flower. On his upper right are three monks; below them is a woman; behind her are two military officers. The sharply cut calligraphy is well-balanced, revealing the strength characteristic of this period.

J.G.C.

Northern Qi Dynasty

China, 550-577

Standing Buddha

white marble with trace polychrome,
25.35 in. (65 cm.)
Gift of Jun Tsei Tai. 87.263

appear on the bases of several Northern Qi stelae and may also be seen in the caves of Xiangtanshen. The New Orleans *Standing Buddha* is similar in subject and style to a dated (577) Buddha from west-central Hubei province, now in the Royal Ontario Museum.

L.R.M.

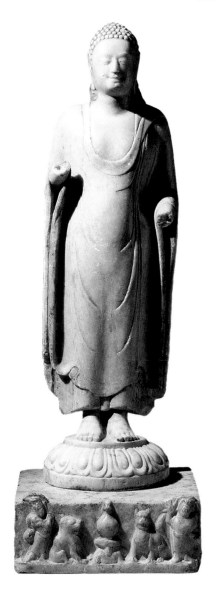

The elongated earlobes, small hair curls, and the *ushnisha*, or cranial bump, present in this *Standing Buddha* are several of the iconographic features invariably seen in artistic representations of the Buddha. The small hair curls turning to the right were probably borrowed from Jain art of India and came to signify the Buddha's divine nature. The elongated earlobes derive from the heavy ear ornaments that the historical Buddha Sakyamuni, as a prince, would have worn. The earlobes thus serve as an indication of his princely nature. The cranial bump, while one of the most prominent iconographical features of the Buddha, has an unclear origin but has come to be seen as a source of wisdom.

This *Buddha* stands in a columnar posture upon a lotus pedestal, which in turn is placed upon a separate carved marble plinth. Behind the Buddha's head is the remnant of a mandorla or halo, but not enough remains to identify the iconography. The Buddha is clothed in the traditional attire of the monk, and traces of polychrome, barely visible on the surface of the robes, indicate that these robes were at one time painted. Although the figure's hands are now missing, they appear to have been held in the gestures of reassurance and charity.

The sides of the plinth on which the Buddha stands is carved with representations of the Eight Spirit Kings. These Spirit Kings

Tang Dynasty

China, 618-907

Horse

sancai-glazed earthenware,
22 x 6 x 17 in. (55.8 x 15.2 x 43.1 cm.)
Gift of Allan Gerdau. 52.37

The Tang Dynasty (618-907) was a period of great cultural splendor in China. The capital Chang'an had a population of approximately one million and was one of the world's most cosmopolitan cities. Because of the thriving trade along the Silk Road, which extended from Constantinople to Chang'an, the city was a popular destination for foreign and domestic visitors and traders, and exotic goods from every region of China and the Western world were sold in the city's markets.

The arts also flourished during the Tang. One of the most beautiful innovations, that of the *sancai*, or three-colored glaze, took place in the field of ceramics. *Sancai* glazes result when fired metal oxides such as iron, zinc, copper, cobalt, and manganese are transmuted into rich yellow, green, brown and blue tones.

The Tang *Horse* is a tomb sculpture, or *mingqi*. The practice of burying objects indicative of the wealth and status of the deceased derived from Shang and Zhou practices of human sacrifice. Most tomb sculptures of the Tang period represent humans, animals or spirits. The strongly muscled *Horse* is a realistic portrait of the new breeding stock available in China during the Tang. The mane and tail that were originally attached survive only partially. This type of large *sancai* horse with a mane attached after firing is characteristic of the Wude through Jinlong periods of the Tang. Apricot leaf-shaped ornaments hang from the trappings, and the saddle and saddle cloth have been left unglazed.

L.R.M.

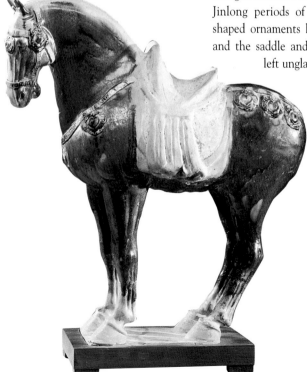

Jin Dynasty

China, 1115-1234

Bottled-shaped Vase, Cizhou ware

stoneware, glazed, 11 in. (28 cm.)
Gift of Dr. Robert E. Barron, III. 93.301

Southern Song Dynasty

China, 1128-1279

Covered Bowl, Longquan ware

Porcellanous ware, raised and carved with celadon glaze,
4 x 5 in. (10.2 x 12.7 cm.)
Gift of Dr. Robert E. Barron, III. 94.320

China, 1128-1279

Bowl, Qingbai ware

Porcelain, *qingbai* glaze with carved peony design,
2 5/8 x 7 1/4 in. (6.7 x 18.4 cm.)
Gift of Dr. Robert E. Barron, III. 85.171

The understated elegance and beauty of Song Dynasty ceramics are unparallel in the history of Chinese art. The Song actually encompasses several distinct political divisions: the Northern Song, 960-1127, which ended with the takeover of northern China by the Jin Tartars, who ruled from 1115-1234, and the Southern Song which ruled the south from 1128-1279.

Northern and Southern kiln sites produced distinctive wares. The white-glazed *Bottle-shaped Vase* belongs to a type of stoneware produced at a series of kilns in northern China from the late Tang (618-906) to at least the end of the 14th century. Charac-terized by their strong shapes and the transparent glaze that is applied over a slipped body. Cizhou wares are also known for their free and varied decoration. NOMA's undecorated *Bottle-shaped Vase* is a beautiful example of the strong potting associated with this folkware.

Longquan ware, as seen in the *Covered Bowl*, is also known as southern celadon, a product of a great number of kilns in southern China. The glaze, composed primarily of wood-ash, was applied in several applications resulting in a thick glaze with a beautiful deep color and gloss. NOMA's *Bowl* is typical of early Longquan ware in the simple carved lotus petals around the outside and on the lid.

Qingbai (literally "clear white") ware is also commonly known as *yingqing* ("shadow blue"). Both terms refer to the slight blue cast of the transparent glaze which covers the pure white porcelain body of this spectacular ware. The first true porcelain in the history of Chinese ceramics, this extremely fragile ware was produced from the beginning of the 11th until the 14th centuries. The NOMA *Bowl*, with its thin walls and delicately incised peony decoration, is a quintessential example of this magnificent achievement.

L.R.M.

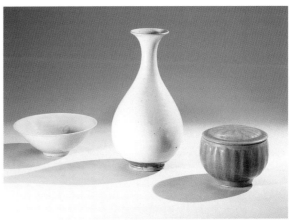

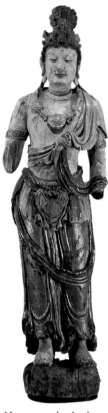

Jin Dynasty
China, 1115-1234

Guanyin.
circa 1175

wood with gesso and polychrome,
91 in. (231.14 cm.)
Gift of Jun Tsei Tai.
85.209.1

Foshuo Shentian qing. dated 1155

woodblock print on paper, 35 x 98 in. (91 x 251 mm.)
Gift of Jun Tsei Tai.
85.209.2

In the 12th century, the native Chinese Song Dynasty (960-1279) ruled central and south China. However, the Juchen tribe controlled North China. Ruling under the dynastic title of Jin, the Jurchen fostered a powerful resurgence of Buddhism in which architecture, painting, sculpture, and printing flourished.

This Guanyin, the Bodhisattva of compassion, is one of the few extant wooden Buddhist sculptures from the Jin. Evidently the victim of a fire in the 1930s, the statue is considerably restored, and much of the surviving polychrome and gilding are the result of later repainting. However, radiocarbon dating of the wood has revealed a date entirely consistent with the Jin period.

Upon its donation to the New Orleans Museum of Art, five documents were discovered in the Guanyin's relic chamber: three 12th century woodblock-printed sutras, fragments of a history of the transmission of Buddhism from India to China, and the original inventory list of objects placed in the statue. Two of the sutras are illustrated and inscribed as to date, place of origin, and donor. The earliest of the sutras is the Foshuo Shengtian qing dated to 1155. The text was dedicated by "The Buddhist disciple Liu Zhi of Changmin cun and his wife Zhang..." A judgment scene from one of the Buddhist Hells illustrates the text. The Arbiter of Hell stands in front of a fortress accompanied by four beings of the netherworld, as he passes judgment on the suffering soul cowering before him.

L.R.M.

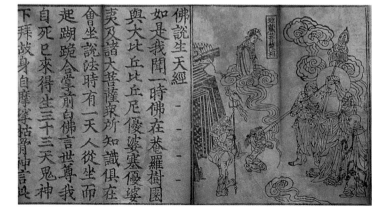

Ming Dynasty

China, 1368-1644

Guardian Figure

earthenware with sancai glaze, 24 ³/₄ in. (63 cm.)
George S. Frierson, Jr. Fund. 93.334

Current scholarship indicates that the first glazed roofs in China were created sometime during the Northern Wei Dynasty (386-534) (Unglazed pottery roof tiles with impressed designs are known from as early as the Western Zhou Dynasty [1027-771 B.C.]). Plain roof tiles are in the form of a half cylinder, used alternately as an under- and over-tile, a shape believed to derive from an early form of roofing made of halved bamboo poles. However, the best-known type of roof tile, and the group to which this Guardian Figure belongs, is that of the larger animal and figurative tiles placed along the ridge lines of the roof.

The tall, fierce armored Guardian Figure standing in an aggressive pose is made of a soft earthenware covered with a low-fire lead glaze. The familiar Tang-style sancai, or three-color, glaze covers most of the body of the Guardian Figure, and the face is covered in a purplish-blue glaze. It is difficult to determine either the provenance or date for this, or any roof tile, as the basic materials for such wares were readily available in many parts of China, and the objects themselves were inexpensive and could have been produced almost anywhere in China. Moreover, a roof may appear to be tiled uniformly but in fact be covered with tiles from different centuries, as replacement tiles created in a similar style and coloration could be easily produced. Acknowledging this, the New Orleans Guardian Figure nonetheless appears stylistically to belong to a group of ridge tiles

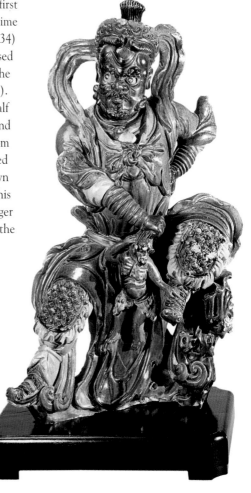

dating to the Ming Dynasty (1368-1644) and is quite similar to a King of Hell from 1523 in the Royal Ontario Museum, Toronto.

L.R.M.

Qing Dynasty

China, 1644-1911, Kangxi period, 1662-1722

Peach Bloom Water Coupe

Kangxi six-character mark on base, porcelain,
3 ¹/₂ x 5 in. (8.9 x 12.7 cm.)
Bequest of Morgan Whitney. 14.53

The long reign of the second Qing emperor, Kangxi, witnessed a blossoming of all the arts, including porcelain. During this period porcelain of many types was produced, but the most notable achievement was in the realm of monochrome glazes. The reintroduction of copper red and the development from this of the "peach bloom" glaze as seen in this *Water Coupe* was one of the most significant developments in the history of late 17ᵗʰ-and early 18ᵗʰ-century porcelains.

The peach-bloom glaze was not painted onto the surface of the piece. Rather, the glaze was blown onto a vessel using a bamboo tube. By repeatedly blowing thin layers of dif-ferent types and amounts of glaze onto the white porcelain body, the characteristic soft pinkish-red color, that varies in tonality from dark to light and often has speckles of pale green, was achieved. The greatest difficulty in producing this glaze came in the firing cycle. Even the minutest of variations in the atmosphere of the kiln chamber could ruin a firing. Because of the great difficulty and expense of production the peach-bloom glaze was largely reserved for small pieces of exceptional quality intended for the scholar's desk and was restricted to such shapes as water pots, brush washers and small jars. The *Water Coupe* is decorated with three medallions of dragons impressed into the body. Each medallion is subtly highlighted by the tonal variation of the glaze. Highly prized by all connoisseurs and collectors, objects of the peach bloom glaze combine technical virtuosity and elegant understatement to form one of the greatest achievements in the history of Chinese porcelain.

L.R.M.

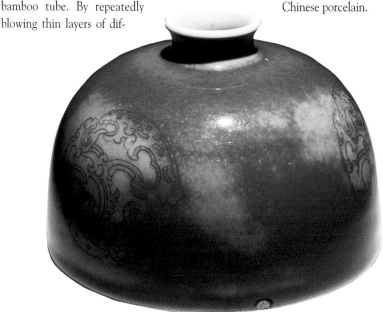

Qing Dynasty

China, 1644-1911,
Qianlong period, 1736-1795

Meiping Vase

Qianlong seal mark on base
blue-and-white porcelain, 13 in. (33 cm.)
Gift of Mr. and Mrs. Robert C. Hills. 94.219

First produced during the 14th century, blue-and-white porcelain retained a special place in the Qing imperial aesthetic, despite the increasing popularity of overglaze enamels and a resurgence in monochrome glazes. Of special interest in the 18th century was a revival of Ming (1368-1644) styles and forms in blue-and-white porcelain, particularly that of the Xuande (1426-35) and Chenghua (1465-87) periods, long considered to be the apogee of Chinese porcelain production.

The Meiping Vase recalls these earlier periods both in its shape and decoration. The shape, characterized by its broad shoulders in relation to a narrow foot, can be traced to the Tang Dynasty (618-907). It was established as a major ceramic form during the Song Dynasty (960-1279). The body of the large Meiping Vase is decorated with sprays of peaches, lychees, and pomegranates, each rising from sprigs of lingzhi. Lingzhi, the "fungus of immortality," symbolizes longevity and the fulfillment of wishes. The peach is one of the most popular motifs denoting longevity.

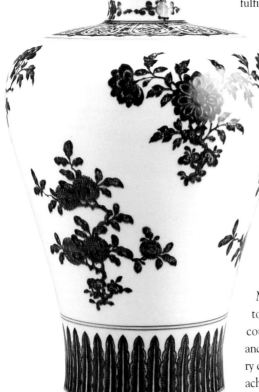

It recalls the legend of Xiwangmu, the Queen Mother of the West, whose magical peach trees bloom every three thousand years and the fruit takes another three thousand years to ripen. At their harvest, a "Peach Banquet" is held and the immortals are invited to partake of this fruit of immortality. The many seeds of the pomegranate are symbolic of fertility and lychees are one of the objects scattered on the marriage bed to assure a fruitful union.

The shape and decoration of the Meiping clearly recall an early Ming prototype. However, 18th-century potters could not replicate the so-called "heaped and piled" effect characteristic of 15th-century cobalt and so used a stippling technique to achieve a similar end.

L.R.M.

Qing Dynasty

China, 1644-1911

Pouring Vessel. 18th century

carved nephrite, 5 x 2 ¼ in. (12.6 x 5.6 cm.)
Bequest of Morgan Whitney. 14.58

Jade has been highly prized throughout Chinese history. During the Neolithic period, jade was shaped into pierced discs, rings and other ornaments as well as tools. In the Shang Dynasty (16th-11th centuries B.C.), bronze replaced stone as the principal material for weapons and tools and was, of course, used for ritual vessels. Jade was used almost exclusively for ritual or ceremonial objects and ornaments. The shapes and some of the symbolism of these ceremonial jades were carried over into the Zhou Dynasty (11th c. - 221 B.C.). By the late Zhou and early Han (221 B.C. - 220 A.D.) jade was thought to embody nine moral virtues: benevolence, wisdom, right-eousness, right conduct, purity, courage, refinement, tolerance and gentleness. It also was thought to have the power to preserve a body from decay in burial.

This *Pouring Vessel*, carved of light green nephrite with brown inclusions and finished to a waxy luster, is a fanciful interpretation of an archaic bronze form. Based loosely on the pitcher-shaped *guang* of the Shang and Zhou Dynasties, it has a large spout and an elaborate, oversized handle. The vessel's thick walls and angular form produce an object of great strength and power. The low-relief scroll work over the body of the piece is also loosely based on archaic motifs. Sharp-corner coils, saw-tooth lines, wing-shaped configurations and comma patterns all recall the dragon and bird motifs found on Shang and Zhou bronzes. Such antiquarianism was common in China, particularly during the 18th and 19th centuries.

L.R.M.

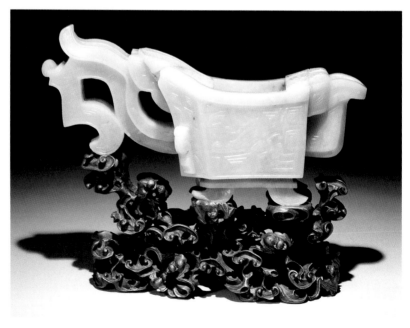

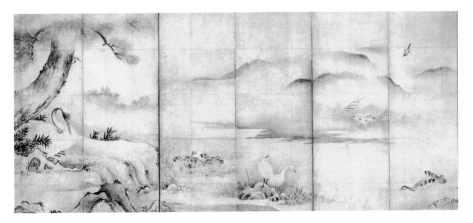

Kanō School

Japan, Muromachi period, 1392-1568

Birds and a Marshy Stream.
circa 1550s

ink and color on paper, six-fold screen,
69 3/8 x 149 in. (176 x 378.4 cm.)
Gift of Mr. and Mrs. Frederick M. Stafford. 71.53

This screen, undoubtedly the left section of what was originally a pair, while bearing neither signature nor seal to identify the artist, was probably produced during the 1550s in the workshop of Kanō Motonobu (1476-1559). The Kanō school was an important stylistic lineage of professional painters synonymous with official painting in Japan from the Muromachi period through the 19th century. It was initially brought to prominence by Kanō Masanobu (1434-1530), Motonobu's father, who served as an official artist to the Ashikaga Shogunate. Motonobu synthesized the range of styles current at the opening of the 16th century into a highly individualized and purely Japanese style, and thereby established a solid foundation for future Kanō school artists. Generations of Kanō artists, beginning with Masanobu and Motonobu, created large-scale paintings for the shogunate and the estates of feudal leaders.

Motonobu was a remarkably versatile painter who specialized not only in landscape subjects, but also in bird-and-flower painting and figure subjects, frequently depicting Chinese themes. In the New Orleans screen waterfowl form the subject. The compositional structure of the New Orleans screen is quite relaxed and shows tendencies toward diffusion and segmentation of space, characteristic of several of Motonobu's works in the 1530s and 1540s. Its motifs come directly from Motonobu's established models, and its brushwork is quite similar to, though more cautious than, Motonobu's. There is a great feeling of repose created not only by the compositional structure but also by the beautifully graded tones of inkwash in this screen from Motonobu's workshop.

L.R.M.

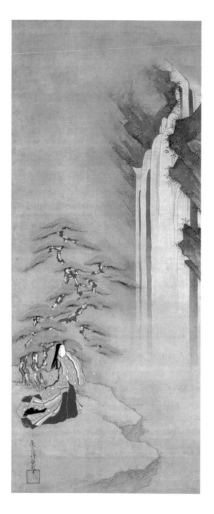

Tosa Mitsuoki

Japanese, 1617-1691

Lady Ise at the Waterfall

Signature: *Tosa Sakon Shogen Mitsuoki*
Seal: *Fujiwara*
ink and color on silk, 37 $^7/_8$ x 15 $^3/_4$ in. (95.9 x 40 cm.)
Women's Volunteer Committee Funds. 76.431

The Tosa school, an important hereditary line of painters patronized by the Japanese Imperial Court from the 15th century on, suffered a decline during the 16th century because of the increased popularity of the Kanō school. By the mid-17th century in the Edo period, however, it was revitalized by Tosa Mitsuoki, the creator of this unusual painting.

Mitsuoki broke from the centuries-old Tosa tradition of painting Japanese themes in the *yamato-e* style, using delicate brushwork and bright colors, by incorporating Kanō-style brushwork, a largeness of design and Chinese compositional elements into his work. In this painting the strong diagonal, a frequently used device in Chinese painting since the Southern Song period (1128-1279), divides the Tosa-style figure of Lady Ise, rendered in fine, detailed brushwork and bright color, from the powerful Kanō-style jagged rocks and waterfall.

The subject, Lady Ise, also is painted in an unconventional setting. Traditionally this famous 9th century poetess was portrayed recumbent in a cascade of multi-layered robes against an empty background with one of her poems inscribed at her side or above her. Here Mitsuoki has adopted a conventional Chinese setting for a poet-portrait—most commonly seen in depictions of Li Bo (701-62)—of the poet standing at the edge of a cliff gazing at a waterfall. Mitsuoki's combination of Chinese and Japanese painting traditions and his artistic juxtapositions of delicacy and boldness created a new and dynamic image that would have been unthinkable in an earlier Tosa painting.

L.R.M.

Hakuin Ekaku

Japanese, 1685-1769

Tenjin

Seals: *Kokan-i* (learning from self-examination),
Ekaku, Hakuin
ink on paper, 46 ¹/₂ x 11 in. (118.1 x 27.9 cm.)
Gift of Kurt A. Gitter, M.D. in memory of
his mother, Dr. Maria Gitter. 85.238

While Zen ink painting had long been practiced in Japan, by the 17th century this tradition had almost ceased. During the Edo period (1615-1868), Zen painting (*Zenga*) underwent a powerful revival, and one of its prime movers was the Rinzai sect Zen master, painter and calligrapher, Hakuin Ekaku. Hakuin's innovations in reorganizing and systematizing the *kōan* system of provocative questions employed in monastic training are still in use today. Late in life Hakuin turned to brushwork as a didactic tool and became an outstanding master in this field.

This painting depicts Tenjin, the deified figure of Sugawara

Michizane (845-903). A leading scholar, poet and political figure, Michizane died in exile, wrongly accused, after a brilliant court career. After Michizane's death the court was plagued by ills associated with his angry spirit. To appease him his titles and honors were restored and shrines were dedicated to his honor. Sugawara Michizane was later deified as the Shinto god Tenjin, patron of scholarship and calligraphy.

Hakuin's *Tenjin* combines painting and calligraphy. Tenjin wears an elaborate headdress and robe and holds a delicately painted plum branch (the plum was his favorite flower). Tenjin's costume is comprised of characters which read: *Hail to Tenjin, God of Great Freedom at Temman Shrine.*

Above the painting is the inscription:
[Even though you cannot tell
That he is wearing a robe of brocade,]
You will know that it is Tenjin
By the plum blossoms
He carries in his sleeve.

Although a Shinto deity, Tenjin was also revered, in the Zen tradition, for his genius, which was understood as a manifestation of his true "Buddha-nature."

L.R.M.

Hon'ami Kōetsu

Japanese, 1558-1637

Tawaraya Sōtatsu

Japanese, ?-1643

Calligraphy, Cypress and Wisteria, from the Shin Kokin Waka Shu

ink on gold and silver decorated paper,
13 ¼ x 17 ⅜ in. (33.6 x 44.1 cm.)
Museum Purchase. 82.94

This collaborative work exemplifies the Rimpa style created by the renowned calligrapher Hon'ami Kōetsu and the influential painter Tawaraya Sōtatsu. Kōetsu and Sōtatsu were inspired by the past and reinterpreted older themes in a bold and decorative manner.

In this work, once part of a longer handscroll, Kōetsu wrote over Sōtatsu's gold and silver designs stamped on white paper. The silver and gold of the cypress, wisteria, and susuki grass capture varying effects of light, while the ink of the calligraphy maintains a steady balance. The poem is from the *Shin Kokin Waka Shū (New Anthology of Ancient and Modern Japanese Verse)* compiled by

Fujiwara Teika in 1201 for the retired Emperor Go-toba. The *waka*, or thirty-one syllable poem, is by Emperor Enyu:

> The fields that
> I once again look out over
> Are no longer the same...
> There are no pines
> To witness my longing for the past.

Kōetsu's *kanji*, or Chinese-style characters, are formed of thick strokes, while the Japanese *kana* characters are written using a thinner line. Unlike most calligraphers who loaded their brushes with ink at natural breaks in the poetry, Kōetsu irregularly dipped his brush, producing both light and thin and thick and dark characters in the same line. The resulting variations in size, thickness and tonality interact with the stamped designs. The cypress fronds contrast and balance the downward movement of the wisteria and the lines of the calligraphy. Fragile, trailing brushstrokes appear to be a continuation of the wisteria, lending the printed design even greater elegance.

L.R.M.

Suzuki Kiitsu

Japanese, 1776-1858

Flowers of the Four Seasons

Signature: *Seisei Kiitsu*
Seal: *Shukurin*
ink and color on silk,
each: 38 ³/₈ x 13 in. (97.5 x 33.1 cm.)
Women's Volunteer Committee Fund. 84.87.1 & 3

One of the last great Rimpa school artists, Suzuki Kiitsu was a 19th century practitioner of the bold, decorative style created by Kōetsu and Sōtatsu during the early years of the 17th century. The style was born in Kyoto and later introduced to the new capital Edo. The most gifted student of Sakai Hōitsu (1761-1828), who pioneered Rimpa-style painting in Edo and evolved a highly stylized and decorative personal style, Kiitsu most often painted bird and flower subjects, such as these two seasonal hanging scrolls.

In *Flowers of the Four Seasons* Kiitsu has painted flowers and grasses associated with spring and fall. The painting on the right has blossoming peonies, poppies and wisteria, which symbolize late spring in Japan. Similarly, the morning glories, narcissus and pampas grass of the other painting are all indicators of fall.

In both works the bright colors and luxurious images of abundant vegetation are balanced in masterful compositions. The upward thrust of the flowers in the lower portions of each scroll are counterbalanced by the delicately hanging vines and grasses. Both works also display Kiitsu's virtuosity in *tarashikomi*, a technique wherein water or a second color is dropped on an area already wet with a first color and then the original color is pushed to the edges of the wet area in order to create a sense of luminosity. This technique, which had been long associated with the Rimpa style, is evident in the larger leaves of both works.

L.R.M.

Matsumura Goshun

Japanese, 1752-1811

Night Banquet in the Peach Garden

Signature: *Goshun*
Seal: *Goshun*
ink and light color on paper, pair of six-fold screens,
each screen: 67 ¹/₄ x 142 ¹/₂ in. (170.8 x 362 cm.)
Museum Purchase. 83.3.1 & 2

Matsumura Goshun, the founder of the Shijō school of painting, was initially a pupil of Yosa Buson (1716-1784) and under his direction became recognized as both a fine Nanga

painter and *haiku* poet. After Buson's death Goshun became interested in the new naturalistic style of Maruyama Ōkyo (1733-95); and

while Goshun offered to join Ōkyo's studio as a pupil, Ōkyo declined, preferring to work with Goshun as an equal and a friend. Goshun gradually evolved a unique style which incorporated elements of Buson's and Ōkyo's styles. After the death of Ōkyo in 1795 Goshun established his own school, which came to be called Shijō after the name of the street in Kyoto where his atelier was located.

These screens illustrate a scholars' gathering. The right screen depicts five servants preparing for the scholars' repast. At the far left a young man carrying a lantern lights the way for two scholars. The narrative then shifts to the left screen. Under the delicately painted peach blossoms additional preparations for the feast are being made. Seated in a bamboo chair, a scholar with his brush in mid-air, is caught the moment before he commences working. The table at which he and the other scholars are seated is covered with books and antiquities for their contemplation and discussion.

These screens were painted in Goshun's final years as a Nanga painter. Following the Nanga tradition, the screen reveals a Chinese literary emphasis enlivened by Goshun's brushwork and lyrical sense of natural expression.

L.R.M.

Nagasawa Rosetsu

Japanese, 1754-1799

Chinese Children at Play.

circa 1792-1799

Signatures: *painted by Rosetsu, painted*
by Heian (Kyoto) Rosetsu
Seals: *Gyo*
ink and color on paper, pair of
six-fold screens, each screen: 61 x 140 ³/₈ in.
(155 x 356.5 cm.)
Women's Volunteer Committee Fund in memory of
Edith Rosenwald Stern. 80.187 a & b

Nagasawa Rosetsu's origins are unclear, although tradition identifies him as the son of a warrior family. By 1779 Rosetsu was a student of Maruyama Ōkyo (1733-1795), a founder of the Maruyama school. While greatly influenced by his teacher, Rosetsu had become an unorthodox painter of innovative and dramatic compositions by the late 1780s.

In this pair of screens Rosetsu reinterpreted the classical Chinese theme of Chinese boys at play. Rosetsu's children are vivacious and humor-filled, and his composition is striking in that the figures are placed within a fully conceived landscape context. The right screen opens with a view of trees and mountains. The trees direct our attention to the playing children. One boy flies a kite, while at his feet another plays a game with stones. To their left a group of children, trying to write, surround a table.

In the left screen one child splashes amidst the waves while his friends play with turtles. The children are framed by an old, massive pine tree, which together with the blossoming plum and bamboo on the right screen form "Three Friends of Winter," a popular motif indicating longevity and endurance.

Rosetsu's large *Gyo* (fish) seal appears on each screen. Part of the upper right corner is broken, an event which occurred between May 1792 and December 1794. Although undated, the New Orleans screens can, nevertheless, be attributed to the last five or six years of the artist's life. These screens are among the finest works by the master Rosetsu outside Japan.

L.R.M.

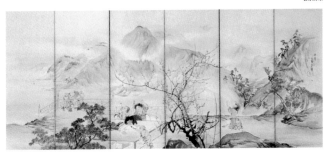

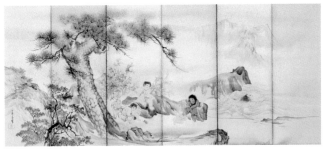

Yamaguchi Soken

Japanese, 1759-1818

Bijin (Courtesan). circa 1800

Signature: *Soken*
Seal: *Yamaguchi*
ink and colors on silk,
40 1/8 x 15 3/4 in. (101.8 x 40 cm.)
William B. Burkenrod, Jr., Birthday Fund. 77.383

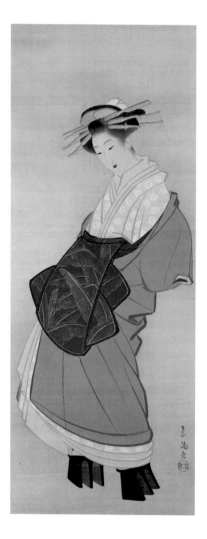

Soken was one of the best students of Maruyama Ōkyo (1733-1795), the founder of the Maruyama school of painting. Favored by the merchant class in Kyoto, artists of this school created a naturalistic, yet Japanese style of painting that included subject matter ranging from courtesans to birds and flowers. Biographical information on Soken is scarce, but he is thought to have been a Kyoto native. Known to have been a book illustrator, he published several popular series in his lifetime. Soken is recorded as being skillful in the painting of figures, landscapes and genre subjects, as well as birds and flowers. He specialized, however, in *Bijinga* (paintings of beautiful women), such as this one.

Soken's depiction of the courtesan is a study in contrasts. The downward tilt of the courtesan's head and her averted gaze give the impression of modesty which is directly contradicted by the dazzling red, blue, white, and gold of her attire. The three-legged *geta* (clogs) worn by the courtesan indicate that she is in the midst of a promenade. Walking upon the tall, heavily lacquered *geta* was an art unto itself, requiring considerable training and practice. The Japanese call this style of walking *hachimonji ni aruku*, or "figure-eight walking," because of the pattern the feet make when walking in these shoes. The rich quality and superb execution of this work establish Soken as one of the finest artists of his day.

L.R.M.

Ike Taiga

Japanese, 1723-76

Sage by a Rock

Signature: *Kasho*
Seal: *Kasho*
inscription by Gōchō Kankai (1739-1835), dated 1809
ink on paper, 46 ⅛ x 10 ½ in. (117.2 x 26.7 cm.)
Gift of Kurt A. Gitter, M.D. and Millie H. Gitter in
memory of Dr. Harold P. Stern, Director, Freer Gallery
of Art, 1972-77. 77.20

The Nanga ("southern paint-ing") or Bunjinga ("scholar's painting") school emerged in early 18th century Japan. Inspired by Chinese literati painting, which was known in Japan through Ōbaku Zen priest-painters who immigrated to Japan, Chinese painters in Nagasaki, Chinese woodblock print illustrations and contem-porary Chinese paintings in Japan, three pioneers, Gion Nankai (1677-1751), Yanagisawa Kien (1706?-1758) and Sakaki Hyakusen (1697-1752), created the new style by incorporating elements of the Chinese tradi-tion. This new style gained popularity slowly, and after the

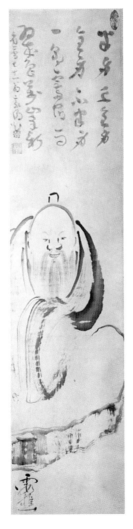

deaths of the three first generation practition-ers, the mantle fell to an exceptional young artist, Ike Taiga.

Ike Taiga became the most influential Nanga master in Japan. A professional painter, Taiga painted in many variations of his highly personal and free style. After hearing Zen ser-mons by the great Rinzai master, Hakuin, Taiga executed works which approached Zenga in their rough, powerful brushwork. One such work is *Sage by a Rock* with a later inscription by the Buddhist monk Gōchō (1739-1835) added "at the age of sev-enty-one." Alluding to the painting in which only a portion of the sage's form is visible, Gōchō wrote:

> Half a body is not a whole body,
> A whole body is not half a body,
> In the morning the rain clears
> And the myriad peaks are newly green.

Taiga's rough and tonally var-ied brushwork creates abbrevi-ated forms the viewer can inter-pret as face, shoulder, sleeve and rock. The interest in pure brushwork is apparent in both the painting and the calligraphy.

S.A./L.R.M.

Uragami Gyokudō

Japanese, 1745-1820

Drunken Landscape

Signature: Gyokudo
Seal: *Hakuhatsu Kinshi* (White-bearded Qin Immortal)
ink on paper, 53 ³/₈ x 21 in. (134.5 x 53.5 cm.)
Gift of Kurt A. Gitter, M.D. and Alice Rae Yelen.
94.334

Appreciated in is own day primarily as a musi-
cian and poet, Gyokudō is today considered to
have been one of Japan's greatest painters. An
hereditary samurai in the service of a local feu-
dal lord in Bizen, Gyokudō was a virtuoso on
the Chinese *qin* (seven-stringed zither) in his
youth; and he composed music and wrote
poetry in his middle years. At the age of fifty
Gyokudō took the highly unusual step of
renouncing his official position to become a
wanderer with his two sons, *qin* and brushes.
During this time Gyokudō mastered the art of
landscape painting and invented a truly per-
sonal technique.

Painted in his sixties, *Drunken Landscape*
displays the remarkable vigor and dynamism
for which Gyokudō is renowned. Evidently
created while the artist was inebriated, the
painting's composition is nonetheless strong
and complex and the brushwork free and
spontaneous. This unusual work has pavilions
out of scale with the landscape elements and
forms that are almost enveloped by heavy
patches of wet ink. However, Gyokudō took
time to go over some of the lighter gray lines
of the buildings in dark, dryer ink. A wet sum-
mer landscape is not merely suggested here; it
is overwhelmingly and forcefully presented.

S.A.

Wanatabe Kazan

Japanese, 1793-1841

White Road Bamboo. 1834

Signature: *Kazan Gaishitsu Noboru*
Seals: *Kazan, Hassen Noboru*
ink on silk, 38 1/4 x 13 3/4 in. (98 x 35 cm.)
Museum Purchase. 82.21

Watanabe Kazan, a student of Tani Buncho, was a leading 19th century Nanga painter. Kazan became fascinated with *rangaku*, or Dutch studies, the avenue of Japan's contact with the West, while in his early thirties. Kazan and several other like-minded scholars were arrested by the Tokugawa Shogunate on a false conspiracy charge in 1839. Kazan's death sentence was commuted to life imprisonment. In 1841 he committed suicide.

In *White Road Bamboo* Kazan created a rich image through his masterful control of ink. Grasses and orchids, painted in light to medium tones, grow at the top of a slight slope, gracefully entwine the bases of two major stalks of bamboo, and gently graze the top of the third, shortest stalk. In his inscription Kazan speaks of his painting technique and artistic sources:

Technically, in ink painting of the Hui school, there are no patterns of compiling leaves in groups of threes and fives. Instead, where thick leaves cross each other, there are small white blank areas called "moon shadows." A native of Jiading, Po Ziting [Chinese, 17th century] developed this technique [that I use here] and added orchids to create a feeling of primitive simplicity and lofty feeling. This is something that people of our era have not imagined, so I followed his idea to create this painting. However, I seem to have followed the influence of the pioneer, which probably could not have been avoided.

Summer of 1834, Kazan Gaishitsu Noboru

The "Hui School" is the Anhui School of painting famous for its sparse brushwork and elegant style. By the mid-17th century this school represented one of the principle currents of Chinese painting.

L.R.M.

Nakabayashi Chikutō

Japanese, 1776-1853

Rain in Spring Trees. Mountain Streams in Deep Distance. 1838

Signature: *Nakabayashi Seishō*
Seals: *Seishō no In, Azana Hakumei*
ink on silk; ink and color on silk,
each 36 x 12 in. (91.5 x 30.5 cm.)
Gift of Kurt A. Gitter , M.D. and
Millie H. Gitter. 75.409 a & b

Nakabayashi Chikutō, one of the foremost conservative Nanga painters and theoreticians in Kyoto during the early 19th century, spent much of his artistic life reworking and personalizing Chinese scholar-painter traditions. Although he emulated painters from the Song and Yuan Dynasties, his actual models were Ming paintings and Chinese woodblock prints.

The monochrome ink *Mountain Streams in Deep Distance* is inscribed as having been painted in the autumn, the ninth month of 1838, at the *Tozansodo*, or the Grass Studio of Higashiyama, a section of Kyoto. Mountains, trees and rocks are created by short brushstrokes and dots, recalling the styles of such Chinese masters as Dong Yuan (10th c.) and Mi Fu (1051-1107), although the repetition of squarish rock shapes also suggests the influence of the eclectic Ming painter Lan Ying (1585-after 1664). Chikutō synthesized these Chinese elements into a personal style of soft and confident brushwork.

The companion landscape, *Rain in Spring Trees,* is a work in the blue-green tradition of Tang-Dynasty China. Painted in soft, muted tones, forms appear and disappear in the mist. A scholar crosses a bridge in the foreground between willow trees, and in the middle ground a palace compound can be discerned. Chikutō wrote a couplet on this painting:

Within the clouds, the palace with paired phoenix halls;

Amidst the clouds, spring trees and numberless homes of men.

Repetition of shapes, the strong influence of Chinese orthodox literary styles, and the eschewing of dramatic effects all illustrate the conservative nature of Chikutō.

S.A./L.R.M.

Yamamoto Baiitsu

Japanese, 1783-1856

Doves and Peonies.
Heron and Autumn Grasses. 1844

Signature: *Baiitsu Yamamoto Ryō; Baiitsu Ryō*
Seals: *Ryō in Baiitsu* (on each)
ink and color on silk,
45 ⁵/₈ x 17 ¹⁵/₁₆ in. (138.73 x 45.56 cm.)
Gift of Mr. and Mrs. George L. Lindemann in
honor of Kurt A.Gitter, M.D. 87.4.1 & .2

Yamamoto Baiitsu, one of the most talented Nanga artists, specialized in bird and flower subjects. The son of a sculptor in Nagoya, Baiitsu began his painting of birds and flowers while still a child. A protégé of the Nagoya businessman and Chinese painting collector Kamiya Ten'yū, he met the slightly older Nanga painter Nakabayashi Chikutō (1776-1853) at Ten'yū's home. Baiitsu, like Chikutō, studied directly from the Chinese models, as well as absorbing the influence of other Japanese painting masters.

This pair of paintings dates from Baiitsu's mature period and is a prime illustration of his bird and flower work. Baiitsu was particularly renowned for his depictions of herons, and here the heron is created with a minimum of outline and a judicious use of white pigment. One of Baiitsu's greatest achievements in this pair was to balance opposing tendencies. Compositionally well-defined, the paintings are saved from seeming static by the fact that various motifs stretch beyond the picture plane. The exacting brushwork is relieved by Baiitsu's use of the "boneless" technique (of delicate outlines covered with rich colors), and the decorative nature of the works is balanced by a sense of naturalism. The rich density of the overlapping forms and the complexity of the artist's brushwork create a greater sense of realism than is usual in Nanga painting.

L.R.M.

Kamakura period

Japanese, 1185-1333

Shigaraki-ware Storage Jar (Tsubo).
circa early 14th century

stoneware with slight ash glaze,
19 1/4 x 18 in. (48.9 x 45.7 cm.)
Gift of Kurt A. Gitter, M.D. and Alice Rae Yelen in
honor of Richard A. Brunswick, M.D.. 93.302

During the Kamakura period (1185-1333), stoneware produced in the Shigaraki valley in southern Shiga Prefecture emerged as a distinct regional type of ceramic. Pottery was initially produced there for local domestic use, largely in response to the agricultural needs of peasants as the feudal estate system grew and farming techniques improved. There consequently came to be a need for safe, long-term storage of food. Large jars capable of containing considerable quantities, such as the *tsubo* seen here, were developed in response to these needs. *Tsubo* can vary in size; but they are typically tall, shouldered jars with a substantial interior capacity.

This *tsubo* was built in at least four sections of coiled clay which was then compacted and smoothed by hand. The shape and subtle brown coloration of the *tsubo* are similar to other extant examples from the Kamakura period: the profile, while erratic, extends from a flared neck (with slightly everted lip) to the broad shoulders and then constricts at the narrow foot. Shigaraki-ware contains a large percentage of feldspar which, when melted incompletely in the firing, dots the surfaces of the finished pots and shines brightly in contrast to the dark bodies. After the mid-Kamakura period, Shigaraki-wares were fired in an oxidizing atmosphere which admitted air into the kiln. The iron-rich clays produced a range of brown-bodied wares, and the glaze effects were dependent on the amount of ash circulating inside the kiln. Ash did not settle thickly on this *tsubo*; it was most likely well-protected by other vessels during the firing.

L.R.M.

Edo period

Japanese, 18th century

Suit of Armor in Dōmaru Style

iron, leather, lacquer, silk and brass
Gift of the J. Aron Charitable Foundation. 92.940 a & b

The earliest examples of defensive armor known in Japan date from the 1st century B.C. Originally formed of horizontal wood strips held together by leather thongs, armor was made from iron by the 4th century. Gradually the style of armor we see here, *dōmaru*, was adopted.

Characterized by a close-fitting, one-piece body armor (*do*) from which its name is derived, *dōmaru* armor is relatively light in weight and more flexible than the bulky *ōyoroi* style. It was first worn by common foot soldiers but by the 14th century higher-ranking military officials came to prefer this more manageable style with an added helmet and upper-arm guards. Japanese helmets and armor, while functional and decora-

tive, manifest the moral and spiritual traditions of the samurai. The beauty and craftsmanship of the armor reflect the clan and the glory of the samurai house. Two gold crests of the Arima, a prominent *daimyo* family, adorn the helmet of this suit of armor. At the center of the helmet is the hammer of Daikoku, a deity of good fortune, representing the strength and power of the wearer and his ability to destroy any obstacle. The horn-like protrusions from the helmet (*wakidate*) are formed from elongated *kanji*, reading *ka*, "possibility." During the peaceful Edo period armor became largely ceremonial. Suits of armor would be displayed in *daimyo* households and battle standards erected in their gardens on the eleventh day of the first month of the year, when the annual petitions for success in military matters would be offered.

L.R.M.

Harui Komin

Japanese, Meiji period, 1868-1912,
active late 19th century

Inkstone Box and Stationery Box.

gold and silver lacquer, silver rims, wooden core
inkstone box: 2 $^1/_4$ x 10 $^1/_2$ x 9 $^1/_4$ in.
(5.63 x 26.25 x 23.13 cm.)
stationery box: 6 x 16 $^7/_8$ x 13 $^5/_8$ in.
(15.24 x 42.9 x 34.6 cm.)
Gift of Mrs. Monroe J. Rathbone. 79.346, 347

Lacquer, a resinous coating usually applied to a wooden core, has been known in Japan for thousands of years and reached a peak of technical virtuosity in the Meiji period (1868-1912). Masters such as Harui Komin used *taka maki-e*, an elaborate technique of high-relief decoration in which the design is formed by placing gold and silver powder in successive layers of wet lacquer to create elegantly designed boxes.

The inkstone box, or *suzuri-bako*, is a small case for storing instruments for writing with a brush. The inkstone *(suzuri)*, brushes, ink stick, water dropper *(suiteki)*, small paper knife, a paper punch and the ink stick holder were kept in the case. The larger stationery box *(ryoshi-bako)* was used to store writing paper and letters. These boxes contained materials essential to cultivated, learned men and were symbols of scholarship and culture. Both boxes are decorated with the traditional "Eight Views of Lake Biwa," a famous scenic area near Kyoto. By the early Edo period it was common for inkstone boxes and stationery boxes to be created as a set and decorated with complementary designs and techniques.

An inscription on one of the storage boxes indicates that these two sumptuous lacquer boxes were made for the use of the Imperial Household. It is possible that these boxes were meant solely for display since the brushes have never been used and the ink stone is made of lacquer imitating the hard stone.

L.R.M.

Chandela period

Khajuraho, North Central India, 950-1310

Female Figure.

11th century

red sandstone, 20 7/8 in. (53 cm.)
Gift of Mrs. Frederick M. Stafford. 94.324

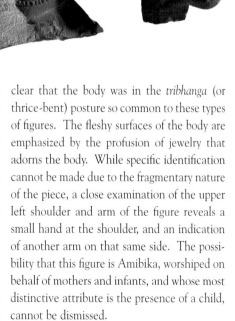

In both provinces of Central North India, Madhya Pradesh and Uttar Pradesh, a new sculptural style appeared at the end of the 1st millennium A.D. It is represented at the temple sites of Sarnath, Gyarapur and particularly Khajuraho, and is the style represented in this *Female Figure*. The walls of these temples are laden with images of guardian spirits, celestial beings, and divinities. At Khajuraho, female figures are shown engaged in everyday activities such as yawning, writing letters, looking in the mirror, applying cosmetics, playing a musical instrument, dancing or engaged in erotic activities with their mates. While some of the female figures can be identified as specific tutelary deities, most, with their voluptuous breasts and emphatic eroticism, denote fertility.

The Chandela sculptor of this fragment from a Khajuraho temple obviously took great delight in exploring the beauty of the female figure. The strong, sinuous movement of the body turned in extraordinary torsion is further heightened by the deep undercutting of the stone. Although only a fragment, it seems clear that the body was in the *tribhanga* (or thrice-bent) posture so common to these types of figures. The fleshy surfaces of the body are emphasized by the profusion of jewelry that adorns the body. While specific identification cannot be made due to the fragmentary nature of the piece, a close examination of the upper left shoulder and arm of the figure reveals a small hand at the shoulder, and an indication of another arm on that same side. The possibility that this figure is Amibika, worshiped on behalf of mothers and infants, and whose most distinctive attribute is the presence of a child, cannot be dismissed.

L.R.M.

Pala period

Nalanda, Bengal, India, 730-1197

Stele with Vishnu and Consorts.

mid 11th century

schist, 28 ³/₄ x 14 ¹/₄ in. (73 x 36.2 cm.)
Gift of Mr. and Mrs. Frederick M. Stafford. 76.458

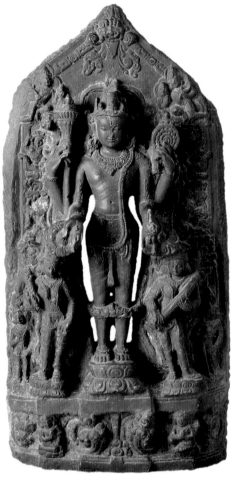

The Nalanda region of Bengal province in northeast India experienced a revival of Hinduism during the Pala period (730-1197). By the late Pala period, Vishnu, a principle Hindu diety, was the focus of a strong cult and the most commonly represented deity in the Hindu pantheon.

Here Vishnu is represented in his most common manifestation, Vishnu Trivikrama with Laksmi and Sarasvati. (Trivikrama refers to the three steps by which Vishnu established his dominion over heaven, earth and the netherworld and also to the seventh of twenty-four iconic representations of the god. The twenty-four forms derive from the number of ways Vishnu's chief attributes can be arranged in his four hands). Vishnu at center stands in an unflexed, frontal posture. A kingly figure, adorned with a crown and jewelry, Vishnu also wears a long floral garland (*vanamala*). His four arms display the characteristic attributes of this form: mace (*ganda*) in Vishnu's upper right hand, the lotus (*padma*) in his lower right hand, the discus (*chakra*) in the upper left hand, and the conch shell (*shankha*) in his lower left hand.

The goddesses Laksmi and Sarasvati flank Vishnu and stand in the thrice-bent (*tribhanga*) posture. Laksmi, goddess of wealth and abundance, stands to Vishnu's right holding a fly-whisk; and Sarasvati at the left holds her *vina*, a stringed instrument indicating her role as a goddess of learning and the arts. Shown in hierarchical scale, Laksmi and Sarasvati are smaller than Vishnu but larger than the other figures in the composition, such as the two small male figures that flank them. Even smaller are two figures on the pedestal; on the left, a kneeling devotee; and on the right, Garuda, Vishnu's vehicle.

L.R.M.

South India

Vijayanager

Dancing Krishna. 17th century

bronze, 7 1/4 in. (19.1 cm.)
Gift of 1983 Fellows trip to India in honor
of Yashodhara Bhansali. 83.1

Krishna is the most popular of the ten main incarnations of the Hindu supreme god Vishnu. All aspects of Krishna's life from infancy to his role as royal cowherd have been the subject of art. Although Krishna was regarded as a divinity as early as the 6th century B.C., it was not until much later that his cult achieved great popularity. In the 9th century the Vaishnava poet-saint Periyalvar composed a set of fifty poems dedicated to every aspect of the infant Krishna's growth into childhood. Individual poems celebrated Krishna's first tooth, his first steps, his protests against a bath, and other commonplace events. These poems further popularized the enchantment and the appeal of the child Krishna, and a cult of the baby Krishna gained great currency, particularly in southern India.

The theme of this bronze derives from the story of Krishna raiding his mother's larder. The infant loved butter and would steal it as often as he could. While Krishna is sometimes presented as a crawling infant with a ball of butter, this harmoniously balanced bronze depicts him in the iconic pose of this theme: Krishna stands on his left leg with his right leg raised and bent at the knee while his left arm is outstretched in a gesture of dance and his right one is bent, holding a ball of butter. Krishna is shown as a chubby, slightly mischievous boy, naked except for his sumptuous ornaments. The small sculpture was probably intended for a domestic shrine.

L.R.M.

Mughal period

India, 1526-1857

Palace Jali Screens. 18th century

sandstone, a: 77 x 22 x 3 in.
(195.58 x 55.88 x 7.62 cm.)
b: 77 x 20 1/4 x 3 in.
(195.58 x 51.44 x 7.62 cm.)
Gift of Dr. and Mrs. Siddharth K. Bhansali. 92.420 a & b

The Mughals, direct descendants of Genghis Khan, governed India from 1526 through 1857. The Mughal rulers of India expended vast sums on the construction of mosques, palaces, fortresses, mausoleums and entire cities. Perhaps the most famous of these building programs is the Taj Mahal, built between 1631 and 1648 in Agra, the seat of the Mughal empire. The Taj Mahal was built as a mausoleum for the wife of Shah Jahan, Mumtaz Mahal, who died giving birth to her fourteenth child. The style of this building was imitated throughout the sub-continent for the next two centuries.

The Mughal architectural style continued for several hundred years in India until the fall of the Empire to the British. These two large Mughal-style *Jali Screens*, once an integral part of an Indian palace, functioned much as a latticed window, letting in light but preserving privacy. With their carved openwork jalis dispelled the harsh rays of the sun during the hot and humid Indian summer and allowed for a cool breeze to circulate inside. Women in pre-modern India used the jalis of balconies and terraces to enjoy looking at the outside world without exposing themselves to public view.

These jalis are each comprised of a large rectangular panel of sandstone, a common material for palace architecture in the 18th century. A smaller, square panel at the base of each jali is carved in the form of a flowering plant. The central openwork panel is carved with an intricate, reticulated foliate design bordered by a checkered frieze.

L.R.M.

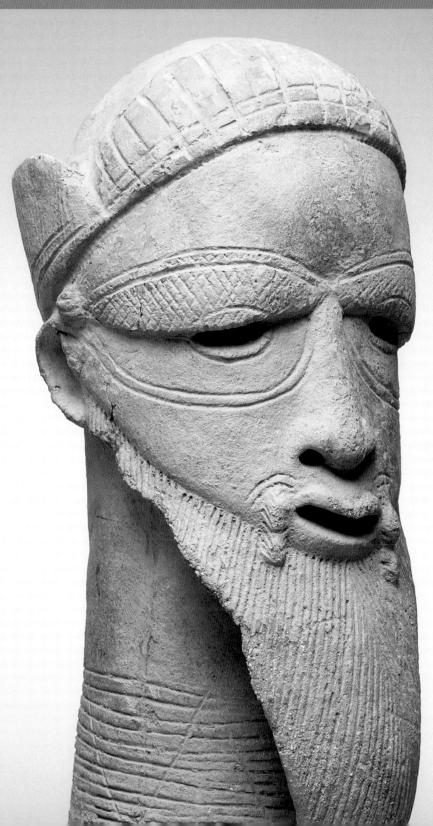

Djenne Area

Inland Delta of the Niger River, Mali, Unidentified Peoples

Three Mythic Ritual Human Sacrifices. circa 1000-1400

terra cotta, 5 $^1/_4$ x 6 $^1/_2$ x 10 $^1/_2$ in. (13.3 x 16.5 x 26.7 cm.);
3 x 5 x 16 in. (7.6 x 12.7 x 40.6 cm.);
9 x 8 $^3/_4$ x 9 in. (22.9 x 22.2 x 22.9 cm.)
Robert P. Gordy Fund. 90.194-.196

The ancient peoples who inhabited the inland delta region of the Niger River from 250 B.C. to 1400 A.D. in the city-complex of Jenne-Jeno (near the present-day town Djenne) developed a prosperous trading culture which became known in modern times only in 1943. Their artisans profited from contact with both the Sahel and the Atlantic coast as the society accumulated copper, tin, gold and iron. Terra cotta was the most favored medium for depicting human figures and animals, while bronze was utilized for smaller figurative forms, implements and objects of adornment.

With the advance of the Sahara Desert into this area, the peoples' religion became centered on the need for and control of water. According to a primordial myth of the neighboring Sonike people, a virgin from the community would be sacrificed annually to the Great Snake, Bida, to assure rain and fertility. When a magician saved the virgin one year, there was a great seven-year drought which forced the Sonike to migrate to the Djenne region where the importance of the snake and control of water remained paramount.

These three sculptures are striking visual affirmations of this ancient oral tradition. In one, a virgin, whose arm is reaching out in vain from a partially sealed chamber, is immured as a sacrifice to protect the village from the flooding waters of the Niger inland delta. Two snakes surround the clay hut to claim their offering. In another, a coiled serpent devours its human offering, while in the third, a river spirit in the guise of a large fish swallows its sacrificial prey.

W.A.F.

Dogon Peoples

Mali

Ancestor Post

wood, 47 $^3/_8$ x 4 $^7/_8$ x 5 $^1/_2$ in. (120.3 x 12.4 x 14 cm.)
Bequest of Victor K. Kiam. 77.249

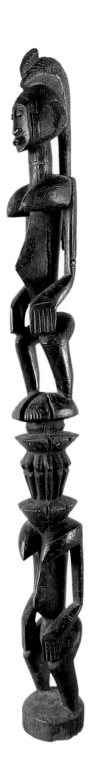

The Dogon arrived in the desolate and rocky terrain of the Bandiagara escarpment of northern Mali around the 12th century. These tenacious cliff dwellers developed a multifarious pantheon of gods with associated ancient myths to explain their origins and to give direction to their lives. A strong and varied sculptural tradition reflects and embodies these beliefs.

This tall, superbly carved post follows the natural gentle curve of the wood in depicting two female figures, possibly ancestors, one atop the other. Salient features of the upper figure include the unusual long crested headdress which falls to mid-back and the pierced chin which could indicate a lost labret, a common cosmetic adornment among Dogon women. The deep luster of the wood patina on the calf portion of this figure's leg suggests that the post was frequently held at this point, possibly as a rhythm pounder.

While the lower figure repeats its companion's composition, the head is made up of a cluster formation of thirteen small heads between two discs. Undoubtedly, the significance of that number relates to ancient Dogon mythology. Elsy Leuzinger states that this rare Dogon treatment with multiheads is "a symbol of the universe, and manifests the eternally valid order of the cosmos to which man must subject himself."

W.A.F.

Bamana Peoples

Bougouni District, Mali

Jo Society Standing Female Figure (nyeleni)

wood, string, iron, cowrie shell,
24 x 7 ¹/₂ x 7 ¹/₂ in. (61 x 19 x 19 cm.)
Bequest of Victor K. Kiam. 77.254

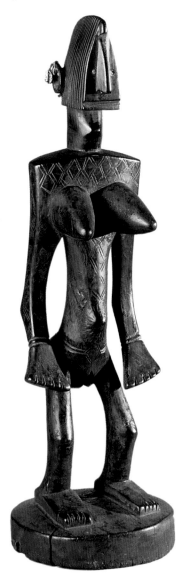

Among the types of figurative sculptures carved and used by the Bamana peoples of Mali is a group, called *nyeleni*, which is characterized by certain common features: females, standing on raised circular platforms, with large, protruding buttocks and conical breasts; broad, angular shoulders; paddle-shaped hands with palms upward and extended slightly forward from the torso richly decorated with scarification. The distinct isosceles triangle shape of this figure's head plays off the sharp corners of the elbows, knees, nose and navel while the long, gentle curves of the arms, torso and legs endow the figure with a sense of lively animation.

Secret societies amongst the sub-Saharan peoples are almost exclusively male. And in the highly unusual cases when women do participate, membership initiations remain segregated, reports Bamana authority Kate Ezra.

This type of carved wood figure is used by the blacksmiths, one of many different male Jo initiation groups. Following their graduation and reintegration into their own village society through celebratory festivities, the new Jo initiates travel for several months to neighboring villages with these wood figures. As an integral part of their performances of song and dance, the new initiates seek praise and gifts of money and food. The sculptures are often washed, oiled, dressed and decorated with jewelry for each of these appearances and represent the ideal beauty in young women sought after for marriage.

W.A.F.

Lobi Peoples

Burkina Faso

Standing
Female Figure

wood, 18 $^7/_8$ x 5 $^1/_2$ x 5 $^3/_4$ in.
(47.9 x 14 x 14.6 cm.)
Museum Purchase. 81.337

The most prevalent and significant artistic works of the Lobi are small wood figures which fall into two distinct stylistic groupings. On the one hand, there are those with strongly abstracted features, roughly and summarily suggested. Quite the opposite is another group of figures with delicate, refined characteristics and smoothly finished surfaces. It is generally agreed among scholars that the function of Lobi figures was either as guardian spirits placed beside doorways of houses to protect families from misfortune and evil, or as ancestor figures placed on family altars. While some researchers have suggested assigning one particular style to one function, art historian Christopher Roy, a specialist in the art of this region, cautions against such a convenient and simplistic deduction without further field research.

Figurative carvings by the Lobi can be characterized by their general lack of static rigidity and strict symmetry, two features common to much African sculpture. This figure has a strong suggestion of movement with legs slightly bent, one forward from the other with the weight of the torso clearly on one hip, giving the body a gentle twist. The figure leans forward imperceptibly with arms bent in a striding gesture. This graceful animation of the figure with subtle asymmetrical treatment of body parts, such as shoulders and breasts, reveals a sculptor with a sophisticated knowledge of the workings of the human anatomy in motion as well as a sublime aesthetic sense.

W.A.F.

Diula Peoples

Côte d'Ivoire

Do Society Mask.

late 18th-early 19th century

leaded tin, brass, copper,
10 1/2 x 6 x 3 in. (26.7 x 15.2 x 7.6 cm.)
Bequest of Victor K. Kiam.
77.179

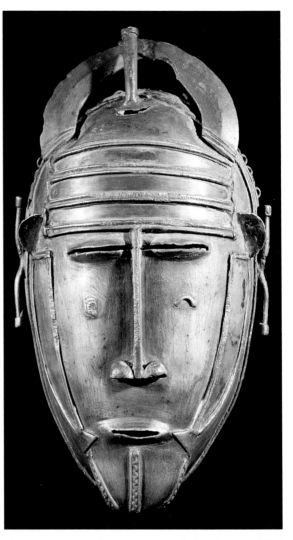

Once attributed to the neighboring Senufo Peoples, this rare type of metal mask is now given to the Diula. As a result of recent field research, Timothy Garrard reports that our mask, one of the most refined and best preserved, can be placed into a group of early cast masks of which only fifteen are known. A date of late 18th to mid-19th century is likely. Garrard points out that while masks of this group are stylistically related, there is evidence that they were made by a number of different hands and workshops over several generations in an area centered around the village of Kong. The highly scratched surface indicates much use, including cleaning and polishing with sand and other abrasives.

Not to be confused with the similar and widely known masks made and used by the Senufo for their village *poro* society festivals in this same region, these metal masks of the Muslim Diula are worn during their *do* celebrations. The *do*, or *lo*, society, most probably originally an old pre-Islamic animist organization which more recently has been modified by Muslim influence, is prevalent throughout West Africa in Côte d'Ivoire, Burkina Faso, Ghana and Mali. Functions of the *do* society include acting as agents of social control, participating in public festivals and major funerals, and keeping the village free of witches and evil spirits.

W.A.F.

Dan Peoples

Liberia/Cote d'Ivoire
Zlan, probable carver

Poro Society Rice Ladle with Janus Head Handle (wa ke mia). 20th century

wood, fiber, iron, 27 x 6 $^1/_2$ x 4 $^1/_2$ in.
(68.6 x 16.5 x 11.4 cm.)
Bequest of Victor K. Kiam. 77.277

A symbol of the possessor's good fortune, generosity and gracious hospitality, this great spoon (wunkirmian or wa ke mia) was used ceremonially to serve rice during harvest festivals and probably was a commissioned portrait to honor its owner, known in the village as the wunkirle or wa ke de. To successfully accomplish all the duties that this prestigious position of Mistress of the Feast requires, the woman, often selected by her predecessor from the younger women in her particular village quarter, enlists the aid of a spirit who manifests itself in the spoon. At the largest feast, the wunkirle is accompanied by her female helpers and dances in men's clothing ("because only men are taken seriously") to demonstrate her position. On other occasions all the wunkirle in a village gather with their assistant followers, each group dancing to excel over the wunkirle assemblages of neighboring villages.

The double-headed handle of this scoop, whose faces are identical except for a raised vertical ridge on one forehead and an incised crosshatch decoration on the other, is most unusual. The hollowed out scoop forms the spoon's body which is symbolically "pregnant with rice." Distinguishing this fine example is a rich, shiny patina on the neck created by usage, a crested coiffure with woven vegetable fiber attachment extending from ear to ear, and small metal teeth inserts.

The carving style of this sculpture has led to its attribution to Zlan, one of the great master carvers of the Liberia/Côte d'Ivoire region in the 20th century.

W.A.F.

Nok/Sokoto Cultures

Nigeria

Head of a Court Figure.
circa 300 B.C. - 200 A.D.

terra cotta, 20 x 8 x 8 ¹/₂ in. (50.8 x 20.3 x 21.6 cm.)
Gift of Mrs. Françoise B. Richardson. 95.357

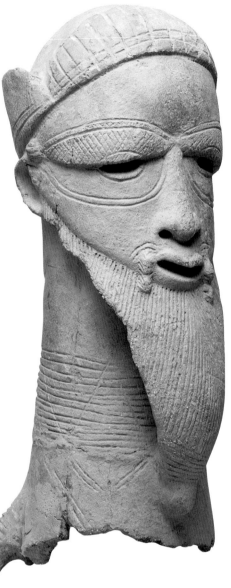

The earliest sculptures to come to light in sub-Saharan Africa are the figural terra cottas dating from 900 B.C. to 200 A.D. found in the Jos Plateau of central Nigeria. First discovered during deep tin-mining operations in 1943, the sculptures were made by an ancient peoples who are referred to today as the Nok and Sokoto Cultures. Since the sculptures display a high degree of complexity and sophistication, it is generally agreed that they were not created by an evolving culture in its initial stages, but by a highly developed society. Nothing, however, is known of the cultures preceding or immediatly following these early peoples. The peoples of the Nok and Sokoto Cultures were the earliest smelters of iron south of the Sahara, as well as agriculturalists, as evidenced by the depiction of tools held be a few of the figures.

While a small number of complete figures has been unearthed, it is primarily fragments, heads and other anatomical parts such as arms, feet and elbows, that have been found. This example's stylistic features are unique, not possessing the classic traits. The life-size head most likely was intended to be a portrait of a particular high priest, ruler or other personnage of noble rank or social status.

W.A.F.

Edo Peoples, Benin Kingdom

Nigeria

Head of an Oba (uhumwelao).

late 18th century

brass and iron, 16 1/2 x 11 1/2 x 12 in.
(42 x 29.2 x 30.48 cm.)
Anonymous Gift. 53.12

The brass casting tradition in Nigeria can be traced to the Igbo-Ukwu bronzes from the 9th century A.D. Later Benin obtained its first brass caster in the first quarter of the 14th century from the Kingdom of Ife. It was during the 16th through 18th centuries that Benin brass casting reached its highest level. The great kingdom flourished until the end of the 19th century when the British led a devastatingly thorough punitive expedition into Benin City in 1897.

These royal funerary portraits, cast in brass by the *cire perdue* (lost wax) process, were placed on altars to commemorate the deceased king in the royal palace at Benin City. More than one head was placed on the altars or shrines, built by the new Oba in memory of his predecessor. Originally this head was surmounted with a curved ivory elephant tusk which fit into the circular hole on the top with the tip of the tusk leaning against the wall of the royal shrine. The tusks were elaborately carved in relief depicting allegorical scenes, hieratic groupings of royal personages and, in some instances, Portugese soldiers.

W.A.F.

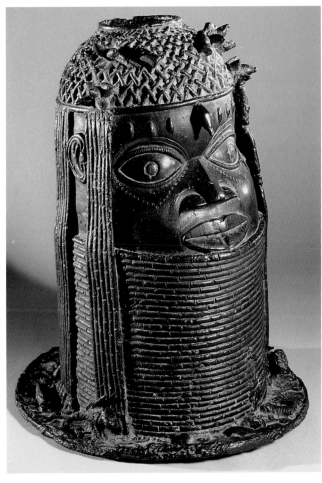

Edo Peoples, Benin Kingdom

Nigeria

Leopard Head Hip Ornament (uhunumwunekhue). 16th-18th century

brass, iron, 6 1/2 x 5 1/2 x 2 in. (16.51 x 13.97 x 5.08 cm.)
Gift of Mrs. Françoise Billion Richardson in memory
of her sister Armande Billion. 90.32

The artists and artisans of the Benin Kingdom in Nigeria over its 500 years existence developed a highly sophisticated, consistent style that was revealed in a plethora of objects made of cast brass, wood, ivory and terra cotta and was associated with the royal court. In addition to the royal funerary portraits (as exemplified by the New Orleans *Head of an Oba*, see page 274) which were placed on commemorative altars in the palace court, other brass objects include full figures of court officials and attendants, altar tableaus, roosters, leopards, rattle staffs, altar bells, altar rings, figurative palace plaques, waist pendants, bracelets, staffs of office, hand held clappers, medicine containers, aquamanile and hip ornaments such as this fine example.

Representations of leopards in Benin culture are used exclusively by members of the royal court. These animals are associated directly with the Oba with whom they share attributes of leadership and ferociousness. Unlike the other type of hip ornament in the Museum's collection which portrays a human face, leopard head ornaments were badges of honor and protection bestowed by the Oba upon his military chiefs signifying their power and bravery. These brass accessories were worn over the gathering of wrapped skirts at the chiefs' left hip as one element of their full ceremonial regalia at formal palace events.

W.A.F.

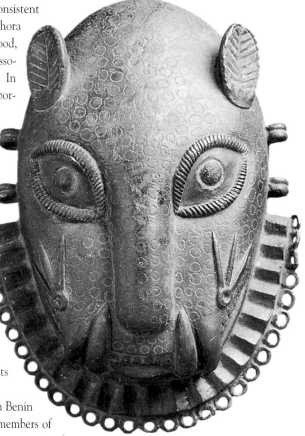

Yoruba Peoples

Ogboni Society, Nigeria

Pair of Onile Figures. 18ᵗʰ-19ᵗʰ century

bronze (female) 12 ¹/₄ x 4 ¹/₂ x 5 in. (31 x 11.5 x 12.7 cm.)
(male) 12 ¹/₄ x 4 ¹/₂ x 6 in. (31 x 11.5 x 15.2 cm.)
Gift of Françoise Billion Richardson in memory of
Lt. Olivier Robert Billion U.S.N. 94.55.1-.2

Kingdom of Owu, Nigeria

Figure of Onile. 18ᵗʰ century

brass, 23 x 6 ¹/₄ x 4 ³/₄ in. (58.4 x 15.9 x 12.1 cm.)
Bequest of Victor K. Kiam. 77.158

This cast brass and pair of cast bronzes depict the shrine figures of onile, the "owner of the house" of the Ogboni or Osugbo Society, one of the main political forces among the Yoruba. Onile represent the first male and female progenitors of the society and community.

The female brass and male bronze figures hold their hands in the characteristic Ogboni salute. The brass example wears her hair dressed as four horns with an incised chevron ornament. A garment is indicated by a series

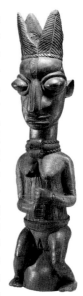

of incised vertical stripes below her exposed breasts and ends with a belt at the waist. She is seated straddling a conical mound in reference to the act of taking of oaths. She wears a single bracelet and around her neck is a double strand necklace with two large tubular beads which probably represent coral. Among the Yoruba, bulging oval eyes, set in raised sockets such as she has, connote wisdom. The channel from the forehead down the nose suggests an original inlay which has been lost.

A thermoluminescence test from the terra cotta core dates the casting of this brass figure to the 18ᵗʰ century, a date consistent with the other five or six known figures of its particular stylistic type. According to art historian Henry Drewal, these figures "come from an Osugbo lodge in the kingdom of Owu, just north of Ijebu, and were taken to Ipern in 1840. When Owu was destroyed and its people fled before 1840, several of these sacred objects were saved and carried to other towns."

Onile figures are generally portrayed in a seated position. Therefore, this bronze pair in a kneeling stance is most unusual. While the male demonstrates the traditional Ogboni greeting with one fist atop the other, the female holds an offertory spoon for seeking Onile's favor. Both wear stylized beards, shirts with geometric patterning, triangular amulet necklaces and curious helmets with flanged finials and dangles attached to the back of their brims.

W.A.F.

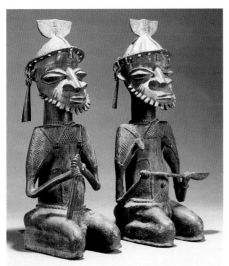

Yoruba Peoples

City of Ikere, Ekiti Province, Nigeria
Olowe of Ise, carver, died 1938

Mounted Warrior (Jagunjagun)
Veranda Post. circa 1910

polychromed wood,
55 ¹/₂ x 23 x 15 in. (141 x 58.4 x 38.1 cm.)
Ella West Freeman Foundation Matching Fund. 70.20

Reportedly born in Efon-Alaye, Nigeria,
Olowe migrated to the southern Ekiti vil-
lage of Ise where he became the great
mastercarver of architectural ornament in
Yorubaland and the messenger of the King
of Ise, known as the Arinjale. It is suggested
that Olowe was lent by his chief patron,
Arinjale, to neighboring local kings in eastern
Yorubaland to execute doors and houseposts
for their palaces. This is no doubt the case
with a group of three veranda posts, of
which this example is one, carved around
1910 for the Palace of the Ogoga of Ikere.
The companion posts are in the collections
of the Art Institute of Chicago and the
Memorial Art Gallery of the University of
Rochester, New York.

Their hieratic composition includes the
central post of the enthroned king with his
senior wife standing behind him. As the power
behind the throne, her head symbolically
supports the roof. Flanking the king on the
right is a mother and child group and on the
left, a warrior mounted on a horse or donkey,
both common Yoruba motifs.

The presence of the warrior in this archi-
tectural context and at the entrance of the
palace connotes honor to the king. In a simi-
lar fashion the scale of the rider in proportion
to the size of the animal demonstrates the
importance of the warrior. The small figure

at the side blowing a hunting whistle empha-
sizes the warrior's right to have retainers.

The distinctive style of Olowe's carvings is
identifiable by its elegance, animation, subtle
use of color and traces of humor.

W.A.F.

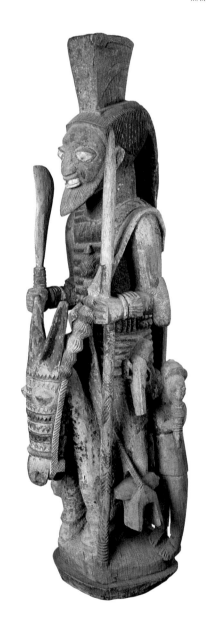

Yoruba Peoples

Ekiti Region, Nigeria.
Arowogun of Osi-Ilorin, 1880-1956, carver

Divination Tray (opon Ifa)

wood, 1 ³/₄ x 18 x 18 ¹/₄ in. (4.5 x 45.7 x 46.4 cm.)
Partial and promised gift of H. Russell Albright, M.D.
90.389

One of the main components of the Yoruba religion is the Ifa divination system performed by trained priests, called *babalawo* or "fathers of the secret" or "fathers of ancient wisdom." Among the implements utilized in this complex ritual is a flat tray, usually round, on which the diviner spreads wood dust or ground kola nut powder, draws a crossroads pattern, and taps the wood while invoking the ancient Ifa priest's presence. Through an intricate system of interpreting the pattern of graphic symbols drawn in the powder numerologically from sixteen palm nuts, the *babalawo* recites the relevant sacred verses from his memorized inventory of 256. From this is determined a concluding message for his client who had humbly petitioned for advice or a solution to his question or problem.

The frontal facial image depicted at the top of the rim of the tray and facing the priest is the popular Yoruba god or *orisha* Eshu. He is the intermediary between the priest and the *orisha* Orunmila, who is the source of all wisdom and knows the secret of the creation of the universe. Known as the guardian of the ritual way and the god of chance and uncertainty, Eshu is respected as the mischievous trickster who can reverse a man's fortune if not properly honored.

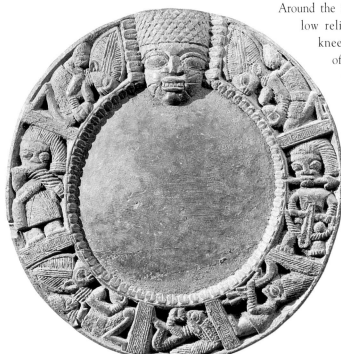

Around the tray flanking Eshu are low relief carved images of kneeling women making offerings who represent the supplicants approaching the Ifa priest. Figures associated with royalty, such as a flute player, a drummer and a soldier with a knife, are also depicted.

W.A.F.

Yoruba Peoples

Town of Efon-Alaiye, Southern Ekiti Region, Nigeria

Epa Headdress
(olomopupo or olumeye). 19th century

wood, paint, kaolin, 44 1/2 x 10 1/2 x 12 1/4 in.
(113 x 26,7 x 31 cm.)
Carrie Heidrich Fund. 87.33

The Yoruba helmet mask is distinctive with its large superimposed figurative headdress worn during the Epa festival. This annual event celebrates the social values which are central to the life of a Yoruba town. According to Yoruba art historian John Pemberton III, "The carving of a headdress for an Epa masquerade is commissioned by the members of a particular descent group to memorialize a long-deceased member of the family. The carvings are not intended to portray a particular person, nor are they generalized expressions of cultural values. Rather they are idealized presentations of historic personages who are remembered for having embodied in their lifetime culturally recognized values. They are figures of praise and figures to be praised."

There is a variety of specific types of figural headdresses which stand atop the pot-shaped helmet mask with its grotesque and grimacing Janus faces. Each spring these enormous masks, which are carved from a single piece of wood and can weigh up to sixty pounds, emerge from the forest in northeastern Yorubaland in an established sequence. The masks are worn by young male dancers who affirm the physical strength and achievements of the living. This mask is the fourth type to appear and in all probability represents a prominent Iyalode, the highest ranking female chief who is called "the mother of all." In her hands she holds the emblems of her status as a chief.

A 19th-century date can easily be assigned based upon its rich surface patination. From the unique, unfinished and unpainted crown it can be hypothesized that a special cloth headdress adorned the sculpture when worn in the Epa masquerade.

W.A.F.

Yoruba Peoples

Kingdom of Owo, Nigeria.

King's Tunic.

late 19th-early 20th centuries

cloth, glass beads, 35 x 48 x 6 ¹/₂ in.
(88.9 x 121.9 x 16.5 cm.)
Robert P. Gordy and Carrie Heidrich Funds.
91.29

The tribal royal kingdoms in sub-Saharan Africa utilize magnificent objects associated with positions of power and prestige. The veiled crowns, vestments, shoes, fans, fly-whisks, footrests, canes, staffs and thrones employed exclusively by the regional kings of the Yoruba are distinguished by their lavish use of beadwork. Such is the case with this extraordinary tunic thought to be the only royal garment of its kind outside of Africa.

The cloth's entire surface is covered with multicolored beads in geometric decorations of alternating vertical panels of interweave and chevron designs. Three dimensional beaded birds are attached at the seams under each sleeve and extend down the cen-

ter panel on the front and back of the tunic. A delicate beaded fringe extends along the bottom hem. Both the cloth and the beads are of European manufacture and were popular trade items in the 19th century.

The tunic's fresh appearance indicates that it was used only on rare, special occasions and that great care and respect were given to this important palace object. Yoruba art historian Roland Abiodun has identified the officials in Ijebuland who probably wore this particular ceremonial outfit at the turn of the century.

The motifs and quality of the work speak of the importance of the wearer. The bird figures represent the king's abilities in the spiritual realm, whether combating witches or seeking religious guidance. The complex, knotted patterns attest to his power to solve the difficult problems confronting his office.

W.A.F.

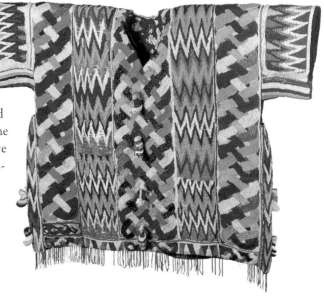

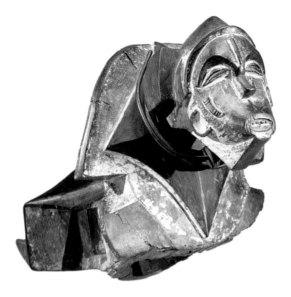

Igbo Peoples

Village of Abakaliki, Izzi Subgroup, Nigeria

Elephant Mask with Human Head (ogbodo enyi)

wood, pigment, iron, coins,
13 3/4 x 12 1/4 x 24 1/2 in. (35 x 31.2 x 62.2 cm.)
Robert P. Gordy Collection in memory of
Frank Kennett. 88.36

Attached to a full tunic costume of knotted rafia, *ogbodo enyi* masks are worn horizontally on top of the masker's head during dry season festivals and funerals of members of the various male age-grades. The masks represent these social units and recognize their contributions to the village community. Igbo scholar Herbert Cole explains that while *ogbodo enyi* literally translates as "spirit elephant," the mask is not

an embodiment of the animal's spirit. It characterizes power and endurance through a highly stylized image of an elephant with two projecting tusks in front, a humanoid nose, a pointed trunk emanating from the forehead, and a human head called *ntepke* in the back.

There is no consistent account for the presence of *ntepke*. Some claim its pleasant features are a foil to placate women and children from the aggressive aspects of the abstract elephant image, while others feel these heads are meant as portraits of recognized persons in the village. However, many agree that *ntepke* are only found on the senior grade masks to assert the higher authority and greater spiritual capacity of those masks.

W.A.F.

Ejagham Peoples

Ukelle Area, Nigeria
Ogwogno Egana, probable carver, died circa 1950

Enyatu Society Triple-faced Helmet Mask.

circa 1900-08

wood, antelope skin, animal fur, wicker caning,
iron, pigments and kaolin,
16 $^1/_2$ x 11 $^1/_2$ x 12 in. (42 x 29.2 x 30.5 cm.)
Gift of Mrs. P. Roussel Norman. 79.198

The Ejagham people are found in the sparsely populated forest area east of the Cross River in southeastern Nigeria and Cameroon. The manufacture of skin-covered masks is unique to this area. Originating with the Ekoi, masks of this type are also associated with and found among numerous neighboring groups. There are two main varieties of these masks. The cap mask sits on top of the wearer's head, while the helmet mask, usually Janus-faced, fits over the masker's head and rests on his shoulders. Such skin-covered masks are used by members of mask societies or associations for specific functions: funerals, ceremonies of state, entertainment and victory celebrations.

This triple-faced mask is carved from a single piece of wood. On the front is a single dark-colored male face and on the back are two light-colored female faces, slightly smaller than the male and thought to represent his wives. The darker color of the male is associated with strength and bravery; the lighter color of the female suggests weakness and submission to the male. From the numerous similarities in form, style and detail treatment, researcher Keith Nicklin suggests that this mask was probably executed between 1900 and 1908 by the renowned carver Ogwogwo Egana (died circa 1950) from the Ukelle area.

W.A.F.

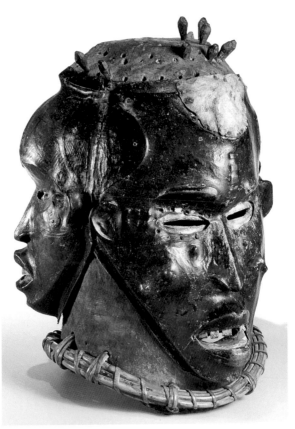

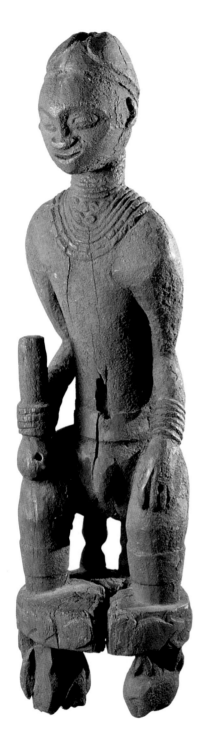

Bangwa Peoples

Cameroon

Royal Memorial Ancestor Figure (lefeur). 19th-early 20th century

wood, 37 5/8 x 9 3/4 x 8 3/4 in.
(95.5 x 24.7 x 22.2 cm.)
Bequest of Victor K. Kiam. 77.172

Portraits of royal ancestors can be found among numerous groups living in Cameroon and Zaire. This particular Bangwa king's (Fon) image is characteristic of these figures by being depicted without clothing but wearing accoutrements signifying his high rank: cloth cap, ivory bracelets, leopard-skin belt, banded anklets and coral, glass bead and cowrie necklaces. Most king figures, like this example, are depicted holding a gourd bottle in the right hand to indicate the king's role of pouring libations. This figure sits on a small elevated stool or throne, an indication of his importance. Although its embellishment has eroded, the stool bears traces of animal form decoration, typical of richly beaded Cameroon royal furniture. Unlike other king portraits, which render the mouth open to reveal prominent rows of teeth, this ruler is described with a most unusual closed, smiling pair of thin lips.

Carved immediately upon the king's accession, such figures are displayed with those of preceding rulers in front of the palace at important ceremonies such as a king's funeral, the induction of a new Fon or the annual ceremonies of the lefeur society to demonstrate the dynasty's continuity and longevity.

W.A.F.

Mindassa/Wumbu Peoples

Gabon

Janiform Guardian Figure for a Reliquary (mbulu-viti)

wood, brass and copper,
22 ³/₄ x 11 ³/₈ x 3 in. (57.7 x 29 x 7.6 cm.)
Bequest of Victor K. Kiam. 77.245

Compared to other fields in the history of art, the systemized study of sub-Saharan art as a scholarly pursuit is in its infancy. It was only during the first decade of this century that artists such as Vlaminck, Derain, Matisse, Braque and Picasso in Paris and *Die Brücke* group of German Expressionist artists in Dresden recognized African sculpture as neither "savage fetishes" nor ethnographic specimens, but as works of art.

Early 20th-century artists were probably inspired by guardian figures. For some time

scholars have attempted to clear up the confusion associated with the originators of these figures. The most recent literature refers to them as the Kota-Obamba people. Like the Fang they live in the thick equatorial rain forests of the Ogowe River Basin and similarly create guardian figures to be placed atop containers (in this case, woven baskets) containing bone relics. Unlike the rounded forms of the Fang figures, these highly-stylized, two-dimensional wood sculptures are completely covered with sheets and strips of brass and copper. Janus examples (*mbulu-viti*) with convex and concave faces, illustrating the opposing forces of the universe, are more uncommon than single faced figures (*mbulu-ngulu*). Generally, *mbulu* have large crescent-like forms, thought to represent animal horns; curving shapes, portraying coiffures that flank ovoid faces; and arms in a lozenge shape attached to the necks.

W.A.F.

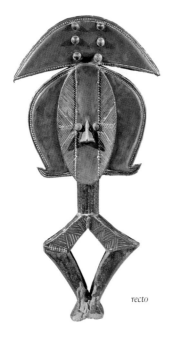

recto

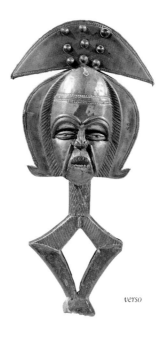

verso

Fang Peoples

Gabon

Three Standing Guardian Figures for Reliquaries (bieri)

wood, 23 ⅛ x 5 x 4 ⅝ in. (58.7 x 12.7 x 11.8 cm.)
wood, bone, 26 ¾ x 5 ⅛ x 6 ¾ in. (68 x 16 x 17.2 cm.)
Bequest of Victor K. Kiam. 77.154, 77.209

wood, 19 1/4 x 4 3/4 x 4 3/4 in. (48.9 x 12.1 x 12.1 cm.)
Gift of Mr. and Mrs. Frederick M. Stafford. 79.338

These carved figures were inserted into the lids of cylindrical boxes that contained the skulls of the village founders as well as skulls and bones of other distinguished persons. Represented variously as heads, heads with torsos, or complete figures such as these pieces, the sculptures symbolized not only the mythical founders of the tribe, but also the very embodiment of the soul of the Fang peoples. They are never merely considered as ancestor figures. Such boxes, made of sewn bark, surmounted with wooden figures and called bieri, possess great power to protect the whole clan and to heal the sick. Concealed from the view of women and the uninitiated, they are venerated on altars in small sanctuaries or in restricted areas of the houses of secret society leaders where the figures are rubbed daily with palm oil. Only during the festive conclusion of initiation ceremonies are the bieri brought out in order that the ancestral spirits may participate and be given their proper honor and respect.

The Museum is fortunate to possess three of there rare figures each of which is an excellent representation of a different substyle of bieri figurative carving. Together they are among the finest African sculptures in New Orleans' distinguished collection.

W.A.F.

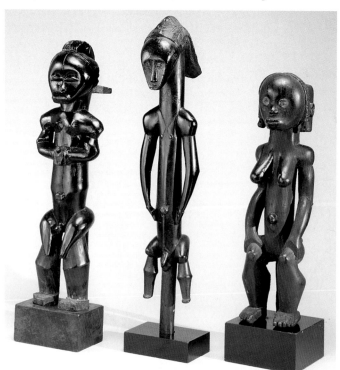

Punu/Lumbo Peoples

Ogowe River Area, Gabon

Two Female Mourning Masks (okuyi)

wood, 11 ³/₄ x 6 ¹/₂ x 5 ¹/₂ in.
Museum Purchase with funds from an Anonymous
Donor in memory of Bryce Holcombe. 92.816

wood, metal and pigment,
13 ⁵/₈ x 8 x 7 ¹/₈ in. (34.5 x 20.3 x 18 cm.)
Bequest of Victor K. Kiam. 77.157

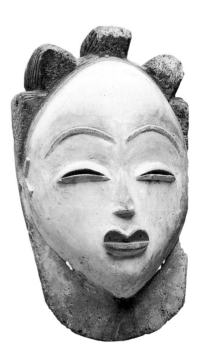

Masks of this type have been variously attributed to numerous peoples who live in the Ogowe River Region of Gabon. The Shango, Kota, M'Pongwe, Lumbo, Punu, Shire, Mitsogho, Bavui and other neighboring groups may use these white faced masks.

Belonging to the *mukui* society, these face masks are thought to represent the spirit of deceased women who have come back from the land of the dead. Hans Himmelheber reports witnessing dancers on stilts wearing these masks. Each dancer, using a hidden device made of small gourds and spider webs to disguise his own voice, speaks for the dead one's spirit.

While each mask is individualized and distinctive, they share recognizable mutual stylistic traits. The quietude, symmetry and refinement of the facial features as well as the delicately carved and sophisticated black hair crested around the chalk white face project an image which is unique to the African aesthetic. The crescent slit openings for the bulbous eyes echo the gentle arcs of the eyebrows and the intertwinings of the coiffure.

W.A.F.

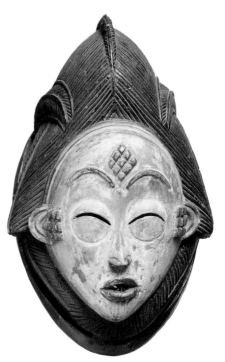

Bembe Peoples

Republic of Congo

Seated Male Figure Holding Musical Rattles (bimbi)

wood and porcelain,
11 x 4 ⅝ x 3 ¾ in. (28 x 11.7 x 9.5 cm.)
Bequest of Victor K. Kiam. 77.113

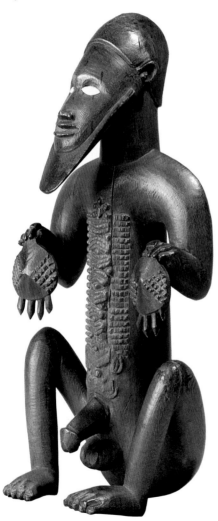

The Bembe are a relatively small group of people living in the Sibiti district outside the capital city Brazzaville near the mouth of the Congo River. Artistically they are best known for small figures carved with exceptionally fine detail and finish. Male figures are commonly represented standing and holding weapons, such as guns and knives, which are related to male dominance in this society. In contrast, female images have outstretched arms, implying subservience, or hands placed on the abdomen or breast, referring to pregnancy and suckling. Most figures have eye inlays of small white porcelain fragments, manufactured in Europe. This bearded male figure, holding a pair of musical rattles or bells in each hand, is unusual in that it is seated and slightly larger than normal.

Instead of thick deposits or magic substances on the abdomen of figures, commonly found among the neighboring Kongo sculptures, the Bembe substituted intricately designed body scarification or cicatrices. They inserted the magic into the torso at the buttock. The figures containing these magic or medicinal potions were thought to harbor ancestor spirits that had power to protect or to punish their owners depending on their behavior. In addition, the figures acted as healers, diviners and exorcisers.

W.A.F.

Tabwa Peoples

Zaire

Standing Male Figure

wood, caning, animal horn, string, bundles
of seed pods, animal hair and brass,
18 $^7/_8$ x 4 $^7/_8$ x 5 $^3/_{16}$ in. (48 x 12.5 x 13.2 cm.)
Bequest of Victor K. Kiam. 77.151

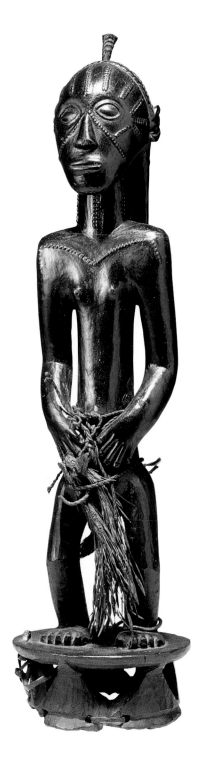

The Tabwa people are a Luba subgroup who
live in southeastern Zaire on the south shore
of Lake Tanganyika. Characteristic of this
uncommon stylistic group are softly rounded
forms and stiffly erect stances. These figures,
decorated with straight lines of raised scarifi-
cation, have their hands on their abdomens,
slightly bent elbows and knees, and broad
shoulders. The stool on which this particular
figure stands is carved in an unusually intricate
open-work structure which has interwoven
caning. Its configuration is a variation of the
balamwezi ("the rising of the new moon")
decorative patterning of single or multiple
triangular shapes found in a variety of Tabwa
utilitarian and secular objects. Other acces-
sories and attachments on this piece include a
bundle of herbal seed pods and animal hair
tied with cord around the waist, the tip of a
small duiker-horn inserted into the top of the
head which identifies its function as a recepta-
cle to hold protective magical medicines.
Holes in the cascading hairdo in the rear,
along with a pair of carved duiker-horns
turned upward, indicate other depositories of
medicinal substances now missing. Sculptures
by the Tabwa are rare, and for its refined carv-
ing this example is among the finest known.

W.A.F.

Luba Peoples

Zaire

Ancestor Figure Amulet

ivory, glass beads, rawhide, iron,
3 15/16 x 1 3/4 x 1 1/2 in. (10 x 4.4 x 3.8 cm.)
Bequest of Victor K. Kiam. 77.114

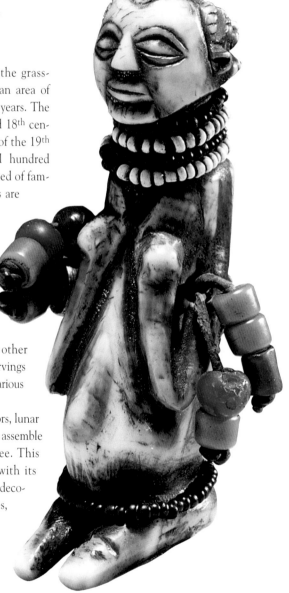

The Luba peoples have dominated the grass-lands, savanna and marshes in an area of southeastern Zaire for hundreds of years. The great Luba empires of the 17th and 18th centuries met their demise at the end of the 19th century. Today there are several hundred thousand feudal kingdoms comprised of family clans whose main occupations are farming and fishing.

The Luba, along with the closely related Hemba to the immediate north, are recognized for their excellent and beautifully carved sculptures. Artistic production focuses mainly on prestige objects and regalia reserved for chiefs and other important officials, while other carvings relate to divination practices and various belief systems.

Their cults venerate clan ancestors, lunar cycles and deceased chiefs and assemble shrines for the worship of all three. This miniature ivory kneeling figure with its hands placed on its chest is richly decorated with colorful beaded necklaces, belts and arm bands. It served as a charm commemorating an ancestor and was strung on a leather thong and worn around the neck.

W.A.F.

Chokwe Peoples

Zaire/Angola. School of Muzamba

Seated Chief-Musician Playing a Sansa (kaponya)

wood, 11 ³/₈ x 4 ⁵/₈ x 4 ⁵/₈ in. (29 x 11.8 x 11.8 cm.)
Bequest of Victor K. Kiam. 77.135

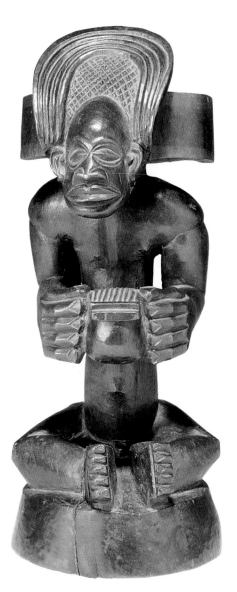

The Chokwe, or Tshokwe, have lived in an area of forest and savanna on the Muzamba plateau of Angola and into southwestern Zaire for over 400 years. Known as farmers, herders and hunters, and for their prowess at warfare, these aggressive peoples became wealthy and powerful in the 19th century by trading guns with Europeans for land, traversal tolls and products such as beeswax, ivory and rubber.

The Chokwe are admired today for their exceptional woodcarvings, most of which are associated with and owned by officials of the royal court. There is no paramount chief for these peoples numbering around 600,000 but power is shared among individual chiefdoms which are inherited from the maternal uncle. Images of chiefs who have divine power are found on a variety of implements and in various figurative poses. This portrait depicts the ruler nude and seated with finely rendered exaggerated hands and feet and wearing the elaborate chief's hat or coiffure. He holds a *sansa*, sometimes referred to as a metal-tongued or thumb piano. Chokwe scholar Marie-Louise Bastin reports that this sculpture of the chief-musician motif is rare among Chokwe art.

W.A.F.

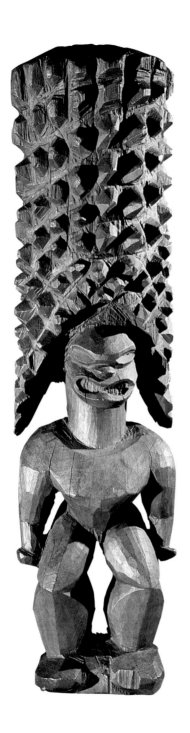

Hawaiian Peoples

United States of America, Polynesia

Temple Figure. 18th century

wood, 31 x 7 5/8 x 5 in. (78.7 x 19.4 x 12.7 cm.)
Bequest of Victor K. Kiam. 77.149

Anthropologist Adrienne Kaeppler has conducted extensive research tracing the history of the artifacts found during Captain James Cook's discovery of Hawaii. She has determined that this early wooden image is one of two collected on Cook's third voyage to the Hawaiian Islands in the year 1778 through 1779. Dr. Kaeppler suggests that both the New Orleans image, "and a likely mate now in the British Museum, may have been part of a fence removed by Cook's men for firewood from Hikiau heiau," an outdoor religious structure. Small wood images, such as this *Temple Figure*, are unpretentious yet served as prototypes for larger and more highly finished images made on the island of Hawaii in the late 18th and early 19th centuries.

The primary function of the temple figure was to protect sacred precincts. These figures are, therefore, made to be aggressive, even threatening. The adze marks evident on the unsmoothed surface of the figure enhance its rough, ferocious quality. The grotesque facial features include a grimacing figure-eight mouth, broad nose, and slanted almond-shaped eyes. The tall, complex headdress, carved in a series of knobular projections, surmounts the figure. In general the emphasis is on musculature and the abrupt divisions of body areas are cubist in concept.

C.F.

Maori Peoples

New Zealand, Polynesia

Pendant (hei tiki)

nephrite, 4 ⁷/₈ x 2 ⁵/₈ x ⁵/₈ in.
(12.4 x 6.7 x 1.6 cm.)
Bequest of Victor K. Kiam. 77.133

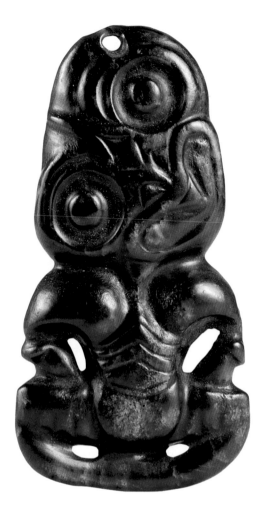

Recognized for their distinct and individual art style, the Maoris of New Zealand are credited with an artistic development found nowhere else in Oceania: they use nephrite, a hard green stone resembling jade, to fashion weapons, tools and ornaments. Among these ornaments, worn by both men and women, the most prized is the *hei tiki*; *hei* meaning pendant; *tiki* referring to a human figure, the first man created by the gods, or even the creator himself.

To shape hei tikis requires months of drilling and abrading with water and sand. Although subtly and intriguingly different, they follow a specific stylistic concept, which is generally derived from the human embryo and thus suggests a magical potency. The New Orleans example, reproduced here actual size, depicts a small, grotesque seated figure with a curvilinear outline, pendants such as the a broad nose, enlarged head which is tilted to the right, a figure-eight shaped mouth with teeth, and protruding circular eyes, probably once inlaid with haliotis shell. The shoulders are rounded; the three-fingered hands rest on upper thighs; and the fishtail feet curl inward to join at the front. Except for the inclusion of ribs, little surface detail is apparent.

Hei tikis are handed down in chiefly families as heirlooms, probably mementos of deceased ancestors. Through age and contact with important people, they are said to gain *mana*, the power of elemental forces.

C.F.

Ramu River Region

Papua New Guinea, Melanesia

Superimposed Crouching Figure

wood, 16 ¹/₂ x 8 ⁷/₈ x 7 ³/₈ in. (41.9 x 22.5 x 18.7 cm.)
Gift of Mr. and Mrs. Frederick M. Stafford. 80.197

The greatest concentration of art produced in the South Pacific islands is found on Papua New Guinea, particularly in the Sepik, Yuat, Karawari and Ramu River regions. The fact that approximately eight hundred different languages are spoken by the three million people living in this area leads to a constant state of tribal warfare. As a result of the complexity of interrelationships between these various cultures, it is often easier to sort and identify their artistic endeavors by geographic region instead of by individual tribal name.

The function of this masterly wood fragment from the Ramu River region is uncertain; possibly it was part of a drum or a canoe prow. Nevertheless, the sculptural integrity of the interrelated figures, in acrobatic, yet naturalistic poses, conveys an image of strength and power. The symmetrical repetition and open-work of the angular limbs is counterbalanced by the ovoid shape of the anthropomorphic faces. Most likely the wood was originally painted and the series of piercings indicate possible ornamental attachments of shells, feathers or boar tusks.

W.A.F.

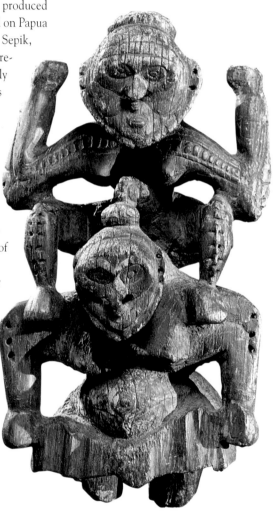

Alamblak Peoples

Karawari River Region, Papua New Guinea, Melanesia

War and Hunting God (yipwon)

wood, cowrie shells, 75 x 2 ¹/₂ x 11 ³/₄ in.
(190.5 x 6.3 x 29.8 cm.)
Bequest of Victor K. Kiam. 77.174

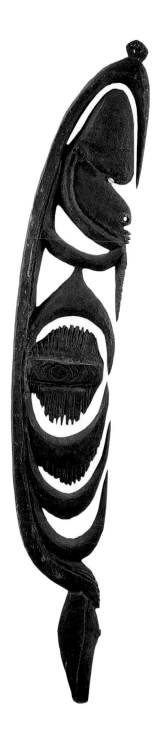

The stylistic trait of a series of curving, concentric, pointed hooks aligned along an axis is commonly known as "opposed hook" and is found only in the Sepik region. The most frequent application of this device appears in the highly abstracted figures, such as this example, made by the Alamblak from the Karawari River region, a tributary of the Sepik. Kept in men's ceremonial houses, these figures, whose aim could only be deciphered by shamans, represent gods or spirits who provide success and good fortune during war and hunting. Much smaller versions act as proctectors and patron spirits for individuals and are carried in the owner's net bag of personal belongings. While the pointed projection above the head represents a bird's beak, the other projections delineate the spirit's ribs which surround its heart, the circular form in the center.

W.A.F.

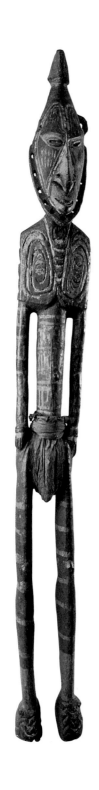

Kopar (?) Peoples

Lower Sepik River, East Sepik Province, Papua New Guinea, Melanesia

Ancestor Figure

wood, tapa cloth, pigment, 66 $^{1}/_{4}$ x 7 x 5 $^{1}/_{2}$ in.
(168.3 x 17.8 x 13.97 cm.)
Bequest of Victor K. Kiam. 77.162

The belief that ancestral spirits could aid or harm their descendants gave rise to a Sepik tradition of sculpture made specifically to serve as memorials. By either housing the deceased or commemorating the dead, the spirits are honored which ensures the protection of the Kopar people. Commemorative ancestor figures, such as this, are not exact likenesses of the deceased, but instead refer to that person by the personal designs exhibited by the deceased at ceremonial occasions during his lifetime.

Exaggerated design is characteristic of this kind of Sepik art and is seen here in the deep carving of the scarification pattern on the figure's pectorals, buttocks, shoulders and feet; and in the blocky, unnaturalistic articulation of knees, breast bone and hands and feet. Naturalistic features, such as the pierced nasal septum, resulting in the elongation of the nose, as well as the protruding, slightly off-center lips and the recessed oval eyes, give the otherwise stylized figure a personalized quality. The substantially frontal, rigid pose of this figure is typical of Sepik art and conveys an attitude of seriousness, even austerity. A dark red ocher was rubbed over the surface which provides the background for the patterns of yellow and orange.

C.F./R.K.L.

Anggoram Peoples

Lower Sepik River, East Sepik Province,
Papua New Guinea, Melanesia

Dance Staff

wood, fiber, cowrie shells, cas-
sowary feathers and pigment,
29 x 5 x 4 ³/₄ in.
(73.7 x 12.7 x 12.1 cm.)
Bequest of Victor K. Kiam. 77.261

The Anggoram peoples bear cultural similarities to the people of the Middle Sepik River and coastal region which is evident in the dynamic, expressive art styles shared by these two groups. Yet local distinctions are evident as individual clan doctrines and symbols are interpreted in original ways. Universal, however, is the belief that the particular articulation of clan symbols and doctrine is the vehicle for the release of magic power enacted by natural, mythological, or ancestral spirits.

An excellent example of the Anggoram approach is found in this *Dance Staff*. Although it is based upon naturalistic forms, those forms have been reinterpreted, dismembered and imaginatively reassembled, creating an arresting effect of energy. Animation is in fact essential to the function of this figure which would have been tied to a short length of bamboo and carried in dances. Composed of an attenuated human form with openwork body, its arms and legs sharply flexed, the figure is surmounted by a disproportionately large and fantastic bird head, possibly a fish eagle. Two hands grasp the tip of the beak which extends downward to a slender vertical form, clasped by two or more hands and terminating in the head of a fish. The surface, rubbed black overall, is decorated with symbolic designs in white, yellow and orange pigments. Cassowary feathers are attached to the top of the head and cowrie shells are fastened to pierced holes at both sides of the beak.

C.F./R.K.L.

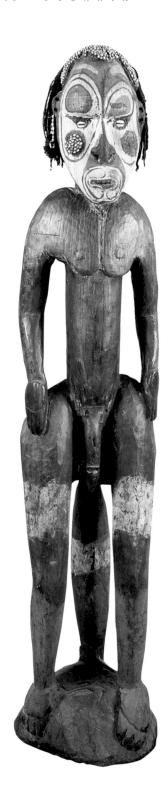

Iatmul Peoples

Anggriman (?) Village, Woliagwi (?) Group, East Sepik
Province, Papua New Guinea, Melanesia

Orator's Stool with Standing Male Figure

wood, seeds, cowrie shells, human hair, string,
tortoise shell and pigment, 52 $^3/_4$ x 11 x 8 $^3/_4$ in.
(133.98 x 27.9 x 22.2 cm.)
Bequest of Victor K. Kiam. 77.195

Formal debate is an important and popular practice for the Iatmul people. The principal accessory of expression during their often violent discussions is a carved represention of an ancestor kneeling or standing beside his personal stool. To emphasize his argument the Iatmul speaker strikes the table-like stool or projection with bundles of leaves.

The disproportionately exaggerated hips, shoulders, and heavy, incised pectorals are characteristic of carvings from this region. The richly colored patterns of spirals, discs, and lozenges, and facial decoration, all worn as painted decoration in daily life, vary in treatment with different villages or groups. Flared nostrils draw attention to the pierced nasal septum and the bridge of the nose, which extends to the upper forehead. Almond-shaped eyes, marked by cowrie shells, are surrounded by tapering black ovoid shapes. While the face is painted white over-all, its contours are accentuated with black and red serpentine lines. A circular configuration of tiny, polished seeds is applied with clay and lime paste to each cheek and to the crown of the head, from which ringlets of human hair are suspended.

C.F./R.K.L.

Northern New Ireland

Melanesia

Malanggan Figure (totok)

wood, sea snail opercula, dried grasses and pigment,
61 $^1/_2$ x 7 $^1/_2$ x 7 $^1/_4$ in. (156.2 x 19.1 x 18.4 cm.)
Bequest of Victor K. Kiam. 77.176

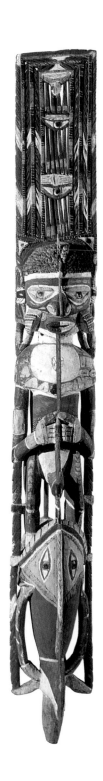

Ancestor rites are the dominant theme of the New Ireland culture and thus theirs is a mortuary art. To commemorate specific physical or mythological ancestors, these people developed a series of festivals, collectively termed *malanggan*, which feature dancing, feasting, carved figures and masks. Rival clans compete in staging the most costly, spectacular *malanggan* within one to five years after the death of a clan member. The dynamics of upholding clan prestige require each *malanggan* to be more original and fantastic than the last. The clan elders commission the most accomplished artists, who work in secrecy for months behind a high-walled enclosure, to design a complex iconography of traditional designs and motifs. At the proper time the stockade is pulled down and the carvings, such as this, are left to be admired.

Made to be stuck in the ground, a *totok* is a sculptural rendering of an ancestor. The figure, rising from the wide open mouth of a large fish, has cheeks carved to simulate falling panels of cobwebs. The entire surface of the *Malanggan Figure* is intricately painted with detailed designs creating a sense of *horror vacui* that is common to New Ireland sculpture. It is not only its elaborate decorative patterning that animates this object. Its vitality is enhanced by the play between the negative space and the solid form and rods which makes the whole figure seem to shimmer.

C.F./R.K.L.

San Christobal Peoples

Solomon Islands, Melanesia

Two Sea Spirits (akalo ni matawa)

tortoise shell, 10 ¼ x 8 ⅛ x 1 in. (26 x 20.6 x 2.5 cm.);
10 ⅛ x 5 ⁷/₁₆ x 1 in. (25.7 x 13.8 x 2.5 cm.)
Bequest of Victor K. Kiam. 77.280, 77.281

The native name for these figures, represent-
ing sea spirits who live, play and travel in the
ocean, means "ancestor of the deep water."
The heads, feet and hands of the humanoid
forms have been replaced by fish such as large
skipjacks (*mwanole*) and small flying fish,
often with perforated eyeholes. The fish motif
is repeated at the knees and buttock as well.
On the head of one figure a tortoise is held in
the mouth of a shark. Expressing animated
movement with its dancing and leaping gesture,
the sea spirit design is frequent decoration on
San Christobal bonito canoes, the gables of
canoe houses, fish floats and wooden bowls.
Such representations were first described by
the Spaniards in 1568 and are still utilized
today on Solomon Island coins and stamps.
While sea spirits are usually rendered in
wood, tortoise shell is an uncommon medium
for image making, in general, and the specific
usage of shell-carved sea spirits such as this
pair is uncertain.

There are many different spirits, each with
its own name, identity and particular habitat
in the neighboring waters around the islands.
Bonito fishermen fear them and pay proper
respect lest they incur the spirits' anger and
receive arrows shot at them. It is believed a
rainbow is the spirits' companion and the
appearance of one indicates their presence.

W.A.F.

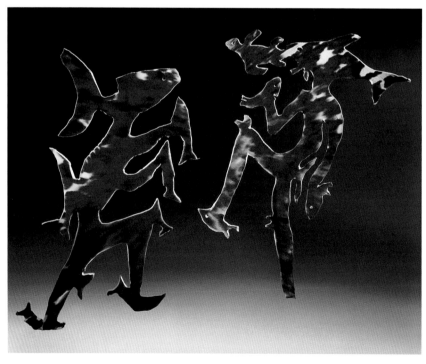

Batak Peoples

Karo subgroup, North Sumatra, Indonesia

Apotropaic Figure

wood, woven fiber, ivory, fur, nails and glass,
21 $^1/_2$ x 3 $^1/_4$ x 3 $^1/_4$ in. (54.6 x 8.2 x 8.2 cm.)
Robert P. Gordy Collection. 88.60

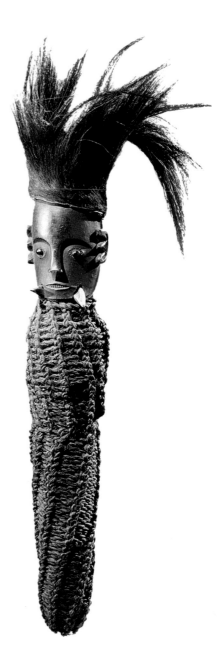

The Batak, consisting of six ethnic groups numbering three million, live in the mountainous highlands of Northern Sumatra, isolated by rugged, deep river gorges and impenetrable forests. This detachment from outside influences has kept their culture relatively pure for centuries, but in recent times Christianity, Islam and Dutch colonialism have made inroads upon the Batak.

Influential in Karo Batak society are magician-priests, called *guru*, who have extensive knowledge of the ancient religion and can perform a variety of useful practices and rituals such as fortune telling through contact with the spirits as well as administering to the sick. These high-ranking men can be identified by their distinctive coats and turbans with white cloths draped over their heads. During their professional duties the *guru* often use magic wands made of a tall bamboo or wood staff surmounted with single or multiple figures. It is believed that the magical powers of these wands include the ability to ward off evil, make rain, cause death, and guarantee the fertility of crops, animals and humans. Wands are rubbed with offerings and held by the *guru* as he performed special ritual dances.

It is unclear if this figure originally served as a finial for one of these wands or acted independently with apotropaic powers.

W.A.F.

MUSEUM FLOOR PLANS

Third Floor

- Non-Public
- Asian
- Pre-Columbian and Native American
- African
- Oceanic

Second Floor

- Decorative
- Photography and Graphics
- European
- American
- Louisiana
- Contemporary
- French
- Portrait Miniatures
- Furniture
- Fabergé

First Floor

- Italian
- Dutch
- Education
- Changing Exhibition
- Museum Shop
- Courtyard Cafe
- Stern Auditorium

New Orleans Museum of Art, 1 Collins Diboll Circle, New Orleans, Louisiana